POP ART: U.S./U.K. Connections, 1956–1966

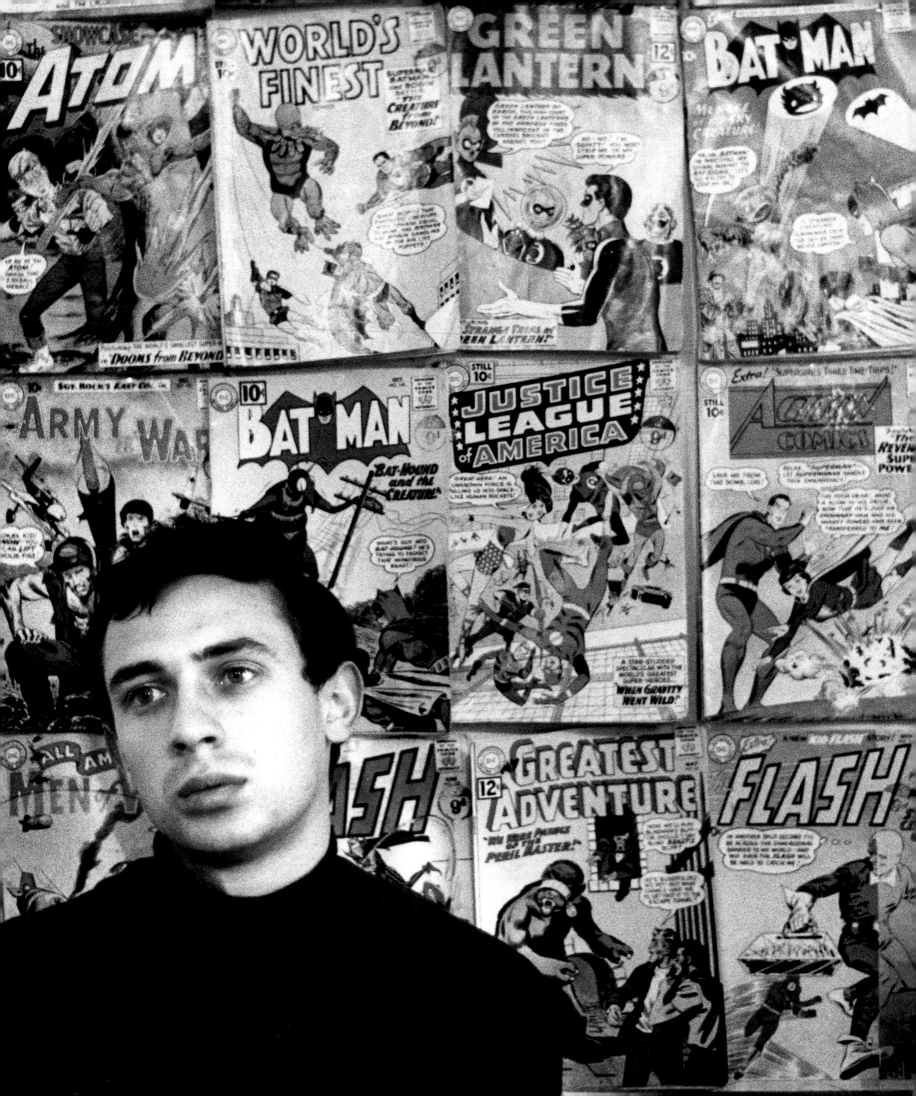

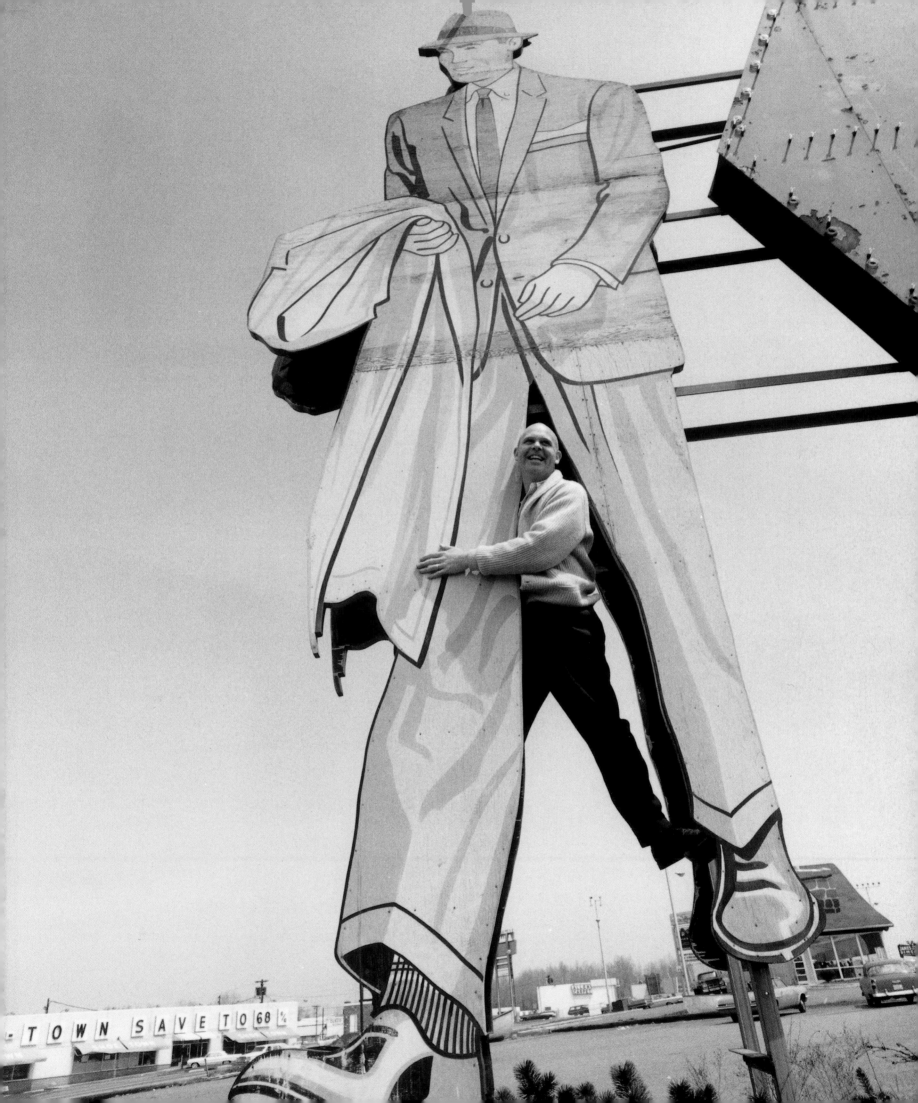

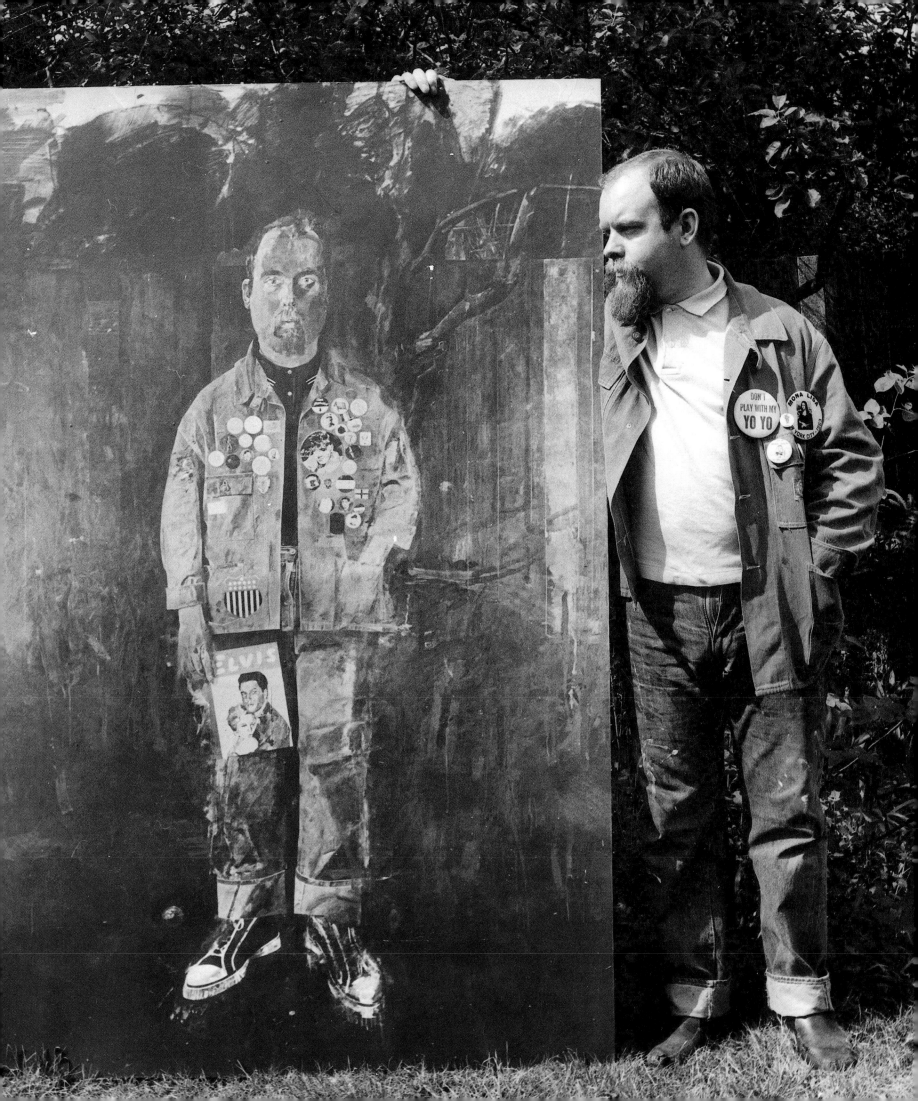

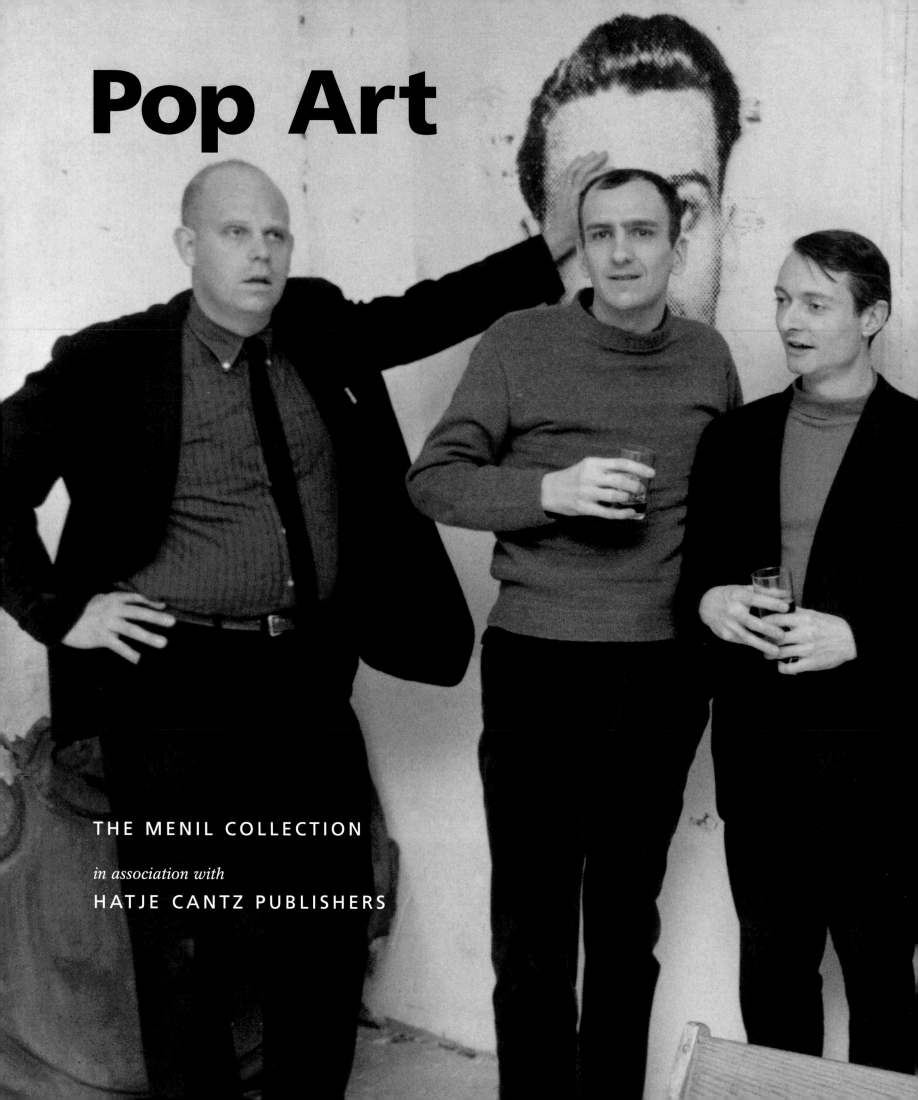

Pop Art

THE MENIL COLLECTION

in association with

HATJE CANTZ PUBLISHERS

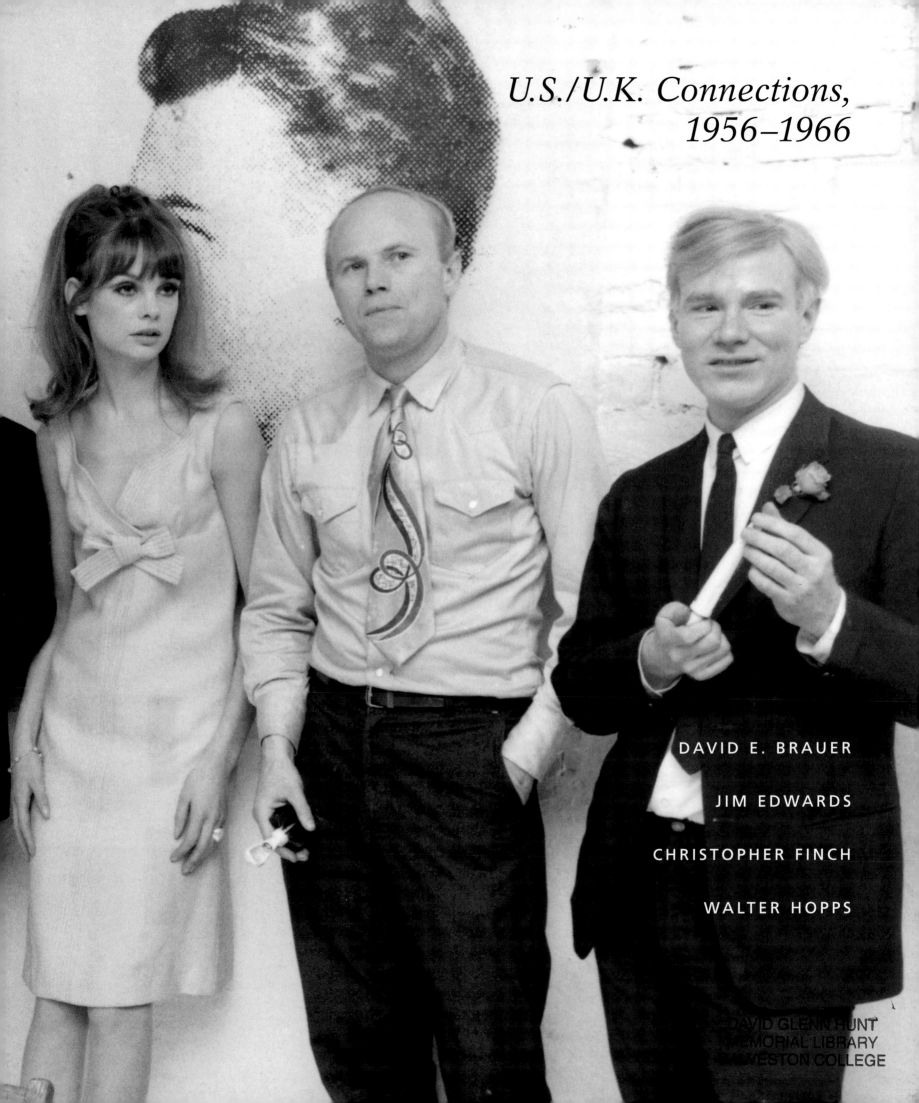

U.S./U.K. Connections, 1956–1966

DAVID E. BRAUER

JIM EDWARDS

CHRISTOPHER FINCH

WALTER HOPPS

This catalogue accompanies the exhibition
"Pop Art: U.S./U.K. Connections, 1956–1966."

The Menil Collection, Houston
January 26–May 13, 2001

This exhibition and catalogue are generously supported
in part by Nina and Michael Zilkha.

This project is also supported in part by a grant from the
National Endowment for the Arts, a federal agency.

cover: A 1959 Cadillac El Dorado parked in Parliament Square near
 Big Ben, London, 1962. Photograph by Robert Freeman.
page 4: Peter Phillips in his Holland Road studio, London, 1963.
 Photograph by Tony Evans.
page 5: Claes Oldenburg with roadside sign outside Newark, New
 Jersey, 1964. Photograph by Ken Heyman.
page 6: Andy Warhol with *Brillo Boxes* (1964) at his Stable Gallery
 exhibition, April 24, 1964. Photograph © Fred W. McDarrah.
page 7: Peter Blake with *Self-Portrait with Badges* (1961) outside his
 studio, London, 1963. Photograph by Tony Evans.
pages 8–9: Claes Oldenburg, Tom Wesselmann, Roy Lichtenstein,
 British model Jean Shrimpton, James Rosenquist, and Andy Warhol
 at a party in The Factory, New York, April 21, 1964. Photographic
 films used to make silkscreens for Warhol's *Most Wanted Men No. 10,
 Louis Joseph M.* (1964) hang on wall. Photograph by Ken Heyman.

Library of Congress Cataloging-in-Publication Data

Pop art : U.S./U.K. connections, 1956–1966 / David E. Brauer ... [et al].
 p. cm.
 Catalog accompanying an exhibition held at The Menil Collection,
Houston, Tex., Jan. 26–May 13, 2001.
 Includes bibliographical references and index.
 ISBN 3-7757-1023-X
 1. Pop art–England–Exhibitions. 2. Art, Modern–20th century–
England–Exhibitions. 1. Pop art–United States–Exhibitions.
I. Brauer, David E. II. Menil Collection (Houston, Tex.)

N6768.5.P65 P665 2001
709'.04'071074764235–cd21 00-0049551

Published by:
Hatje Cantz Verlag
Senefelderstrasse 12
73760 Ostfildern-Ruit, Germany
tel 49.711.440.50
fax 49.711.440.5255
www.hatjecantz.de

Distributed in North and
South America by:
D.A.P., Distributed Art Publishers
155 Avenue of the Americas, 2nd floor
New York, N.Y. 10013
tel 212.627.1999
fax 212.627.9484

Copyright © 2001 by Menil Foundation, Inc.
1511 Branard, Houston, Texas 77006

Printed in Germany

Contents

Lenders to the Exhibition

Bruno Bischofberger, Zurich

Terry Blake

Derek Boshier

Rosalyn Drexler

Betty and Monte Factor Family Collection

Hal Glicksman

Richard Hamilton

Jasper Johns

The Sydney and Frances Lewis Collection

The Patsy R. and Raymond D. Nasher Collection,
Dallas, Texas

Kimiko Powers

Edward Ruscha

Clodagh and Leslie Waddington

Alice F. and Harris K. Weston

Richard L. Weisman

and those lenders who wish to remain anonymous

Alan Cristea Gallery, London

Albright-Knox Art Gallery, Buffalo, New York

Allen Memorial Art Museum, Oberlin College,
Oberlin, Ohio

The Broad Art Foundation, Santa Monica

Frederick R. Weisman Art Foundation, Los Angeles

Fredericks Freiser Gallery, New York

Georges Pompidou Art and Culture Foundation

High Museum of Art, Atlanta

Hirshhorn Museum and Sculpture Garden,
Smithsonian Institution, Washington, D.C.

The Mayor Gallery, London

The Menil Collection, Houston

The Modern Art Museum of Fort Worth

Museum Ludwig, Cologne

The Museum of Modern Art, New York

Museum Sztuki, Lodz, Poland

Norton Simon Museum, Pasadena, California

Orange County Museum of Art,
Newport Beach, California

Royal College of Art Collections, London

San Francisco Museum of Modern Art

Solomon R. Guggenheim Museum, New York

Swindon Museum and Art Gallery,
Swindon Borough Council, England

University Art Museum, University of New Mexico
Fine Arts Center, Albuquerque

Virginia Museum of Fine Arts, Richmond

Yale Center for British Art, New Haven, Connecticut

Yale University Art Gallery, New Haven, Connecticut

Foreword and Acknowledgments

The relationship between art and culture is interdependent. Culture exists as a larger overall environment that underlies art, cinema, architecture, music, drama, literature, and dance, and finds popular expression in the applied arts such as design, fashion, advertising, comic books, and the realm of journalism, including magazines and television. The cultural world could be said to be an accumulation of stimuli, some high-minded, others crassly commercial. From time to time, the larger culture feeds aspects of the contemporaneous art.

In contrast, the world of art focuses emphatically on personal expression via traditional media such as painting, sculpture, and drawing, as well as newer ones like photography, video, installation, and language text. Art is the locus of the individual's attempt to realize his or her unique vision. Not intended for mass consumption, as is generally the case for culture, art is presented more often within a relatively rarified context: e.g., the private home, an art gallery, or the more public museum.

An important historical fusion occurred at the interface of art and culture in the early twentieth century with the two phenomena known as Dada and Surrealism. Artists in these movements were intent on demonstrating the social, political, and psychological relevance of everyday images and objects within the intellectual sphere of fine art. It is little wonder, then, that Surrealism in particular has remained a widely popular form of art—witness the crowds flooding museums for recent exhibitions of the work of Salvador Dalí and René Magritte.

During the postwar period, a movement developed between the late 1950s and mid 1960s that came to be called Pop Art. The very term "Pop"—previously applied to music that was not classical and required little, if any, academic familiarity—implies the deliberate use and adaptation of the vocabulary of popular culture. Pop artists in their studios were attempting to do what Robert Rauschenberg meant when he coined the phrase "working in the gap between art and life."

For many of these artists, the rich imagery available in popular culture was in decided contrast to the self-referential, nonobjective quality of Abstract Expressionism, where earlier American artists of the postwar period were still exerting a profound influence. Even before artists in the United States began actively working in this new genre, their counterparts in Great Britain were experimenting with Pop. "Pop Art: U.S./U.K. Connections, 1956–1966" examines the coincidences of timing and the relative differences between the art made in England and that made in America, including a further examination of the relationship between Pop Art on the East and West Coasts of the United States.

The exhibition had its genesis in the invitation extended by Paul Winkler, former director of The Menil Collection, and followed up by interim director Thomas Leavitt, to David E. Brauer and Jim Edwards, both professors of art history and independent scholars in contemporary art, to bring a fresh contribution to our understanding of this now historic movement. In addition to their curatorial duties of research and investigation, Brauer and Edwards produced essays and chronologies that succeed in embodying the separate aspects of U.K. and U.S. Pop in a revealing and personal manner. Walter Hopps, founding director of The Menil Collection and himself a crucial player in the early years of Pop Art, being the first American curator to organize a museum exhibition of these artists in a manner that cogently defined the phenomenon, was also instrumental in initiating this present undertaking. In an interview with Edwards, he provides a firsthand account of "New Painting of Common Objects," the seminal 1962 Pop Art exhibition at the Pasadena Art Museum. The esteemed British critic Christopher Finch has provided a similarly intimate look at those same years from the viewpoint of an active and knowledgeable participant in the British Pop scene. This talented foursome brings an unparalleled degree of insight and sensitivity to the subject.

Without lenders of art, there can be no exhibitions. I would like to warmly thank all the lenders listed on page 12 for their willingness to live without their treasured artworks for the period of time they have traveled to Houston and graced the walls of The Menil Collection.

Numerous individuals and institutions gave their generous assistance to the creation of this exhibition.

They include Douglas G. Schultz and Douglas Dreishpoon, Albright-Knox Art Gallery; Mitchell Algus, Mitchell Algus Gallery; Sharon Patton and Lucille Steiger, Allen Memorial Art Museum, Oberlin College; Tracy Bartley, R. B. Kitaj studio; Ivor Braka; Juliana Hanner, The Broad Art Foundation; James Corcoran and Tracy Lew, James Corcoran Gallery; Jessica Fredericks, Fredericks Freiser Gallery; Thomas Krens and Natasha Sigmund, Solomon R. Guggenheim Museum; Ella O'Halloran, Hayward Gallery; Lannie Ethridge, High Museum of Art; Phyllis Rosenzweig and Margaret Dong, Hirshhorn Museum and Sculpture Garden, Smithsonian Institution; Karen Holtzmann; Frederick R. Brandt, The Sydney and Frances Lewis Collection; Annette Lagler, Ludwig Forum für Internationale Kunst; William Brockmeyer and Michelle Kong, Marlborough Gallery, Inc.; Ariane Banks, Marlborough Graphics; James Mayor and Andrew Murray, The Mayor Gallery; Victoria Mikulewicz; Marla Price and Rick Floyd, The Modern Art Museum of Fort Worth; Liz Bradley, Museum of Contemporary Art, Los Angeles; Evelyn Weiss, Museum Ludwig, Cologne; Kirk Varnedoe, The Museum of Modern Art; Miroslaw Borusiewicz and Maria Morzuch, Museum Sztuki, Lodz; Ellen Gordesky, assistant to Raymond Nasher; Sara Campbell and Andrea Clark, Norton Simon Museum; Naomi Vine and Tom Callas, Orange County Museum of Art; Alan Selby and Juliet Thorpe, Royal College of Art; David Ross and Rose Candelaria, San Francisco Museum of Modern Art; Patricia Shea; Manny Silverman, Manny Silverman Gallery; Sylvia Sleigh; Louise Weinberg, archivist for Sylvia Sleigh and the late Lawrence Alloway; R. C. Dickinson and Rosalyn Thomas, Swindon Museum and Art Gallery; Sandy Nairne, Tate London; Mark Cattanach, University Art Museum, University of New Mexico Fine Arts Center; Katharine C. Lee and Mary L. Sullivan, Virginia Museum of Fine Arts; Sir Thomas Lighton and Suzy Raffal, Waddington Galleries; Billie Milam Weisman and Mary Ellen Powell, Frederick R. Weisman Art Foundation; Patrick McGaughey and Timothy Goodhue, Yale Center for British Art; and Jock Reynolds and Lynne Addison, Yale University Art Gallery.

The many individuals who helped in researching the Pop period include Irving Blum, Jim Eller, John Kaiser, Dorothy Seiberling, and John Weber. The generous bequest by Rosalind Constable of her papers to the Menil Archives has proved an important resource for vintage materials on the Pop era.

A number of others were instrumental in helping to acquire a wealth of photographic documentation. They include Susan Backman, San Francisco Museum of Modern Art; Terry Blake; Julie Braniecki; Patti Bratby; Woodfin Camp; Mikki Carpenter and Thomas D. Grischkowsky, The Museum of Modern Art; Mary Dean and Paul Ruscha, Ed Ruscha studio; Jeanie Deans, Carroll Janis, David Janis, and Sidney Janis Gallery; Marci Driggers, Modern Art Museum of Fort Worth; Caroline Edwards, Tony Evans Estate; John English and Armet Davis Newlove & Associates; Erin K. Fitzpatrick, Salander–O'Reilly Gallery; Robert Freeman; Carlotta Gelmetti and Marc Nowell, Tate Gallery Publishing; Karen Hanus, Museum of Contemporary Art, Los Angeles; Michael Harrigan, James Rosenquist studio; Martin Harrison; Penny Haworth, The Whitworth Art Gallery, The University of Manchester; Courtney Herman; David Hillman; Dennis Hopper and Julia Paull, Alta Light Productions; Nicole Hungerford, Norton Simon Museum; John Kasmin; Steven Konover; Karen Kuhlman, David Hockney studio; Shelley Lee, Roy Lichtenstein Estate; Cassandra Lozano; Anthony Martinez; Fred W. McDarrah; Robert R. McElroy; Margaret Mims and and George Zombakis, Museum of Fine Arts, Houston; Melina Mulas, Archivio Ugo Mulas; Peter Namuth, Hans Namuth Estate; Gabriel Navar, Mel Ramos studio; Dr. Roswitha Neu-Kock, Stadt Köln Rheinisches Bildarchiv; Michael Parkin; Liz Parks; Thomas Powel; Hope Pym, *Private Eye*; Seymour Rosen; Vivian Rowan; Delmore E. Scott; Odyssia Skouras; Joanna Stasuk, Leo Castelli Gallery; Michael Stier; Jim Strong; Stephen Stuart-Smith, Allen Jones studio; Sarah C. Taggart, Jasper Johns studio; Suzanne Warner, Yale University Art Gallery; and Sarah Waters, News International Syndicate.

In coordinating the exhibition, Alberta Mayo oversaw all the details of the project from start to finish, scrupulously tracking all that needed doing with impressive diligence and endurance, and providing indispensable assistance and advice. For the design of this catalogue, thanks go to Don Quaintance, Public Address Design, whose involvement in

the content as well as the form of this beautiful publication was integral. Elizabeth Frizzell ably assisted with design and production. Polly Koch provided expert editorial work on all aspects of the writing.

We are fortunate at the Menil to have a gifted and dedicated staff of art professionals. Julie Bakke, our registrar, and her assistant Carol Shanks executed innumerable loan requests. Our conservation department, headed by Carol Mancusi-Ungaro, gave careful attention to the exhibition's sometimes delicate works, and Brad Epley assisted with the examination of paintings. In researching the Pop period, Librarian Phil Heagy located books, Linda Fernandezlopez provided research assistance, and Mary Kadish supplied data on works in the collection. Our team of art handlers, Buck Bakke, Gary "Bear" Parham, and Doug Laguarta, seamlessly moved and installed the exhibition's works. Thanks also go to Deborah Brauer, head of exhibitions; Mark Flood, exhibitions associate; Tony Martinez, program coordinator; Vance Muse, director of communications, and his assistant Melissa Brown; Geraldine Aramanda, archivist, who provided editorial assistance; Gayle de Gregori, administrative assistant; and Lana McBride and Kristin Schwartz-Lauster for their great perseverance.

On behalf of The Menil Collection, I would like to acknowledge the generous support of Nina and Michael Zilkha whose contribution helped make both this exhibition and catalogue possible. In addition, The National Endowment for the Arts has provided an important grant toward the realization of this project. I would also like to express my thanks to the board of directors of the Menil Foundation, which provided wholehearted support for this endeavor.

Looking back from the vantage point of forty-five years, we believe that through this exhibition and publication Pop Art demonstrates its importance and vitality. What was once seen as new and different can now be understood with greater insight and seriousness. The Menil Collection offers this opportunity to our visitors in the hopes that we may see the present more clearly with the perspective that only the past can provide.

Ned Rifkin, *Director*
The Menil Collection
Menil Foundation, Inc., Houston

Introduction

Pop Art has often been considered an essentially American phenomenon, but in fact British artists and theorists in the 1950s were the first to debate and formulate Pop's main tenets. Soon a number of artists on both sides of the Atlantic would be radically redefining the subject matter deemed fit for aesthetic use. These Pop precursors began "letting the world in" by taking up the objects and events of everyday life now being refracted through the prism of a pervasive mass media culture. Both the British and American artists who were eventually grouped under the rubric of Pop Art looked toward the United States as the primary source of this subject matter. The result was a radical new form of contemporary expression in the visual arts.

As the essays in this book make clear, Pop Art was not a movement in the conventional sense. It promoted no specific agenda other than the investigation of the prevailing American environment, focusing on the worlds of entertainment, mass media, and technology. The connections linking American and British Pop Art were a shared interest in American culture, an acceptance of a clearly delineated iconography, and a general desire in the art to make a fresh approach to contemporary life. Even the moniker "Pop Art" was much debated: it began as shorthand for popular culture, then evolved to describe the artistic expressions of that culture. Yet there was no collective effort on the part of the artists involved to formulate a "school of Pop Art." In the United States especially, during Pop Art's infancy, artists associated with this mode of expression may have worked on closely related themes and subject matter, but it was almost always in near isolation from one another. Even though many of the British and American artists chafed at being labeled Pop, intent on developing their work along decidedly more individual lines, this did not deter curators, critics, gallery dealers, or mass media itself from collectively lumping the artists together for purposes of exhibition, coverage, and promotion. Many were still being pegged as Pop artists long after any semblance of a movement had vanished, movements in art being somewhat akin to carnivorous plants in nature: easily entered, but difficult to escape.

We have elected to present in this exhibition only art-work by those American and British practitioners of what we consider "pure" Pop. This definition of Pop begins with the aforementioned adoption of preexisting or received images from mass media sources of advertising, television, and movies, and shows the personalities, common objects, and scenery of vernacular culture. Beyond this point of agreement, however, American and British Pop artists moved along two parallel and fundamentally cohesive tracks. In terms of technique, the Americans generally used a more reductive method, arriving at a centralized iconic image, while the British preferred an episodic approach that generated an implied narrative. In part, British Pop arose in response to the seductiveness of Abstract Expressionism—which was not widely exhibited in London until the later 1950s—and so tended to be more painterly. American artists, on the other hand, had thoroughly digested and, for the most part, rejected overt evidence of the brush stroke; their response was more to the hard-edge and color field abstraction that was concurrently emerging in the United States. On the psychological front, both British and American artists sought in a serious way to reflect elements of American popular culture while exploring its relationship to, and impact on, high culture. But where the British were more self-conscious, and hence didactic, about this encounter with a culture once removed, the Americans easily embraced the products of their own society in a matter-of-fact and largely unreflective manner.

"Pop Art: U.S./U.K. Connections, 1956–1966" makes no claim to be either the definitive statement on the period or an encyclopedic examination of Pop Art. A shared language and a mutual fascination with American brand names and media stars connected the otherwise parallel but separate pop cultures of the United Kingdom and the United States during this decade. Nor do this exhibition and its accompanying book support an uncritical acceptance of the mythology that so quickly accrued to the period. Our curatorial points of view, in fact, are highly personal, each of us formulating the exhibition's two elements largely independently of one another [Jim Edwards with American Pop and David E. Brauer with British Pop]. But in an attempt to link British and American Pop

Art, and to present a more equitable history of Pop Art in general, we have selected works that point to its interrelated developments. Because certain works, especially in American Pop, have been so widely and repeatedly reproduced, attention was also paid to presenting a selection of less seen but equally important examples.

In our research we were guided by the wealth of written information on Pop Art. We took particular note of the primary critical writings and documentation available from the time of Pop Art's emergence. An added dimension has been provided by the contributions of the American curator Walter Hopps (in an interview with Jim Edwards) and by British artist and critic Christopher Finch, both of whom were intimately acquainted with this time in art history. The lion's share of published Pop Art documentation has been devoted to American artists, particularly those in New York, due in part to the enormous amount of press dedicated to American Pop and to the greater number of venues available to its artists. We believe that one result of this comparative look at Pop Art in Britain and America will be an alleviation of this imbalance.

The American selection stresses an evaluation of Pop from the vantage points of the two principal cities where the issues of American Pop Art were explored and its artifacts exhibited: New York and Los Angeles. Interestingly, most of the American Pop artists had grown up in other locales, primarily in the Midwest, before congregating at these densely populated points on the East and West Coasts. A major subtext of this book is the how the art produced at these two American geographic extremes intersected. In contrast, British Pop Art originated from one center: London. Its artists were concentrated even further by their association—as students and teachers—with the city's art schools. London was a city on the rebound from the devastation of World War II. Seeking a way out of the pall of gloom that hovered over old Europe, young British artists looked to America's freewheeling and highly visible prosperity for inspiration, and their early ventures into popular American culture helped initiate Pop Art. For a decade this new art form would connect the aesthetic concerns of all three cities: London, New York, and Los Angeles.

We consider the ten years from 1956 through 1966, which bracket this exhibition and book, to represent the classic era of transatlantic Pop Art, a time when its definitive works were produced in both the United Kingdom and the United States. The window of public visibility for American Pop Art, in particular, was very small—less than four years. Recognized as a new form of iconographic image-making by the latter part of 1962, Pop Art in 1965 was being declared over by Andy Warhol, who was only saying aloud what many Pop artists were already keenly aware of. In fact, by the end of this period on both sides of the Atlantic, most Pop artists were already moving in new directions. The tenor and texture of Pop had changed, and the vast majority of what has come to be widely recognized as the canonical images of Pop already had been created.

One of our primary goals was to remove the filters imposed by the late sixties, which have obscured the serious achievements of early Pop in a haze of psychedelic imagery and bubblegum-color design. The classic Pop included here is not a prologue to this later diffusion of the movement, but the real thing. The elliptical statements of Pop Art's most visible spokesman, Warhol, have tended to contribute to a misguided apprehension of Pop Art as a jokey spoof. On the contrary, all the British and American Pop artists were making a serious attempt to assimilate—rather than ignore—the elements of modern media culture. We believe a fresh and unencumbered look at the works themselves proves this point.

The speed at which Pop Art excited the popular imagination was a corollary to the very brief period of time in which Pop Art blossomed. Like much of its subject matter, the central elements of Pop Art had a relatively short shelf life. Nevertheless, classic Pop manifestations would continue to reverberate throughout both countries, not only through high art but also in the presentation and packaging of the culture from which it arose.

David E. Brauer and Jim Edwards
Guest Curators

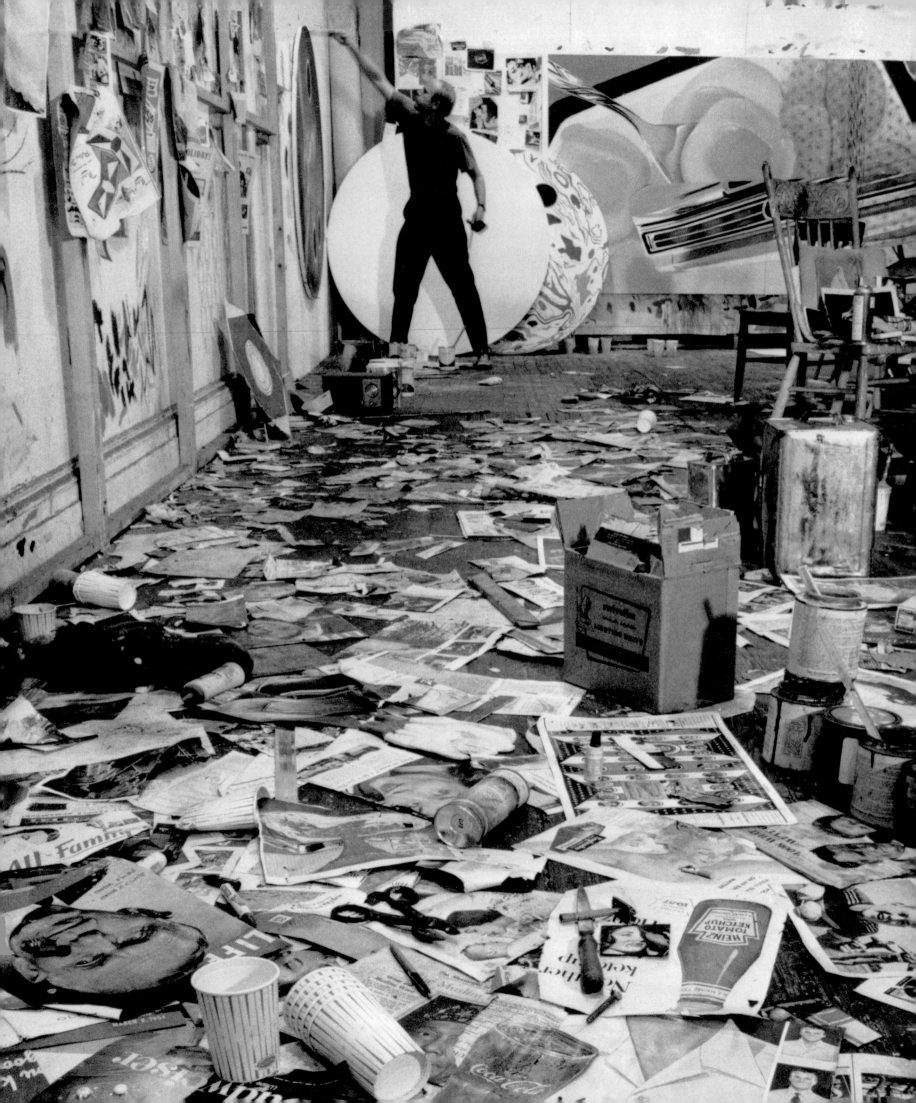

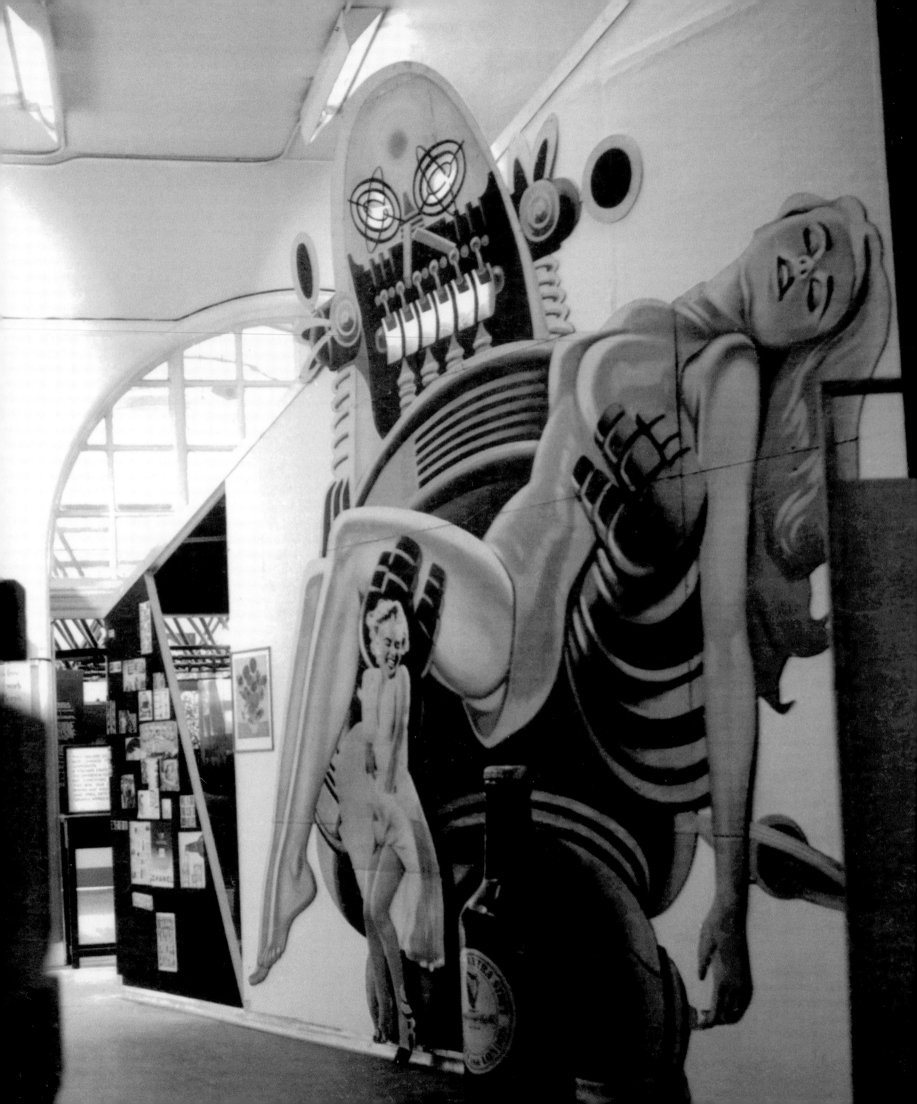

London Pop Recollected

CHRISTOPHER FINCH

Revisiting the many accounts of Pop Art that have accumulated over the past three and a half decades since Mario Amaya's pioneering 1965 study, *Pop as Art: A Survey of the New Super Realism*, I am struck by how the events of those years have frozen into a kind of Popsicle version of history. There has been some worthwhile writing about Pop Art by Lawrence Alloway, Lucy Lippard, John Russell, Marco Livingstone, and others, but the further we become removed from the period, the more Pop Art is presented as yet another set piece movement, much like all those that preceded it.

In the case of British Pop Art, in particular, I detect much oversimplification, especially in the potted narratives found in general histories and reference works. To some extent, this is inevitable, but it is difficult to accept for those who had a personal investment in the period, especially since the oversimplifications have themselves become oversimplified into *idées reçues*. The standardized version of the story includes stock references to "the repudiation of Establishment art," "the revolt of the younger generation," and "the imagery of the mass media," especially "American mass culture."[1] These themes are conventionally and conveniently set down in accordance with a timetable that first presents Pop's immediate antecedents beginning in the early fifties, then describes an initial breakthrough in 1956, and finally shows the movement coming to full maturity (if that is the appropriate term) in the early sixties. All of this is correct, so far as it goes, but it fails to convey any of the flavor of the period, and the chronology tends to distort the way in which events were perceived at the time. Where British Pop Art is concerned, event "A" did not always lead directly to consequence "B." As often happens, in fact, the pioneers

did not receive full recognition until after their heirs had already enjoyed a considerable measure of success. The seeds of Pop Art may have been planted by 1956, but the London art world was not ready for so radical a phenomenon until several years later.

When I enrolled at Chelsea School of Art in September 1957, London was a city still hung over from the effects of World War II. The urban fabric was pockmarked with bomb sites and a spirit of austerity remained pervasive. The only living British visual artists with significant international reputations were Henry Moore and Francis Bacon. Otherwise, London was looked upon by the art world as a stagnant backwater. More ominous still, it was acknowledged as provincial even by the artists who lived and worked there—and many of them liked it that way. It gave middle-aged painters the right to dress like bookmakers and sit in the Chelsea Potter, a local pub, arguing about the relative merits of James Abbott McNeill Whistler and Walter Sickert over pints of bitter and snorts of whiskey and soda. Among those who then enjoyed prominence in Establishment circles were more than a few who were proud to think of themselves as latter-day realist representatives of the Edwardian era Camden Town Group, while others saw themselves as continuing the struggle with systems of representation suggested by the later work of Paul Cézanne. As for the more established British nonfigurative artists—Ben Nicholson, Barbara Hepworth, and Victor Pasmore, for example—they proffered a somewhat gentrified form of Ecole de Paris modernism. There were, it's true, gutsier modernists on hand—Alan Davie and William Scott, for example—and members of the so-called St. Ives school—notably Peter Lanyon, Patrick Heron, Terry Frost, and Roger Hilton—

were attempting to come to terms with the legacy of Abstract Expressionism, but these painters had relatively little influence on the dominant mood of the London art scene.

This is not to say that there were not cracks in the prevailing façade of seedy gentility. Anyone familiar with the published histories of British Pop Art will be aware that a highly significant event in the evolution of the movement had taken place one year earlier. I refer to the now celebrated but then relatively obscure exhibition "This Is Tomorrow," held at the Whitechapel Art Gallery in the summer of 1956 (figs. 1, 2). This show was organized to provide a forum for the interests of the Independent Group, a loose federation of artists, architects, writers, and intellectuals that had come into existence at the Institute of Contemporary Arts (ICA) in 1952 and met regularly to discuss subjects ranging from American advertising iconography to science fiction to the onset of the computer age.[2] It was in connection with "This Is Tomorrow" that the term "Pop Art" was first used, its coining attributed to Alloway, who employed it not in its ultimate sense but as a description of what he saw as an unavoidable "continuum" between fine art and popular culture.[3] Of the artists who participated in "This Is Tomorrow," the most established at the time was Eduardo Paolozzi, who was known to garden-variety gallerygoers primarily for his Art Brut sculpture and less for the pop

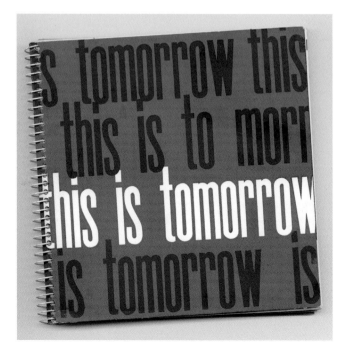

fig. 2. Cover of the exhibition catalogue *This Is Tomorrow* (1956), Whitechapel Art Gallery, London.

culture-derived collages and assemblages he had been making since 1947. In contrast, Richard Hamilton—who would be recognized in retrospect as the star of "This Is Tomorrow"—was largely absent from the London gallery scene in the late fifties. He in fact was patiently working on such seminal canvases as *Hommage à Chrysler Corp.* (1957), preparing his 1960 typographic version of Marcel Duchamp's *Green Box*, and lecturing in the fine art department of the University of Newcastle. His public impact on the London art world at that time, however, was limited to such under-remarked activities as the organization of "an Exhibit" at the ICA and occasional magazine contributions.

In the late fifties, any ambitious British art student was caught between the gravitational pull exerted by the Ecole de Paris—the afterglow was so breathtaking that it was hard to ignore—and the punk magnetism of the New York school. That attraction was an aspect of a British fascination with transatlantic culture in general: Hollywood movies, American music (jazz as well as rock), and American literature, especially the Beats. Allen Ginsberg's *Howl* and Jack Kerouac's *On the Road* were de rigueur reading matter, and copies of *Evergreen Review* were treasured. Few young artists could afford subscriptions to *Art News* or *Art in America,* but one could thumb through these periodicals at Zwemmer's on Charing Cross Road, the only London bookstore I'm aware of that carried them. In those pages, one learned of new American trends, but it was difficult to absorb the full implications of the work of Jasper Johns and Robert Rauschenberg when the British art world had not yet entirely come to terms with Abstract Expressionism and its offshoots.

In many respects, Britain over the past half century has been very successful in adopting American cultural innovations and transforming them into something distinctively British. Rock 'n' roll is the obvious example. An even earlier instance would be the Teddy Boys, who reinvented the zoot suit style with an aggressively British flair. Abstract Expressionism, however, did not translate, despite the fact that members of the British art scene spent years trying to crack the code, despite increasing exposure to New York school art (such as the 1958 Jackson Pollock exhibition at Whitechapel Art Gallery), and despite the fact that London could offer first-rate critics like Alloway and David Sylvester who wrote and spoke fluent Abstract Expressionese.

The problem was, perhaps, that Abstract Expression-

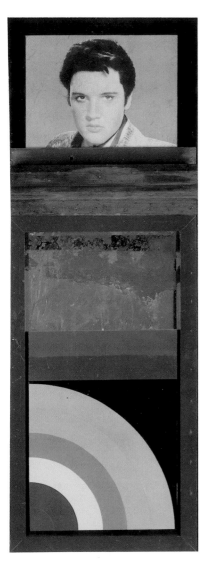

ism represented an attitude more than a language. Several British artists, such as Davie, Heron, and Hilton as well as young Royal College of Art (RCA) graduates like Richard Smith and Robyn Denny, learned the language well enough to make interesting visual statements, but while these were more than pastiches, they lacked the extra something that had enabled Pollock, Willem de Kooning, Clyfford Still, Mark Rothko, Franz Kline, and Barnett Newman to stand out from the established hierarchy of twentieth-century art. (In fairness, that extra something was also missing from the second generation of American Abstract Expressionists.) Colloquially, it might be called a "fuck you" attitude—hard to come by (at least in the context of abstract art) for middle-class painters in a country recently devastated by war, where many of their compatriots were still mourning the loss of empire. Since the early days of the London Group, formed in 1913 with a strong interest in Post-Impressionism, and the avant-garde Unit One of the thirties, nonfigurative art had been presented to British artists as something dripping with idealism and refinement. How then could it simultaneously be raw and confrontational? This was a problem that proved insoluble to the generation that came of age in the fifties.

fig. 3. Peter Blake, *Elvis Wall*, 1961, oil, printed reproduction, and wood, 43¼ x 15½ in. (110 x 39.4 cm), whereabouts unknown.

Pop Art would present an entirely different kind of challenge. When one is adapting images purloined from mass culture to a fine art context, an ability to understand and analyze visual languages is paramount. British artists proved to have a gift for this. Also, many of the students who entered art school in the late fifties were less rooted in empire-exalting Kiplingesque traditions than their immediate forebears. They were dissatisfied with the status quo, possessing an attitude—idiomatically described as "bolshy"—born of early frustration with the privations and class hypocrisies that fueled the postwar zeitgeist. Rather than embracing the kind of ersatz upper-middle-class bohemianism that had prevailed in the British art world for a century or more (despite the valiant efforts of Wyndham Lewis), they opted for a pseudo-blue-collar dandyism, heavily influenced by American rock and

movie stars such as Marlon Brando, James Dean, and Elvis Presley (fig. 3).

In part because of this, British Pop Art has commonly been presented as consciously political in nature. As early as 1969, for example, John Russell wrote in his introduction to *Pop Art Redefined* that "Pop in England was . . . a facet of a class-struggle, real or imagined."[4] The last phrase—"real or imagined"—is all-important here. I believe that the political nature of British Pop Art was fundamentally ambivalent and largely devoid of focused ideology. Certainly there were artists who marched to the weapons factory at Aldermaston to demonstrate against Britain's nuclear stance, and most of them voted Labor, but that hardly warrants handing out badges for radicalism, or even for strict class empathy.

It was difficult for a young and culturally aware artist in the late fifties and early sixties, whatever his or her background, to identify with rank and file members of a Trade Union movement that seemed determined to wallow in bitter memories of the General Strike of 1926, which briefly brought Britain to a near standstill before the Trade Unions buckled, let alone with the smug, pipe-smoking Labor Party leaders in their ill-fitting suits. (Hamilton had his tongue firmly in his cheek when he painted *Portrait of Hugh Gaitskill as a Famous Monster of Filmland*.) Even harder to accept, however, were the sugar-coated platitudes handed out by the sanctimonious leadership of the Conservative Party, especially after the 1956 Suez debacle, which saw Britain uniting in secret with France and Israel to invade Egypt and overthrow the nationalistic President Gamal Abdel Nasser.

It was in Bedford in 1957 that Prime Minister Harold Macmillan made a speech introducing the Tories' latest upbeat slogan—"You've never had it so good"—intended to usher in a postwar boom. Anxious for an end to austerity—fish fingers in every frying pan and an Austin Seven in every carport—millions of voters lapped up this glad-hand propaganda and along with it the notion that the nation's nuclear arsenal meant that Britain could retain its status as a superpower and hence its right to the wet dreams of abundant consumerism. Not everyone bought into this dubious utopianism, of course, and certainly most younger British artists were disdainful of what they saw as its preposterous claims. David Hockney, for example, ended a stint at Bradford Art School the year of Macmillan's speech and promptly lived up to his pacifist principles by refusing to be drafted into the armed services,

fig. 4. Richard Hamilton, *Hers is a lush situation*, 1958, oil, cellulose, metal foil, and collage on wood, 32 x 48 in. (81 x 122 cm), collection of Sir Colin St. John Wilson.

spending the next two years as a hospital orderly.

Immunity to the sort of rhetoric practiced by the Tory leadership did not in itself guarantee political upheaval, however, nor even ensure the pantomime of revolution enacted from time to time within the London art world. In looking at this aspect of British Pop, it's important to distinguish between the older artists who had contributed to "This Is Tomorrow" (Hamilton was born in 1922) and the younger painters who emerged in the early sixties (Peter Phillips was born in 1939). There were two distinct generations here, and this was reflected in their cultural and political stances.

Hamilton and Paolozzi, for example, had grown up in the Depression and had been through World War II as adults. Their experiences made them skeptical of glib political promises without rendering them overly cynical.[5] Both—Hamilton in particular—possessed a strongly analytical turn of mind that made them suspicious of easy solutions. Their sympathies were with the political left, but they understood from their scrutiny of American advertising and mass culture imagery and methodology that the world was changing in ways that defied easy socialist dogma. As the sixties progressed, Paolozzi came to embrace American pop culture wholeheartedly, expressing special admiration for masters of creative kitsch such as Walt Disney. Hamilton's point of view, on the other hand, could best be expressed as fascinated ambivalence. In paintings such as *Hommage à Chrysler Corp.* and *Hers is a lush situation* (1958, fig. 4), he both dissected and celebrated the popular culture of mid-century America. To

think of work of this kind as being representative of a class struggle in any straightforward way is, to my mind, entirely misleading.

As for the younger Pop artists—especially the group that emerged from RCA in the early sixties—they encountered success at an age when youthful idealism can all too easily be confused with more mature political attitudes; early public acceptance may even have stunted their political evolution. As it would be foolish to attribute a common political attitude to these diverse and complex characters, I find it hard to interpret the younger wing of British Pop as constituting a monolithic bloc in favor of "the class struggle," nor did I ever hear any member of the group claim that this was the case. It should be acknowledged, however, that several of the younger artists associated with the second wave of British Pop did make effective use of overtly political imagery. Some of Derek Boshier's paintings, for example, refer to events such as the Sharpsville massacre in South Africa in which the police brutally repressed black dissidents, and his employment of pop imagery was often inflected with a marked critique of consumerism. Pauline Boty produced canvases that both celebrate the Cuban revolution and anticipate feminist concerns that had not yet gained wide currency. Yet only one of the younger artists associated with British Pop—Colin Self—was consistent in producing politically explicit art and then in a very idiosyncratic way.[6]

In his references to class struggle, John Russell suggests that the British Pop artists were advocates for science and cybernetics and opponents of the humanities.[7] I think

this is misleading (someone like Hamilton, while certainly for science and cybernetics, was hardly against the humanities), but it does hint at an important truth: the social group that these artists most identified with, consciously or not, was the new middle class—distinct from the traditional bourgeoisie—to which scientists and technocrats belonged, as did many people in the media and in the fashion world that was about to play such an important role in British culture. Members of this class tended to be capitalists by instinct, yet somewhat left of center in their social leanings and cautiously anti-authoritarian. They, too, marched to Aldermaston (those who were not actually involved in building the bomb). Many of them voted Labor and felt sympathetic to Fidel Castro in a rooting-for-the-underdog sort of way. But only retrospectively—and with the help of mytho-historical license—can their political attitudes be seen as belonging to any radical-proletarian tradition. In practice, they were (dare we say it?) liberals. In the sixties, many of them would find themselves far more in sympathy with the American middle-class dissidents who supported integration and opposed the Vietnam War than with any of the sociopolitical conventions then current in the British Isles. From the outset, they were very open to American culture, especially the demotic variety.[8]

It is difficult today to convey just how exotic American popular culture seemed in postwar Britain. It's true that American films and records had been easily accessible for half a century, and shows like *I Love Lucy* and *Gunsmoke* had found their way into British television schedules, but that was mainstream fare. When it came to hot rod magazines, obscure rhythm-and-blues records, or genuine American Sunday newspaper comics, to stumble upon a cache of these in Britain was almost like unearthing Tutankhamen's tomb.[9] American cars were simultaneously ridiculed and worshiped. Levi jeans were fought over on the rare occasions when they appeared in stores.

Very few Brits actually visited America in the fifties, and only a handful of under-forty artists—such as William Turnbull, Bernard Cohen, and Anthony Caro—made it to New York. Thus, Smith's move there for two years in 1959 as a recipient of a Harkness Fellowship proved something of a turning point. Smith had written articles about popular culture as early as 1956, and by the time he arrived in New York, he was already incorporating shapes and col-

ors derived from packaging and advertising art into paintings that otherwise employed a formal language still owing a good deal to the Abstract Expressionists. In these works, Clement Greenberg's never-the-twain-shall-meet division between high art and kitsch was definitively challenged.

Soon everyone would be heading for Manhattan and points west, but British artists in the meantime busied themselves with cutting out ads from *Life* and *Esquire*, pinning them to walls, and pasting them into sketchbooks. A few began going beyond that. By 1959 Peter Blake—who had graduated from RCA four years earlier—was incorporating photographs clipped from movie magazines and other ephemera as collage elements in paintings such as *Girlie Door*, works that were otherwise laid out as casual geometrical abstractions. Even earlier, in *On the Balcony* (1955–57), he had made a proto-Pop "painted collage" in which items such as a *Life* magazine cover were reproduced by hand. A very different hand-painted Pop image dating from 1958 was Tony Messenger's *30th September, 1955*, a graphic portrayal of the wrecked Porsche in which James Dean met his death. Messenger was yet another RCA product, as was William Green, a flamboyant self-promoter who had already achieved considerable notoriety as the "bad boy" of English painting. In the late fifties, Green began to integrate photographic images of pop icons into his oeuvre, which till then had derived from Action Painting in a rather obvious way. His Errol Flynn show at the New Vision Centre Gallery was one of the talking points of London's would-be avant garde in 1959, though his choice of hero soon appeared somewhat dated.

That was an auspicious year for RCA. Hockney, Boshier, Phillips, and Allen Jones were all in the entering class in 1959, joining Boty, who had enrolled a year earlier. They were followed in 1960 by Patrick Caulfield, the same year that Jones was expelled, apparently as an example to other students who dared to flaunt traditional standards. Also a key player in the RCA scene was R. B. Kitaj, who transferred there from the University of Oxford's Ruskin School of Drawing in 1959. As an American—admittedly one who had immersed himself in European culture—Kitaj was looked on as a guardian of the Holy Grail. The fact that he could make verifiably contemporary paintings that incorporated rich imagery and complex constellations of multicultural references made him a potent model for the other students.

Nevertheless, some members of this group continued

to struggle with the implications of Abstract Expressionism. When I was introduced to Hockney late in 1959 or early in 1960, in the old RCA building adjacent to the Victoria and Albert Museum, he was dressed in blue overalls and a proletarian cloth cap, and was working on a canvas that seemed to derive somewhat from Davie's paintings—a loose abstraction incorporating seemingly random letters. (This may have been one of his so-called "vegetarian propaganda" pictures, now lost.) I was very impressed: it was the most accomplished student painting I had ever seen. As I recall, the way the letters were painted reminded me of Johns' number paintings, and certainly by this point the RCA students were thoroughly familiar with Johns' early targets and flags, as well as with Rauschenberg's combines.

In fact, from about 1960 onward—as the availability of American art publications improved in response to demand—British students became aware of new developments in American art almost instantaneously, so that the New York Happenings were discussed enthusiastically, and the work of emerging artists like Jim Dine and Claes Oldenburg was known virtually overnight. Meanwhile, Kitaj was making explicitly figurative pictures, such as *The Red Banquet* (1960) and *The Death of Rosa Luxembourg* (1960), while Hockney responded with images like *The First Typhoo Tea Painting* (1960). Boshier was quick to explore the emerging idiom with works like *Man Playing Poker and Thinking of Other Things* (1961), and Phillips added a new element to the mix when he began to produce paintings such as *Purple Flag* (1960) that blended pop imagery with somewhat hard-edge decorative elements deriving, in part at least, from his early training as a mechanical draftsman. Works by these artists attracted a great deal of attention at the 1960 and 1961 editions of the annual "Young Contemporaries" exhibition, a large juried show held annually in London. During the same period, Blake's work was strongly featured in group shows at the ICA and several other galleries.

This flurry of art activity was matched by an increasing level of commentary. A body of critical writing supporting this kind of pop-inflected art had been quietly growing since the time of "This Is Tomorrow." Alloway and John McHale were its chief early British proponents, and Roger Coleman played a pivotal role during his tenure as editor of *ARK*, the RCA magazine. Also highly regarded were the ideas of Marshall McLuhan, whose 1951 book *The Mechanical Bride* was much prized; it was

particularly influential with Smith and Hamilton, whose highly analytical vision of Pop continued to evolve somewhat independently of the more spontaneous version practiced by the younger painters. Both, of course, were aware of the younger artists' work, as was Paolozzi, who was pursuing Pop-related projects including collage books such as *Metafisikal Translations* (1962).

This was a time of growing ferment in the London cultural scene as a whole. In architectural circles, for example, members of the Archigram group were circulating visions of the future derived from many of the same sources used by the Pop painters. The Beatles were still in their Hamburg phase (as was Paolozzi, who was teaching at the Hochschule für Bildende Künst), but the British rock explosion was about to happen, and it is far from irrelevant to this discussion to note that a large number of future rock legends, including Keith Richards, Eric Clapton, Pete Townshend, and Ray Davies, were students at art schools in or near London during the early sixties, exposed to the same influences as the younger Pop painters. Mary Quant had already inaugurated the British revolution in women's fashion that would give the world the miniskirt; several of her immediate successors—such as Ossie Clark, Sally Tuffin, and Marion Foale—were then students at RCA. Men's clothing had found a new home in Carnaby Street with a further link to RCA in the form of Domino Male, a pioneering boutique that opened in 1960, decorated by Michael Davies, a recent RCA graduate, in an eclectic blend of Saul Bass and high Italian camp.[10]

For a while, the artists were the ones who took the lead, and the symbolic event that marked their arrival on a stage larger than the one afforded by the ICA and the Cork Street galleries was a documentary film by Ken Russell—soon to become internationally famous for feature movies like *Women in Love* (1970) and *Tommy* (1975). Called *Pop Goes the Easel*, the film attempted to define the emerging Pop Art movement in Britain. News that this opus was being planned was greeted with much scorn in pubs like Finch's and the Queen's Elm, where the art community congregated. "A pretentious waste of energy" was a common opinion, as was "a ridiculous title."[11] The film was made, however, and shown on *Monitor*, the BBC's weekly cultural magazine show, in March 1962.

Ken Russell had produced shorter *Monitor* segments

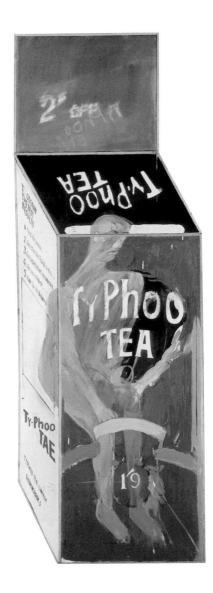

on artists including Green (shown making an Action Painting by riding a bicycle across a canvas spattered with paint), but this project was altogether more ambitious, not only because of its length (50 minutes) but because it presumed to identify a whole new movement. Ken Russell had wanted to use Hockney as one of the four featured artists, but Hockney was in America when the show was to be shot, so the filmmaker settled on Phillips, Boshier, Boty, and Blake.[12] *Pop Goes the Easel* was not exactly profound in its exploration of the fledgling movement, but it did permit the artists to define their aesthetics in catchy visual terms—Phillips riding around London in a big American convertible, for example—and it gave British Pop Art an immediate legitimacy with the general public. Millions of people who had never been to a London gallery, let alone seen a Pop painting, could now believe that they knew what Pop Art was all about.

After this flashy start, the role of publicist for British Pop Art fell to Hockney, who embraced it with enthusiasm and flair. Hockney had quickly become a legend in the London art world, both for Pop-inflected paintings such as *A Grand Procession of Dignitaries in the Semi-Egyptian Style* (1961) and *Tea Painting in an Illusionistic Style* (1961, fig. 5) and for his personal demeanor. As has been amply documented, he returned from his first visit to America in the summer of 1961 sporting platinum bleached hair and a new wardrobe that included a gold lamé jacket.[13] Journalists were not slow to pick up on Hockney's evident willingness to be noticed. *Queen* magazine featured him in February 1962, and before long he was a media darling on a par with the movie stars and rock idols of the era. Without the attention that accrued to Hockney, in fact, it is questionable whether British Pop Art would have achieved the international recognition that it did—this despite the fact that he was a Pop artist only by the loosest of definitions.

In 1962, however, loose definitions were all that critics

fig. 5. David Hockney, *Tea Painting in an Illusionistic Style*, 1961, oil on canvas, 78 x 30 in. (198 x 76 cm), Tate Gallery, London.

fig. 6. David Hockney working on etching series *A Rake's Progress* (1961–63), Royal College of Art print studio, London, c. 1963. Photograph by Tony Evans.

had, and Hockney's work was impressive—especially in the provincial context in which it was first seen. The two paintings mentioned above, made in the self-described "semi-Egyptian" and "illusionistic" styles, belong to a group of four that were shown at the 1962 "Young Contemporaries," the others being *Figure in the Flat Style* (1961) and *Flight into Italy–Swiss Landscape* (1962). Taken together, these were intended as a tour de force demonstration of Hockney's mastery of various idioms then current. As such, they made an enormous impact on the younger British artists. Of the quartet, only *Tea Painting in an Illusionistic Style*—based on the packaging for Ty-Phoo Tea—is truly Pop. Still, advocates of the evolving movement could not afford to ignore Hockney's contribution, and they extended the definition of Pop to include his etchings for *A Rake's Progress* (1961–63, fig. 6), which after all were set in contemporary New York, and his early homoerotic paintings and drawings, many of them based on photographs reproduced in the Los Angeles magazine *Physique Pictorial*, which the artist took as the basis for his vision of a gay domestic Arcadia.

The link between Kitaj and Pop Art was equally tenuous. Certainly, the way he combined fragments of imagery—captured with an assured graphic touch—with patches of pure color and painterly gestures had a vernacular liveliness that caught the imagination of the younger painters.[14] But Kitaj's subject matter, with its allusions to high art,

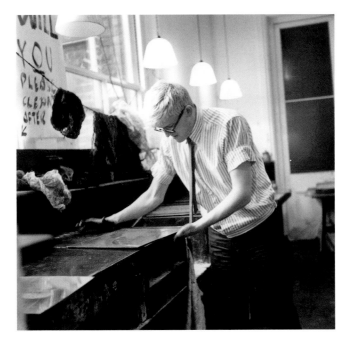

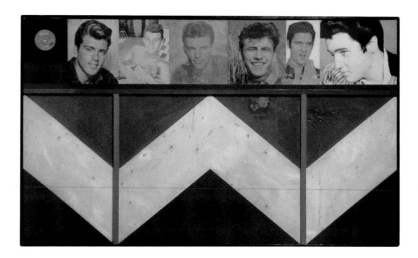

fig. 7. Peter Blake, *Got a Girl,* 1960–61, oil, wood, printed reproductions, and 45 rpm record on wood, 37 x 61 in. (94 x 155 cm), The Whitworth Art Gallery, The University of Manchester.

fig. 8. Richard Smith in his studio in front of *Gift Wrap* (1963), London, 1963. Photograph by Tony Evans.

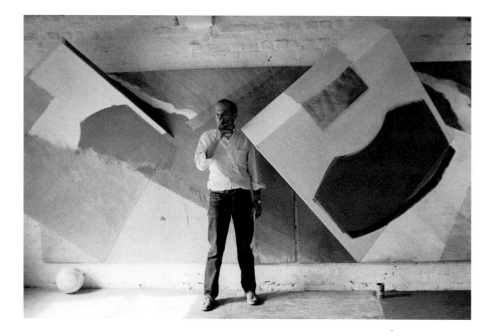

literature, and politics, was in many ways at odds with the content of Pop proper. Back in the early sixties, however, the distinction was blurred since it was so desirable to have Kitaj—like Hockney—in the British Pop pantheon: it was major art world news when Kitaj signed on with the Marlborough New London Gallery, then considered England's most important commercial venue for contemporary art.[15] In retrospect, Kitaj's position in that pantheon is justified by the impetus he provided to the movement, by his example as a manipulator of visual languages, and by his stylistic influence on painters like Hockney, Boshier, and Jones. It might be added that he

encouraged British artists to think, though their thought processes sometimes took them in directions he might have found disconcerting.

The third major influence, as the sixties began to turn into "The Sixties," was Blake, who had his first solo show at the Portal Gallery in 1962. One imagines that Blake would have evolved much as he did even if the RCA generation had never happened. His interest in popular culture was firmly in place by the mid fifties, when he painted *Children Reading Comics* (1954) and *Loelia, World's Most Tattooed Lady* (1955). A few years later, he was making collage constructions, such as *Got a Girl* (1960–61, fig. 7), that are now deservedly considered among the classics of British Pop. Although he often incorporated images taken from American sources, Blake remained profoundly British. There is a strain in his work that brings to mind the art of Carel Weight, on staff at RCA from 1947 to 1973, who managed to invest a provincial vein of realism with such an intensity of feeling and affection for his subject matter that his paintings were able to transcend the presumed limitations of their genre. Blake's collage constructions are as near as he would ever come to assimilating the international idiom of the time, and they were justifiably influential.

Just as important was the influence that Blake exerted through his personal relationships. He was an indefatigable organizer of trips to such events as the Hampstead Heath fair, the tent show that visited Clapham Common every summer, and wrestling matches at the Albert Hall. These occasions prompted endless discussions on aspects of popular culture, both British and American, ranging from *Beano* comics to Norman Rockwell, from the fortunes of the Fulham football team (which Blake avidly supported) to the current James Bond movie, and from the rise of Stax Records to the exploits of the Temperance Seven.[16]

All of the younger Pop painters learned from Blake, showing his stylistic influence sometimes quite overtly—as was the case with some of Boty's canvases, such as *5-4-3-2-1* (1963) on which the title is blazoned in ornate fairground lettering—and sometimes more obliquely. What all of them had in common at this early stage was a willingness to combine imagery derived from popular culture with graphic elements derived from a knowledge of contemporary abstract art. It should be kept in mind that British Pop Art was not evolving in a vacuum. It was finding its way in a visual landscape that included not only

fig. 9. Allen Jones, *Second Bus,* 1962, oil on three canvases, 60 x 61 in. (152.4 x 155 cm), collection of Granada Television, Manchester.

emerging Pop influences as exemplified by various New York painters, but also the entire, vital world of nonfiguration, which most Pop artists had probably considered as an option in some form at one time or another. As British Pop made its mark, so in a less dramatic way did a new brand of British abstraction. Influenced by American art, yet displaying a healthy independence of spirit, this movement was in the hands of painters such as Denny, John Hoyland, and the Cohen brothers, Harold and Bernard—sometimes referred to as the "Situation" group after a pair of exhibitions that bore that name—as well as sculptors such as Caro and Turnbull. There was a good deal of interaction among these painters and sculptors and the Pop artists, which is evident in the way that British Pop images are structured.

This influence was strengthened in 1961 when Smith returned to London after a two-year sojourn in New York and a solo show at the Green Gallery, an early home to such American Pop artists as James Rosenquist and Tom Wesselmann. His paintings still displayed an allegiance to the Greenberg school of abstraction, but they now made more use than ever of references to popular culture—especially to the "soft sell" techniques of advertising art—evident in paintings such as *Revlon* (1960). Smith used scale to suggest the impact of billboards and of wide screen movies, and succulent color to evoke the seductive mood so prized by ad men, while in works such as *Gift Wrap* (1963, fig. 8) the actual pop icons remained veiled

in gestural paintwork. It might be said of these paintings that the artist had managed to separate the artistry involved in creating, say, an advertising campaign from its commercial exigencies—in effect, skimming the cream from advertising art and using it to create something new. Smith had a foot in both camps—abstraction and Pop—but his influence on the young RCA painters, and on students like Gerald Laing at St. Martin's School of Art where Smith taught for two years, was considerable. Not only did his own work have an impact, but he also provided a direct link to the New York scene, where he had already established the beginnings of a reputation.

Jones (fig. 10) was probably the most painterly of the younger Pop group and the one most concerned with formal plastic values, especially in his early work. Paintings such as *The Artist Thinks* (1960) seem almost entirely nonfigurative until one becomes acquainted with Jones' highly elliptical visual vocabulary. This remains true to a considerable extent of paintings like *Bikini Baby* (1962), although in this canvas the shape of a door and the components of a bikini swimsuit are fairly explicit. The series of London bus paintings, including *Second Bus* (fig. 9), he began that same year are easier to read, but these works still depend on broad areas of nonrepresentational color and a concept of space that derives partially from Abstract Expressionism. In fact, Jones' work of the period is replete with references to a wide variety of intellectual and aesthetic ideas to which he was being exposed at school and elsewhere, including the influence of Robert Delaunay as well as the Futurists and the Surrealists. Only in paintings like *Falling Woman* (1964) and *Curious Woman* (1965, pl. 45) does the fetishistic eroticism always latent in his work become fully articulated. It was

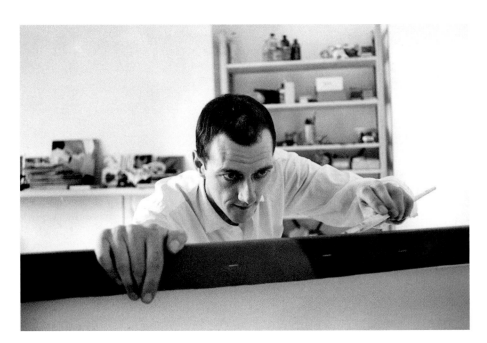

fig. 10 . Allen Jones working in his studio, London, 1963. Photograph by Tony Evans.

fig. 11. Derek Boshier, *The Identi-Kit Man,* 1962, oil on canvas, 72 x 72 in. (182.9 x 182.9 cm), Tate Gallery, London.

at this point that his pictorial language began to approximate more closely the tenets of Pop Art by recalling images found in girlie magazines and the Frederick's of Hollywood lingerie catalogue. Even then, however, Jones continued to display an almost Parisian finesse in his paint handling, which perhaps explains why he gained the attention of Arthur Tooth & Sons, Ltd., a relatively conservative London gallery where he exhibited from 1963 to 1970.[17]

Among the first of the younger group to gain attention was Boshier. His work was prominently seen at the 1961 and 1962 "Young Contemporaries" exhibitions, and his initial solo show, "Image in Revolt," at the Grabowski Gallery in 1962 was well received. His take on Pop owed something to both Hockney and Kitaj, but it displayed a distinctive personality. In early paintings like *Airmail Letter* (1961), he showed himself able to handle simple,

diagrammatic form to good effect. Beyond that, though, he was a skilled manipulator of imagery, often exploiting forms that (to use an anachronistic term) seemed to "morph" into something else. This is well illustrated in the so-called toothpaste paintings made in 1962. In *The Identi-Kit Man* (fig. 11), for example, a man's torso becomes a set of teeth being buffed by a toothbrush, and his arms and legs are transformed into candy-striped toothpaste. The painting is clearly a sardonic comment on consumerism, as is true of other Boshier works of the period such as *So Ad Men Became Depth Men* (1962), its title borrowed from Vance Packard's 1957 book *The Hidden Persuaders* (fig. 12). It is probably true to say, in fact, that Boshier seldom if ever celebrated pop culture in a wholly uncritical way, and in this he was typical of many British Pop artists. His work of the early sixties is sometimes quite complex in its organization and frame of reference, and it often has a definite narrative bent, as is the case with *The Most Handsome Hero of the Cosmos, Mr. Shepard* (1962, pl. 18), an oblique commentary on the space race. At the same time, Boshier could be painterly in an almost hedonistic way when he chose. He appropriated American imagery when he needed to, yet many of his paintings depend upon British references, from the Union Jack to Swan Vestas wooden matches. In his paintings, Boshier was critical of some of the underlying forces behind popular culture yet at the same time accepting of Pop iconography. In these respects, it could be argued, he was the typical British Pop artist, his talents rooted in his ability to see the ways in which the world was changing and to resolve some of the perceived contradictions—at least in his art.

Similar to Boshier in her range of interests, Boty was less adept at mastering and combining varied idioms. Boshier, who was a close friend, has suggested that her real talent was for collage,[18] and her more ambitious canvases, such as *It's a Man's World II* (1965–66, fig. 13), often resemble painted photomontages, a somewhat academic technique used to recreate images that originated in the viewfinder of a camera. Boty combined these images in rather basic juxtapositions on a grid similar to those Blake used for his collage constructions. What makes these paintings resonate today, however, is their proto-feminist rhetoric, which is all the more powerful because it pokes fun at the conventional Vargas-derived eroticism found in the work of artists like Jones and Phillips without becoming shrill.

If Boshier was the typical British Pop artist, Phillips

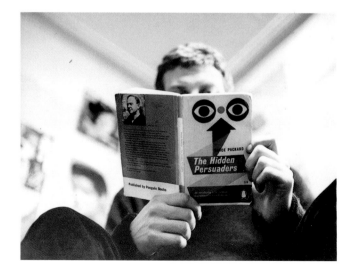

fig. 12. Derek Boshier in his Royal College of Art studio reading *The Hidden Persuaders* (1957), London, 1963. Photograph by Tony Evans.

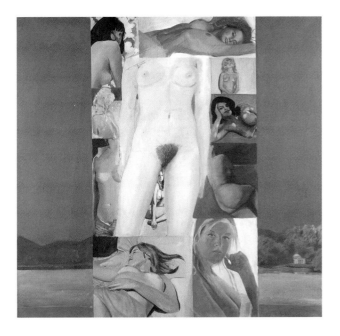

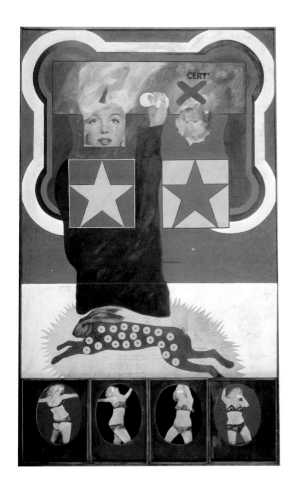

fig. 13. Pauline Boty, *It's a Man's World II*, 1965–66, oil on canvas, 49¼ x 49¼ in. (125 x 125 cm), The Mayor Gallery, London.

fig. 14. Peter Phillips, *For Men Only—Starring MM and BB*, 1961, oil, wood, and printed reproductions on canvas, 107½ x 60 in. (274.3 x 152.5 cm), Gulbenkian Foundation, Lisbon.

fig. 15. Peter Phillips' diploma exhibition (spring 1962), Royal College of Art, London, installation view.

was the one most ferociously Pop (fig. 15). He seems, in retrospect, to be the single artist who came closest to fitting all the criteria retrospectively—and perhaps inaccurately—applied to define British Pop. He was anti-Establishment; he wholeheartedly embraced popular culture, especially the American variety; and he recycled its icons and idioms into compositions that had as much in common with pinball machine art and bikers' tattoos as they did with the arcane dialects of fine art (not that he was ignorant of, or indifferent to, those). This imagery was not subjected to analysis or social commentary, but it was accepted and relished for what it was. And Phillips had the ability to set it down with a deliberate slickness that recalled mass-produced objects and the elegant manipulations of advertising art. At a time when other Pop-oriented artists were still embracing the gestural brushwork of the Abstract Expressionists, Phillips had begun using the airbrush, deemphasizing calligraphy in favor of shapes and surfaces that were as anonymous as those of the billboard artist.

The youngest of the RCA group, Phillips was already producing explicit Pop images in 1960, the year he turned twenty-one. These so outraged some members of the RCA staff that he was forced to paint at home and eventually transferred to the college's television school. (As

already noted, Jones had actually been expelled for similar transgressions.) The London galleries also found Phillips' work hard to deal with, and he did not have a solo exhibition until the Kornblee Gallery in New York showed him in 1965. In retrospect, though, his paintings of the early sixties, such as *For Men Only—Starring MM and BB* (fig. 14) and *War/Game* (both 1961, pl. 9), are clearly central to the evolution of British Pop.

Caulfield was also attracted to a determinedly nongestural manner. He was, however, a very different kind of painter from Phillips when it came to the sorts of images he employed. An independent spirit, he was reluctant to

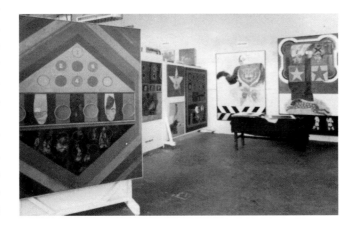

be seen as part of the Pop group, even though he was sympathetic to many of its aims (fig. 17). Some scholars would argue that he should not be included in the group, largely because he did not make use of American popular imagery or even, to any great extent, the more obvious examples of British mass culture iconography. In reality, though, Caulfield contributed a good deal to the evolution of British Pop, both through his cool technical approach—flat colors contained by bold black outlines—and through his thoughtful and ironic attitude toward popular culture.

Caulfield's take on popular culture proceeded at a tangent to that of most other Pop artists. Rather than recycling packaging and pinups, he turned to such sources

as print ads for cheap jewelry in *Engagement Ring* (1963) and travel brochure graphics in *View of the Bay* (1964). He also painted images that either derived from fine art sources, as in *Greece Expiring in the Ruins of Missolongi* (1963), or simply portrayed "ordinary" subjects, as in *Still Life with Bottle, Glass and Drape* (1963), *Corner of the Studio* (1964, pl. 43), and *The Artist's Studio* (1964, fig. 16). His many still lifes are almost always modulated by affectionate memories of Cubism. The sophistication of his vision is evident in his early perception that by the fifties Cubist masterpieces had been transformed, through familiarity bred of reproduction, into something resembling Pop icons. At the same time, he recognized that the Cubists had anticipated Pop by incorporating the quotidian—newspapers, cigarette packs, and other everyday items—into their compositions.

The fact that Caulfield's early work seems to rely so heavily on quotes from European modernism would imply that he had turned away from American influences, but this was far from the case. He refrained from borrowing American imagery—in part at least because of a temperamental disinclination to jump on the current bandwagon—but he learned a good deal from American precursors of Pop, especially Stuart Davis and Edward Hopper. He also followed the work of his American contemporaries as closely as anyone, acknowledging their achievements but resisting mere imitation at all cost. (In the sixties, many people saw a close resemblance between the work of Caulfield and that of Roy Lichtenstein.) Caulfield's role within Pop is far from easy to define, but without him, the British group would have seemed distinctly weaker.

If I have given the impression that British Pop Art emerged entirely from the Independent Group and RCA, that in fact was the case until well into the sixties. At that point, several young artists from other backgrounds began to make their marks. Included in this group were Laing, Anthony Donaldson, Self, Clive Barker, Jann Haworth, and Nick Munro.

Like Phillips, Laing had a natural feel for Pop. Enrolling at St. Martin's School of Art after a spell in the army, he soon came to know many of the principal players on the London Pop scene. He visited New York in 1963, working briefly as one of Robert Indiana's assistants, which gave him a privileged view of the New York Pop scene. From the outset, he painted archetypal mass culture icons. Early examples are 1963 portraits of the French actresses Anna Karina (fig. 18) and Brigitte Bardot, blown up from black-and-white newspaper photographs with the dots of halftone printing reproduced by hand (rather than with a benday stencil à la Lichtenstein). Later came images of hot rods and skydivers with a confrontational emphasis on strong design: black-and-white areas using the same faux halftone method described above were contrasted with strongly colored elements that sometimes made use of fluorescent pigment. In some instances, to emphasize the status of his paintings as ob-

jects rather than illusionistic representations, Laing made use of shaped canvases, a device that was used frequently by Smith and Jones, and occasionally by other Pop artists including Hockney.

Laing lived in London only briefly before taking up residence in New York. Still, he made a significant mark. Despite his subject matter, his version of Pop was more British than American in flavor—a touch breathless in its attitudes to "exotic" New World subject matter and ultimately dependent on the knowing manipulation of visual languages. This was true, too, of Donaldson, who began working in a mainstream Pop manner in 1962, at about the time he finished his studies at the Slade School of Fine Art, University College London. Always well-crafted, his paintings show a strong if somewhat conventional sense of design and a predilection for automobiles and pinups.

A far more interesting 1962 graduate of the Slade, Self was one of the most elusive yet powerful British artists of his generation. The Slade had a reputation for producing great draftsmen, and Self did much to keep that tradition alive, though in a way that probably would have seemed alien to his predecessors of the Augustus John generation. While still in school, he made contact with Hockney and other members of the RCA group. Upon leaving the Slade, he spent a considerable amount of time traveling in the United States and Canada, with extended stays in Los Angeles and New York. These sojourns provided him with startling imagery that was most memorably set down in two groups of drawings, the cinema series and the fallout shelter series.

These drawings were made on a small scale with obsessive precision utilizing ordinary lead pencils and colored pencils, sometimes supplemented with collage elements and adjuncts such as applied glitter. (In the most literal sense, Self was an exponent of Arte Povera, deliberately using commonplace, cheap, and easily available materials.) Images in the cinema series consist of fashionably dressed women, sometimes subjected to anatomical distortion, portrayed in Art Deco movie theaters. The fallout shelter series is more overtly political. Unlike Moore's World War II drawings of people seeking safety against bombing raids in deeply buried tube stations, Self's images do not portray actual shelters but rather juxtapose scenes of New York life—a strip club, for example—with the fallout shelter signs that were then ubiquitous. The message, conveyed with the skill and precision of a great visual satirist—a modern Hogarth—is

fig. 19. Colin Self, *Car Drawing*, 1964, pencil and colored chalk on paper, 21⅞ x 15 in. (55.5 x 38.3 cm), The Whitworth Art Gallery, The University of Manchester.

quite straightforward: mankind continues to indulge its baser instincts while the world hovers on the edge of disaster.

More than any other artist associated with British Pop, Self saw himself as involved in a class struggle, with the future of the human race at stake. Nor was this in any way a pose. He believed that a nuclear holocaust was probably imminent. He was not arrogant enough to think his work could forestall the consequences of society's follies, but he felt it was his job to set down a record of those follies in his own singular way. His attitude was marked by a determination to avoid grandiosity at all costs. "The more important the subject is," he once told me, "the smaller I make the drawing."[19]

Self remains, then, yet another artist identified with British Pop who in many ways was at odds with the movement's purported aims. His imagery of the period might include hot dogs or American cars, as in *Car Drawing* (1964, fig. 19), but it is presented neither with tacit approval nor with the kind of analytical distancing that is commonplace in the work of the London Pop group. Self's approach at this period was Swiftian, fueled both by love of life and by despair at the follies of humankind.

Equally enigmatic is Barker's work. After studying at Luton College of Technology and Art, Barker worked for Vauxhall Motors and then for a London pawnbroker. During this period, he made abstract paintings and came into contact with Alloway, Blake, and other art world fig-

ures. In 1962 he began making neo-surrealistic objects such as small boxes bound in leather and fitted with a zipper. In 1964 he produced a work called *Two Palettes for Jim Dine* (pl. 36), with one of the palettes finished in leather and the other chrome plated. This led to the series of chrome-plated works that established his reputation in the mid sixties, including *Van Gogh's Chair* (1966, pl. 56), a three-dimensional rendition of this famous fine art/pop culture icon in The National Gallery, London, (fig. 135), complete with pipe and ashtray, cast in steel and chrome plated. Other works of the period include chrome-plated dentures in glasses of water and tributes to favorite artists such as a chrome-plated sculpture of a pair of lace-up boots ending in toes, derived from a painting by René Magritte.

I wrote about Barker at the time, noting that "[his] objects function within the framework of irony that derives from Duchamp's ready mades," and this is certainly true. The fact that the objects were manufactured rather than simply found, however—they were cast in various metals, then finished in chrome, nickel, and even gold—gave them a singular presence. They seemed to be frozen in time. In one of his most reproduced works, *Splash* (1967, fig. 20), an illusionary stream of water, represented by a

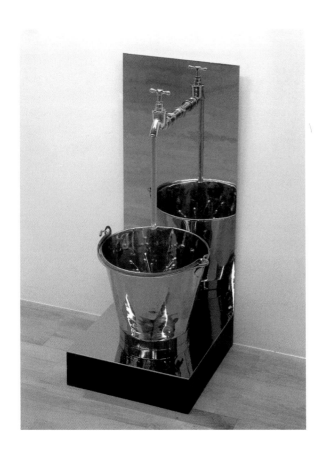

fig. 20. Clive Barker, *Splash*, 1967, chrome-plated faucet and pail, brass, and steel with plastic, 34 x 15 x 14 in. (86.3 x 38 x 35.6 cm), Tate Gallery, London.

chrome-plated steel rod, "pours" from a chrome-plated faucet into a chrome-plated bucket. This bucket is half full of ball bearings, representing water, from which emerge arcs of chrome-plated, hand-shaped metal depicting a splash caught by a high-speed camera. Time is stopped, and an ordinary event involving everyday objects becomes magical.

In retrospect, it may be difficult to see how Barker's work relates directly to Pop. At the time, however, it seemed to fit in very comfortably. If Oldenburg could make hamburgers from painted plaster of Paris and telephones from stuffed vinyl, then surely it was not surprising to find a British Pop artist producing cowboy boots plated in chrome. In instances such as *Three Coke Bottles* (1969), Barker did in fact produce works that clearly belong within the Pop canon. Like so many of the British artists associated with the group, however, his relationship with Pop was often tenuous. At the same time, the context provided by Pop helps provide a perspective on his work that permits the viewer to come to terms with its remarkable lyrical strength.

Haworth and Munro also worked in three dimensions, and each played a significant if marginal role in the story of British Pop. Raised in Southern California, Haworth moved to London in 1962 and spent a year at the Slade School of Fine Art before marrying Blake. By the mid sixties, she was making soft sculptures and "soft paintings" using sewing and quilting techniques. Some of these, such as *L.A. Times Bedspread* (1965), used specifically American imagery, and certainly her American connections, including her links to the motion picture industry (her father was a prominent art director), opened up a new world both to Blake and to the couple's many London friends. Munro, on the other hand, could not have been more British. Enrolled at Chelsea School of Art in the late fifties, he became friends with Caulfield, whose influence can be felt in the fiberglass sculptures Munro began making in the sixties. These range from a lively pair of ballroom dancers to a flock of reindeer that for several years resided happily in a meadow beside the artist's Wiltshire home.

A much more important figure was Joe Tilson. A friend and contemporary of Blake and Smith at RCA, Tilson was older than the Phillips-Jones-Boshier-Hockney generation. I have not introduced him sooner because he did not really play a significant role in the Pop world until after the younger artists began to make their marks. His

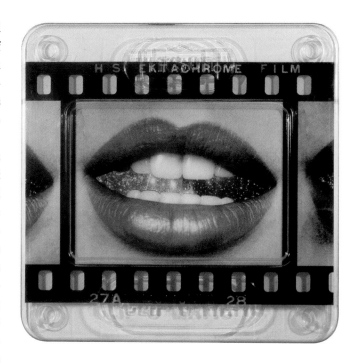

work from the very early sixties consists of constructions and reliefs made from largely unpainted planks and blocks of wood. The fact that some bear names—such as *Epistrophy* and *Giant Steps* (both 1961)—appropriated from the jazz world reveals that he already had a keen interest in American popular culture. This, however, is not especially evident in the work itself, which emphasizes traditional craftsmanship and architectonic values. By the end of 1962, Tilson was modifying this approach. *Odeon* (1962) is a colored wood relief whose architectonic quality specifically references that of Art Deco movie theaters. From that start, the artist moved on to a series of box constructions that gradually brought his work closer to the Pop orbit. These involved the use of facsimiles of ordinary objects (a gigantic metal keyhole plate, for example) and often incorporated words, sometimes painted in bold block lettering. *Vox-Box* (1963) was composed around a large, stylized mouth stuffed with exclamation marks.

Not long after these were fabricated, Tilson made his first trip to New York, after which his work took on a far more overtly Pop flavor. New materials—polyurethane and vacuum-formed acrylic, for example—would enable him to create effects like the "transparencies," including *Transparency, The Five Senses* (1968–69), that were essentially blowups of 35mm slides featuring images such as the Empire State Building and Marilyn Monroe's lips (fig. 21). He did not abandon working in wood entirely, but now

his reliefs had a different flavor, as in the ziggurat series that took its geometries from the setbacks of the New York skyline.

Like Blake, Tilson served as a catalytic figure for the British Pop scene. The West London house he occupied with his wife, Jos, was the scene of many memorable evenings and Sunday brunches at which one was likely to encounter any and all of the major figures involved with London Pop Art as well as visiting American artists and personalities from the worlds of books, movies, music, and fashion.

With the exception of Haworth and Munro, all of the artists I have mentioned were producing Pop Art images, or Pop-related images, by 1962, and a kind of Pop Art anti-Establishment Establishment was in place by 1963 or 1964. By then several of the artists had had solo shows, and the success of the movement was certified by a number of important group exhibitions, such as the British contribution to the 1963 Biennale des Jeunes in Paris and "The New Generation: 1964" exhibition at the Whitechapel Art Gallery.[20]

It was soon after this that the whole flavor of the London art scene began to change. It did so for a number of reasons. One of these was in some ways incidental to the art scene proper, yet it capitalized on Pop imagery and had a tremendous effect on the way the Pop artists perceived themselves. This was the social revolution that saw the seedy but lovable "Big Smoke"—the London of jellied eels and bowler hats—transmogrified over a couple of years into "Swinging London," billed as the hippest place in the known universe. Just when this transformation began is hard to pinpoint, but by the end of 1963, the Beatles were already major recording stars and the Rolling Stones were on their way up, as were any number of aspiring rock groups, many of them featuring former art students. At the same time, the fashion scene exploded, given a strong helping hand by RCA graduates who opened boutiques on King's Road or went to work for the more progressive rag trade companies along Margaret Street. Before long, *Time* magazine was devoting a cover story to Trendy Town in a celebrated issue that found room to also celebrate the city's art stars.

Some of the artists in fact did begin to think of themselves as stars, and soon enough they were hobnobbing with the rock world glitterati. Blake returned home one evening to his modest row house in Chiswick to receive a phone call from somebody called Paul who timidly asked if he could stop by. Blake thought this was one of his students, looking for an after-hours critique, and only reluctantly agreed to see the caller. The person who rang the bell shortly after turned out to be Paul McCartney, who wanted to buy a painting and did not know how to go about it. This led to a friendship that culminated in Blake's setting up and art directing the 1967 record sleeve for *Sgt. Pepper's Lonely Hearts Club Band* along with Jann Haworth and photographer Michael Cooper. Probably the most famous album cover of all time—with its waxwork figures and cutouts of pop culture celebrities, plus the Beatles themselves in period band uniforms—this grafted the world of the Temperance Seven onto the new "groovy" zeitgeist. In a sense, it is the ultimate work of British Pop Art.

Soon rock celebrities were regulars at art show openings (or *vernissages* as they were still quaintly called). The most spectacular of these were held at the Kasmin and Robert Fraser galleries, both of which opened in 1963. Aggressive and publicity conscious, these two young dealers brought a breath of fresh air to the London scene, very much in contrast with the self-consciously understated Bond Street establishment. Kasmin had Hockney in his stable but otherwise tended to feature top nonfigurative artists, both British and American. Starting in 1964, Fraser represented many of the British Pop artists including Paolozzi, Hamilton, Blake, Boshier, Caulfield, Self, Barker, Haworth, and Munro. He also gave shows to American Pop artists such as Dine and Oldenburg, and he staged a memorable California exhibition that provided a European debut for Edward Ruscha among others.

Fraser's gallery on Duke Street and his nearby apartment on Mount Street became the twin nuclei of a freewheeling salon that attracted writers, musicians, models, and movie stars as well as artists. At Mount Street, you were likely to encounter Andy Warhol or Wallace Berman, Tom Wolfe or William Burroughs, Marianne Faithfull or Warren Beatty. At one packed opening on Duke Street, the guests included Marlon Brando, Tony Curtis, Malcolm X, a Motown girl group in matching satin dresses, Julie Christie, Jean Shrimpton, the captain of the England soccer team, Mick Jagger, Brian Jones, Paul McCartney, and John Lennon and Yoko Ono (not yet together).

This was the *real* Pop world, and the artists loved being a part of it, but it did change their role. They no longer represented the cutting edge. Mass culture had overtaken

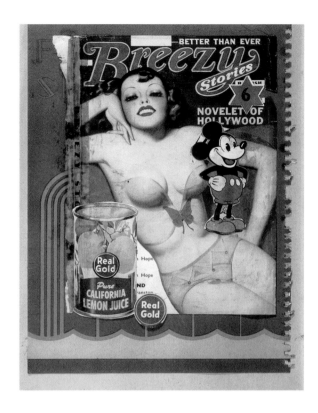

fig. 22. Eduardo Paolozzi, *Real Gold,* 1950, printed reproductions on cardboard, 11 x 6⅛ in. (28.2 x 41 cm), Tate Gallery, London.

them, challenging them to test the validity of the values they had chosen to espouse (or were presumed to espouse). The reality of this would take a while to sink in, but the long-term impact would be profound, making it impossible ever again to approach Pop imagery with the innocence that had once given British Pop its character.

That innocence had been further eroded by the direct interchange between British and American artists, which by the mid sixties was commonplace, and by the widespread exposure of British artists to the realities of American art and culture. In 1964 Rauschenberg was given a major retrospective at the Whitechapel Art Gallery. In 1966 both Dine and Oldenburg spent several months in London, and Dine later returned to stay for several years. Many other New York artists paid shorter visits, as did Californians like Ruscha, Berman, and Ken Price. Another important American arrival was the critic and curator Amaya who, as founding editor of *Art & Artists* and as the host of another informal salon, provided an intellectual boost to British art. Even more significantly, almost all of the British Pop painters began to spend time in America—some teaching, some on traveling fellowships (especially from the Harkness Foundation), and some paying their own way. By 1965 only a couple had yet to at least visit New York, and several—most notably Hockney—had traveled to Los Angeles, too.

The sixties is remembered as a period when British pop culture—moptops and miniskirts—had a tremendous appeal for Americans. As far as art was concerned, however, the gravitational pull was still in the other direction: contact with American pop culture on its home turf only reinforced British certainties that this was important subject matter. They felt more passionate than ever about it. (I remember Tilson telling me that he wept when he boarded the plane to return to London after his first trip to New York.)

But encounters with the real thing also meant an end to naiveté. The iconography became harder to deal with because it was now weighted with meanings that had previously gone unsuspected. Some of the Pop group turned away from kitsch-derived figuration at this point, as if it seemed now a superficial way of presenting their vision. In New York, Laing began making metal constructions—some freestanding, some conceived as wall pieces—that were essentially nonfigurative, though they derived from Pop in terms of the machine-made forms he employed and their finish (chrome and baked enamel). Boshier, re-

turning to London from a year in India (another favorite destination of the sixties), abandoned Pop iconography altogether for color-saturated, optically lively, nonfigurative paintings on shaped canvases. Meanwhile, Smith—the originator of what might be called Abstract Pop—had taken his explorations into new territory by working on canvases that featured dramatic three-dimensional extensions, much like those used on billboards. By 1966 these works—though still made of canvas stretched over a frame—had become, in effect, wall sculptures.

Other artists began to move in different directions. Blake, for example, turned away from the hard-edge geometrical formats he had employed for the collages of the early sixties and eased back into a more conventional, almost academic approach to his material. He was still painting Pop subjects, ranging from wrestlers to movie stars, but he was doing so with a warmth that tended to undermine the commercial callousness of the originals. He said of a series of pinups painted in the mid sixties that he was trying to give them back their humanity.[21]

The artists who came most fully into their own when Swinging London was at its height were the veteran Independent Group pioneers, Paolozzi and Hamilton. As previously noted, though Paolozzi enjoyed a considerable reputation for his sculpture, his Pop-related work had been largely overlooked. Having collected print ads, girlie magazine pictures, science fiction illustrations, and other kitsch items since World War II, turning some of them into collages (fig. 22), he exhibited this material in 1952 at the first meeting of the Independent Group—the

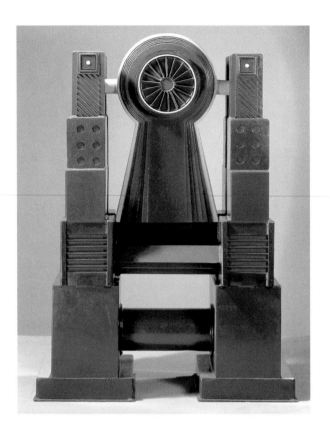

discovered screenprinting while teaching fabric design at the Central School of Art and Design in the early fifties. The technique provided a perfect way of reproducing collaged images, and between 1965 and 1967, Paolozzi created elaborate works like *Moonstrips Empire News* (a box containing a hundred prints) and *Universal Electronic Vacuum.* Each print features dense constellations of iconography, ranging from Mickey Mouse to aerospace technology. References to Ludwig Wittgenstein and computer languages invite the viewer to "read" the fragmented imagery, much as one would read a "cut-up" text by Burroughs or Bryan Gysin.[22]

Paolozzi also played a major role in fueling the enthusiasm of younger artists. Filled with toy robots and overflowing files of magazine clippings, his studio on Dovehouse Street was a place where artists could draw on Paolozzi's two decades of experience in interpreting popular culture. He also had a knack for forging connections between different groups, for example, engineering a bridge between Pop artists and the *New Worlds* science fiction writers such as Michael Moorcock and J. G. Ballard.

The artist who benefited most from the climate created by the success of Swinging London was the one who was perhaps the most detached from it, Hamilton. This is not to say that he was uninterested in what was happening, or that he disapproved, but rather to emphasize the fact that the fascinated detachment that characterized his attitude toward popular culture had been present from "This Is Tomorrow," if not before. For that exhibition, Hamilton prepared (in cooperation with McHale and John Voelcker, though Hamilton was clearly the controlling spirit) an environment that featured among other things a sixteen-foot robot, a life-size cutout of Marilyn Monroe, a colossal Guinness bottle, a science fiction capsule, some Duchamp rotor reliefs, and a jukebox blasting in front of a wall pasted with film posters (fig. 1). Several movies were projected at the same time, and the area was permeated with a variety of scents. Almost lost among all this was Hamilton's now celebrated collage *Just what is it that makes today's homes so different, so appealing?* (1956, pl. 1). Featuring a pinup, a body builder, the Ford logo, a television set, a comic book cover, and other Pop icons, this tiny work—just 26 x 25 centimeters—not only came to be seen as summing up the entire "This Is Tomorrow" project but is often taken as the wellspring of all British Pop Art. Without wishing to detract from its originality and importance, it is worth noting that, although it received a

images were projected and enlarged by an epidiascope (opaque projector)—to suggest that a world of visual invention existed outside the purview of the studio artist. In 1956 for "This Is Tomorrow," he collaborated with the architects Peter and Alison Smithson and the artist Nigel Henderson in creating a basic living unit that purported to offer all the essentials for a full life, from shelter to pinups. By then he was producing sculptures, cast in bronze and reminiscent in spirit of Jean Dubuffet's graffiti paintings, whose elements were formed by the impression of machine parts. Starting in 1962, he began work on a series of towers, including *Diana as an Engine* (1963) and *Wittgenstein at the Casino* (1964, fig. 23), cast from engineering templates and machine parts, and sometimes brightly painted. Resembling robots or humanoid slot machines, these marked a definite move into the Pop world. They were followed by sinuous sculptures welded together from existing machine parts, such as *Pisthetairos in Ipsi* (1965), and a series of jazzy, chrome-plated "corrugations" (*Durenmal* [1965]).

All of the sculptures of the sixties were heavily informed by a Pop sensibility, but his most thoroughly Pop work by far can be found in the editions of screenprints that he produced during the same period. Paolozzi had

fig. 24. Richard Hamilton, *Pin-up,* 1961, oil, cellulose, and collage on panel, 48 x 32 x 3 in. (122 x 81.3 x 7.6 cm), The Museum of Modern Art, New York, Enid A. Haupt Fund and anonymous fund.

flurry of attention in 1956, *Just what is it . . . ?* did not become really well known until the mid sixties, when Hamilton had solo shows at Hanover Gallery (1964) and at Robert Fraser (1966 and 1969) that deservedly established him as one of the leading figures in the British art world.

If Paolozzi's embrace of popular culture was wholehearted, Hamilton's approach to the same subject matter was always wary and analytical. The first major work he embarked on after "This Is Tomorrow" was *Hommage à Chrysler Corp.,* an exercise in the analysis of automobile styling as filtered through the scrim of advertising. This was followed by paintings such as *She* (1957–61) and *Pin-up* (1961, fig. 24). The former employs the fragmented language of advertising to explore the theme of how sex is used to sell domesticity in the kitchen. It is the latter, however, that shows how completely Hamilton differed from other British Pop artists. Instead of giving the viewer a straightforward sexy image, as might be found in the work of Blake, Jones, or Phillips, Hamilton broke his pinup into a diagrammatic grouping of stylized parts— stockinged legs, breasts bisected by tan lines, a bra dangling from an unseen hand—that added up to a catalogue of erotic triggers without the usual sensual payoff. In *Pin-up,* Hamilton turned sex into an elaborate, ironic game in somewhat the same way as had his friend and mentor Duchamp when he conceived *The Bride Stripped Bare by*

fig. 25. Richard Hamilton, *My Marilyn,* 1965, oil on collage on photograph on panel, 40¼ x 48 in. (102.2 x 122 cm), Ludwig Forum, Aachen, Germany.

Her Bachelors, Even almost a half century earlier.

As the sixties progressed, Hamilton produced slicker— more conventionally handsome—but still analytical and somewhat detached paintings, including *Interior II* (1964, fig. 123), an elegant exploration of the illusory space created by the movies; *My Marilyn* (1965, fig. 25), a montage-like composition of publicity images overlaid with painterly marks; and *Swingeing London 67* (1968–69), based on a photograph of Fraser and Mick Jagger in custody after a drug bust that sent Fraser to jail. Especially striking are Hamilton's three-dimensional fiberglass facsimiles of the Guggenheim Museum, which treat the New York landmark as a Pop icon (pl. 55).

Although his output has been small, Hamilton's work is so varied and rich it is impossible to give anything approaching a full account of the problems he tackled in a brief survey such as this. Not as naturally gifted a painter as some of the other British Pop figures, he nonetheless occupies a preeminent position as the artist and thinker who uncovered the richest vein of material within the Pop canon and exploited it with unfailing intelligence and inventiveness.

By the time Hamilton was accorded a retrospective at the Tate Gallery in 1970, the classic Pop period was already over, though some of the artists of the era continued to make strong images in the now established idiom. Phillips, for example, produced increasingly virtuosic versions of his own unrepentant variety of Pop until well into the seventies. Hockney captured the high kitsch ambiance of the west side of Los Angeles in paintings and prints that helped make him Warhol's only rival as the world's most famous living artist (pl. 54). Jones explored overtly erotic scenarios without losing sight of his Pop roots, and Caulfield evolved into one of the finest British painters of his generation while exploring such quotidian subject matter as restaurant interiors.

Looking back at that classic period, certain things seem apparent. Although there was a good deal of interchange between the older and younger artists, the two waves of British Pop did not form a simple causal continuum. The artists who emerged in the early sixties would have discovered Pop even had there been no "This Is Tomorrow." Members of the Independent Group benefited from the success of their younger contemporaries, which was of especial value to Hamilton whose complex vision—full of ambiguities and contradictions, and not overtly crowd pleasing—required time to evolve and mature.

Seen retrospectively, British Pop seems more British than it did at the time. In the fifties and sixties, the American iconography found in the work of Blake, Phillips, Laing, and others was so startling that it tended to dominate viewers' impressions. In reality, homegrown imagery—from London buses to circus performers—provided as much or more material to the British artists. And all of this imagery, native or imported, was treated by most of the artists within an analytical framework that kept it at a distance, giving British Pop a flavor very different from American Pop. The American artists seemed to be saying, "What you see is what you get." The British artists were not so certain. Their attitude was more along the lines of, "Let's take this apart and find out what makes it tick."

At the same time, I believe that British Pop represented an important step forward in the European understanding of New York school art. It came to terms with how the various elements in a painting—whether figurative or not—could be organized to create a whole. In this respect, the British Pop painters were strikingly close in spirit to the concerns of nonfigurative artists like Denny and Hoyland, who at the time seemed at odds with them.

Newly forged ties with America and American artists were also factors in the changing political climate as British Pop evolved over the period of a decade. So long as British artists were somewhat isolated, they identified with the traditional class struggles, at least in a tenuous sort of way, but as they came to be "culturally Americanized," their radical impulses drew them to international issues such as the war in Vietnam. To be against American "adventurism" cut across class distinctions—and incidentally provided some interesting moral problems for artists who were attempting to make a niche for themselves in New York or Los Angeles. While British artists were refurbishing lofts in SoHo, their friends back home were staging protests in Grosvenor Square outside the U.S. Embassy.

In the end, little was clear-cut about British Pop except for the consensus, by a dozen or so otherwise disparate artists along with a handful of critics and dealers, that a continuum between art and mass culture was both legitimate and filled with great potential. This continuum applied not only to imagery but to the way in which art could be made. Although most of the artists continued to paint, several of them also began to experiment with new materials and techniques (and almost all of them expended a good deal of effort in making prints, seeking to reach a wider audience). The movement was given additional impetus by the fact that artists in the United States, simultaneously but independently, began to make use of similar visual materials and methods of fabrication.

Like most movements, then, British Pop Art was in actuality a loose association of mutually sympathetic spirits. This should not be seen, however, as detracting from the role these artists played in the evolution of British art. If anything, that role has been underestimated. I would go so far as to suggest, in fact, that the Pop painters helped create a more radical break with the past than did Roger Fry with his Post-Impressionist shows or Lewis with all his Vorticist blasting and bombardiering. In the end, those would-be revolutionaries failed to clear the vines of provincialism that had long smothered British art. (Fry was too genteel, and Lewis perhaps too radical for his own good.) It took the half decade from 1961 to 1966 and the new energy of the Pop group to finally tear British art free of the tendrils of morbid traditionalism.

The London art world would never be the same again.

NOTES

1. These quotes are taken from the 1981 edition of *The Oxford Companion to Twentieth-Century Art,* edited by Harold Osborne.

2. The Institute of Contemporary Arts—better known as the ICA—was a focused if low candlepower beacon of internationalism in this provincial scene, home to the Independent Group and sponsor of such events as a lecture by Yves Klein and a cheerfully disruptive appearance by members of the French Situationist group. Its atmosphere in those days, however, was decidedly clubby, and its influence was limited to a small inner circle.

3. A summary of Alloway's theory of the continuum between fine art and popular culture can be found in his essay "The Long Front of Culture," first published in *Cambridge Opinion,* no. 17 (1959, Cambridge University), and reprinted in *Pop Art Redefined,* edited by John Russell and Suzi Gablik (New York and Washington D.C.: Praeger, 1969), pp. 41–43.

4. John Russell and Suzi Gablik, eds., *Pop Art Redefined* (London: Praeger, 1969), p. 32.

5. That, at least, is the impression I formed during a period in the mid to late sixties when I had frequent conversations with them.

6. I do not include R. B. Kitaj, despite his huge influence on the evolution of the aesthetics of British Pop, because the political content of his work was filtered through intellectual attitudes totally at odds with the vernacular mind set of Pop Art; although his presence in the London scene was not felt until about 1960, he actually had more in common with the older artists associated with the Independent Group.

7. Russell and Gablik, p. 32. Russell here appears to be making a reference to Alloway's essay, in which the influence of the humanist is seen as having become strictly limited in modern society.

8. It is important to understand that it was commonplace for British liberals and intellectuals to be anti-American, in the sense of opposing what was perceived as American political arrogance and neo-imperialism, and yet at the same time intensely enthusiastic about American popular culture, which was understood as constituting an upheaval that could undermine the Establishment.

9. Many American comic books—especially of the violence-prone *Chamber of Chills* variety—were banned as likely to incite British schoolboys to unleash mayhem upon their elders. The same applied to certain films. You had to be able to pass for sixteen to be admitted to something as innocuous as *The Creature from the Black Lagoon* (1954), and theaters were forbidden absolutely from screening Stanley Kramer's *The Wild One* (1954).

10. Davies' decor for Domino Male is described in more detail in *The Sixties Art Scene in London* by David Mellor (London: Phaidon, 1993), pp. 119–20. Mellor's avowedly revisionist account of British art in the late fifties and sixties is stimulating if sometimes willfully eccentric. It is especially strong when dealing with the interface between art and homegrown demotic culture, and it provides a useful timetable of events in and around the British art scene from 1956 to 1969.

11. I was present at the Queen's Elm in 1961 when Ken Russell attempted to convince a group of artists of the seriousness of his intentions in producing *Pop Goes the Easel.* The response was noisy derision.

12. Blake was the subject of a major profile in *The Sunday Times Colour Magazine* a month before *Pop Goes the Easel* was screened. John Russell, the author of that profile, probably aware of the title of the upcoming television show, specifically identified Blake as a Pop artist, apparently the first time the term was used in print in the way that has become common practice.

13. Hockney wore the jacket at all times of day, not just as evening fancy dress. I recall encountering him striding down Bond Street quite early one morning, glittering in the watery autumn sunlight.

14. As with Hockney, it is almost impossible to understand the impact of Kitaj's early work unless you were there at the time, when it seemed to open up infinite new possibilities.

15. Marlborough Fine Art Ltd., the parent company of the Marlborough New London Gallery, represented Moore, Bacon, and a number of major international figures.

16. The Temperance Seven was a band, made up largely of former art students, that played hits of the twenties and thirties while dressed in period costumes, much as a current group might revive the style and songs of the fifties or of the disco era. The Temps had a number one hit—"You're Driving Me Crazy"—on the British charts in 1961. The band's members were typical of a local subculture that thrived on an unlikely mix of nostalgia and absurdist cynicism. Appalled by the shoddy goods that fueled the burgeoning consumer culture, disciples of this particular form of social protest surrounded themselves with relics of the recent past, from Victrolas to World War I uniforms to stuffed owls under glass domes. They also cultivated a kind of anarchistic, neo-surrealistic humor derived from the legendary BBC radio program *The Goon Show*—the fifties equivalent of *Monty Python*—which had starred Peter Sellers and Spike Milligan. Blake was a leading member of this subculture, whose ambiance pervaded his work. Through him, it was a sometimes strong influence on British Pop Art and on the sixties in general.

17. Howard Hodgkin—seen in the sixties as having some marginal connection to British Pop—is another Tooth alumnus of that period.

18. Derek Boshier, conversation with the author, November 1999.

19. Colin Self, conversation with the author, c. 1967.

20. The success of the British artists at the Biennale des Jeunes was an early indicator of international recognition. The main prize—Le Prix des Jeunes Artistes—was voted on by a committee of young Paris-based artists. A faction led by several Pop-influenced painters including Hervé Télémaque and Jacques Monory was determined that one of the British artists should win the prize; their first choice was Phillips who, it seemed to them, embodied Pop in its purest form. They were opposed, in true French fashion, by a rival faction that saw Phillips' art as a threat to the painterly heritage of the Ecole de Paris. In the end, a compromise was reached with the prize going to Jones, who was seen as both Pop and painterly.

21. Peter Blake, conversation with the author, c. 1966

22. Paolozzi acknowledged to me on more than one occasion that he felt a technical affinity with Burroughs and Gysin. It seems, however, that he developed his own version of the cut-up technique independently, based on his long experience with collage.

New Painting of Common Objects

an interview with WALTER HOPPS

by JIM EDWARDS

Jim Edwards What I particularly want to talk with you about is your 1962 exhibition "New Painting of Common Objects" at the Pasadena Art Museum [now the Norton Simon Museum], which was really the first Pop museum show. When you look back, there was the previous "New Forms—New Media" exhibition at Martha Jackson Gallery in New York in 1960, which included Jim Dine, Robert Indiana, and Claes Oldenburg but primarily had Assemblage and abstract artists.

Walter Hopps Yes. It wasn't a Pop show, per se. An important Pop show that came after "New Painting" was the "International Exhibition of the New Realists" in New York at Sidney Janis Gallery, also in 1962. That included Americans and Europeans. Jim Dine put a painting in there with a real lawnmower attached [*Lawnmower* (1962)] that drove Willem de Kooning nuts—if not the whole show.

JE But your show in Pasadena preceded that one by two months.

WH Yes. Here's how all that began. By 1959 I had bought out my partner, Edward Kienholz, and taken over Ferus Gallery. I shopped around for another partner because I was supposed to still be going to UCLA. When Irving Blum came into Ferus Gallery, I gave him a third of the stock to act as its director. Then Billy Al Bengston had solo Ferus shows in 1960 and 1961, which was about the time that I met both Edward Ruscha and Joe Goode through Henry Hopkins [director of Huysman Gallery, Los Angeles]. Ruscha was in "New Painting" before he had his first one-person show at Ferus in 1963.

In 1960 in New York, I met a man named David Herbert

fig. 26. Andy Warhol, *Icebox,* 1960, oil, ink, and pencil on canvas, 67 x 53⅛ in. (170.2 x 135 cm), The Menil Collection, Houston.

who had worked for Betty Parsons, then Sidney Janis; later he worked briefly for Poindexter Gallery. Herbert knew Andy Warhol, whom we had never heard of in California. Herbert said, "You've got to meet this artist, Andy Warhol," and this finally happened in the fall of 1961. Herbert's friends hung out in this trendy Manhattan store called Serendipity. Herbert arranged the meeting there and finally Warhol showed up.

Irving Blum and I went to Warhol's studio on Lexington Avenue in the Upper East Side. It was this big place with pine stairs leading to the second floor. The building had been some sort of lodge or meeting hall. When we met with Warhol, he struck me as strange. We followed him up these stairs and passed this amazing assortment of Americana and memorabilia that he had collected, and then we entered this large, high-ceilinged room that was mostly bare except for a vast sea of magazines, almost ankle deep.

I was just blown away by the art on view—I really had never seen anything like it. There was his big painting where Superman is going "Puff!" as he blows out a fire (1960). There was the *Dick Tracy* painting with his sidekick Sam Ketchum (1960). There was work from the same era as The Menil Collection's *Icebox* (1960, fig. 26), paintings that are based on printed advertising. I hadn't seen anything specifically called "Pop Art" before visiting Warhol's studio. That type of work wouldn't even acquire a name in America until 1962. The name "Pop" really comes out of England, from the writings of Lawrence Alloway [the British Pop Art theorist and critic who became a curator at the Guggenheim Museum, New York].

Warhol gave us copies of his little book of cat drawings [*25 Cats Name Sam and One Blue Pussy* (1954)].

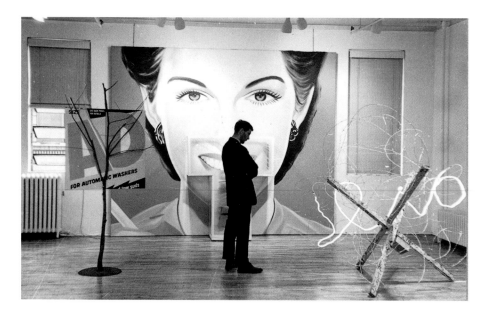

fig. 27. "James Rosenquist" (January 28, 1964), Green Gallery, New York, installation view. Works shown are *AD, Soapbox Tree* (1963, destroyed), *Candidate* (1963; repainted as *Silo*, [1963–64]), and *Tumbleweed* (1964–66). Photograph © Fred W. McDarrah.

Then he brought out of the closet a large painting that wasn't stretched yet and rolled it out. It was done in a whole new, more highly refined style—another Superman flying through the air, this time with Lois Lane in his arms. The style was far more precise, with the flat look of the original comic strip. That Superman and Lois Lane painting has since disappeared.

Some of the paintings, like those of a large black-and-white telephone, a smaller Underwood typewriter, and other advertising takeoffs, were rendered precisely. The lost Superman painting was just as smooth as it could be, though it wasn't silkscreened: it was hand-painted. Others, like the *Dick Tracy* painting, were looser and more painterly. Even in those with obvious brushwork, the subject matter was just startling.

When Warhol came over from Pittsburgh, he was a roommate for a while with Philip Pearlstein. In the early 1950s, Pearlstein had done an expressionistic version of Superman [*Superman* (1952)], which was a subject that doesn't conform to what we think of now as Pearlstein's focus: nudes in domestic settings. [Pearlstein made, but overpainted, works about at least two other proto-Pop subjects: *Statue of Liberty* (1951–52) and *Dick Tracy* (1952).]

JE John Walker, the British writer, put that Pearlstein *Superman* in his book. A bad reproduction, but there it is.

WH Most people would not think of Warhol and Pearlstein as having any association, but they did. [Both were students together at Carnegie Institute of Technology.]

At some point, we may have also seen, in Warhol's studio, work in progress that included one of his first Campbell's Soup cans. Blum was running Ferus Gallery, but I still had ownership stock and had stayed involved. I said to Warhol, "Absolutely, I want to take some of this work for a show in Los Angeles." Warhol, who had never been to California, answered with some excitement, "Oh, that's where Hollywood is!" In the sea of magazines and fanzines scattered on the floor, so deep it was hard to walk around, were all those *Photoplay* and old-fashioned glamour magazines out of the Hollywood publicity mill. So a show in L.A. sounded great to Warhol. He agreed, and thus the multiple-image soup can show came to Ferus in 1962. Warhol missed that first exhibition of his Pop images, but he finally made it to California in September 1963 for the opening of the Marcel Duchamp retrospective at the Pasadena Art Museum and his own second Ferus show.

The trip to Warhol's studio in 1961 really shocked Blum and me. A little later that year, before Warhol's Ferus show took place, I visited Leo Castelli Gallery in New York, which Ivan Karp managed. I was there on a Saturday and in a back room—the old Castelli on 77th was laid out with apartments in the back—where I met this thin, sort of quiet guy: he was Roy Lichtenstein. Some of Lichtenstein's small paintings were set up and Karp was very excited about them. I was immediately fascinated with his work, especially since I had just seen Warhol's. Lichtenstein had arrived independently at his paintings using comic strip images. I said to Lichtenstein, "I teach an extension class at UCLA, and I'd love to get some slides of your work." So I got a box of slides and showed them in my class. Really just snapshots, some had his son standing in front of the paintings.

JE So, you got a very early introduction to both Warhol's and Lichtenstein's Pop work.

WH Later [in January 1962], at Green Gallery in New York (fig. 27), I saw Jim Rosenquist's early Pop images. From the similarity of approach and subject matter in the work of these three artists, it became clear to me that a new direction in art was developing—post-Robert Rauschenberg and Jasper Johns, both artists who had opened the door for much of Pop.

Another important gallery, apart from Martha Jackson, was Eleanor Ward's Stable Gallery. After Warhol's Ferus show, Ward took on Warhol (Jackson had turned him down), and Stable Gallery showed him in November 1962 before Leo Castelli did.

JE Even though Martha Jackson had presented "New Forms–New Media" with some Pop artists, by then her aesthetic was pretty well set with the abstract painters.

WH Yes. But her young director John Weber did another show with Pop undercurrents, "Environments Situations Spaces" [1961, which included Jim Dine, Allan Kaprow, Claes Oldenburg, and Robert Whitman]. Weber then moved to Dwan Gallery in California and worked on the full blown Pop show "My Country 'Tis of Thee" [November 1962].

Another important space in New York was Hansa Gallery, where George Segal showed before he went to Green Gallery, then Sidney Janis. Segal's cast figures often got thrown into the early Pop shows, but I don't see him as part of Pop at all. In the same way, I think I was quite wrong about putting Wayne Thiebaud in "New Painting of Common Objects." Thiebaud's work really relates more to the Bay Area painterly tradition of David Park and Richard Diebenkorn.

JE In "New Painting" you included five artists from the West Coast: Robert Dowd, Joe Goode, Phillip Hefferton, Edward Ruscha, and Wayne Thiebaud. And from the East Coast you had Roy Lichtenstein, Jim Dine, and Andy Warhol [see exhibition checklist on page 53]. You had eight artists, three works each. I have a checklist, but you didn't do a publication—I guess you didn't have the money?

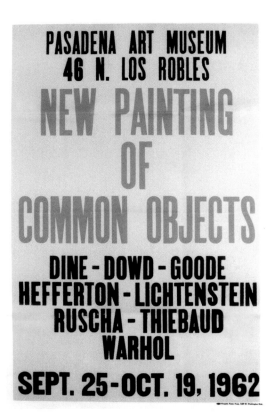

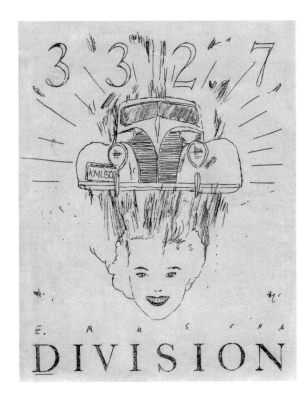

WH No, we couldn't afford a full catalogue, so instead we created a special portfolio—copies are rare now. What I was able to do—we didn't have photocopiers or fax machines in those days—was crank out a checklist and my gallery notes by hand from a mimeograph stencil. Then I got every artist in the show to do a page as a stencil, and we ran off these line drawings (figs. 29, 97). We put the whole package in a white envelope with a gummed label, red on white. I had a rubber stamp made that I stamped on the label in blue ink: "New Painting of Common Objects."

Edward Ruscha designed the poster by calling up a commercial printer who made posters for concerts and boxing matches. Ruscha dictated all the copy over the phone, and his only directions on the type and style were to "make it loud!" The poster came back with bold red and black type on a bright yellow background (fig. 28). Our limited budget dictated the portfolio and poster, though the off-the-shelf look fit right in with the show's aesthetics.

JE John Coplans wrote a review of the "New Painting" show [*Artforum* (November 1962)].

WH Joe Goode's painting [*Happy Birthday* (1962)] was on the cover (fig. 111). I remember taking a group of docents

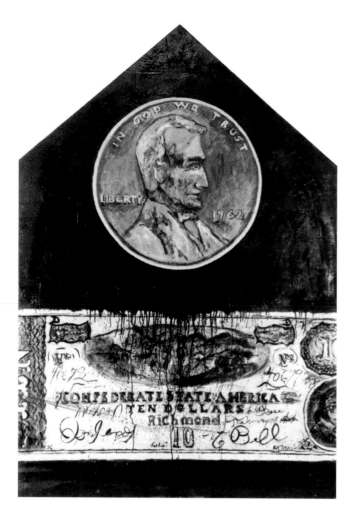

fig. 30. Phillip Hefferton, *The Line,* 1962, oil on canvas, 71 x 47½ in. (180.3 x 120.7 cm), whereabouts unknown.

JE He moderated that symposium at MoMA [December 13, 1962] that caused so much friction between Leo Steinberg and Hilton Kramer, from my reading of that account. Tell me more about the origins of your Pasadena exhibition.

WH As I said, I met some of the young artists included in "New Painting" through Henry Hopkins. Hopkins showed Joe Goode at Huysman Gallery and introduced me to Edward Ruscha, who had moved out from Oklahoma in 1956 and then went to school at Chouinard Art Institute. Goode, but not Ruscha, was part of a Huysman exhibition called "War Babies" (1961). The show had that wonderful poster, but the controversy it generated practically shut down the gallery. The poster showed the artists each eating food native to their culture on top of an American flag used as a tablecloth. Ron Miyashiro, a Japanese American, had noodles and chopsticks; Joe Goode was eating mackerel since he has a Catholic background; Larry Bell, a Jew, was chewing on a bagel; and the black artist Ed Bereal was eating a slice of watermelon.

JE All the politically incorrect clichés, right? Joe Goode had three paintings: the pink one with the milk bottle, titled *Happy Birthday,* and two other works. One was called *Purple,* and the other one was called *Dark Garage* (both 1962). Was *Happy Birthday* the only bottle painting in the show?

WH *Purple* was a milk bottle painting. *Dark Garage* was a painting with collage of a metal rack of milk bottles similar to Goode's drawing in the "New Painting" portfolio (fig. 97).

JE It's interesting that you chose three works by each artist.

WH That number represented each artist well and fit the space gracefully. An awareness of what physically fits a venue often is what makes an exhibition memorable.

JE Twenty-four works, three each. Were the Jim Dine works paintings or were they drawings on canvas?

WH One way he made his paintings at the time was to embed a tie in the canvas, then draw the form out with a thick impasto of paint. One was a large necktie painting that was salmon-colored, similar to the smaller version that Jasper Johns owns, *Flesh Tie* (1961, pl. 8).

JE Then from Phillip Hefferton and Robert Dowd, you chose essentially money paintings? Hefferton's paintings in the checklist are titled *The Line, Twenty,* and *Two* (all 1962).

on an orientation tour of the exhibition, and they focused on why the painting was called "Happy Birthday." I explained that I felt the title was ironic, since the work seemed a little melancholy, as if someone alone were sadly singing "Happy Birthday to me, Happy Birthday to me…."

JE Coplans did a nice review. He also cited Thiebaud as a kind of odd man out, although he was very positive about the show. The other main review was Jules Langsner's in *Art International* ["Letter from Los Angeles" (September–October, 1962)]. The exhibition was beyond him essentially—he was struggling with the whole concept of the work.

WH Langsner championed abstract art. He literally coined the term "hard-edge painting" to describe the refined geometric renderings of John McLaughlin, for example—I will give him credit for that. He also wrote the first positive reviews of the young Abstract Expressionists in California such as Craig Kauffman.

JE He probably got caught in the same dilemma that stymied so many others: how to reconcile a radical new subject matter with the romantic view of older abstract work.

WH Peter Selz, a curator at The Museum of Modern Art, for example, just went ballistic about Pop Art.

WH Yes, they both did large-scale paintings based on American money. Incidentally, although Lichtenstein created work like his *Ten Dollar Bill* lithograph in 1956, both Dowd and Hefferton used money as a subject before Warhol did. Dowd's paintings were more straightforward painterly compositions. Hefferton had whimsical titles like *Winkin' Lincoln* (1963). His painting called *The Line* (1962, fig. 30) had an Abraham Lincoln penny at the top and a Confederate ten-dollar bill at the bottom, divided by the Mason-Dixon line.

JE Hefferton had humor in his paintings in a way that Dowd didn't.

WH Hefferton did a painting called *The Money Truck* (c. 1962), showing a funny cartoon vehicle with golden wheels. On the back of that painting—he had already seen some of Lichtenstein's work—he wrote: "*The Money Truck.* Here's to you, Lichtenstein, you son of a bitch. I'm still the king."

JE The Lichtenstein paintings you put in "New Painting" were a fairly representative sample of his work of the time. You had *Masterpiece* (1962), which was the comic strip painting with the woman admiring her artist boyfriend's work.

WH I also included *Roto Broil* (1961), an advertising image of an electric cooker.

JE And you had *Spray* (1962, fig. 31), the close-up of a spray can. Surprisingly, all three of those paintings were already in Los Angeles collections. Betty Asher owned *Roto Broil*, and Melvin Hirsch had *Masterpiece*, and according to the original checklist, Donald Factor had *Spray*.

WH That last one was appropriate, since Donald Factor was related to the Max Factor cosmetics fortune—hair sprays and so on. Donald and Lynn Factor were wonderful collectors. On the West Coast, we thought of them as our Ethel and Robert Scull [the New York taxicab magnates who zealously collected Pop Art]. They also owned a Jasper Johns work called *Tennyson* (1958), one of the three word paintings Johns did starting with the letter T. Their collection went all the way from Johns to Bruce Conner.

JE That *Tennyson* painting was very important to Edward Ruscha. Did he get to see it early on?

WH No, not the actual painting—at that time, Ruscha only knew Johns from reproductions. But Johns' work was still a big influence on many artists just from being in art magazines, especially after Thomas Hess put *Target with Four Faces* (1955) on the cover of *Art News* in 1958.

All these Americans were scattered around, working in related ways but somewhat isolated from one another. Then between 1960 and 1962, all this work suddenly

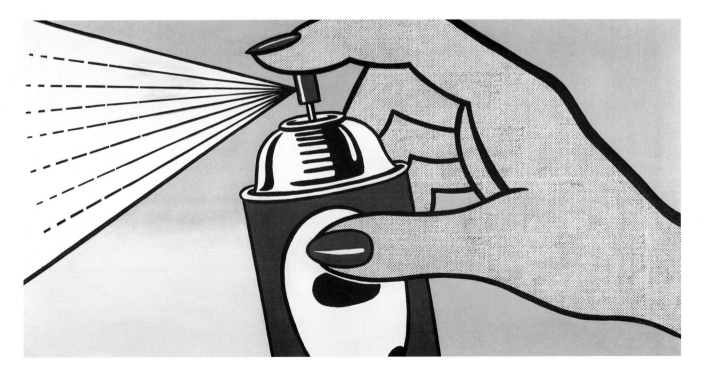

fig. 31. Roy Lichtenstein, *Spray,* 1962, oil on canvas, 36 x 68 in. (91.4 x 172.7 cm), Staatsgalerie Stuttgart, Germany.

popped up all around the country. It's interesting that many of the artists had migrated from Midwestern origins to either Los Angeles or New York. Still, most of them didn't even know of one another until we were well into 1962. It is astounding to think about that in hindsight.

On the other hand, when I first visited Warhol in New York, he was as talkative as he ever would be with me, asking me lots of questions about other artists. He asked if I knew Rauschenberg. Did I know Johns? Well, yes, I did, thanks to Leo Castelli. What did I think of them? Warhol is one of the absolute pioneers of object art in America. It's so important to understand how aware he was of both Rauschenberg's and Johns' work.

JE Warhol and Rauschenberg both started using silkscreens in their work at about the same time.

WH Yes. But all the Warhol art—in fact, all the work—in "New Painting" was hand-painted; the idea of using silkscreens in fine art would come almost simultaneously, but quite independently, to Warhol and Rauschenberg in the fall of 1962. I think it's astounding that both were drawn to this technique at the same moment. Coming from the commercial art world, Warhol was already familiar with the silkscreen process; a somewhat mechanical sign-painting or display technique was appealing to him. For Rauschenberg, silkscreening was a way to manipulate and reuse media images at an enlarged scale beyond that of his collage and transfer-drawing techniques. His transfer drawings are the real DNA behind both Warhol's and Rauschenberg's silkscreened works.

JE How did the Los Angeles artists respond to Warhol's first show of Campbell's Soup cans at Ferus Gallery?

WH The show received a tremendous response from most of the more adventurous artists; even an abstract painter/sculptor like Larry Bell liked the work enough to write a little appreciation for *Artforum*.

By the time the Warhol show hit, I was working full time as curator and then director at the Pasadena Art Museum. I had started doing some shows there in 1960, never having thought of my future as being a gallery dealer. Somebody asked once why I did the gallery work and it was like when Max Ernst was asked why he painted. He replied, "So I have something I like to look at." In a

fig. 32. Dennis Hopper, *Edward Ruscha*, 1964, gelatin-silver print, 16 x 24 in. (40.6 x 61 cm), courtesy of the artist and Tony Shafrazi Gallery, New York.

fig. 33. Dennis Hopper, *Roy Lichtenstein*, 1964, gelatin-silver print, 16 x 24 in. (40.6 x 61 cm), courtesy of the artist and Tony Shafrazi Gallery, New York. Lichtenstein is seated in his studio at 36 West 26th Street, New York, with *Crying Girl* (1964).

tablecloth, making it probably one of his bigger adjusted readymades. Then all sorts of artists got together and ended up signing that tablecloth. Gerald Malanga, Joe Goode, Ken Price, Robert Irwin, Billy Al Bengston, and Craig Kauffman all signed it. Edward Ruscha certainly did. And Warhol wrote the nom de plume "Andy Pie."

JE Gerald Malanga, Taylor Mead, and California painter Wynn Chamberlain came to Los Angeles with Warhol. They all drove out together from the East Coast. Was that the first time Ruscha and Goode met Warhol?

WH Yes. Dennis Hopper also signed the tablecloth. That was during the period in Hopper's life when he was blackballed by the movie industry and he plunged into his photography really seriously. His first book, *Out of the Sixties*, has all these extraordinary portraits. Hopper's photos of Pop artists, both East and West Coast, are terrific; he made some of the British Pop artists, too. There's a great shot of Rosenquist at an L.A. billboard company and one of Lichtenstein in his New York studio (fig. 33).

JE He published that in *Artforum*. They're wonderful, especially the portrait of Edward Ruscha in front of a radio service store (fig. 32).

WH That's the most beautiful shot ever done of Ruscha—fantastic shot. By the end of 1963, all the artists knew who everybody else was.

JE The year 1962 was the coming out date, don't you think?

WH Absolutely.

JE Your show at Pasadena was the first strictly Pop museum show. It exploded on the scene, and several other exhibitions happened right after that. Virginia Dwan's Pop-flavored show "My Country 'Tis of Thee" came right on the heels of "New Painting" in L.A., and Sidney Janis' "International Exhibition of the New Realists" in New York also followed closely after yours. Then there were half a dozen shows within the next six months that started to put artists together with the Pop tag. But the West Coast people kind of stayed on the West Coast.

WH The one who broke through was Edward Ruscha—somehow he was the one. Alexander Iolas Gallery gave him his first show in New York [1967]. Then Leo Castelli took him on, which made a big difference, and certain key collectors had his work. Today in The Museum of Modern Art, he hangs side by side with Lichtenstein and Warhol.

way, I did the gallery work because the art that the California artists and I wanted to look at, we couldn't see in Los Angeles in the late 1950s, early 1960s.

JE By the time Irving Blum did the second Ferus show with Warhol in L.A. (1963), the one with the multiple Elvis and Elizabeth Taylor paintings, you had mounted the Duchamp retrospective in Pasadena. So Warhol came out for his second show and also got to meet Duchamp.

WH The gathering of people at that exhibition was amazing—that was a real moment. There is a tablecloth from the dinner after the Duchamp opening—a big round pink tablecloth. Just out of amusement, Duchamp signed the

Oddly enough, the one thing that was purchased by the Pasadena Art Museum from "New Painting" was a black, red, and white Robert Dowd painting of Lincoln on a five-dollar bill [*Part of $5.00* (1962)]. But Phillip Hefferton has virtually disappeared. Last thing I heard, he was living in a trailer park somewhere near Santa Cruz. He and the other artists in Lawrence Alloway's "Six More" exhibition [1963, the West Coast addendum to the Guggenheim's "Six Painters and the Object"] were some of the first West Coast artists to be written about in a national magazine. Hefferton not only got mentioned in the *Time* magazine review of the exhibition, but they even reproduced *Sinking George* (1962, pl. 21), showing Washington sliding out of the oval frame of a one dollar bill. [*Time* (August 30, 1963); Mel Ramos' pinup *Futura* (1963) was also illustrated].

Alloway really liked Hefferton's work. Alloway is one of the most important curators of the Pop era: not only was he a big part of the genesis of Pop Art in England, but he was another one of the first people to do a museum show mixing artists from the East and West Coasts. And such a prolific writer.

JE Alloway's "Six Painters and the Object" had Dine, Johns, Lichtenstein, Rauschenberg, Rosenquist, and Warhol, and "Six More" had Bengston, Goode, Hefferton, Ramos, Ruscha, and Thiebaud.

WH That mixing was very important. Alloway ... what a loss! I especially liked him. He stayed at my house in Pasadena, and we traveled a bit and visited San Francisco.

He was the first bridge in this country, as a writer and museum person, between the earlier British Pop artists and the Americans—absolutely the first one. And he brought his knowledge of the British scene along as a curator, working with Thomas Messer at the Guggenheim in New York for several years in the early 1960s.

JE He certainly knew the British side of Pop.

WH Alloway knew so much about all the American artists, too. He had a very interesting range.

JE When Richard Hamilton, who is sometimes called the Father of Pop, came out to Pasadena for your Duchamp show, did he get a chance to see Warhol or any of the other Americans?

WH Oh, yeah. There was a lot of interaction and excitement at that opening. Hamilton is a very erudite man, but in his quiet way he is really aware of all kinds of contemporary developments. We are well overdue for another show of his work in America.

JE So, by 1963 Pop was starting to receive wide exposure?

WH Henry Luce of *Time-Life-Fortune* employed Dorothy Seiberling as the *Life* magazine art editor, and part of her job was exploring interesting new cultural trends. I remember seeing a piece that she had circulated, trying to summarize this new direction, what would finally be called Pop Art. [Pop made its first *Life* appearance in an article on the expanding art market (September 20, 1963).] The general print media was usually unflattering, sometimes

hostile, but had definitely picked up on the trend, and by 1964 the awareness of Pop Art had spread out dramatically, even to a general audience.

Pop didn't feel like an instant success at the time, though. The Warhol soup can show back in 1962 at Ferus (fig. 34)—the one we thought was going to be such a terrific success—was just ridiculed. The op-ed page of the *L.A. Times* ran a cartoon of two gallerygoers (naturally depicted as Beatniks) staring at a row of Warhol soup can paintings in the "Farout Art Gallery" and one is saying "The chicken noodle gives me a Zen feeling" (fig. 35). I think the individual paintings were priced around $1,200 or $1,500, but only one painting sold and two more were put on reserve. Meanwhile, the gallery was dying of humiliation. You have to understand that at this point, there had been no Pop show of Warhol's work back East. Blum was really depressed, but he saved the day by first reclaiming the sold painting and then convincing Warhol to sell him the entire set of thirty-two. Recently, the whole group was acquired by The Museum of Modern Art in New York.

fig. 35. Editorial cartoon, *Los Angeles Times*, August 1, 1962.

JE Some of the magazines played a big part in Pop's eventual acceptance, I think, *Artforum* in particular. It started out on the West Coast, first in San Francisco and then L.A., before going to New York. Now, of course, you say "Pop" and people think of Lichtenstein and Warhol. Maybe Claes Oldenburg is thrown in, along with Dine and Rosenquist. Warhol himself said the movement was over in 1965.

WH I think twentieth-century American art falls generally into three modes. There's the realist mode including artists as diverse as Edward Hopper and George Segal. There are the modernists, concerned with real abstraction and nonobjective art, whether Arthur Dove's work or most of Jackson Pollock's. Then there are the imagists, a category that covers a wide range, from artists like Joseph Cornell and Robert Rauschenberg to the Pop artists in this current exhibition. Imagist work can be as goofy as a little Ben Talbert postcard collage [...*dis mess*... (1962, pl. 16)] or as expressionistic and provocative as one of Edward Kienholz's TV works (fig. 125, pl. 37). Or, in contrast, as clean and refined as Jim Eller's small Assemblages or as stark and blunt as Ruscha's Ball mason jar sculpture entitled *1938* (1958).

JE That's the glass jar that he painted black on the inside and scratched the date "1938" into.

WH Somehow the original got broken. When he confessed to me that he had broken it, I said, "Oh God, you've done so few sculptural things." It was actually his first sculpture before he began to take found books and use them as mounts for his own cut-out photographs. Later he made a miniature version from a mayonnaise jar (fig. 36) to replace the original: a black-painted Ball mason jar with the added numbers "1938."

JE Why "1938"?

WH He just loved those numbers, and the shape of the black jar reminded him somehow of the rear of a '38 Chevy. He slipped a piece of white paper inside so the transparent numbers on the inside of the glass would stand out.

JE The idea of "imagism" runs so strongly through so much Pop Art. Much more so than what sometimes looks like realism in Ruscha's and Rosenquist's work.

WH No, Ruscha and Rosenquist are quintessential imagists. Take Ruscha's *Standard Station* series (c. 1963–64)

fig. 36. Edward Ruscha, *1938,* 1994 (miniature version of 1958 original), epoxy paint on glass jar with metal lid and paper, 4³/₈ x 2³/₈ in. (11.1 x 6 cm) diameter, private collection.

or *Norms, La Cienega, On Fire* (1964, pl. 42), for example, where the image represents more than simply an abstracted rendering of a gas station or coffee shop. One common thread among the Pop artists is their tendency to be icon painters. Ruscha, like Warhol, often features a single, symmetrically placed element, while Rosenquist's multilayered compositions evoke a more complicated kind of visual poetry. Dine's Pop period, on the other hand, divides both ways: *Flesh Tie* is clearly an icon, while *3 Panel Study for Child's Room* (1962, pl. 14) generates a visual discourse among the objects assembled on the canvas in a way that defines a child's room without being a literal depiction.

JE The Popeye figure, the tiny raincoat, the little train set.

WH Artists like Dine and Rosenquist are stringing together the words of a visual poem.

JE One of the aspects that made your "New Painting" show so memorable on the American side was its timing: fall of 1962. Right after that, it was like a floodgate opened. I don't imagine that you had any idea that your show would be remembered as having such an impact.

WH Several things were happening concurrently on the art scene. Some of the interest was market-driven and there was the media interest we talked about, but some of the activity was simply based on availability, suddenly having access to large amounts of Pop work. The enthusiasm was generated by the desire to be part of this excitement of the new.

By the early sixties, we had lost major figures from the American Abstract Expressionist movement—Jackson Pollock, Franz Kline, some of the others. Arshile Gorky was long dead, of course. Other artists had left the country, like Sam Francis who was living abroad. Lives were really changing. And the mid-century work of these major figures was becoming incredibly expensive, even by 1960s standards. For museums organizing exhibitions, many of the paintings had already become harder to borrow.

At the same time that Pop was getting wider exposure, a real polarity was developing in the New York art world as two amazing figures began setting themselves apart from the work of the mid forties to the mid fifties: on the one hand, Warhol and Pop, and on the other, Frank Stella and hard-edge abstraction. That's where American art just opened up and broadened out.

Plus you had the beginnings of some exciting new European influences on American art. First, the recognition and influence of Duchamp (a naturalized American) accelerated. Then Jean Tinguely, an Assemblist [his *Homage to New York* was staged in 1960], and Yves Klein, a Conceptualist, became important forces. Although Yves Klein was dead by late 1962, the better availability of his work stateside had sparked a growing interest.

This was how the stage was set when I began doing shows at the Pasadena Art Museum. After the Kienholz show in 1961 ["Edward Kienholz: Recent Works" (June 20–July 17)], the first exhibition that I considered really mine was the big Kurt Schwitters retrospective that opened in June of 1962. The show touched on his affinities with two prominent strains of 1960s work: on the one hand, Assemblage and found objects, and on the other, the Pop-related use of commercial reproductions as collage elements.

I also did "Collage: Artists in California" (1962) concurrently, featuring artists from both Northern and Southern California, some of whom worked in a Pop vein. I had William Copley (CPLY), Bruce Conner, Fred Martin, Edward Ruscha, and Ben Talbert. There was a strange little Assemblage by Talbert that I hung high since it contained a really obscene picture. Artworks were hung floor to

fig. 37. Jim Eller, *Kitchen Unit with Three Rats*, 1962, enamel tin toy with rubber rats, 11½ x 6⅝ x 5⅛ in. (29.1 x 16.8 x 13 cm), private collection.

go out to the track and watch him race, worrying whether he was going to get maimed or killed.

One day Hefferton decided to introduce me to Eller. Hefferton brought over this "bright young man" to the Pasadena Art Museum office, and Eller said, "I have some work to show you. I'm parked out front." So we went down and all we found outside was this immaculate car: a brand new Buick Skylark. It could have been in one of those Hamilton collages in the British "This Is Tomorrow" show, which was a hymn to America's commercial culture. At that point, we had barely heard of the British term "Pop Art." That's why I didn't use it for "New Painting."

JE I was going to ask you why you didn't incorporate "Pop" into the exhibition title.

WH I think I first learned through Duchamp about the pre-Pop activity that had gone on in Britain with the likes of Hamilton and Alloway in the mid 1950s. Duchamp and I had been in touch since 1962 through William Copley. Copley just crossed over everywhere—as an artist, as a dealer, as a patron, as a connection between all sorts of worlds. He was definitely a Pop precursor.

When I wrote a review for *Artforum* of Wayne Thiebaud's show at the de Young Museum in San Francisco in September 1962—right at the time of the Pasadena exhibition—I put in a long footnote that gave all kinds of examples of synonyms that were floating around for what this new confluence of work could be called. But looking back, the Pasadena title "New Painting of Common Objects" still seems exactly right.

Interview took place on May 13, 2000, in Houston.

ceiling, so you would see this incredible wall of different artists: there were about one hundred in the show. William Dole, who was very traditional, was in one corner, and across the room you had the found object Assemblages of George Herms.

Early in 1962, about the time of the collage show, I met Jim Eller. Eller had shifted gears into these immaculate little Pop Assemblages made of found toys, such as his *Kitchen Unit with Three Rats* (1962, fig. 37) or *Scrabble Board* (1962) with only the word "RAT" spelled out.

JE That's in Lucy Lippard's *Pop Art* book.

WH Eller had also turned on to the master motorcycle and hot rod customizer, Von Dutch Holland, whom I knew through Billy Al Bengston. All that beautiful custom car spray painting that influenced Bengston's lacquer work was spilling over into California art. As you know, Bengston was a professional motorcycle racer. We used to

"New Painting of Common Objects"
Pasadena Art Museum (September 25–October 19, 1962)
Works in the Exhibition

Jim Dine: #1, #2, #3, #4, #5, #6, #7, #8, #9; *Rainbow*; *Rainbow* (all 1960)
Robert Dowd: *$1.00*; *Part of $5.00*; *Travel Check* (all 1962)
Joe Goode: *Happy Birthday*; *Dark Garage*; *Purple* (all 1962)
Phillip Hefferton: *The Line*; *Twenty*; *Two* (all 1962)
Roy Lichtenstein: *Roto Broil* (1961); *Masterpiece* (1962); *Spray* (1962)
Edward Ruscha: *Box Smashed Flat* (1961); *Actual Size* (1962); *Falling, But Frozen* (1962)
Wayne Thiebaud: *Five Hot Dogs*; *Lemon Meringue Half*; *Pie a la Mode* (all 1961)
Andy Warhol: *Campbell's Cream of Chicken*; *Campbell's Pepper Pot*; *Green Stamps* (all 1962)

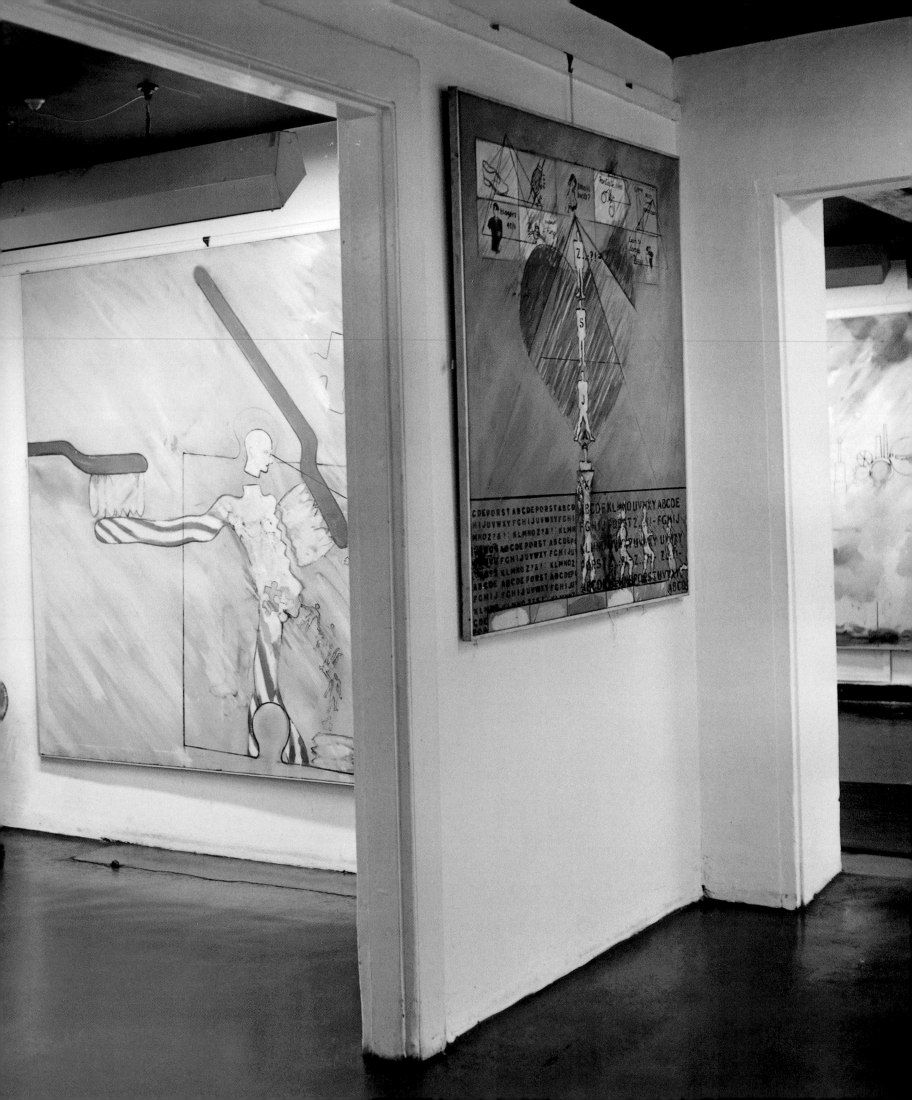

British Pop Art: 1956–1966
A Documentary Essay

DAVID E. BRAUER

Contrary to general belief, pop art did not come from the U.S.A., it was born in England. Lawrence Alloway first coined the phrase "pop art" in 1954, and his exact definition of what it meant was very different from the meaning ascribed to it now. When Alloway spoke of "pop art" he meant: advertisements in glossy magazines, posters outside cinemas, leaflets, pamphlets, all give-away literature forcefully communicating a single message. He meant, in fact, the whole paraphernalia of public art—art made by the few for the many, not for its own sake but for the sake of what seems to be naively speaking, an ulterior motive. Thus, pop art accompanied one during breakfast, on the way to work, during one's leisure hours and it infiltrated its way into one's dreams, forcibly and inevitably.[1]

—Jasia Reichardt

Why and how did Pop Art originate in Britain before it emerged in America? What distinguishes British Pop Art, based as it is on a recognition and response to postwar popular and high American culture, from the American Pop works? In brief, what elements are unique to British Pop?

British Pop Art emerged after a decade of rationing, rebuilding, and national reconstruction of identity following World War II, a period in stark contrast to the portrayals of American wealth that permeated Britain at that time through American movies and occasional magazines. One could say, then, that British Pop arose from a relationship with American culture analogous to standing outside the toy shop with one's nose pressed against the glass as opposed to owning the shop and all its contents. That distance is critical to understanding the idea-fueled nature of British Pop as opposed to the experiential quality of its American counterpart.

While this British fascination with things American

may have been made more acute by the immediate postwar contrast between a devastated Britain and a prosperous America, it is not a new phenomenon. It goes back to the sensation caused by eighteenth-century American artist Benjamin West's exhibition in London of *Death of Wolfe* (1770), portraying not only Native Americans but whites wearing native costume, and the arrival of Buffalo Bill Cody's Wild West Show in nineteenth-century and early twentieth-century Europe, complete with souvenirs and postcards.[2]

In a similar way, John McHale of the British Independent Group, returning from America, would bring to London a trove of American magazines, comics, and advertisements in the fifties. It was that group's discussions of American pop culture and mass media that laid the foundation for the subsequent upheaval in British art. Echoing Gustave Courbet's maxim that an artist must concern himself with his own time, the early Pop theorists focused on contemporary urban life, projected through the popular media of cinema, television, and advertising. Defending the then new urban modernism, Édouard Manet believed that the artist must be of his time and work with what he sees.

Nurtured by exhibitions such as the annual "Young Contemporaries" and the "John Moores Liverpool Exhibitions," young art students began to come together in a shared spirit that reflected the confluence of rapid changes in British society, including a heightened consumerism and new wealth. Indeed, the meteoric rise of British Pop is to a large extent a mirror image of the greater openness and freedom possible in Britain as the late fifties gave way to the early sixties.

Throughout its rise and culmination, British Pop Art

fig. 38. "Image in Revolt" (October 5–November 3, 1962), Grabowski Gallery, London, installation view. Works shown are Derek Boshier, *The Identi-Kit Man* and *ABCDEFGHI* (both 1962). Photograph by Tony Evans.

preserved its unique character relative to American Pop by maintaining that observant difference. While Andy Warhol could declare, "I feel I'm very much a part of my times, of my culture, as much a part of it as rockets and television,"[3] the British Pop artists, whatever their degree of fascination with American culture, remained always in their own work—essentially—removed.

POSTWAR BRITAIN: SOCIAL AND CULTURAL RECOVERY

The germ of the British Pop evolution is to be found in the wartime stationing throughout Britain of a million or so U.S. troops, ordinary Americans whose prolonged presence, as an army not of occupation but of alliance, exposed equally ordinary Britons to American vernacular culture—food, music, fashion, and slang. Not the least of these was the culture (especially the music) of African-American soldiers, who would find themselves welcomed and admired in Britain.

But with the arrival in London of the first American troops in April 1942 came a glaring disparity both in pay and in access to common luxuries, like cigarettes: the Americans were, as the current quip said, "Overpaid, Oversexed and Over Here." By the end of the war, the contrast between a massively damaged Britain and a relatively untouched United States, except in lives lost, was acute. Four million British homes were damaged, including half a million totally destroyed, and the country was economically devastated and in debt. Soon the year 1947 would bring the worst winter in memory: the meat ration was cut even further, and even potatoes were rationed.

Ironically, with consumer spending inhibited by rationing and a new National Health Service giving free medical care, Britons had a modest surplus of disposable income. One of the few outlets was the cinema. While popular demand led to a resurgence of filmmaking in postwar Britain,[4] there rapidly grew a perception in British and European film studios that the American motion picture industry posed a minatory situation to their attempts to recover from years of wartime censorship. During the war, the American film industry had accumulated a vast reservoir of product that was released, as though from a burst dam, on the postwar European market, from musicals to film noir, averaging some 500 films a year. The fact that these films were popular in no way mitigated the fact that they impeded the growth of the resurgent European film studios.

The conterminous nature of British and American history and culture was not shared by Europe. Newly liberated, defeated, and occupied by America, a Europe that once had ignored Euro-Americans like Gertrude Stein, patronized American jazz, and mocked American fashions found its prewar prejudices deepened. Fears regarding American cultural imperialism in the late forties could hardly have been assuaged by reading a *New York Times* article in which Barney Balaban, president of Paramount Pictures, specializing in popular and populist movies, stated, "We, the [film] industry, recognize the need for informing people in foreign lands about the things that have made America a great country and we think we know how to put across the message of our democracy. We want to do so on a commercial basis and we are prepared to face a loss in revenue if necessary."[5]

The British poet Stephen Spender, then living in America, wrote an article commenting on the postwar American "hearts and minds" campaign in Europe and the realization that in the new Cold War a choice had to be made between America and Russia. Spender argued that instead of heavy-handed propaganda—to which Europeans would be resistant, having had years of it from both communism and fascism—America should apply the subtler influences of culture and education.[6]

Meanwhile, Britain began formulating its own form of cultural defense when in 1945–49 the state attempted to assume far greater responsibility for (if not direct control of) the conditions of public culture. The Labor victory of 1945 presaged a nationalization of culture as well as of education and the major industries: "After the war the leaders of both parties supported Keynes's brainchild the Arts Council. Reverence for the arts and respect for the intellect became fashionable, and Britain no longer seemed to be a philistine country. It followed Europe in recognizing that the state owed a duty to subsidize the arts."[7]

The postwar period in Britain saw a marked growth of interest in the visual arts. During the war, most of the paintings in the National Gallery had been shipped out of the city,[8] and nothing sharpens attention on the value of beautiful things more than making them inaccessible. The creation of the Arts Council of Great Britain in 1946 and the Institute of Contemporary Arts (ICA) in 1948[9] brought about a wider discourse with the existing Royal Academy of Arts and the Tate Gallery. The ICA had originated in a letter signed by British art historians Roland Penrose and Herbert Read and the collector E. L. T. Mesens

PRIVATE EYE

incorporating THE FLESH'S WEEKLY

VOL 1 No 4 Wednesday 7th February 1962 Price 6d.

BRITAIN'S FIRST MAN INTO SPACE

ALBERT GRISTLE AWAITS BLAST-OFF

fig. 39. Cover of *Private Eye* (February 7, 1962).

that outlined the desirability of London's having its equivalent to The Museum of Modern Art in New York. As Read wrote, "What is needed is some centre where artists of all kinds can meet with cooperative intention, and where their activities can be presented to a public ready to encourage art in those preliminary stages which are so vital for its development."[10] The Statement of Policy of the ICA argued that ". . . a living art, that is to say, a progressive art made for and understood by its contemporaries, is an essential in any vital community, and we believe it can be fostered in England. The spirit of the time speaks through the work of all artists . . . and art should be a part of the life of the community as a whole." However, an artistic battle would rage between the assumed values of the Royal Academy and other established institutions, and the "modern" agenda of the new organizations.

In 1953 the coronation of Queen Elizabeth II brought about much talk of a new Elizabethan era. The coronation was one of the first great events covered by live television, and it firmly established the media ascendancy of television over radio. By the early 1960s, however, a growing intellectual antipathy toward television would be expressed. F. R. Leavis, one of the most influential literary critics of the time, believed that while popular culture once had been shaped by the moral worth of literature, today's popular culture had been corrupted by mass media. Many others shared his view. Their attacks were not only anti-mass media but also implicitly anti-American since a number of American television programs were shown on British networks. Social historian Raymond Williams noted, "At certain levels, we are culturally an American colony,"[11] acknowledging that while not all American cultural influences were negative, in the area of entertainment that influence was disastrous.

By the mid 1950s, the younger generation was increasingly impatient with the postwar climate, and new attitudes began to surface. Literature, poetry, and theatre took on the "taboo" issues of class, sex, religion, and the Establishment in an increasingly combative tone. Most of the British Pop artists were old enough to have memories of the war; some were evacuated from London as children. The majority of them did compulsory National Service, the last generation in Britain to do so. This experience in-

stilled in them a profound contempt for authority, a sharpened awareness of the difference between the individual and the system.

Radio did something to disseminate this new attitude, and the proliferation of television brought it into the home. Although the BBC was largely perceived as part of the Establishment, a change occurred in January 1960 when Hugh Carleton Greene became Director-General of the BBC and announced that he intended to encourage enterprise and the taking of risks, believing that most of the best ideas come from below, not above.

Satire also grew in the late 1950s and early 1960s, emerging in the very bastions of Oxbridge conformism. The graduate review club The Cambridge Footlights had been a university institution since 1883, but by 1959 their revue *The Last Laugh* had started taking on social rather than collegiate issues. In August 1960, Peter Cook and Jonathan Miller from Cambridge joined forces with two Oxford graduates, Dudley Moore and Alan Bennett, to put together *Beyond the Fringe,* a satirical sketch revue for the annual Edinburgh Festival. *Beyond the Fringe* subsequently opened in London in May 1961 to solid commercial success. Among the sketches that seemed daring at the time were those critical of nuclear defense and capital punishment, and a parody of Prime Minister Harold Macmillan. By October 1961, Cook had opened a small nightclub called The Establishment, at about the same time that Richard Ingrams founded the satirical magazine *Private Eye* (fig. 39). In April 1962, Cook became *Private Eye*'s principal shareholder. As Ingrams would later write, "The heroes of the day in addition to James Bond, Lawrence Durrell and Ingmar Bergman were the cast of *Beyond the Fringe*."[12]

This period also felt the immediate and deep impact of a new presence: rock and roll. The effect of this catalytic music was to release a pent-up emotional and frequently physical violence in postwar British working class society: "A great change suddenly came over London at that time [1957]. The American civilization had caught up with us. Everything was speeded up and slicked up, and there was a great deal of violence in the streets."[13] Rock and roll provided a psychic release as powerful as a steam valve, and the early appearances not only of recordings but also of personal tours by American performers such as Bill Haley and the Comets provoked violence, destruction, and appalled press attention throughout Britain. As Jeff Nuttall noted, "Early British performances of the

fig. 40. William Green, *Elvis*, 1958–59, gelatin-silver print, 10 x 8 in. (25.4 x 20.3 cm), courtesy of England & Co. Gallery, London.

Bill Haley band and the first showing of Elvis Presley films were celebrated by rows of razored [slashed] seats in the theatres concerned. These again did not indicate dissatisfaction with the performance or anger with the management. They were signatures."[14]

Little Richard, Fats Domino, the Everly Brothers, Jerry Lee Lewis, Gene Vincent, Buddy Holly, and Elvis Presley (fig. 40) were the immediate and enduring favorites among British audiences (including artists), along with some homegrown proto-pop performers. There was also a covert but influential following for rhythm and blues music. For the second and third waves of British Pop Art, the presence of rock and roll would introduce a new treasure trove of subject matter.[15]

POSTWAR BRITISH ART: ORIGINS OF POP

Perhaps the biggest change that modernism effected from the mid nineteenth century on was the realization that culture was not just the past but also the present: virtually anything and everything, given a context, could acquire meaning and significance. The subsequent acceptance of mass media as art material necessitated a change in the definition of culture and in what ideas it represented. Modernism's greatest gift was the capacity to look at anything and everything with an open and unprejudiced eye, and the roots of Pop Art lie firmly in its achievements.

Modern art in Britain before World War II had been dominated by the two great inter-war movements of Constructivism and Surrealism. The year 1936 saw two representative exhibitions open in London: the Constructivist

fig. 41. Walter Sickert, *Jack and Jill*, c. 1936–37, oil on canvas, 24½ x 29½ in. (62.2 x 75 cm), private collection. Based on a film still from *Bullets or Ballots* (1936) starring Edward G. Robinson and Joan Blondell.

"Abstract and Concrete" in the spring and the "International Surrealist Exhibition" that summer; the latter, not surprisingly, drew a great deal of media attention. Both these exhibitions showed the links between British and European modernist art, and the influence of these two movements persisted in Britain into the postwar period through artists as diverse as Victor Pasmore and Graham Sutherland.

Neo-Romanticism was also a significant postwar presence, a movement whose gothic, shadowy quality infused films such as *Stairway to Heaven* (1946), *Oliver Twist* (1948), *Great Expectations* (1946), and *Brief Encounter* (1946), among others. Neo-Romanticism informed the poems of Dylan Thomas and much other British poetry, and was a strong presence in the paintings of Sutherland, John Craxton, John Minton, Michael Ayrton, and Francis Bacon.[16]

Alloway credited Bacon's use of photography as influential on British Pop, to which one must add the less acknowledged contribution by Walter Sickert (1860–1942). Sickert was the first major British artist to draw upon photographic material from media sources such as news photos and film stills (fig. 41). His extraordinary achievement in utilizing such imagery as primary, rather than secondary, source material is hardly paralleled anywhere. Noting that Bacon's photographic material from Eadweard Muybridge and Sergei Eisenstein was already, in a sense, "old," Alloway remarked that the early Pop artists had available a much greater diversity of photographic sources: in the 1953 London exhibition at the ICA "Parallel of Life and Art," the collection of a hundred images showed

fig. 42. John Bratby, *Still Life with Chip Fryer*, 1954, oil on canvas, 51½ x 36¼ (131 x 92 cm), Tate Gallery, London

how "the range of photographic sources was suddenly exploded, X-ray, high-speed and stress photographs . . . ," thus linking the first phase of British Pop Art (1953–58) "with themes of technology, as opposed to the pastoral and primal ideas of British neo-Romanticism."[17]

The term "Kitchen Sink" was coined by David Sylvester in 1954 for his article in *Encounter* magazine.[18] Kitchen Sink art was an antidote to both postwar neo-Romantic and Constructivist abstract painting. The principal Kitchen Sink artists were John Bratby, Jack Smith, Derrick Greaves, and Edward Middleditch (fig. 43). They were the art world counterparts of the "Angry Young Men" in literature and theatre and, like them, had strong provincial roots:

> In the mid-1950's, quiet good taste took a tremendous formal beating in British art. . . . The use of ready-made images from billboards and girlie-magazines and pierhead postcard-stands was meant to blow up standard notions of taste and substitute . . . a perfected democracy. . . . Subject matter went the same way: cheap underclothes and the toilet seat were favorites of Bratby; Derrick Greaves and Jack Smith patrolled the debris of kitchen and nursery.[19]

The apogee of the Kitchen Sink school came in 1956 when they represented Britain at the Venice Biennale, along with the sculptures of Lynn Chadwick and the decidedly un-Kitchen Sink landscapes of Ivor Hitchens. After the Kitchen Sink appearance at the Biennale, most of the artists evolved towards brighter colors or subjects, or to abstraction. Nevertheless, Bratby's chaotic working-class still lifes of cornflakes packets and bottles of milk were admired by, and influential on, several future Pop artists (fig. 42), and the Kitchen Sink influence is clearly seen in early works by David Hockney, Clive Barker, and Derek Boshier, who wrote his senior thesis on the Kitchen Sink school.

fig. 43. Kitchen Sink painters (Jack Smith, Edward Middleditch, John Bratby, and Derrick Greaves) and Helen Lessore, gallery owner, Beaux Arts Gallery, London, 1959.

Other elements would change the balance of British painting—in particular, the St. Ives school. The St. Ives school, named after the small Cornish village where the artists lived and worked, originated just before World War II with the Constructivist abstract artists Ben Nicholson, Barbara Hepworth, and Naum Gabo. A new postwar St. Ives group brought a painterly fusion of abstract and landscape elements with the works of Patrick Heron, Peter Lanyon, Terry Frost, Roger Hilton, and William Scott.

Both St. Ives factions were influenced by the 1956 Tate Gallery exhibition "Modern Art in the United States," a survey of Abstract Expressionism, although the American emphasis on improvisation met with a certain resistance in a country not renowned for its spontaneity.[20] It was the 1959 Tate Gallery exhibition "The New American Painting," however, that had the most overwhelming effect on the St. Ives school and British Constructivism, sweeping them away even as it provoked a virulently negative critical response. The exhibition included some eighty-one works, four or five apiece by William Baziotes, James Brooks, Sam Francis, Arshile Gorky, Adolph Gottlieb, Philip Guston, Grace Hartigan, Franz Kline, Willem de Kooning, Robert Motherwell, Barnett Newman, Jackson Pollock, Mark Rothko, Theodore Stamos, Clyfford Still, Walter Bradley Tomlin, and Jack Tworkov. Some 14,000 visitors saw the exhibition in London. In Britain the critical response to the exhibition was

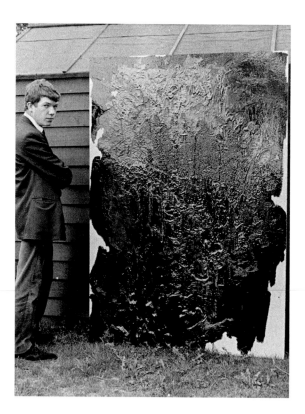

Banham and included Alloway (fig. 45), Hamilton, McHale, and Eduardo Paolozzi, among others. From the start, architects and designers were included, which served to bring about a wider social (though not necessarily political) discourse as to the future of modernism.

The Independent Group platform was to voice a protest against the institutionalized view of twentieth-century art represented in the government-sponsored ICA programs and in the "high" art tradition advocated by critics such as Roger Fry and Read. This narrowing of the distance between "popular" art and "fine" art, rejecting Fry's "disinterested contemplation," lies at the very nexus of the British Pop sensibility. The Independent Group's agenda was also to provide an open and serious discussion about the impact of popular culture, particularly from America. Members felt that the images from American advertising were more than a match for the images of the fine art of the time, even though everyone knew that to like commercial art was heresy and that the mass media were the enemies of culture. The meetings at the ICA slowly changed that. The old observation that Britain and America are two countries separated by one language had its truth, but mass media and popular culture were giving rise to a demotic commercial idiom, and Pop Art would become a commentary, embrace, celebration, and critique of this cultural Esperantism.

However, in a cultural and political climate where anti-Americanism had become de rigueur, the group's embrace of American consumerism as culture went provocatively against the grain. This pro-American stance came at a time when very few of the Independent Group had been to America; indeed, for a variety of reasons, travel to America was infrequent before 1960. However, one intrepid member, McHale, did go to America in 1955 and brought back with him to London a cabin trunk full of magazines, records, and other ephemera that was greeted

overwhelmingly negative, even derisory. Reviews included such descriptions as "disgusting," "filth," "lucrative muck," and "fraudulent absurdities" that made the writer regret that "Hitler died too soon."[21]

The influence of the American works was twofold, demonstrating new possibilities in what could be expressed through abstraction and, more importantly, offering many new technical processes, including large-scale formats and a new primer of mark-making: the stained, poured, scumbled, dragged, and incrassated surfaces enlarged and enlivened the techniques of both abstract and figurative British painting (fig. 44). Many of the British Pop artists incorporated the surface qualities of the new American abstraction into their figurative works, just as they had the earlier Kitchen Sink realism.

The Independent Group

As noted by John Russell and Suzi Gablik, the earliest developments of Pop Art took place in the meetings of a group of British artists and designers who first saw the art value of popular culture: "There is no doubt that the Independent Group did establish a working dialectic for Pop long before Pop as such made its appearance in America, and that [Richard] Hamilton's alembications of Pop material preceded anything of the kind on the other side of the Atlantic."[22] The Independent Group—so named to distinguish it from a Painter's Group that also met at the London ICA—began meeting in Dover Street during 1951 at the prompting of design historian Reyner

by his associates with the same sense of amazement that must have greeted the first viewing of Montezuma's gold when it was brought to the port of Antwerp in the early sixteenth century:

> McHale was one of the earliest British artists to visit the United States to study with Joseph Albers at Yale University in 1955–56. He returned with a great collection of popular magazines and a familiarity with color reproduction of a level not yet usual in Europe. For instance, the European editions of *Time* had far less color than the American editions. Hence, McHale's use of full-spectrum color (particularly in food ads) was media-induced and innovative.[23]

The first Independent Group exhibition, "Growth and Form," was organized by artists Hamilton and Paolozzi and photographer Nigel Henderson. Held at the ICA in July 1951, it was a dimensional collage environment using photographic, scientific, X-ray, microscopic, and "found" imagery from commercial publications.

In April 1952, Paolozzi gave a talk at the ICA in which he used overhead projections to show scores of images from science fiction paperbacks, magazine advertisements, and other pop culture sources. Later Alloway would recall that Paolozzi had always collected "weird" images and that the effect of this presentation had "stunned everyone," adding that it was difficult to realize its impact twenty-seven years later.[24]

In September 1953, the group's second exhibition, "Parallel of Life and Art," arranged by Paolozzi, Peter Smithson, and Henderson, was a free-form installation using over a hundred primarily photographic images, demonstrating that such images charged the daily experience of life far more than "serious" art did.

A subsequent series of meetings was held in 1954–55, during which Alloway recalled, "we discovered that we had in common a vernacular culture that persisted beyond any special interest or skills in art, architecture, design, or art criticism that any of us might possess." [25] He continued:

> The area of contact was mass-produced urban culture: movies, advertising, science fiction, Pop music. We felt none of the dislike of commercial culture standard among most intellectuals, but accepted it as a fact, discussed it in detail,

and consumed it enthusiastically. One result of our discussions was to take Pop culture out of the realm of "escapism," "sheer entertainment," "relaxation," and to treat it with the seriousness of art. These interests put us in opposition both to the supporters of indigenous folk art and to anti-American opinion in Britain.

In the summer of 1955, the Independent Group exhibition "Man, Machine and Motion" focused on images of aircraft, automobiles, and machinery (figs. 46, 47). "The American cars . . . link with the movies. The panoramic view from inside the luxurious car (comfortable as a first-run cinema) echoes the horizontal screen."[26] The group's early exhibitions often took on the aspect of a Dada collage environment, whose quality of multiple reprographic imagery would be seen later in the works of many British and American Pop artists.

In October and November 1955, BBC Radio broadcast a series of Reith Lectures delivered by Nikolaus Pevsner, a respected historian of architecture and design. His topic was "The Englishness of English Art," and it offered a scholarly, concise, and sensitive reading of British visual culture from William Hogarth to Constructivism. The lectures were published in 1956 and attracted much favorable criticism and, for such a work, a wide readership.[27] There is no small irony in the fact that Pevsner's book appeared in the very year that two events effected major changes in British art.

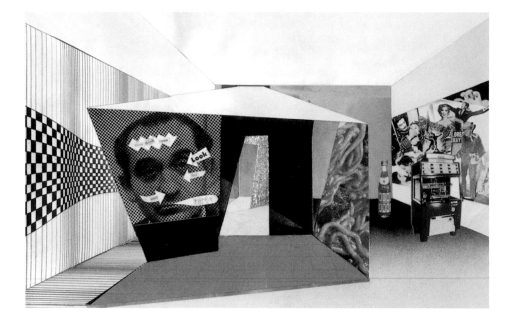

The first was "Modern Art in the United States" at the Tate Gallery, an overview of American painting that included works by Rothko, Pollock, de Kooning, and other Abstract Expressionists. The other was the Independent Group participation in the important exhibition "This Is Tomorrow," presented at Whitechapel Art Gallery, London, on August 8–September 9, 1956, at a time when members were beginning to disperse and had ceased to hold meetings. A last injection of enthusiasm, however, enabled them to put what had been ideas into practice, and "This Is Tomorrow" was conceived. Although Independent Group adherents made up only half the show, they got all the attention.

Long regarded as the seminal exhibition of early British Pop Art, "This Is Tomorrow" explored the possibilities of integrating a wide spectrum of the visual arts, emphasizing in the process the connection of art to modern life (figs. 48, 49). Twelve teams, each comprising two to four architects or artists, collaborated to create installations that invited the viewer to walk around and through them, to be surrounded by them, just as he or she was surrounded by everyday life. The most memorable of the twelve stations was the one built by John Voelcker, McHale, and Hamilton:

> The final structure, designed by John Voelcker, reflected the topological motive and housed two specific types of imagery: sensory stimuli and optical illusions from the Bauhaus and Marcel Duchamp (the theme of perception), and images from popular art, chiefly from the cinema and science fiction (the theme of what we perceive at the moment).... Projectors [and] gramophone motors for moving the Duchamp rotoreliefs, film posters, and probably the jukebox, were supplied by Frank Cordell. The exhibit was regarded as the most successful contribution to "This Is Tomorrow." Certainly it drew a good deal of attention, with its sixteen-foot-high image of

Robbie the Robot; Marilyn Monroe, her skirt flying, in a scene from *The Seven Year Itch*; the giant bottle of Guinness; the spongy floor that, when stepped on, emitted strawberry air freshener; the optional illusion "corridor"; the total collage effect of the "Cinemascope" panel; the jukebox; and the reproduction of van Gogh's *Sunflowers*. This last item was the most popular art reproduction on sale at the National Gallery.[28]

In the catalogue, for which he created his famous collage *Just what is it that makes today's homes so different, so appealing?* (1956, pl. 1), Hamilton wrote, "We reject the notion that 'tomorrow' can be expressed through the presentation of rigid formal concepts. Tomorrow can only extend the range of the present body of visual experience."[29] And at a later date, another Independent Group member, Theo Crosby, who had worked on the Group One station in "This Is Tomorrow," stated, "The show did ...make it clear that there was to be no simple, direct road to the future, but a maze of contradictory paths and personal preferences. It was diffused, unedited and innocent.... It had no progeny, but it brought amicably together a great variety of intelligence."[30]

While the Independent Group had done much of the pioneering work in looking at popular American culture through the prism of a fine art sensibility, its influence was slow to be absorbed. Ultimately it was through the group's ideas, rather than the minimal amount of imagery it produced, that the Independent Group would influence the incoming 1959 generation of Royal College of Art (RCA) students, a few of whom later claimed to have had little awareness of it at the time although the RCA magazine, *ARK*, published several influential articles by group members.[31] Because the very source material that the Independent Group examined and discussed was already widespread in society at large—in movies, television,

advertisements, science fiction, fashion—artists did not so much come to an analysis of mass media through the group as have their personal experience of it verified by the group's discussions.

In his 1957 article "Personal Statement," Alloway did precisely that. He began by stating, "If I have a reason for writing a personal statement it is because of my consumption of popular art." He went on to say that "for me . . . the consumption of popular art (industrialized, mass produced) overlaps with my consumption of fine art (antique, luxurious)." He saw two problems for people of his generation (he was born in 1926):

> (1) We grew up with the mass media. Unlike our parents and teachers, we did not experience the impact of the movies, the radio, the illustrated magazines. The mass media were established as a natural environment by the time we could see them.

> (2) We were born too late to be adopted into the system of taste that gave aesthetic certainty to our parents and teachers.[32]

Alloway then continued:

> We begin to see the work of art in a changed context, freed from the iron curtain of traditional aesthetics which separated absolutely art from non-art. In the general field of visual communications the unique function of each form of communication and the new range of similarities between them is just beginning to be charted. It is part of an effort to see art in terms of human use rather than in terms of philosophical problems. The new role of the spectator or consumer, free to move in a society defined by symbols, is what I want to write about.

Most of the salient aims and aspirations that developed in British Pop Art are found in this article by Alloway. For all its brevity, few other texts from the period better sum up the argument for the new art. Its vision of what the new art could be was generous and democratic. Who would have read it? Surely members of the by then dispersed Independent Group, certainly Hamilton and Paolozzi, both of whom were teaching. The RCA students at the time—such as Hockney, R. B. Kitaj, Boshier, and Allen Jones—would have read most issues of *ARK* (fig. 50). Slowly the ideas of the Independent Group were becoming well assimilated into the general discourse in classrooms, studios, common rooms, pubs, and parties.

In January 1957, Hamilton, then thirty-five and teaching at Newcastle University, observed that all the basic material requirements—for example, some kind of shelter, some kind of equipment, some kind of art—were being met by mass production (housing, clothing, food, books, recorded music, reproductions). The aesthetic uniting them he called "Pop Art," following Alloway's definition. In his oft-quoted "Letter to Peter and Alison Smithson" of January 16, 1957, Hamilton wrote:

> Pop Art is:
>
> Popular (designed for a mass audience)
> Transient (short-term solution)
> Expendable (easily forgotten)
> Low cost
> Mass produced
> Young (aimed at youth)
> Witty
> Sexy
> Gimmicky
> Glamorous
> Big business [33]

Hamilton's list pertains to popular culture—movies, television, magazines, and advertisements—rather than artworks. At the time of writing, Hamilton himself had made no actual work that related to this list, other than the collage done in 1956 for the "This Is Tomorrow" exhibition catalogue.[34] Even Paolozzi's pioneering collage works fell within the domain of private scrapbooks of reference material, truly remarkable for their anticipation of things to come but virtually unknown (other than to those who visited his studio) until 1971. Hamilton himself acknowledged that the program listed above was used only as a "theoretical basis for a painting called *Hommage à Chrysler Corp.* [1957], the first product of a slowly contrived programme."[35] The Independent Group discussions had addressed issues of mass media's influence on culture, specifically mass media *as* visual culture; as Hamilton commented, whereas Renaissance Italy had had Florence, Venice, and Rome, we now have Madison Avenue, Detroit, and Hollywood. But still at this point, the group was using the term "pop" art to identify the culture of mass media, but not as yet the art works inspired by it:

fig. 50. Cover of *Ark,* no. 28 (Spring 1961), designed by Allan Marshall.

ARK 28 Journal of the Royal College of Art 3 shillings or 75 cents

The connection between fine and pop art, then, is not basically one of subject matter.... The difference the arrival of pop art makes to art is part of a larger shift in attitude. As a result of psychological, sociological, and historical study, and a sensitivity to iconology, art can now be sited within a general field of visual communications. It is now necessary to make a new set of connections between art and the spectator, more accurate and extensive than the currently run-down state of traditional aesthetics allows....[36]

The principal achievement of Pop Art theorists like Alloway and McHale was to offer an alternative cultural model. Until then, the fine arts had been seen as the apex of the cultural pyramid, with the popular arts as the broad base. Now, Alloway asserted, there was a "long front of culture," the title of an article published in 1959. Mass production and growing wealth had changed the definition of culture. "The aesthetics of plenty oppose a very strong tradition which dramatizes the arts as the possession of an elite... Acceptance of the mass media entails a shift in our notion of what culture is."[37]

EMERGENCE OF BRITISH POP

Meanwhile, the "Young Contemporaries" exhibitions of 1960 and 1961 were functioning as the *Urgrund* of a new phase of British Pop. These showcases for works from art schools throughout Britain had begun to attract the attention of collectors, dealers, and critics on the lookout for new (and cheap) talent. By the later 1950s, over fifty art schools were represented in the shows, and by 1960 the new wave of young Pop artists was making its appearance:

> The main straw in this year's wind is that the Painting Department of the Royal College of Art, for long the home of the realism of Bratby, Smith and Middleditch is climbing out of the kitchen sink; this appears to be a spontaneous move among the students.... In particular Richard Smith and Robyn Denny showed large painterly abstractions. Smith, who is about to leave the College, is an artist who has successfully replaced the realist and pseudo-antique discipline of art school with a thorough assimilation of American art.[38]

While the "Young Contemporaries" exhibitions brought into focus the new generation of RCA painters, this did not as yet characterize a "united front" of British Pop; even at this point, the perception as to who was Pop and who was not Pop was, for artists and critics alike, a matter of personal selection. But the sense of something new was palpable, as the artist, critic, and teacher Norbert Lynton later recalled: "By 1962, and the next 'Young Contemporaries' [Pop] show, it looked as though ... art might actually become popular again.... The media, amazed to find themselves *loved* by art, loved it in return and celebrated it. Its images reproduced well, even on newsprint. Some of the artists were themselves good picture and gossip material."[39]

With regard to British Pop, there are differing opinions as to whether there were two or three distinct waves of activity. If the former, that would mean the Independent Group artists Paolozzi and Hamilton, followed by the 1959–61 RCA generation (along with several ancillary figures). The present exhibition takes the latter view, that there were three overlapping and mutually penetrating waves, the first represented by the Independent Group, which might be characterized as proto-Pop, although carried forward by Hamilton and Paolozzi. The second wave was represented by Peter Blake and Joe Tilson. The third wave comprised the 1959–61 postgraduate RCA generation, namely Kitaj, Hockney, Boshier, Jones, Patrick Caulfield, and Peter Phillips.

Several other figures must be added to the scene: Pauline Boty, who entered the RCA postgraduate program in 1958, but within a year came to know the new generation; Gerald Laing, who attended St. Martin's School of Art, London, in 1960–64; and Barker, who studied at Luton College of Technology and Art in 1957–59.

The American artist Larry Rivers entered this scene for a year beginning in the fall of 1961, when he was invited by Robin Darwin, principal of the RCA, to visit the studios of the RCA painters. He had his first London exhibition at Gimpel Fils Gallery the following May, featuring sixteen paintings, among them *Cedar Bar Menu* (1960–61), *Camels* (1962), and two versions of *Lucky Strike* (both 1961). At about the time his show closed, an Ellsworth Kelly exhibition opened at Arthur Tooth & Sons, Ltd., London; the previous year, the London Gallery had featured works by Kenneth Noland and Morris Louis. In 1961–62, then, the strongest American influence on both abstraction and much new RCA Pop was Noland's and Kelly's hard-edge painting, Louis' soft-stain works, and the gestural, graffiti-like quality of Rivers.

The nature of the art scene in London by 1961–62 was such that everyone knew of everyone, to a greater or lesser degree, and the group exhibitions of the period mixed them up like shuffled cards; many of these artists

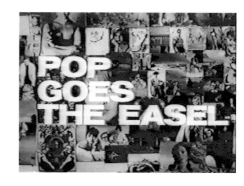

also taught. As the British artists participated in group exhibitions, collaborated as teachers, worked in the same class at the RCA, or joined the same gallery, the new London art scene was loosely but effectively bound together.

Pop Goes the Easel

A documentary film by Ken Russell for Monitor
(broadcast March 25, 1962)

One of the most important documents of this period is the legendary Ken Russell film *Pop Goes the Easel*, made for the BBC Television arts program *Monitor* (figs. 51–59). Russell examined four British Pop artists—Blake, Phillips, Boshier, and Boty—and introduced them to a wider British public. The documentary is an early example of Russell's innovative, even anarchic film technique. Because it was made before color television, it was filmed in black and white.

The film opens with a pan of a collaged wall showing images of Marilyn Monroe, Elvis Presley, and so on. A moderator, Huw Weldon, prepares the audience, saying, "This is a world you can dismiss, if you are so inclined, as tawdry and second-rate.... [Yet] mass media for these artists is a world packed with mythology." An early sequence shows the four artists walking around an amusement park at night to a pop music soundtrack: riding on bumper cars, playing pinball machines. Blake is shown in a circus dressing room, drawing midget clowns as they dress for a performance.

Russell then devotes a segment to each artist, beginning with Blake, at twenty-nine already the group's elder statesman. We see him asleep in his bed under a coverlet collage of Edwardian images of royalty, flags of the British empire, Union Jacks, and the American Stars and Stripes. To the pop song "Brigittey Bardot Bardot," Blake turns over in bed and dreams of the French actress. Blake's room is filled with flea market bric-a-brac, often indistinguishable from his paintings. Visible is the *Reveille* magazine pinup of Brigitte Bardot, and his door and cupboards are collaged with photographs of movie actresses like Kim Novak and Tuesday Weld. In the back of the room, Blake's work *Everly Wall* (1959, pl. 3) can clearly be seen, and his famous painting *Self-Portrait with Badges* (1961, page 7) leans against a wall.

The Phillips segment shows the artist completely Americanized: driven down a London freeway by a black chauffeur in a large American convertible, cool jazz playing.

He arrives at his studio to the sounds of Charlie Mingus. Here again the walls are covered with collaged images; in one room a dark-haired girl sits on a bed reading a comic book, while in another room a blond girl plays at a pinball machine. Phillips looks at a pinup magazine. The camera jump-cuts among the noisy pinball action, magazine images, and Phillips' paintings on the wall, including *War/Game* (1961, pl. 9).

In the next segment, Boshier talks about his interest in politics, mass media, and current events. As the camera

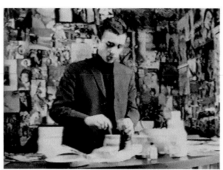

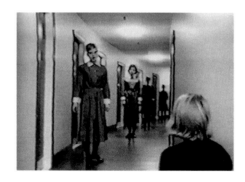

pans his studio, Boshier is heard in voice-over: "I'm interested in the whole setup of American influence in this country. The infiltration of the American way of life. It's through advertising and advertising techniques that this infiltration has come through." Examining a box of Kellogg's Special K, Boshier says, "I think the Englishman probably starts with America at the breakfast table . . . with the cornflakes . . . American in design and American in the whole setup, the giveaway gifts, the something-for-nothing technique." Boshier's *England's Glory* (1962) is seen, with the American flag creeping in to replace the Union Jack. Next Boshier declares his interest in the space race as the film cuts to a poster of Russian cosmonaut Yuri Gagarin, then to views of the earth taken from an American rocket, and back to several paintings in Boshier's studio, including *The Most Handsome Hero of the Cosmos, Mr. Shepard* (1962, pl. 18). As Buddy Holly's song "Every Day" plays, Boshier discusses the painting *I Wonder What My Heroes Think of the Space Programme* (1962), which includes images of Lord Nelson, Abraham Lincoln, and Holly. "They all died a hero's death," Boshier says.

The last sequence features Boty. It is a more familiar Russell dreamlike treatment: trapped in a perspectival office corridor, Boty is confronted by German Naziesque nurses from whom she flees, pursued by a gaunt woman in a wheelchair who wears dark glasses. Escaping into an elevator, Boty is shocked to discover the woman in there, too, as the elevator's shrill bell wakes her from her nightmare, becoming her own front door bell. Boshier, Blake, and Phillips are at the door; they all enter Boty's studio, whose walls also are entirely collaged, and proceed to decode the images.

Next the four artists walk through a typical London street market, looking at cheap toys and American comic books while we hear the song "I'm the Duke of Earl," playing as if from a cheap radio. Then they attend a local wrestling match, followed by a party in Smith's studio in Bath Street, East London. Everyone is dancing to "Twist Around the Clock." Hockney is seen briefly, looking blond, bespectacled, and very American. Tilson is seen dancing. Everyone is having a *very* good time. Russell's film ends with brief segments showing the artists at work in their studios. The last shot is of Boty's face.

Pop Goes the Easel is a major document in the history of British Pop Art. Its primary importance is that it was made at all and, having been made, that it was shown on BBC Television. Its immediate effect was to bring the words

"Pop Art" into thousands of unsuspecting British homes for the first time. Outside of London, exhibitions of contemporary art were rare ("John Moores Liverpool Exhibition," only recently founded, being an unusual exception).

The reception of Russell's film among the London art community was mixed. Many thought it undermined the art's serious aspect, while others felt that it had captured some of its novelty and sheer fun. The word "Pop," not yet over-familiar, was already tied to the new rock music and had other colloquial applications as well, meaning soda, or father, or to "pop" in on a visit. The one thing that all these uses connoted was that of a lower-class, uncultured milieu, and in a country shot through with infinite stratifications of class, this could not help.[40]

An audience probably in the tens of thousands (this being Britain and the program an arts program shown on a Sunday night) saw with some sense of shock four young British artists looking either somewhat bohemian like Blake, or clever and political like Boshier, or hip like Phillips, or young, talented, and beautiful like Boty. Even worse, they all seemed to be interested in America and to be having more fun than "Pudding Island," as Durrell called Britain, deemed proper. This and much more must have raised eyebrows and probably not a little envy. How "London" it all seemed.

Russell's documentary clearly showed several connecting strands of British Pop Art. This art was made by young artists who were interested in a variety of subject matter not traditionally associated with fine art: memorabilia bought in flea markets, the vernacular culture of street markets, wrestling matches and fairgrounds, and American popular culture including, in the case of Boshier, the space program. There was a predilection for collage environments. In each of the four artists' studios, we see a kind of museum of tacked-up and collaged images, perhaps not so far removed from André Malraux's *musée imaginaire*. This display of visual material is of a different order than that seen, for example, in Bacon's studio, with the images pinned up as sources for his paintings. The Pop collage covered a wider spectrum of personal interests, and as we see in Russell's film, the game was to decode someone else's visual alphabet through the new Pop iconography.

The end of the documentary, showing the artists working in their studios, reminds us that however much they drew on imagery from the contemporary urban landscape—advertising, pop music, and so on—at the end of the day, these were serious artists producing serious art.

This was art created in studios, exhibited in galleries, bought by collectors, acquired by museums, and written about in art catalogues, selling, even at this early date, for far more than their source material. The clarity of purpose of each of the artists is apparent in the film, but it is an unselfconscious purpose free from the somewhat deadening hand of irony. Irony in Pop Art is more of an American tendency than British, with the exception of Hamilton (who is an ironist by nature).

Pop Goes the Easel was made before the celebrity cult aspect of Pop Art had arrived, and the film functions as a rare glimpse into that period in British art. Russell's film, fascinating in and of itself as a stepping-stone in his career, captures an authentic experience of the times.[41]

"Image in Progress"
Grabowski Gallery, London
(August 15–September 8, 1962)

Mieczylsaw Grabowski opened his gallery in 1959, where he showed postwar Polish painting while at the same time developing an interest in what would come to be called British Pop Art (figs. 38, 60).[42] Grabowski's exhibition "Image in Progress" featuring the work of Boshier, Hockney, Jones, and Phillips, among others,[43] has long been recognized as a seminal show for early Pop.[44] Jasia Reichardt's catalogue introduction "Towards the Definition of a New Image" mentions that the words that were

fig. 60. "Image in Revolt" (October 5–November 3, 1962), Grabowski Gallery, London, exterior view of 84 Sloane Avenue. Photograph by Tony Evans.

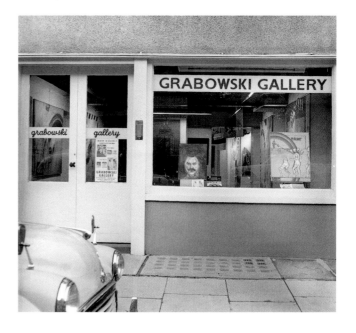

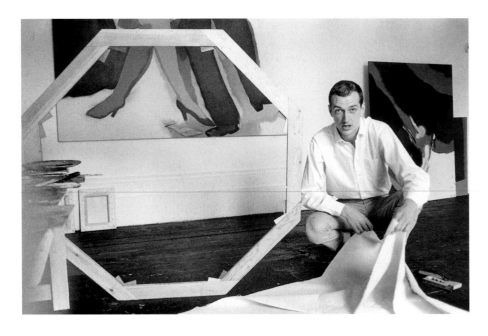

fig. 61. Allen Jones working in his studio, London, 1963; *Man Woman* (1963) partially visible on rear wall. Photograph by Tony Evans.

fig. 62. David Hockney in his Powis Terrace studio, London, 1963. Works shown are *The Hypnotist*, in progress (1963), and *Domestic Scene, Nottinghill* (1963). Photograph by Tony Evans.

"passed from mouth to mouth were 'neo-dada' and 'pop-art.' Somehow these titles stuck. The painters objected: first of all, to the titles, and secondly, to being bundled together." [45] Each of the artists contributed a statement to the catalogue. Hockney, for example, began his statement by saying "I paint what I like, when I like, and where I like, with occasional nostalgic journeys."

A striking thing about many of the works by Boshier, Hockney, Jones, and Phillips was their scale (figs. 61, 62). These four artists were only one year out of art school, and while they had enjoyed reasonably expansive spaces at RCA, the sizes of their paintings were surprising in their confidence—for London and London studios, these were large scale. This strong residual impression of the exhibition clearly showed the influence of the Tate Gallery's 1959 "New American Painting" exhibition. Reichardt summed up:

> One could say certainly that their preoccupations run parallel to the newspaper headlines, bill hoardings and fashions, reflecting topical events and trends of thought through emotion.... There is no clear cut definition of their aims and one should refrain from trying to rationalise the purpose of these young artists, whose greatest contribution is a sly, bitter-sweet comment on the reality of things, which might one day evolve into a fully fledged satire.

It is interesting that Reichardt, a critic of tremendous acuity, should pick up that strain of satire that was such a mainstay of early sixties life in London.

Reviews of the exhibition were predictably mixed. The *Times* critic noted that the recent "Young Contemporaries" shows, the last "John Moores," and others had introduced a new block of painters whose new attitude to figurative subject matter has brought them the appellation of Pop, although they as artists are diverse.[46] Their subjects are topical and refer to "astronauts and pinball alleys, movie stars and cereal packets, newspaper headlines, neon lights, women's magazines and advertising slogans." These comprise the "common currency of ideas and values." The values represented by Pop works were clearly a bone of contention for many critics in Britain and America. Pop subject matter, the *Times* review continued, represents "... cheapened values by most standards, and art has until now generally avoided reflecting them." The writer informed the reader that American painters who draw upon the same material have been characterized as "the new vulgarians" but also noted that the enjoyment of that vulgarity is precisely the point, admitting that "there is something rather vital about vulgarity" and that its optimism, "however banal, is the unflagging

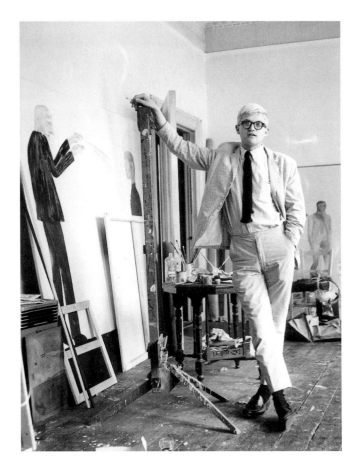

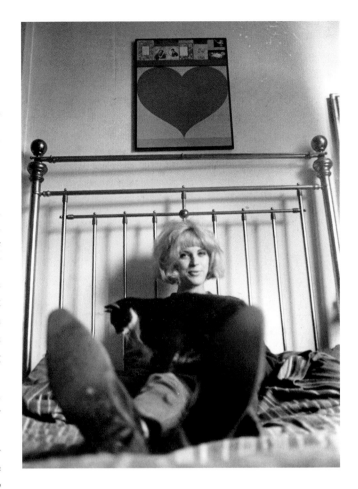

message relayed by mass media." The personal nature of Pop's ideas, the writer felt, is what distinguishes the British works from the American, "even from . . . Larry Rivers whose work has directly influenced many of them (Hockney, Kitaj, among others)."

All in all, a rather fair review, in contrast to that which appeared a few days later in *The Observer Weekend Review* where the writer contrasted the professionalism of the Americans with the British "pictorial parodies."[47] The article's title, "'Private Eye' Painters," refers to the satirical magazine, though the comparison was not meant as a compliment. The *Observer* critic wrote: "Their sources are plain. Francis Bacon and the Americans Larry Rivers and Jasper Johns are as influential as . . . pin-ups, advertising slogans, and pin-ball alleys. . . . These Royal College artists . . . are too involved with the mixed idioms of commercial art, or too enslaved by some American mannerism, to make any very profound comment of their own."

Both of these reviews, one positive and the other dismissive, used illustrations of works by Boshier to make their points: *Epitaph for Somewhere over the Rainbow* (1962) in the *Times* and *So Ad Men Became Depth Men* (1962) in *The Observer*.

"New Approaches to the Figure"
The Arthur Jeffress Gallery, London
(August 28–September 28, 1962)

Another early British Pop Art exhibition, "New Approaches to the Figure" featured works by Blake, Boshier, Boty, Hamilton, and Hockney, as well as works by Enrico Baj, William Copley, and Patrick Hughes.

The Pop artists were by now receiving some attention. Blake, Boshier, and Boty had all appeared in March in Russell's *Pop Goes the Easel*. Boshier and Hockney were strong presences in the concurrent "Image in Progress" exhibition. Boty (fig. 63) would have her first one-person show the next year at the Grabowski Gallery. Blake had already received a prize at the "John Moores Liverpool Exhibition" the year before with his *Self-Portrait with Badges*. And Hamilton had received a William and Noma Copley Foundation[48] award for painting in 1960. Hamilton was an interesting inclusion, known within only a fairly small circle as a participant in the "This Is Tomorrow" exhibition and not at this time a wholly London-based artist.

Blake had two works, both titled *Pin-up Girl* (both 1962). Boshier, who had already left London to spend a

year in India, had one painting: *Icarus Gives a Man Oxo Appeal* (1962), "Oxo" being the brand name of a popular bouillon cube still widely used in English cuisine. Boty's three works included *Epitaph to Something's Gotta Give* (1962), *Red Maneouvre* (1962), and *Doll in Painted Box* (1962). Hockney also had three works in the show: *Detail of a Picture I Had Intended to Paint in July 1989* (1961), *Sam* (1961), and *Demonstration of Versatility: A Grand Procession of Dignitaries in the Semi-Egyptian Style* (1961). The last was Hockney's largest painting to date. All three were distinguished by Hockney's signature use of titles: naive, tongue-in-cheek, and anarchic.

Hockney was well on his way to international recognition, having not only won a "John Moores Liverpool Exhibition" prize but also exhibited at the "Young Contemporaries." He was already represented in the collections of the Arts Council of Great Britain, the Victoria and Albert Museum, London, and The Museum of Modern Art, New York (Hockney had spent July and August 1961 in New York City). *A Grand Procession of Dignitaries . . .*, his first major work after returning to England, had been featured in a photo piece in the upscale *Queen* magazine (February 27, 1962).

The inclusion of Hamilton as a first-generation Pop

artist, Blake as the principal figure of the second wave, and Boty, Hockney, and Boshier representing the younger RCA generation made this exhibition a first. Clearly this was not just another group show, but an indication of a new presence in British art.

"Pop Art Since 1949"

A radio talk by Lawrence Alloway for Third Programme (November 8, 1962)[49]

Alloway opened by pointing out that "the term 'Pop art' has been very popular this year, welcomed by critics, who think that the use of a slogan confers awareness to their sluggish prose, and by dealers, who always prefer a trend to a single artist." Alloway noted that the use of popular art sources in fine art is as old as modernism itself, citing Max Ernst's use of Charlie Chaplin, and de Kooning's *Marilyn Monroe* (1954), the difference being that until Pop Art such use was incidental to the main purpose of these artists. He reiterated his 1954 assertion that "Pop art begins in London c. 1949 with works by Francis Bacon," and that the difference marked by Bacon's use of images from the mass media lies in the recognition of their photographic origins.

After Bacon, Pop Art became linked to technology. Alloway mentioned three widely read books that were admired even more for their profusion of illustrations: Amédée Ozenfant's *Foundations of Modern Art* (1932), Sigfried Giedion's *Mechanization Takes Command* (1948), and László Moholy-Nagy's *Vision in Motion* (1947). "They were pro-science, pro-urban . . . pro-technology." Even though, as Alloway mentioned, the Constructivists read these books, for the emerging Pop artists, it was the visual material that was compelling, the mixing of art and non-art illustrations.

Alloway differentiated the second phase of British Pop Art as beginning in 1957, its distinguishing feature being the assimilation of the new abstraction from America. He identified Smith as its central figure through his synthesis of abstraction with the urban imagery identified by the Independent Group. Smith's paintings brought together the scale of the American abstract work and its gestural mark with the billboard presence, the new Cinemascope movie experience, and the super-heated colors of advertising, like "the green identified with menthol cigarettes." Alloway saw art now as "one of the battery of messages in the world today, not as an act in

relation to an absolute." The first two phases of Pop had shifted the focus from the new image of man to the new sense of the urban environment.

Alloway devoted the latter half of his radio talk to reviewing what he called the third wave of British Pop, brought together in the 1961 "Young Contemporaries" exhibition, which he oversaw: "That [exhibition] marked the beginning of the situation in which we now find ourselves." Alloway made the point that this third phase was figurative, but that it drew its imagery from a large range of visual material, much of it personal and often, as in the case of Hockney, autobiographical. This added a new dimension to one of the period's key terms, "iconography."

Iconography, the study of visual meanings in art, traditionally meant the study of references in art that derived from other art—for example, the pose of *Apollo Belvedere* reappearing as the pose of General Monckton in West's 1763–64 painting. Now iconography had to cover the new world of mass media: one had to be able to identify the quotation from a movie or an advertisement. The reading of Pop Art demanded new skills from critics, curators, collectors, and public. As Alloway himself had noted humorously in a 1958 article, "It is no good giving a literary critic modern science fiction to review, no good sending the theatre critic to the movies, and no good asking the music critic for an opinion on Elvis Presley."[50] What is extraordinary about the phenomenon of Pop on both sides of the Atlantic was how quickly this new language was coined.

Somewhat surprisingly, Alloway ended his broadcast on a cool note, pointing out that he felt that this third wave of Pop Art had betrayed the premise (and promise) of the first two waves, which, Alloway reminded the listener, effectively reduced the "idealism and snobbery" of British aesthetics and art criticism. In a chastising tone, the critic ended: "Now . . . the Pop artists lack a grasp of the history their art belongs to. . . . Instead of contributing to the expanded communications system, which *is* nineteenth- and twentieth-century art, they are coasting along and relaxing. Pop Art has become a game for those who want to tell themselves and their peers that they 'think young.'"

But Alloway was perhaps not taking into consideration the degree to which not only British Pop Art but the social milieu itself was changing. London of 1962 was not the London of 1952. The city itself was in the process of transformation, and a whole new social class had emerged. For a brief while, it seemed that the simultaneous rise of

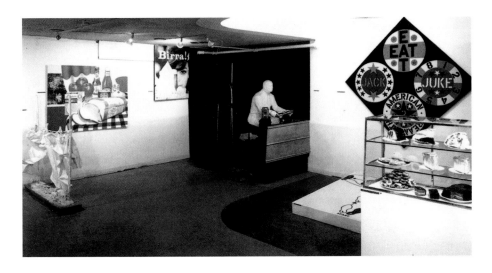

fig. 64. "International Exhibition of the New Realists" (November 1–December 1, 1962), Sidney Janis Gallery, temporary annex, 19 West 57th Street, New York, installation view. Works shown are (left to right): Peter Agostini, *The Clothesline* (1960), Tom Wesselmann, *Still Life No. 19* (1962), Mimmo Rotella, *Birra!* (1962), George Segal, *The Bus Driver* (1962), Andy Warhol, *Dance Diagram (Fox Trot)* (1962), Robert Indiana, *The Black Diamond American Dream* #2 (1962), and Claes Oldenburg, *Pastry Case* (1962).

so many young and talented people from so many different professional and social/class backgrounds was eroding, if not erasing, the barriers that act as such an albatross around the neck of British life. This erosion, however, was largely illusory. Jonathan Aitken, author of the book *The Young Meteors* (1967), had to concede that "Britain is still a very class-obsessed country, and because some young Londoners have recently become highly successful in their class mobility, this has added rather than detracted from the class obsession."[51] Hockney has observed that as a working class person from outside London, he felt like an outsider, even a foreigner.

BRITISH POP ARRIVES IN AMERICA

The rapidity with which both American and British Pop Art rose between the spring of 1961 and the fall of 1962 has been the focus of much critical attention. Postwar abstraction on both sides of the Atlantic had endured a protracted recognition, and much to the chagrin of those artists, at the very moment of their success, Pop came and stole their thunder. By 1962 American critics and curators were becoming aware of the new tendencies in British art and began to represent them in group shows. The presence of Alloway in America as a curator at the Guggenheim beginning in 1962 did much to facilitate this recognition of British art.

"International Exhibition of the New Realists"
Sidney Janis Gallery, New York
(November 1–December 1, 1962)

A few weeks after the Grabowski and Jeffress exhibitions in London closed, Sidney Janis Gallery opened what is regarded as the first international overview of Pop Art seen in America. Among British artists, the "New Realists" show included one work each by Blake (*The Love Wall*, 1961) and by Phillips (*Wall Machine*, 1961); there were also two Assemblage works by John Latham.

The planned exhibition was too big for Janis' 15 East 57th Street gallery, so he rented an empty store at 19 West 57th Street (fig. 64). In his brief introduction in the catalogue, Janis set out his premise, using the term "factual artist" to describe the overall aesthetic of the artists in the show.[52] "Factual" was a term, he wrote, first published in the 1962 book *Collage* by Harriet Janis and Rudi Blesh. These new "factual" artists—called Pop artists in England, Polymaterialists in Italy, and New Realists in France (and presumably now in America)—represent a new front of international modernist activity. Janis footnoted other current names for this new art: Commonists, Neo-Dadaists, Factualists, Artists of Pop Culture, and Urban Realists. City-bred, Janis then continued, the New Realist is a kind of urban folk artist. Rediscovered by the artist and lifted out of its commonplace milieu, the daily object, unembellished and without "artistic" pretensions, is revealed and intensified. It becomes, through the awareness that it evokes, a new aesthetic experience.

Janis clearly intended this New Realism, this "factual" art, to be distinguished from slightly earlier works, such as those by Rivers and Robert Rauschenberg (and even Jasper Johns, although Janis called him an "established Factualist"). He also culled out "the important directions of collage and assemblage," adding that due to limitations of space, other artists who fall within the domain of the New Realism were omitted (including Hockney). Nor did the exhibition aspire to be an overview of the history of the object: Joseph Cornell, Picasso, Kurt Schwitters, Duchamp, and Man Ray were exempt.

Janis concluded his introduction by clarifying the Neo-Dadaist label, acknowledging that while the earlier Dadaist and contemporary New Realist artists "have certain common ground, aims of each are in fact quite polar." The Dadaists, embittered by their experiences of World War I, had set out to destroy art, while the "present-day

fig. 65. Cover of the exhibition catalogue *British Art Today* (1962), San Francisco Museum of Art.

Factualist eschewing pessimism is . . . intrigued and stimulated—even delighted—by the environment out of which he enthusiastically creates fresh and vigorous works of art." Finally, Janis stressed the importance of Duchamp,[53] whose example is "encouraging to Factualist artists everywhere. Duchamp's 'Readymades' of 1914 remain today art works of vision and of particular significance and inspiration to the New Realists."

The Janis exhibition consolidated two important developments in Pop Art: first, the growing realization of the importance of Duchamp, still very much alive in 1962, and second, Walter Hopps' achievement only a few weeks earlier when he organized what is generally held to be the first museum exhibition of American Pop Art, "New Painting of Common Objects." The biggest difference between the two exhibitions was that the Pasadena show included only works by American artists, whereas the Janis exhibition took an international overview.[54]

In his retrospective essay, Bruce Altshuler evoked the somewhat bemused American critical reaction to the presence of the few British works in the Janis show, in which Thomas Hess' disdainful comment marked an inversion of earlier American respect for European modernism:

> As for the English artists, certainly John Latham's reliefs of abused books seemed much like late fifties assemblage. And while Peter Blake's large *Love Wall* of postcards, pin-ups, and Pop image of a heart looked neat and new between the Klein sponge sculptures and Christo's package, and Peter Phillips's *War Machine* used comic book panels, their visual restraint was obvious when compared with the boisterous American way of recycling media imagery. As [Thomas] Hess remarked in *Art News*, the Europeans "look feeble in this lineup. Some Englishmen do comic-strips that try to say 'WOW' but can only manage the equivalent of 'Coo, matey.'"[55]

Because postwar American confidence permeated American art criticism, it allowed for the flexing of a rather patronizing muscle. In large part because of this condescending tone, Blake would never pursue nor accept a one-person exhibition in America.

"British Art Today"

San Francisco Museum of Art, San Francisco
(November 13–December 16, 1962)

"British Art Today," a significant touring exhibition in 1962, was organized by the San Francisco Museum of Art on the occasion of London Week in San Francisco (fig. 65).[56] It offered an overview of British modernism with work by Blake, Jones, Paolozzi, Phillips, Smith, and Tilson representing British Pop Art.

Alloway wrote the catalogue introduction, noting that the traditional view of British art, especially in its neo-Romantic aspect, may seem at odds with the current exhibition. Interestingly, given some of those included in the exhibition, Alloway made no identification of British Pop Art other than to comment at the end of his short piece that:

> American influences can be detected in this exhibition, whether the work originates in London or St. Ives, and the reason for this is not hard to find. American painting of the last fifteen years [since 1947] has led the world . . . in the sense of doing more with the shared and common themes of 20th Century art. . . . Visitors to this exhibition who know American art will see that English artists are using American influences for their own ends . . .[57]

POP ART IN LONDON

In 1963 art activity on both sides of the Atlantic was accelerating, with increasing representations of works by American artists in London and by British Pop artists in the United States and Europe. Americans Rothko, Louis, and Noland (fig. 66) had all exhibited in London, and while they are not Pop artists, their technical processes were influential—in particular, the stained techniques of the last two. In February–March 1963, Hamilton, Smith, and Blake gave individual talks at the RCA on "The Nature of Pop." That same year, Hamilton and photographer Robert Freeman produced a tongue-in-cheek cover for *Living Arts* littered with American goods featuring Hamilton in an American football uniform (fig. 68). In the fall the "Troisième Biennale de Paris" at Musèe national d'art moderne de ville de Paris would include works by a significant group of British Pop artists including Tilson, Laing, Phillips, Blake, Boshier, Jones, and Hockney (fig. 67). The summer of 1963 was an opportune time for an overview of British art.

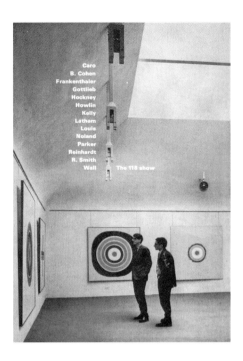

"British Painting in the Sixties"

The Tate Gallery and Whitechapel Art Gallery, London (June 1–30, 1963)

The introduction to the catalogue immediately gave the premise of this exhibition: "We are so accustomed in London to seeing exhibitions of contemporary painting from Australia, the United States, the Ecole de Paris and almost every European country that it seems remarkable no attempt should have been made to show the British contribution of our time."[58]

"British Painting in the Sixties" was not just another commercial gallery show or an American-style anthology, but something of a national attempt at cultural parity. In selecting works for the exhibition, the Contemporary Art Society acknowledged in the catalogue that "There was not always unanimity about the choice.... The main sufferers have been the good middle-of-the-road painters, but it seemed right to put the emphasis on upon what is new and most original."

The large exhibition made clear its attempt to be comprehensive. Bacon, Frank Auerbach, Sir William Coldstream, Lucian Freud, and many other luminaries were included. The Tate Gallery section included the older artists, while in the Whitechapel section were to be found Blake, Hockney, Jones, Kitaj, Phillips, and Tilson. Each was represented by three works, all from 1962–63. (Boshier,

who was viewed as having departed the scene, was not included, nor was Boty.) Interestingly, the term "Pop" did not appear in the catalogue.

In his leading article for *The Sunday Times Colour Magazine*, Sylvester essentially offered a long review of the exhibition. The article was accompanied by numerous photographs of artists and their works taken by Lord Snowdon, and the cover of the magazine featured Coldstream, representing the older group of artists.

Sylvester opened his article, largely devoted to the older painters at the Tate, by stating something of the problems of British art:

> British painting always inclines to have a somewhat forced, unnatural air, like ladies' cricket or hip clergymen. It's obviously the product of a nation that prefers dreaming, reflecting, moralising, story-telling to the act of looking. It doesn't rejoice in an easy animal spontaneity, and on the other hand doesn't attain a high perfection of style. It can be very elegant, it can be very poetic, but there's virtually always something incomplete about it, something tentative, something unfulfilled.[59]

About the younger painters shown at Whitechapel, he hedged his bets, first asking, "What of our younger painters? Where are they going?" then proceeding to identify three distinct groups into which the best under-forty painters can be fit. One group is the abstract painters influenced by certain developments in New York in the wake of Abstract Expressionism, by which Sylvester meant both hard-edge and color field painting. The other two are groups either "committed to figuration" or "return[ing] to the image," which has been "the expected reaction to the international dominance of abstraction during the fifties."

The last group encompasses Pop Art, which takes its imagery from a whole range of mass cultures and mass communications: "It incorporates into 'fine art' things that ordinary people are interested in looking at, makes us look at them again in a new way." Sylvester saw Pop Art as satisfying the same needs as the old-fashioned Royal Academy picture or Victorian narrative art, but doubted its lasting effect: "What other needs does it fulfill? I find it too early to say: the subject-matter is so attractive to me that I can't tell how long the attraction will last once the subjects aren't up to date."

He made the point that Hockney, "as bright and stylish a Pop artist as there is," is more effective in his graphic work than in his paintings and ended with an expression of belief in Auerbach's future. A photograph of Hockney in a gold lamé jacket followed the article.[60]

Later, Roy Ascott, Blake, Anthony Caro, Bernard Cohen, Harold Cohen, Denny, Kitaj, Smith, William Turnbull, Brian Wall, Paolozzi, and Anthony Benjamin signed a letter to the *Sunday Times*, printed June 9, rejecting the expressed views of Sylvester as to the "amateur" nature of British art:

> Sir, – A professional painter is one whose profession is painting: not art politics, not market manipulation, not commodity manufacture, but painting. The amateur, in art as in other aspects of our society, is characterized by his diminished commitment, and consequently by his diminished responsibility.

…Mr. Sylvester seeks to drag British Art back into the suffocating club atmosphere of amateurism and dilettantism at a moment when, for the first time in this century, a generation of artists has deliberately taken up a position outside it and against it. We believe that any painting which will not stand on equal terms with the best painting produced anywhere in the world is not worth bothering about. Mr. Sylvester's wish to limit this intention is his own concern. His success in doing so, if he should have any, would be the concern of us all.[61]

"the popular image"
ICA, London
(October 24–November 23, 1963)

An entirely revelatory exhibition for British artists, "the popular image" was the first major overview of American Pop Art to be seen in London. It presented artists whose works previously had been known solely in reproduction or not at all as a cohesive front of new American art. The show was organized by the ICA in collaboration with the Ileana Sonnabend Gallery in Paris (which would later premiere several American Pop exhibitions in France) and included loans from many distinguished American galleries.

The artists represented, many exhibiting major works, covered a wide spectrum of American Pop Art: Mel Ramos John Wesley, James Rosenquist, Rauschenberg, Jim Dine, Allan D'Arcangelo, Tom Wesselmann, Roy Lichtenstein,

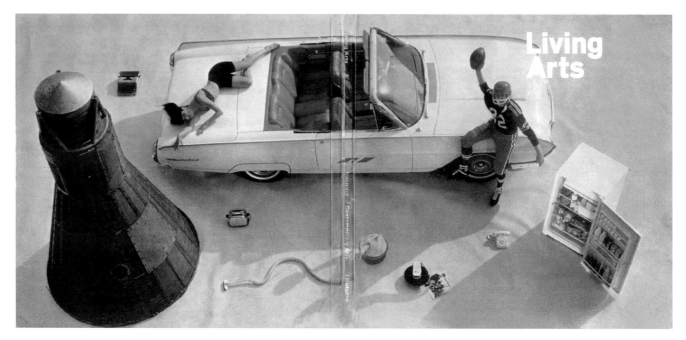

fig. 68. Front and back covers of *Living Arts* 2 (1963). Tableau arranged by Richard Hamilton to accompany his article "Urbane Image"; Hamilton poses in American football uniform. Photograph by Robert Freeman.

fig. 69. Dennis Hopper, Untitled [Andy Warhol, Henry Geldzahler, David Hockney, and Geoffrey Goodman, New York], 1963, gelatin-silver print, 16 x 24 in. (40.6 x 61 cm), courtesy of the artist and Tony Shafrazi Gallery, New York.

Claes Oldenburg, Johns, Wayne Thiebaud, and Warhol (fig. 69). In his catalogue introduction, Alan Solomon, director of the Jewish Museum, New York, wrote:

The new art comes out of an intense need for deeper meanings than those provided by the art which preceded it, an art which had accepted the difference between art and life,... the new art represents a search through the detritus of our culture for uncanny qualities which have somehow been produced in an unconscious way by the process of mass culture.[62]

Solomon proceeded to extol Rauschenberg as "the first to acknowledge positively the necessity for reconciling art and life, for breaking down the isolation of art from conventional modes of experience, for accepting art as a significant condition of life, rather than as adjunct to it."

Rauschenberg's work had appeared in an earlier retrospective at the Jewish Museum and in Alloway's Guggenheim exhibition "Six Painters and the Object" (1963). The following year he would have a major retrospective in London at Whitechapel Art Gallery. The impact of Rauschenberg's works was deeply felt in the London art scene in his integration of reprographic silkscreening processes with Abstract Expressionist gestural painting. Two years later, in his introduction to the 1966 "Young Contemporaries" exhibition, Anton Ehrensweig wrote:

Instead of jeering at urban civilization—as our British pop artists like to do—[Rauschenberg] makes us fall in love with the colourful drabness of slum streets. When I walked out from the Rauschenberg exhibition at the Whitechapel Art Gallery I found London's East-end wonderfully transformed. What a triumph for a truly incentive artist if he can change our experience of life; not to a conscious hatred of corruption—as modern art liked to do and dada in particular—but to a new affirmation of goodness.[63]

"Pop Art: Way Out or Way In?"
*The Sunday Times Colour Magazine, London
(January 26, 1964)*

The year 1964 opened with the image of Lichtenstein's painting *Hopeless* (1963) on the cover of *The Sunday Times Colour Magazine* (fig. 70). (Lichtenstein had been strongly represented in the recent exhibition "the popular image.") The accompanying article, "Art in a Coke Climate" was written by Sylvester who, having hesitated the previous June to commit himself to an analysis of British Pop, now felt more up to that task. Sylvester's compelling and exploratory piece is worth looking at in some detail, especially as its opening paragraphs have been frequently quoted, as often happens, detached from their broader context, substantially altering their meaning. Sylvester wrote:

"There's as much culture in a bottle of Coca-Cola as there is in a bottle of wine." An American painter said that to me 15 years ago in Paris, which made it more unnerving. I rose to the bait, told him how depraved he was. It wasn't that I personally didn't like Coke as well as Côtes du Rhône, Cadillacs as well as Bugattis, Hollywood films better than French films; I only couldn't take the juxtaposition of 'Coca-Cola' and 'culture,' and of course I was wrong.

The point is not whether Coca-Cola culture is wiser and nicer than wine culture: the point is that it is a culture—a set of tribal tastes and customs which implies certain values and attitudes and a conception of what life could ideally be.[64]

This is where the quotation usually ends; however, Sylvester went on to ask:

What does wine culture mean? It means techniques which have been learned through centuries of trial and error.... Believing that stability is the prime source of good.... It means living with flies and bedbugs. Fruit which tastes as if it were grown, not made.... It means buildings with surfaces weathered and crumbled by time.... The sanctity of the unique object. It means durability; it means inequality.

In other words, for Sylvester "wine culture" meant the Old World, not just in Europe but also in America. He went on to describe "Coke culture":

Coke culture means added chemicals. Boarding a plane as if you were boarding a bus. Going into any drugstore knowing that when you order a tuna salad sandwich you can predict its taste and edibility. Endless, exhilarating freeways along which drivers fall asleep. Sanitary, pre-cooked, pre-packed food. Sanitary girls like canapés bought ready-made with a gelatine varnish. It means that mid-town New York is awesomely beautiful only because its proportions are, and

THE SUNDAY TIMES
COLOUR magazine
JANUARY 26, 1964

THAT'S THE WAY--IT *SHOULD* HAVE *BEGUN!* BUT IT'S *HOPELESS!*

POP ART: way out or way in?

fig. 70. Cover of *The Sunday Times Colour Magazine* (January 26, 1964, London) with Roy Lichtenstein's *Hopeless* (1963).

not because of anything it gains from surface-texture.... More people having a good time than have ever had a good time before. It means expendability; it means standardisation.

In the next section, subtitled "When the Parthenon goes for a ride," Sylvester compared British and American sensibilities with regard to automobiles: the Rolls-Royce and the Cadillac. "The Rolls Royce," wrote Sylvester, "pretends that technology can be integrated into a wine culture.... Its image relates to an ideal past, the Cadillac's to an ideal future of moon-bound men. One harks back to a Golden Age, the other says that we are in the Golden Age right now."

Meanwhile, Sylvester fine-tuned his definitions of what and whom he regarded as Pop. In America, he included Johns, Lichtenstein, Rauschenberg, Dine, and the "marginal figures" of Rivers and George Segal, followed by Oldenburg, Wesselmann, and Robert Indiana; in Britain, "committedly Pop" artists included Blake, Smith, and Hamilton, and "part-Pop" artists were Jones, Kitaj, Paolozzi, and Hughes, excluding Hockney "because he's not a Pop artist, though usually called one." Six months before, in an article published in the same *Sunday Times Colour Magazine* on June 2, 1963, Sylvester had described Hockney as being "as bright and stylish a Pop artist as there is," but he now had concluded that neither Hockney's themes nor his style related to Pop's sources.

In the next section, "Not the bottle but the brand," Sylvester attempted to analyze the constituents of Pop:

The peculiar thing about Pop Art is that it is more often a form of still-life painting than of figure-painting.... it doesn't depict men drinking, but the can of beer; it doesn't depict families out for a Sunday drive, but the car they drive in. When Pop Art brings figures in, it doesn't depict stars as they appear in the flesh, but the posters announcing their appearance.... In general, Pop Art's preoccupation is not so much with cult-heroes and cult-objects as with the means of communication by which they are popularised.

Sylvester narrowed his focus to precedents and found one in the 1921 painting *Lucky Strike* by Stuart Davis: "This, I take it, is the first Pop painting." Davis' heir is Johns, "the finest of Pop painters and the most original, intelligent, and interesting artist under 40 now working anywhere," who, Sylvester determined, has a sense of the presence of emblems in all their beauty and banality that is rivaled only by Lichtenstein's.

In the next section, "As commercial as antique," Sylvester discussed sources. "Pop Art uses pop imagery as a source in the same sorts of ways as Renaissance and neoclassical art used antique sculpture." Sylvester later reiterated his point: "Pop Art can use motor-cars and cigarette packs as Renaissance art used antique sculptures of Venus or Apollo because its models too are part of a mythology. The design of objects in common use is more symbolic in our Coke culture than in any previous phase of Western Civilisation." But is there enough substance in Coke culture to:

provide a mythological basis for art in the sense that it has been provided in the past by religions which had transcendental aspirations and a tragic sense of life?... Can the Pop artist feel respect for Coke culture, let alone commitment to it? The posing of such questions as these has tended to lead to a supposition that the Pop artists must surely be satirising their subjects, or that they're assuming an attitude of sympathy with them in order to shock.

Sylvester began to draw his conclusions:

There is evidence of a difference of attitude to their subjects between the majority of American and the majority of British Pop artists.... The British artists by and large take a far more romantic and optimistic view of Coke culture than the Americans do. If this is so, the reasons would clearly be that Coke culture has not yet completely taken Britain over and so exerts a more exotic fascination for us.

The end of the article pursued these differences between British and American Pop Art, with the British found wanting: "Most of British Pop Art is a dream, a

wistful dream of far-off Californian glamour as sensitive and tender as the Pre-Raphaelite[65] dream of far-off medieval chivalry. I like it as I like Millais's *Ophelia* and Arthur Hughes's *The Long Engagement.*"

Sylvester compounded his point, noting how Paolozzi and Johns had used similar imagery of targets, but whereas Paolozzi quoted them in their shooting-gallery environment, to "charming and quaint" effect, "The Johns targets are strong, demanding, palpitating with a life of their own . . . and have an unaccountable quality of loneliness. . . . Paolozzi is one of the most inspired artists of his generation anywhere. But that old British amateurishness stops him short, where an artist like Johns goes beyond inspiration into rigourous thinking and painting." Sylvester went on to laud Lichtenstein in the same vein: "His GIs in action and teenagers in tears are mythological figures like classical gods and nymphs in that their antics are larger than life."

Sylvester ended by further consolidations of the "fine art" qualities of both American artists Johns and Lichtenstein, bringing in analogies to Fernand Léger, Jean-Baptiste-Siméon Chardin, and Georges Seurat and stressing that the power of the works can be experienced only in its proper scale, "Which is to say that these artists are using the most mass-produced of emblems as subjects for paintings which emphasise above all the value of the unique object. A reverence for the unique object is, I take it, the basic moral assumption of a wine culture, which is the kind of culture to which art can't help belonging."

"The New Generation: 1964"
Whitechapel Art Gallery, London (March–May 1964)

"The New Generation" showcased twelve artists; half were Pop artists: Boshier, Caulfield, Anthony Donaldson, Hockney, Jones, and Phillips.

In his preface to the catalogue, Bryan Robertson, director of the Whitechapel, emphasized the financial straits of the artists, the inadequacies of private patronage, and the fact that the artists had to divert their time and energy into poorly paid teaching. He noted, "We are still at the beginning of public patronage in England."[66]

Robertson added, "As well as providing what I hope will be a beautiful and revealing spectacle for the London public, the exhibition gathers together for the first time in a clear-cut way twelve artists whose work is conspicuously brilliant and gifted."

David Thompson, then art critic for the London *Sunday Times,* wrote a short introduction to the catalogue in which he stated, "This exhibition has nothing to do with any artistic grouping, or 'movement,' or 'situation.' . . . the one thing shared by the twelve painters . . . is their age-group, . . . their 'generation,' the under-30s."[67] He went on:

> The immediate past contains two artistic phenomena of special relevance. . . . One was the advent of a "new figuration"—in other words, the much-publicised, ill-named "Pop Art.". . . Apart from the generally Americanized aspect of modern city-culture that occurs in it, it developed not directly from American example, but from the example of such painters as Richard Smith, R. B. Kitaj and Peter Blake.

Thompson made no reference, nor gave any credit, to the activities of the Independent Group and ended his introduction by pointing out, "If there are two words that can be said to characterize the aesthetic aims and style of the generation represented here, they are 'toughness' and 'ambiguity.' The one reflects a desire both to play it cool, be objective, unsentimental. . . . The other can be seen in new colors, new shapes, and in techniques which spurn the marks and traces of the painting hand."

The exhibition attracted a mixed reception, especially the Pop Art aspect of it. The abstract painter Denny wrote in his review that "it is the *interpretation* of ideas that counts, and it is this, sadly, that succeeds in being so jaded, academic, and drained of content."[68] While excepting Bridget Riley, Hockney, and Caulfield, Denny ended his review by noting that "the New Generation is bedevilled by plagiarism, parody, guileful make-believe, and the absence of any kind of risk, and it is a combination of just these things which . . . has doomed in English art all attempts, in the past, to come to terms with the future, and which makes the New Generation so like the old."

"Richard Hamilton: Painting etc. '56–64"
*Hanover Gallery, London
(October 20–November 20, 1964)*

Hamilton's second one-person show at Hanover Gallery comprised thirty-five works in a variety of media (fig. 71), the earliest being the now-famous collage made for the poster and catalogue of "This Is Tomorrow" in 1956. Hamilton's name was known as much, if not more, through his teaching and writing as through his art. Now a wider London audience could see an overview of Hamilton's works, spanning all three waves of British Pop Art development.

fig. 71. Cover of the exhibition catalogue *Richard Hamilton: Paintings etc. '56–64* (1964), Hanover Gallery, London. Hamilton pictured with *Epiphany* (1964).

Quite different is the attitude of those who, like Richard Hamilton . . . are indebted to the U.S. for a large part of their idiom and for continuous inspiration at a profound level. This is not to say that they are mere epigones, tame continuers of trends long tried and discarded across the Atlantic. . . . In Hamilton's work these ideas find expression in a way which combines the aims and disciples of high art with the idiom of movie stills, automobile advertising, muscle- and pulp-magazines and elaborate catalogues. In Hamilton's hands these things, fragmented, attain a detached dignity; over and above this, they get involved in situations remote from those for which they were conceived, so that a toaster, the smoke of an exhaust, the pink of a Playboy pin-up background, the flame of a cigarette lighter, a fiberglass crash helmet and a fullback's numbered shirt take their place in one of Hamilton's cryptic rituals. Hamilton is at once drastic and tender, direct and elliptic, ironical and deeply involved, parodistic and entirely sincere. It is a curious mingling, unlike anything in living art. . . . Hamilton does not "owe" anything to any American artist, in a literal sense.[70]

This show was particularly timely, coming as it did some months after "The New Generation: 1964" show had persuasively presented the broad front of the recent RCA wave of Pop—the children of the Independent Group. In his introduction to the catalogue, Hamilton set out the argument for his own works, including the period and polemical spirit they reflected, and how although they were unfashionable and even illegible at the time they were made, subsequent events have given them a general context they once lacked. He then described how the largely didactic activities of the Independent Group had been put into pictorial practice in the late fifties, creating a new anti-hierarchical frame of reference:

> A quest for specific aspects of our time and the contribution that new visual tools make to the way we see our world, certainly generated the things seen here. Coupled with an obsessive interest in modes of seeing at a purely technical level is a strong awareness of Art. TV is no less or more legitimate an influence than New York abstract expressionism, for example. The wide range of these pre-occupations led to a willful acceptance of pastiche as a keystone of the approach—anything which moves the mind through the visual senses is as grist to the mill but the mill must not grind so small that the ingredients lose their flavour in the whole.[69]

John Russell, a strong supporter of both British and American Pop Art, understood the British relationship to the American scene and appreciated the original nature of Hamilton's works. A few months after Hamilton's exhibition had closed, he gave a timely summing up of Hamilton's achievement:

TRANSATLANTIC POP

In 1964, Russell took a wider and longer view of British Pop Art. Recognizing that in 1945 the question "What does 'New York' mean to you?" posed to a British artist would have elicited the response "Nothing," while in 1958 the response might have been "Everything," he concluded that by 1963 the response would have become "Something." By this, Russell meant that the British artists had acquired a confidence in their own reading of the sources of Pop Art, a confidence impossible in the 1950s when the full impact of American Abstract Expressionism had been felt. It was the American example, the American processes, that had been influential, rather than individual American artists and their works:

> What British artists really got from New York . . . is the sense of liberation . . . from the sense of inferiority which Paris had instilled . . . a liberation from timidity, the smallness of scale . . . and the polite restricted ambitions which were all that the British public expected of its artists . . . What we got from New York was, therefore, as much a new attitude to art as a new kind of art . . . as people caught in the machinery of the art-trade in the 1960s, the younger British artists owe a great deal to New York. . . . Where American pop-painting is concerned, most young British artists greet it with the friendly conviction that this is a field in which they themselves got there first and did it better . . . but it remains true . . . that it was from New York . . . that our artists learned the dimensions of adventure.[71]

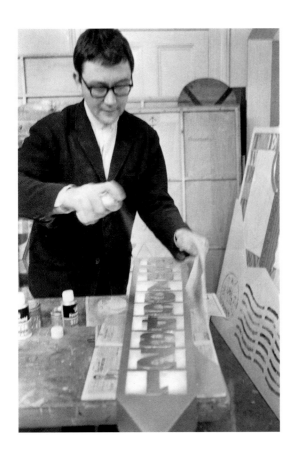

fig. 72. Joe Tilson working on *Obelisk 1–9* (1962–63) in his studio, London, 1963. *21 St* (1963) is partially visible at right. Photograph by Tony Evans.

"London: The New Scene"
Walker Art Center, Minneapolis
(February 6–March 14, 1965)

While by no means wholly a Pop exhibition, this important show included works by several major British Pop figures: Blake, Hockney, Jones, Smith, and Tilson. This large though hardly comprehensive look at the contemporary British art scene traveled to several American and Canadian museums over the next year.[72]

The main catalogue essay was by Martin Friedman. It addressed the whole exhibition, which ranged far beyond Pop, but the focus here is on Friedman's interpretation of the Pop artists alone. Friedman began his essay by noting the traditional alienation of British art from the European continent, but then stated that "now there is an efflorescence of activity."[73] He made the case that the impact of American art in Britain over the preceding decade had made a British generation "painfully aware of its provincialism" and that during the late fifties, excepting Henry Moore and Bacon, the British art scene had been "bland and soggy." By contrast, the American works (Friedman meant Abstract Expressionism) "projected a sense of boldness and immediacy," to which the young British artists reacted. Friedman noted that in spite of a crisis of currency, the London art scene, especially the growth of the new galleries, has been vigorous.

Talking about the figurative presence in the exhibition—works by Blake, Hockney, Jones, and Howard Hodgkin—Friedman saw Blake, along with Hamilton, as one of the progenitors of Pop Art, which he noted evolved during the mid fifties "more or less simultaneously" in Britain and America. Blake was using "Pop images as early as 1954, fabricating a series of 'walls' and 'doors'... He employed such devices as the repetition of a topical photograph, considerably before the technique was associated with Andy Warhol. He not only pioneered such methods, but also freely borrowed and combined elements from the diverse vocabularies of Pop, Hard-Edge and assemblage."

Friedman detected something deeper, perhaps even darker, in Hockney's work, saying, "David Hockney's calm surfaces and confectionery colors veil a mordant view of the world." Friedman was dismissive of those critics who found Hockney's works to lack seriousness, saying that they had ignored the "internal consistency" of Hockney's painting and noting Hockney's relationship to Hogarth and the English tradition of social commentary.

But Friedman also pointed out that Hockney is "above all a picturemaker," mentioning the affinities between certain aspects of British Pop, particularly in the work of Blake and Hockney, to Pre-Raphaelite art.[74]

Friedman began his section on Jones by quoting the artist: "I have no special regard for my figuration; it is a means of commencing and any recurrence of an image could be said to reflect the inability at that time to solve a pictorial problem in a new way." Referring to Jones' use of hermaphroditic figures, "weightless, floating high or upside-down within a stilled atmosphere," Friedman observed, "Thus, Jones has created his own hallucinatory and sexual iconography whose forms appear in endless combinations."

In his discussion of Tilson and Smith, Friedman began, "Joe Tilson and Richard Smith are 'object' artists who deal with the symbols and methods of mass-communications media. Tilson's painted constructions are an iconography of the prosaic. Strident and exuberant, his constructions invest the absurd with unsettling profundity." As he did when discussing Hockney, Friedman showed himself adept at making a deeper reading of works that, at this period, were habitually written off as superficial. He observed that both Tilson (fig. 72) and Smith were "interested in the increasingly ambiguous area between painting and sculpture."

Critic Sidney Simon reviewed the exhibition, writing that "a new onslaught of Pop was to be expected. Happily,

this limitation is not oppressive. To be sure, an aura of Pop hangs over much of the exhibition, but very few of the works are pegged entirely to the obvious or banal."[75] Simon stated that while a thesis of the exhibition is that it represents "Young London's dialogue with the world," the fact that the artists were mostly under thirty, that the works were recent, and that "the variety of individual styles is still strongly in debt to American prototypes ... urges a realignment of our thinking."

From the perspective of the present with the world-wide spread of American franchises, Simon's observation that "What is ... blatant in one cultural situation is not always equally blatant in another, as any visit to London by an American will demonstrate," might seem somewhat obscure, but it should be borne in mind that London, Europe, and the world were far less "franchised" even in the mid sixties. Though they would soon begin to appear in London,[76] American outlets were still a minimal presence, even in the heyday of "Swinging London." From Simon's—and, for that matter, Friedman's—viewpoint, the ambient differences between America and everywhere were still marked: "To eyes conditioned by American's popular imagery and its ever ready techniques of the hard-sell, Blake's iconic images are essays in the un-obviously obvious."[77]

Describing Tilson's localized response to American culture, Simon noted that Tilson's works, "very close in feeling to pure Pop, can also have a regional tinge: *Look* ... is just un-swish enough to register a lack of identity with our accustomed responses. The same distinction holds true ... for David Hockney's responses to America: he mirrors the familiar in New York, Iowa or California in a manner which is delightfully obvious, but at the same time obviously foreign and, hence, fascinating."

Simon's point seemed to be that the American Pop artists are hostile to their subject matter whereas the British are "more attracted to it than repelled," and that Hockney's approach—in, for example, *Plastic Tree Plus City Hall* (1964)—is not concerned only with "formal qualities nor apparent satire, but the fact that it is a ... deadly portrait of Los Angeles ... represent[ing], perhaps, a more radical departure than we have as yet given it credit for."

In his conclusion, Simon stated that the British works did not extend to extremes—"the point (literally) of no return"—and continued, "The question relevant to a Newman or a Warhol, 'If it is not art, what is it?' is simply not raised by the work of any of the artists of 'The New

Scene.'" Simon ascribed this to the American painters, Abstract Expressionist and Pop alike, for having "welcomed an art of rejection: what the artist left out was more important than what he put in." For the British artists, Simon felt the problem lay in what to "affirm and, in effect, to assimilate." Simon ended: "If the visual dialogue between the two does in fact build up sufficient impetus, it will be of absorbing interest to see if the tide of American art in its heroic phase of 'anything goes' will begin to recede, and if a new generation of British artists can succeed in creating their own climate for the radical."

By the time Simon published his review, his final question had become somewhat moot. By 1965, Pop on both sides of the Atlantic had become, in commercial if not always critical terms, successful, and even modest success inevitably rings the radical's death knell. But neither British nor American Pop had ever pleaded the cause of radicalism, except in insisting on its own subject matter and formal processes, even if that meant opposing—or, in the sense of Pop, subverting—the prevailing standards of culture. In effect, the circle was almost complete: if transatlantic Pop had its origins in a serious examination of popular culture transmitted through mass media, now the media had repaid the favor by reassimilating its own images back to itself after their digressive journey through "high" culture.

"London/NYC: The Two-Way Traffic"
Art in America (April 1965)

John Russell's article "London/NYC: The Two-Way Traffic" served as a useful assessment of the new dialogue between the Americans and the British Pop artists. Russell began by citing the example of Edgar Degas arriving in America in 1872, primarily to visit family in New Orleans and attend to the failing family business there. Degas produced a considerable body of work during his months in New Orleans, the first such body of work done in America by a European modernist. Russell wrote that Degas' openness to America made him "an ideal predecessor for the young British artists of today who dream, almost without exception, of going there." Whatever the influences of American art ... [it] "has been by far the strongest and most general influence of the Fifties and Sixties in our country, even if it is now something to rebel against, as much as to submit to in awe."[78]

After the war, travel to America had been difficult:

fig. 73. Cover of *Newsweek* (April 25, 1966).

there were severe currency restrictions and problems in acquiring a visa. While British painters such as Scott and Keith Vaughan had visited and worked in America, for them "the experience of the U.S. was ... an experience among many others." After discussing the works of Kitaj and Hockney as they had affected the British view of America, Russell closed: "What does now exist among many younger British artists is a spirit of independence as far as the U.S., and New York, is concerned. The total enthusiasm of ten years ago is now less common than an acceptance of what has been achieved, allied to a conviction that we can really do just as well and that London is anything but a fief of New York."

"POP!: It's What's Happening"
Newsweek, April 25, 1966

Just over a month after "London: The New Scene" closed at its final venue in Ottawa, an issue of *Newsweek* magazine devoted its cover story to "POP!: It's What's Happening: in art, fashion, entertainment, business" (fig. 73). The story is all there in the title of the inside special report: "The Story of POP: what it is and how it came to be." Peter Benchley wrote:

> It's a fad, it's a trend, it's a way of life. It's pop. It's a $5,000 Roy Lichtenstein painting of an underwater kiss hanging in a businessman's living room. It's a $1 poster of Mandrake the Magician yelling, "Hang on, Lothar! I'm coming!" taped on a college-dorm wall. It's 30 million viewers dialing *Batman* on ABC every week. It's Superman zooming around on the Broadway stage attached to a wire, while the sophisticates in their $12 seats are carried back to childhood. It's a Pow! Bam! commercial for Life Savers on TV and a huge comic-strip billboard for No-Cal glaring down on Times Square. It's lion-maned Baby Jane Holzer in a short-skirted wedding dress. It's the no-bra bra and the no-back dress. It's Andy Warhol's new nightclub, The Plastic Inevitable, where three movies flicker simultaneously and a man lifts barbells to a rock beat.[79]

"So what's pop?," Benchley asks. "Pop is what's happening ... it's anything that is imaginative, nonserious, rebellious, new, or nostalgic; anything, basically, fun." Just as in Britain in the fifties, the American term "pop" had evolved from referring to the popular arts to meaning fine arts that took popular imagery as its source material. Now pop was being further extended to a mood, a feeling, a "happening."

The perception of Pop as a mood, a life style, clearly went far beyond the realm of art, but this is where things stood by the spring of 1966. The art, like the music, had become a backdrop for fashion, food, and entertainment. It all seemed far removed from Hamilton's 1961 observation: "It isn't surprising ... to find that some painters are now agog at the ability of the mass entertainment machine to project ... the classic themes of artistic vision and to express them in a poetic language which marks them with a precise cultural date stamp."[80]

In the *Newsweek* report, Benchley went on to state that Pop has already come and gone, at least as a hip, urban event: "Pop started in the big cities—particularly London and New York—and now, just as it is infiltrating the hinterlands, urban esthetes are pronouncing it dead." Like any commodity, it has a limited shelf life. "Naturally enough, pop has turned up most insistently in those places where what's new is what sells—the world of art, television, fashion and advertising." What began as a commentary on commodities had now become another commodity itself.

Benchley continued:

> Good or bad, the important question is, why pop? Why the nostalgic preoccupation with comics, with trivia, with 1930s movies? Certainly there is an element of escapism from a complex, computerized, nuclearized world.... Many people ... have seen the future—and prefer the past. When

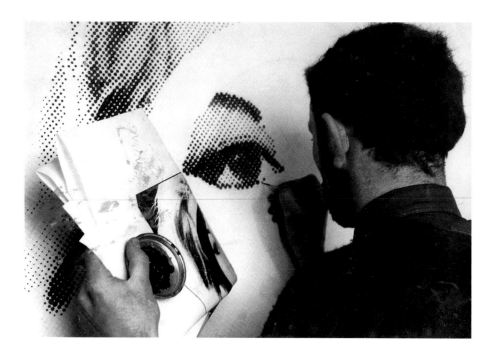

fig. 74. Gerald Laing working on *Brigitte Bardot* (1963) in his St. Martin's School of Art studio, London, 1963.

By 1966 several books and articles had appeared that either took a retrospective look at Pop or assumed its integration into the larger cultural scene. *The Sunday Times Colour Magazine* carried the article "Faces of Pop," and a month later *The London Observer Colour Magazine,* with a painting by Jones on the cover, *Neither Forget Your Legs* (1965), published "The New Isms of Art: A Quick Guide to Modern Painting." *Time* magazine placed on its cover the title "London: The Swinging City" over a collage quoting pop music and art. The accompanying article on London as a Pop center began: "In this century, every decade has had its city.... Today, it is London, a city steeped in tradition, seized by change, liberated by affluence, graced by daffodils and anemones, so green with parks and squares that, as the saying goes, you can walk across it on grass. In a decade dominated by youth, London has burst into bloom. It swings; it is the scene."[82] The next week *Newsweek* carried its Pop cover feature. Pop was being legitimized.

It was simultaneously being eulogized. Both the British artist Heron, in his article "The Ascendancy of London in the Sixties" published in *Studio International*, and the British art critic Edward Lucie-Smith in *Art and Artists* posed the question: "Whatever happened to British Pop?" And two major books set the cap on the decade: *Pop Art* by Lucy Lippard, with an essay on British Pop Art by Alloway, and *Pop Art...and After* by Mario Amaya.

One of the distinctive features of British Pop Art lies in the close relationships it created among art, music, and fashion. Students at many British art schools made posters and hi-tech, of-the-moment graphics that soon found their way into television and the movies, while others experimented with hairstyles and clothes. By the early sixties, the extreme edges of art, fashion, and music were to be found in the regular dances and parties that were held at RCA, St. Martin's School of Art, Chelsea School of Art, and other institutions. Many members of rock and roll groups had links to these art schools—the Rolling Stones, The Kinks, and The Who's lead guitarist Pete Townshend, who had attended Ealing School of Art along with Ron Wood and Freddie Mercury. Townshend would later be quoted in the rock press:

the Gemini 8 astronauts were in trouble and the networks interrupted their programming to switch to NASA headquarters, thousands of calls flooded the networks, complaining, in effect, about the cancellation of their fantasy universe. They were watching ABC's *Batman* and, ironically, CBS's *Lost in Space.*

Toward the end, Benchley described the final irony: that Pop art as a movement, an investigation, an embrace of the modern world is now interpreted as an adolescent retreat from that world, a shift from technological triumph to trivia, instead of a strong gaze at the present. Not an uncritical one either.

Banham later gave us a glimpse into the dilemma that Pop Art faced in 1966:

> ...one of the crises of our time: how to reconcile unavoidable admiration for the immense competence, resourcefulness and creative power of American commercial design with the equally unavoidable disgust at the system that was producing it?
>
> It is important to realise how salutary a corrective to the sloppy provincialism of most London art.... The gusto and professionalism of widescreen movies or Detroit car-styling was a constant reproach to the Moore-ish yokelry of British sculpture or the affected Piperish gloom of British painting. To anyone with a scrap of sensibility or an eye for technique, the average Playtex or Maidenform ad in American *Vogue* was an instant deflater of the reputations of most artists then in Arts Council vogue.[81]

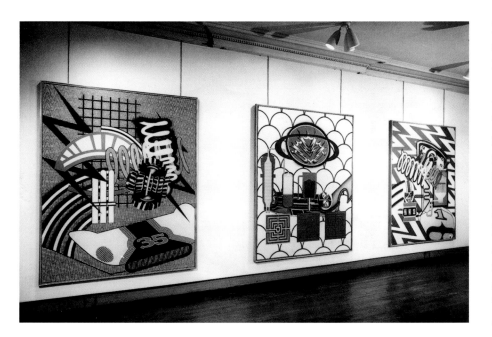

fig. 75. "Peter Phillips" (November–December 1965), Kornblee Gallery, New York, installation view. Works shown are *Custom Paintings #4, #1,* and *# 3* (1963–65).

What is pop-art? For weeks the hit-parading London group, The Who, have been at the centre of a big storm.

Some say it is a lot of bunk. Others defend pop-art as the most exciting musical development since the electric guitar boom started.

Who guitarist Pete Townshend defined pop-art for the MM this week.

"It is re-presenting something the public is familiar with, in a different form.

Like clothes. Union Jacks are supposed to be flown. We have a jacket made of one....

We stand for pop-art clothes, pop-art music, and pop-art behaviour. This is what everybody seems to forget—we don't change offstage. We live pop-art."[83]

By 1966, both Pop and rock and roll had moved beyond their first "pure" phases and in the process became classic. As Kurt von Meier noted, "...rock and roll split up into so many different, healthy, and fruitful directions that it effectively ceased to exist as a coherent stylistic or musical idiom.... By the end of 1966 we could look back over the history of rock and roll—one that had pretty well come to a close by that date."[84] What Meier said about rock and roll was no less true for Pop Art. By 1966 most of what are now viewed as the canonical works of transatlantic Pop Art had been made.

Barker visited America for the first time that year. Boshier, after returning from India in 1963, painted large-scale, hard-edge abstractions, often on shaped canvases, and eventually abandoned painting until 1980, in the meantime producing a wide variety of work in many media.

Blake with his wife, American artist Jann Haworth, was soon to design the kinetic tableau for the cover of the Beatles' *Sgt. Pepper's Lonely Hearts Club Band* album.

Boty died in 1966. Her appearance in Russell's *Pop Goes the Easel,* and the loyalty of her friends and family who kept her works, sustained her reputation, and her paintings and collages have in recent years begun to appear in exhibitions and paintings. Caulfield had his first one-person exhibition in New York.

Hamilton showed his *The Solomon R. Guggenheim* reliefs depicting the museum's exterior (1965–66, pl. 55) in London after organizing the important exhibition "The Almost Complete Works of Marcel Duchamp" (1966) at the Tate Gallery. Hamilton also supervised the relocation of Schwitters's *Merzbau* from its location in Ambleside, Yorkshire, to Newcastle University. Hockney showed his drawings for the London stage production of Alfred Jarry's absurdist play *Ubu Roi*; Hockney's first major involvement with design for the performing arts would become a major area of activity for him. In the summer of 1966, he returned to Los Angeles, which became his home.

Jones, after having lived, worked, and exhibited in New York in 1964–65, was awarded a Tamarind lithography fellowship in 1966. His work in New York paved the way for his erotic "furniture" sculptures and influenced his subsequent work in monumental public sculpture. Kitaj returned to America in 1965–66 after an absence of almost a decade; he taught at Berkeley for a year in 1967, reassimilating America life and making contacts with several major American poets. This period saw the production of naturalistic drawings and less fragmentary imagery in his paintings. Laing's "dot" paintings using photographic imagery (fig. 74) had already begun to take on the formats of shaped canvases, and by 1966 this had evolved into an exploration of abstract sculpture.

In January 1966, Paolozzi showed recent sculpture at Pace Gallery in New York and collages at Robert Fraser Gallery in London. In addition to his major sculpture, Paolozzi from 1965 onwards produced several series of complex and influential screenprints. Phillips lived in New York in 1964–66, returning to Europe in 1966 after having shows at Kornblee Gallery, New York (fig. 75); over the next several years, most of his exhibitions would be in Europe. Tilson spent most of 1966 teaching at the School of Visual Arts in New York and showing his new graphic work at Marlborough Graphics in New York.

The lines of transatlantic dialogue were well established

by 1966, all the major British figures having spent longer or shorter periods in America, while American artists such as Rivers, Dine, and Oldenburg had left their imprint on the London scene.

The embrace of "today" by British Pop had been a necessary and welcome antidote to the hermetics of much postwar abstraction, the opaque utopias of Constructivism, and the harsher, if ultimately successful, Existential figurations of Alberto Giacometti and Bacon. Pop drew the curtains back, opened the windows, and let the noises and smells, the realities and vitalities, of the "now" enter into the moribund and inward-looking postwar British modernism. Pop Art could invest meaning and beauty in things that were intended for the most part to be fugitive, a relevance where none was necessarily intended, a historicism in the disposable, a permanence in the insignificant. Pop Art became the history painting of our time.

If Hogarth is often quoted as the ancestral figure for British Pop, that comparison extends beyond his contemporary subject matter or his spirit of vulgarity to embrace his theoretical and didactic aspects as well. Hogarth's rejection of Continental styles, especially Franco-Italian Rococoism, anticipated the rejection by the British Pop artists of the aesthetics of the postwar School of Paris. Well before the full impact of American Abstract Expressionism was felt in Britain, the early Pop artists found, in their contemporary urban popular culture fermented by a new consciousness of mass media, a living vernacular art.

At the mid fifties nadir of British painting, as it lapsed into a kind of creative anaudia, British Pop Art brought a new vigor into the scene by returning to the roots of creative experience, the contemporary world. If that new world was American instead of French, offered Coke culture as an alternative to that of wine, and proposed television and cinema as an alternative to theatre and opera, so much the better.

The question "What elements were unique to British Pop?" was asked at the beginning of this essay. The obvious response would have to be the difference in the environments of America and Britain—the difference, that is, between the thing lived and the thing assimilated, analyzed, and intellectualized. The intellectualism of Hamilton and that of Johns is equal but different: Johns' conclusions are drawn from being inside the situation, those of Hamilton from the outside.

A listing of some characteristics of British Pop Art says much about how the content of art in Britain had changed since the war: automobiles, autobiographical, historical, sociological, intellectual, political, sexual, humorous, astronauts and cosmonauts, parachutists, drag racers, pinups, flags, quotations and homages to other art and artists, advertising, movies and movie stars, rock and roll stars, and technology.

Some of the techniques typical of British Pop Art include episodicity, fragmentation, and compartmentalization; use of writing, quotations, and photographic imagery along with graphic and painterly marks; mixtures of figuration with Abstract Expressionist gesturalism and later with color field and hard-edge staining into the unprimed canvas; collaged elements with paint; large-scale formats and shaped canvases; and screenprints and printing on canvas.

Each of the British artists in this exhibition employed complex combinations of these technical and expressive ingredients, and while most of these ingredients are also present in American Pop Art, the different emphases will be legible in the plates of this catalogue.

There is, of course, no end proper to this period. As stated, the artists continue to work and produce images of interest and originality, while they also belong to a clearly defined (depending on who is doing the defining) period—the sixties. Yet much of what has come to define and color that decade resides in its latter half, an overlay that consistently occludes the early history, which is too often seen as a prologue rather than the achievement itself. In the purest sense, and that word is used without irony, the period from "This Is Tomorrow" in 1956 to the complex confluence of events that occurred by 1966, including that year's "Young Contemporaries" show, comprises a concrete decade of activity by the end of which, on both sides of the Atlantic, the work of Pop had been fulfilled. More British art was seen in America, and more American art seen in Britain, than ever before:

> I doubt if there was ever a school of painting in which painters of two countries went to work in a spirit of such harmonious good nature. Dine, Kitaj and Oldenburg have contributed a great deal to our understanding of England; I shall never again think of London without remembering what Dine did with Selfridge's pink-rosed wrapping paper and what Oldenburg would have liked to do with Green Park.[85]

Some critics have suggested that once the British artists came to America, the initial Edenic vision was lost. But it might be truer to say that the ideal had been assim-

ilated, not dissipated—the point of the exercise was achieved. (Predictably, one generation's aspirations became, for the next generation, the very thing to reject, and the "Young Contemporaries 1966" exhibition presented a roster of new and unfamiliar talent, a distinctly new generation with new attitudes.)

If the agenda of early Pop Art in Britain had been to create a new dialogue between fine art, popular art, mass media, and technology—to create a new branch of visual semiotics, an iconography that would enable artists and viewers alike in a world of new sign systems to communicate in a new "long front of culture"—then surely that aspiration had been achieved by 1966. Nor were these considerations relevant only for that time. Virtually every issue that the Independent Group raised in the early fifties and passed on to the next generation is still with us. If the issues that fueled British and American Pop Art are still being assimilated with the use of the tools that Pop Art delivered, cannot a case be made for it as the most constructive movement in the visual arts in the second half of the twentieth century? As Russell concluded:

> Pop has been called vulgar, aggressive, jokey, ephemeral and sensation-seeking. We have tried to present it here ... as something quite different—as an art, not seldom, of austerity; an educated art; a responsible art; an art of monumental statement; an affectionate art; and, even, a healing art.[86]

NOTES

1. Jasia Reichardt, "Pop Art and After," *Art International* (February 1963), pp. 42–47.

2. The attractions of popular American culture extended to Europe. The Paris magazine *Soirées de Paris,* which flourished in 1913–14, devoted an issue to "Popular American Epics," featuring the likes of Buffalo Bill Cody and Deadeye Dick, and a later issue would quote, in English, all eight lines of the song "Take Me Out to the Ball Game."

3. Andy Warhol, quoted in *Artforum* 25 (April 1987), cover.

4. Many of the best British films of the time presented either a gritty realism, as in Carol Reed's *The Third Man* (1949), in which a seedy, rundown Vienna is redolent of bombed-out, black market London, or a romanticized realism, as in David Lean's *Brief Encounter* (1945). Lean also made two of the great classics of postwar British film: *Great Expectations* (1946) and *Oliver Twist* (1948). Another major neo-Romantic, gothic source of popular films was Ealing Studios, creators of such masterpieces as *Kind Hearts and Coronets* (1949), *The Lavender Hill Mob* (1951), *The Man in the White Suit* (1951), *The Ladykillers* (1955), and *The Bridge on the River Kwai* (1957).

5. Barney Balaban, quoted in "Mission of the Movies Abroad" by Thomas M. Pryor, in Serge Guilbaut, *How New York Stole the Idea of Modern Art: Abstract Expressionism, Freedom and the Cold War* (Chicago: University of Chicago Press, 1983), p. 136 (first published in *The New York Times,* March 29, 1946, p. 6).

6. Stephen Spender, "We Can Win the Battle for the Mind of Europe," *The New York Times Magazine,* April 25, 1948, p. 15. For a fuller analysis of Spender's article, see Guilbault, *How New York Stole the Idea of Modern Art,* pp. 173–75.

7. Noel Annan, "Gentlemen vs. Players," review of *The Pride and Fall: The Dream and Illusion of Britain as a Great Nation* by Correlli Barnett, *New York Review of Books,* Sept. 29, 1988, pp. 63–69.

8. The paintings from the National Gallery were stored for the duration of the war in a Welsh slate quarry near the mining town of Ffestiog. Works from the British Museum were stored in a disused stone quarry at Westwood, near Corsham, Wiltshire.

9. The ICA was founded following the creation of the British Council in 1935, CEMA (Council for the Encouragement of Music and the Arts) in 1940, and the Arts Council in 1946.

10. Herbert Read, letter, *The Times* (London) 1947.

11. Raymond Williams, *Communications* (Baltimore: Penguin Books, 1962).

12. Richard Ingrams, *The Life and Times of* Private Eye *1961–71* (London: Penguin Books, 1971), p. 7.

13. Bernard Kops, *The World Is a Wedding* (London: MacGibbon & Key, 1963). Quote is from extract published in *The Faber Book of Pop,* edited by Hanif Kureishi and John Savage (London: Faber + Faber, 1996), p. 67.

14. Jeff Nuttall, *Bomb Culture* (London: MacGibbon & Kee, 1968), p. 30. To understand this is to understand the particular violence of emotion released in the popular culture of the time, which has persisted in the manic nihilism of 1970s punk rock and the present-day ritualized violence of British soccer hooliganism. Pop artists Peter Blake, Richard Smith, and Clive Barker all saw Bill Haley perform.

15. "Although rock and roll music really begins in 1954, the process of its solidification . . . is completed only during the year 1956. Elvis Presley articulated this development with his first smash single for RCA Victor released in early 1956, 'Heartbreak Hotel.' He followed up with 'I Want You, I Need You, I Love You,' 'Hound Dog,' 'Don't Be Cruel,' and 'Love Me Tender' . . . By the end of 1956 there was no significant segment of either public or professional thinking that could seriously deny rock and roll was the most artistically vital and commercially potent field in the whole domain of popular culture" (Kurt von Meier, "The Background and Beginnings of Rock and Roll," *Art International* [October 1969], pp. 28–34).

16. See David Mellor, ed., *Paradise Lost: The Neo-Romantic Imagination in Britain 1935–55,* exh. cat. (London: Barbican Art Gallery and Lund Humphries, 1987).

17. Lawrence Alloway, interviewed in *Fathers of Pop (The Independent Group)* (1979), an Arts Council of Great Britain documentary film written and narrated by Reyner Banham.

18. David Sylvester, "The Kitchen Sink," *Encounter* (December 1954).

19. John Russell, "Art News from London," *Art News* 61 (March 1962), p. 46.

20. Not surprisingly, it was the Scottish painter Alan Davie who

most energetically pursued the example that the new American painting held out. Davie, also a jazz musician, had seen works by Jackson Pollock in Peggy Guggenheim's collection in Venice and would visit Pollock in 1956. His own impressive body of large-scale, brilliantly colored, and vigorous paintings exerted an influence on many British artists, as may be seen in Hockney's early work.

21. Alloway, in his review of the reviews, wrote: "To get the full weight of that it is worth remembering that some of the American artists at the Tate are Jews," a reminder, as though another were needed, that new art invariably invokes old prejudices (Lawrence Alloway, "Sic, sic, sic," *Art News and Review* [January 1959]).

22. John Russell and Suzi Gablik, *Pop Art Redefined* (New York and Washington D.C.: Praeger, 1969), p. 40.

23. Lawrence Alloway in *The Expendable Ikon: Works by John McHale*, exh. cat. (Buffalo, N.Y.: Albright-Knox Art Gallery, 1984), p. 32.

24. Lawrence Alloway, interviewed in *Fathers of Pop (The Independent Group)* (1979).

25. Lawrence Alloway, "The Development of British Pop," in *Pop Art* by Lucy Lippard (London: Thames and Hudson, 1966), pp. 31–32.

26. Lawrence Alloway, "City Notes," *Architectural Design* 29 (January 1959), pp. 34–35.

27. Pevsner's book was reissued in paperback in 1964, the year of "The New Generation" show at the Whitechapel Art Gallery. In spite of the enormous changes that had occurred in the British art scene over the intervening eight years, the author wrote in his brief foreword to the new edition: "It has been gratifying to see that no changes worth mentioning had to be made between 1955 and 1963." In his conclusion to the book, Pevsner asks the question, "If in planning today England has something of great value to offer to other nations, can the same be said of painting, of sculpture, and of architecture proper? Concerning painting my answer would on the whole be 'No.'"

28. David Robbins, ed., *The Independent Group: Postwar Britain and the Aesthetics of Plenty*, exh. cat. (Cambridge and London: MIT Press, 1990), p. 139.

29. Richard Hamilton, "Are They Cultured?" in *This Is Tomorrow*, exh. cat. (London: Whitechapel Art Gallery, 1956), Group 2 section, unpaginated.

30. Theo Crosby, "Night Thoughts of a Faded Utopia," in *The Independent Group: Postwar Britain and the Aesthetics of Plenty*, pp. 197–99.

31. The first issue of *ARK* stated the magazine's purpose: "The elusive but necessary relationships between the arts and the social context are the real objects of our enquiry . . . and our policy will be to set a subject, give our answers as students of the arts and ask a selection of those who will see the same subject from other and different viewpoints." In 1956 *ARK* changed in both content and form, becoming a mouthpiece for the intellectual Pop wing of the Independent Group. For a college magazine, *ARK* had a wide circulation, peaking in 1963 at 3,000. Most were by subscription, and many went straight to college art libraries throughout Britain. *ARK* had subscribers in thirty-two countries, and the magazine itself was the subject of articles.

32. Lawrence Alloway, "Personal Statement," *ARK*, no. 19 (Spring 1957), pp. 28–29.

33. Richard Hamilton, *Collected Words 1953–1982* (London: Thames and Hudson, 1982), p. 5.

34. Alloway would later comment that he was more interested in Hamilton's iconography than in the paintings themselves: "His paintings seem to me to be a form of super-graphics, and as such, not tremendously engaging" (from *Fathers of Pop*).

35. Richard Hamilton, quoted in *Pop Art, A Critical History*, edited by Steven Henry Madoff (Berkeley, Los Angeles, and London: University of California Press, 1997), p. 6.

36. Lawrence Alloway, "Notes on Abstract Art and the Mass Media," *Art Notes and Review*, no. 12 (February 1960), pp. 3–12.

37. Lawrence Alloway, "The Long Front of Culture," in Russell and Gablik, pp. 41–43 (first published in *Cambridge Opinion*, no. 17 (1959), pp. 25–26.

38. Lawrence Alloway, "Art News from London," *Art News* (May 1957), p. 57.

39. Norbert Lynton, "Addressing Pop," *The Royal Academy Magazine*, no. 32 (Autumn 1991), pp. 25–29.

40. Anyone who viewed the documentary would have known that the title punned on that of a familiar nursery rhyme, "Pop Goes the Weasel," which actually refers to the jobbing works associated with the clothing industry, a "weasel" being special irons that were often pawned in hard times.

41. Ken Russell began his career as a filmmaker in 1956. By 1959 he was making films for the BBC television arts program *Monitor*. In 1961 Russell made the first of his documentaries on composers, *Prokofiev*, which began to establish his reputation for innovative technique influenced by Fellini, Resnais, Godard, Antonioni, and Hitchcock. *Pop Goes the Easel* followed in 1962, and subsequent documentaries included *Elgar* (1962), *Bartók* (1964), *The Debussy Film* (1965), *Isadora Duncan, The Biggest Dancer in the World* (1966), and *Dante's Inferno* (1967), by which year Russell began making feature films that established his reputation among a wider public.

42. Mieczylsaw Grabowski, a pharmacist, was one of some 350,000 exiled Poles living in London during World War II. Known as a tough businessman, he acquired a rather "Harry Lime" reputation for his frequent postwar visits to Poland where, it was rumored, he sold pharmaceuticals on the black market. Grabowski gave lavish parties, courting a clientele of émigrés and the minor English upper classes, and the gallery always had a distinctive smell of garlic, mothballs, pot, and Gitanes cigarettes. The openings were always crowded with a rather exotic and raffish crowd, squeezed among the fig plants. (Author's notes.)

43. Boshier was represented by three works: *Epitaph for Somewhere over the Rainbow* (1962), *So Ad Men Became Depth Men* (1962), and *First Toothpaste Painting* (1962). Hockney showed three works: *Flight into Italy–Swiss Landscape* (1962), *Boy with the Portable Mirror* (1961–62), and *In Memoriam: Checcino Bracchi* (1962). Jones had three works in the show: *The Something Sisters, Two More* (1962), *My Secret Valentine* (1962), and *First Bus* (1962). Phillips also had three works: *Miss / Running–Flush* (1962), *Wall Machine* (1961), and *Distributor* (1962). Max Shepherd, Norman Toynton, and Brian Wright contributed a variety of non-Pop works.

44. All the artists in the Grabowski exhibition had been represented in the 1961 "John Moores Liverpool Exhibition." John Moores was the only British art patron to finance and organize a national competition for contemporary art, one of the few and most important venues for seeing contemporary art outside of London. The agenda of the exhibition was to "attract the best artists to show their work in Liverpool, and to support and encourage living artists, particularly the young and progressive." A decade later, Hockney would win the first prize of £1500, and Tilson £500.

45. Jasia Reichardt, "Towards the Definition of a New Image," in *Image in Progress*, exh. cat. (London: Grabowski Gallery, 1962), unpaginated.

46. "Pop Art's Success in Exploiting a New Source of Imagery," *The Times* (London), August 14, 1962, p. 11.

47. Neville Wallis, "Private Eye' Painter," *The Observer Weekend Review* (London), August 19, 1962.

48. The William and Noma Copley Foundation, an Illinois corporation for the encouragement of the creative arts and sciences, existed to help "individuals of outstanding talent." The first British recipient of Copley Foundation aid was Paolozzi.

49. Alloway's talk was published in *The Listener* (London), vol. 68, no. 1961 (1962), pp. 1085–87.

50. Lawrence Alloway, "The Arts and the Mass Media," *Architectural Design* 28 (February 1958), pp. 84–85.

51. Jonathan Aitken, *The Young Meteors* (London: Secker & Warburg, 1967).

52. Sidney Janis, "On the Theme of the Exhibition," in *The International Exhibition of the New Realists*, exh. cat. (New York: Sidney Janis Gallery, 1962), unpaginated.

53. Duchamp had yet to have his first museum retrospective; that would happen the following year when Walter Hopps organized the event at the Pasadena Art Museum in California. Hamilton personally brought Duchamp and his wife by automobile from New York to Pasadena to attend the exhibition and was later invited by the Arts Council of Great Britain to organize the second Duchamp retrospective, this time at the Tate Gallery, London. These two exhibitions consolidated Duchamp's position as a founding figure of the modern sensibility.

54. At the time, Janis also represented several of the major American Abstract Expressionists, who retaliated by resigning from the gallery: Guston, Motherwell, Rothko, and Gottlieb resigned, leaving only de Kooning.

55. Bruce Altshuler, "Pop Art Triumphant: A New Realism," in *The Avant-Garde in Exhibition: New Art in the 20th Century* (New York: Harry N. Abrams, 1994), pp. 192–219.

56. Later venues included the Dallas Museum for Contemporary Arts and the Santa Barbara Museum of Art.

57. Lawrence Alloway, "Introduction," in *British Art Today*, exh. cat. (San Francisco: San Francisco Museum of Art, 1963), unpaginated.

58. *British Painting in the Sixties,* exh. cat. (London: Tate Gallery, 1963).

59. David Sylvester, "'British Painting Now': Dark Sunlight," *The Sunday Times Colour Magazine,* June 2, 1963, pp. 3–14.

60. This article and its photographs served as the nucleus for the large-format art book *Private View* by Bryan Robertson, John Russell, and Lord Snowdon (London and Edinburgh: Thomas Nelson & Sons, 1965).

61. Letter, *Sunday Times* (London), June 9, 1963, p. 34.

62. Alan Solomon, "Introduction," in *the popular image*, exh. cat. (London: Institute of Contemporary Arts, 1963), unpaginated.

63. Anton Ehrensweig, "Introduction," in *Young Contemporaries 1966*, exh. cat. (London: Arts Council of Great Britain, 1966), p. 5. Ehrensweig, Lecturer in Art Education at Goldsmith's College, died in 1966, shortly after completing the book for which he is best remembered in the art world, *The Hidden Order of Art: A Study in the Psychology of Artistic Imagination* (London: Weidenfeld & Nicholson, 1967), the culmination of his ideas on art and creativity. This short "Young Contemporaries" introduction has a sense of both summing up and farewell.

64. David Sylvester, "Art in a Coke Climate" *The Sunday Times Colour Magazine,* January 26, 1964, pp. 14–23. This article appears in a revised version in David Sylvester, *About Modern Art: Critical Essays 1948–1997* (New York: Henry Holt and Company, 1997), pp. 213–22.

65. Michael Compton, author of one of the best early books on the subject, *Pop Art* (London: Hamlyn Publishing Group, 1970), observed that "Pop has the quickest and widest impact in the history of British art since the Pre-Raphaelite Brotherhood" (p. 52). The Pre-Raphaelites, founded in 1848 by Dante Gabriel Rossetti, were the most influential presence in later nineteenth-century British art. Rossetti understood that the new, rich industrial meritocracy did not want the everyday world of the Industrial Revolution to appear in the art that decorated their huge mansions but rather an art that would provide an escape from that world. Rossetti became wealthy by supplying his clientele with images from Arthurian romance and medieval chivalry—but nothing too "religious." Rossetti and his young contemporaries, like the "Young Contemporaries" of the early 1960s, brought an optimistic new vision to British art.

66. Bryan Robertson, "Preface," in *The New Generation: 1964*, exh. cat. (London: Whitechapel Art Gallery, 1964), p. 5. The Peter Stuyvesant Foundation had not only subsidized the exhibition and given six awards—five for travel to Europe and one for travel to America—but had also bought one work from each of the six prize-winners as the nucleus of a permanent collection.

67. David Thompson, "Introduction," in *The New Generation: 1964*, pp. 7–8.

68. Robyn Denny, "London Letter," *Art International* 8 (May 1964, p. 53.

69. Richard Hamilton, "Introduction," in *Richard Hamilton: Painting etc. '56–64*, exh. cat. (London: Hanover Gallery, 1964), unpaginated.

70. John Russell, "London/NYC: The Two-Way Traffic," *Art in America*, no. 2 (April 1965), pp. 130–31.

71. John Russell, "Tenth Street and the Thames," *Art in America*, vol. 52, no. 2 (April 1964), pp. 74–76.

72. Venues included The Washington Gallery of Modern Art, Washington, D.C.; Institute of Contemporary Arts, Boston; Seattle Art Museum Pavilion; The Vancouver Art Gallery; The Art Gallery of Toronto; and The National Gallery Of Canada, Ottawa.

73. Martin Friedman, "London, the New Scene," in *London: The New Scene*, exh. cat. (Minneapolis: Walker Art Center, 1965), pp. 11–52.

74. Hockney in 1961 had painted a variation on Madox Brown's *The Last of England* (1855), one of the masterpieces of the Pre-Raphaelite movement, and as Friedman commented, Hockney's drawing was done with "Pre-Raphaelite delicacy and formality. His paintings are basically colored drawings."

75. Sidney Simon, "From England's Green and Pleasant Bowers," *Art News* (April 1965), pp. 29–64.

76. The first British McDonald's opened in London in 1974.

77. Simon, p. 31.

78. Russell, "London/NYC," pp. 126–36.

79. Peter Benchley, "The Story of POP: what it is and how it came to be," *Newsweek* (April 25, 1966), pp. 56–61.

80. Richard Hamilton, "For the Finest Art try—Pop!" *Gazette* (London), no. 1 (1961), p. 3.

81. Reyner Banham, "Representations in protest," *New Society* 13 (May 8, 1969), pp. 717–18.

82. "London: The Swinging City," *Time* (April 15, 1966), p. 30.

83. Nick Jones, excerpt from *Melody Maker* (July 3, 1965), in *The Faber Book of Pop* (London: Faber + Faber, 1980), p. 239.

84. Von Meier, pp. 28–34.

85. Russell and Gablik, p. 40.

86. Russell and Gablik, p. 21.

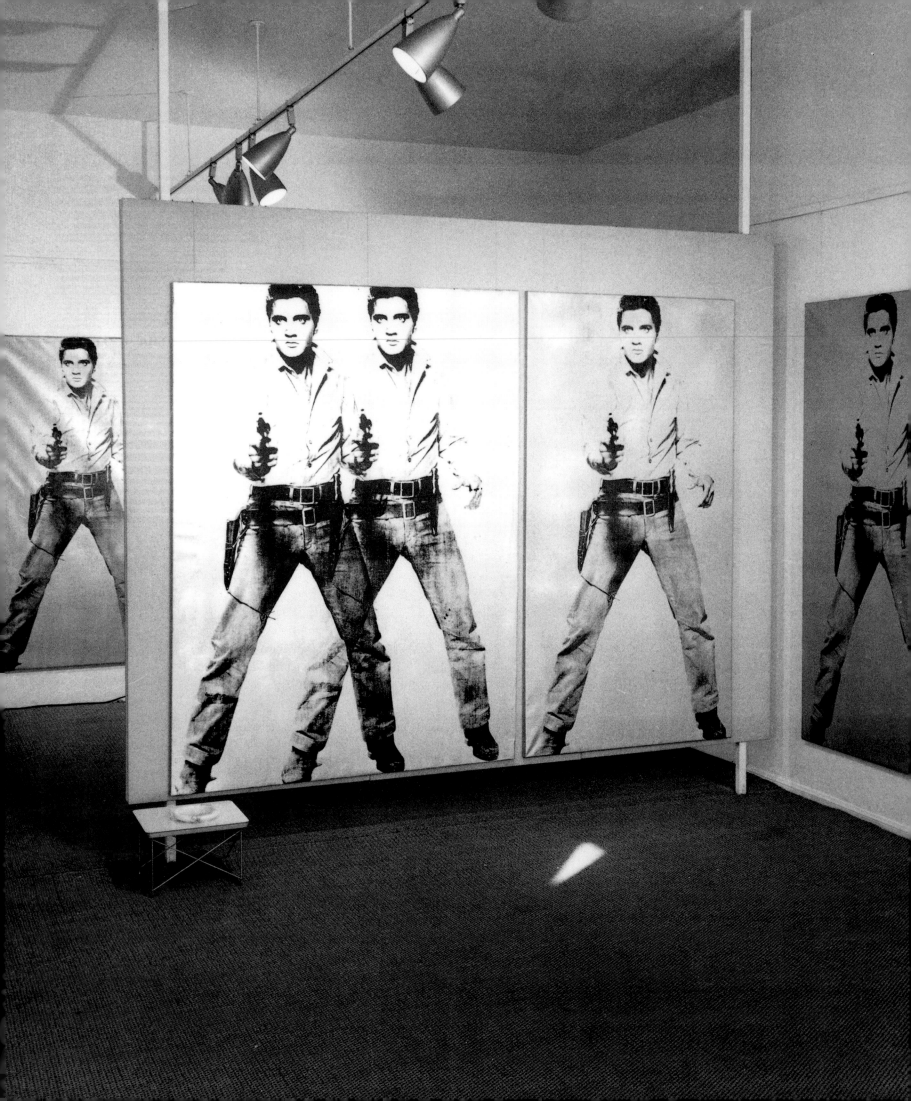

The Confluence of East and West Coast Pop

JIM EDWARDS

In the early 1960s, when Pop Art began to assert itself as a new presence upon the American art scene, New York was already holding court as the center of the international art world. It had been doing so since World War II made a shambles of Europe, scattering the artists associated with the once-dominant School of Paris. Of the American artists whose Abstract Expressionist paintings had made the initial and most dramatic break with Europe, Jackson Pollock was recently deceased and Franz Kline was soon to follow. Still, the other brilliant originators of the New York school—Willem de Kooning, Mark Rothko, Barnett Newman, and Clyfford Still—were at or just past their prime. These artists were the champs, and at the start of the sixties New York was their city.

The upstart emergence of Pop Art, and its instantaneous acceptance by a general public in love with its newly cultivated positive self-image, set up a classic confrontation. That the serious, brooding, introspective Abstract Expressionists were being shoved from center stage by the brash, bright, extroverted Pop artists was a story custom-made for the media. The real story, of course, was much more complicated than that. For one thing, all of art in some sense had started to be pervaded by mass media, packaged right along with technology and consumer goods and delivered to a capitalist society enjoying its prosperity to the fullest. Popular culture, particularly those elements fueled by the booming entertainment business and by most Americans' newly disposal incomes, was slowly encroaching on territory once claimed by more elitist art.

Pop Art, both in Britain and the United States, grew entirely out of this consumer-driven American popular culture. With the United States' unchecked industrial growth after the war came a vast profusion of American magazines, films, and television programs. It is no surprise that New York and Los Angeles, the two principal cities where American Pop Art originated, were also centers of both mass media and entertainment. The mass-market material being steadily churned out—all of it decidedly American in nature—provided ample grist for the Pop Art mill. In fact, it is safe to assume that without the booming United States economy of the mid twentieth century, there would be no Pop Art as we know it today.

The real thorn in the collective side of the Abstract Expressionists was that the American Pop artists were choosing the most mundane aspects of American life as their subjects: advertisements, comics, and Hollywood "B" movies and celebrities (fig. 76), the kind of stuff that most attracted the younger inhabitants of a recently war-torn Europe. But as the American critic and curator John Coplans pointed out, the emergence of Pop Art was more than a supposed move from the profound to the shallow; it was also a move in art practice from Europe to America:

> ...the painters of the soup can, the dollar bill, the comic strip, have in common not some moral attitude toward their subject matter that some say is positive and others say is negative, but a series of painting devices which derive their force in good measure from the fact that they have virtually no association with a European tradition.[1]

In short, it is the "Americanness" of Pop Art that sets it apart.

Who the American Pop artists were and what comprises their contributions are questions that continue to be debated. During the classic period of American Pop, from roughly 1961 through 1965, a widely varied group of artists showed work in exhibitions advertised as Pop

fig. 76. "An Exhibition by Andy Warhol" (September 30–October 26, 1963), Ferus Gallery, Los Angeles, installation view. Works shown are from the *Elvis* series. Detail of photograph by Frank J. Thomas.

fig. 77. Jasper Johns, *Target with Four Faces*, 1955, encaustic on newspaper and cloth over canvas surmounted by tinted plaster in wood box with hinged front, 33⅝ x 26 x 3 in. (85.4 x 66 x 7.6 cm), The Museum of Modern Art, New York, gift of Mr. and Mrs. Robert C. Scull.

resting not in their Pop-like description of the image or object, but rather in the kind of poetic reverie their associations suggested.

By the mid 1960s, Pop Art anthologies were beginning to appear as critics attempted to define the new movement. In 1966 Lucy Lippard identified a core group of five Pop artists, those who "... employ more or less hard-edge, commercial techniques and colours to convey their unmistakably popular, representational images ..."[2] Her ranking "in order of their commitment to these principles [was]: Andy Warhol, Roy Lichtenstein, Tom Wesselmann, James Rosenquist, and Claes Oldenburg."[3] In the same anthology, Nancy Marmer cited California artists Billy Al Bengston, Edward Ruscha, Joe Goode, Wayne Thiebaud, and Mel Ramos as artists for whom "... Pop art did take root easily, early ... flourish[ing] smartly, if diversely, in a milieu in which it could well have been invented."[4] More than thirty years later in another anthology, *Pop Art: A Critical History*, editor Steven Henry Madoff had reduced the pantheon to just four Pop Art masters: Lichtenstein, Oldenburg, Rosenquist, and Warhol. He listed no Californians.[5] Madoff also pointed out the absence of women:

> After poring over hundreds of articles and catalogues for this book, one aspect of Pop art's life became particularly notable. For all the diversity of opinions, the vast historical body of writings on Pop makes one thing clear: the roster of artists generally considered members of the Pop camp barely included the mention of women.[6]

That the consensus can produce only this small group of names points primarily to American Pop Art's lack of an agreed upon agenda. Even though artists made use of some of the same sign systems, common objects, and a range of similar media, the variety of approaches they took to achieve their individual ends left the impression of a movement constantly in flux. And because few artists stayed exclusively with one approach or one subject for long, gradually extending the range of their shared topics, it is now difficult to arrive at a narrow or conservative reading of what was or was not Pop Art. Still, it is safe to conclude that the emergence of Pop Art tended to signal a general turning away from the exploration of the inner self. Existential self-absorption (a strong refrain in both abstract and realistic American art during the postwar era) was giving way to a preoccupation with outward appearance. Brand name products; bold, eye-catching color; and a more forthright, clean, and

Art. And in spite of their seemingly narrow range of subject matter (whatever could be gleaned from mass media), the work of the artists who participated in these shows was notably diverse. It is important to emphasize that unlike British Pop, American Pop Art had no real center: it was not supported by a particular group of artists and only began to find a general definition after many of its originators had independently arrived at their own solutions.

Nevertheless, the early Pop artists, restlessly in search of an art practice that went beyond the well-traveled path of Action Painting, found a common touchstone in the work of two very important pioneers, Jasper Johns and Robert Rauschenberg. Both Johns and Rauschenberg served as a bridge between the era of Abstract Expressionism and what was to become known as Pop; their incorporation and/or depiction of recognizable objects within their compositions had a dramatic effect upon the younger artists. Of the two, Johns cast the longest shadow. The iconic nature of his flags and targets (fig. 77) appealed to the Pop sensibility more than Rauschenberg's continuous flow of images, which—although contemporary in subject matter—were more varied than John's and more prone to seemingly unrelated juxtapositions, their power

fig. 78. "International Exhibition of the New Realists" (November 1–December 1, 1962), Sidney Janis Gallery, temporary annex, 19 West 57th Street, New York, installation view. Works shown are (left [near ceiling] to right): Daniel Spoerri, *le parc de Marcelle* (1961), Roy Lichtenstein, *Refrigerator* (1962), Martial Raysse, *Pump Torso* (1962), and Jim Dine, *Five Feet of Colorful Tools* (1962). Photograph by Eric Pollitzer.

fig. 79. Ferus Gallery and Paul Rivas Gallery, Los Angeles, exterior view at 723 North La Cienega Boulevard, November 1964. Work shown in window is Roy Lichtenstein, *In* (1962). Photograph by Frank J. Thomas.

hard-edge presentation of subject matter were taking root. The subject matter of Pop Art—consumer products and popular culture—demanded a cool and detached approach, an outward optimism, rather than the anxiety-ridden inward-looking viewpoint of the preceding generation of American artists.

The history of American Pop Art at first glance appears to be one of place—a tale of two cities, New York and Los Angeles. Pop Art in New York was nurtured by artist-driven alternative art spaces, a few commercial galleries, and a small group of collectors. In early 1960s, places like Manhattan's downtown Reuben Gallery, its midtown Green Gallery, and the more established Leo Castelli, Sidney Janis (fig. 78), and Martha Jackson galleries played extremely important roles in advancing the careers of artists who were creating Pop-related work. Artists' conclaves, such as Coenties Slip at the tip of Manhattan, also allowed artists of varying sensibilities to commingle, trading support and influence. In Los Angeles, Ferus (fig. 79) and Dwan galleries provided venues for both New York and West Coast Pop-related artists. Museums in both cities began to participate a bit later—the Pasadena Art Museum near Los Angeles was the first, presenting curator Walter Hopps' exhibition "New Painting of Common Objects" in September 1962.

The most vibrant developments in American Pop Art, however, occurred through the interactions of its early practitioners. It was Oldenburg, for example, who first encouraged Jim Dine to participate in the creation and performance of a Happening—what Dine liked to refer to as a "Painter's Theater." They began by collaborating on the construction of an environment as part of Oldenburg's "Ray Gun" exhibition held at Judson Gallery in New York's Judson Memorial Church in 1960 (fig. 80). It was actually in two parts, appearing within separate but connected spaces in the gallery: Oldenburg's environment was designated "The Street," and Dine's was "The House." Then, within these collage environments, Dine and Oldenburg produced a number of loosely scripted Happenings that were performed as an accompaniment to the gallery exhibition. The dialogue that accompanied these theater events retained the gritty street language of contemporary urban life and involved, much more than in conventional theater, a degree of audience participation.

To create these environments, the artists met in the evenings and scoured the neighborhoods around Washington Square for street trash, salvaging newspapers, cardboard, rags, string, and concrete—all the bits of broken and wasted debris that littered the city streets. This trash then became the ephemeral stuff of their Happenings as they brought inside, into the gallery, what they had found outside (fig. 81). This was not nature but, as Dine expressed it, "a man-made landscape of garbage."[7] Not that they looked upon this garbage in an entirely negative way. Like Rauschenberg before them, who collected street trash as material for his combines, Oldenburg and Dine were recycling garbage in a celebratory manner. Oldenburg stated in his "Ray Gun" notes of 1959, "Its aim is to *people* the world with hallucinations, *make the inanimate, animate*, create visages everywhere, and thus restore the excitement and meaning of simple experience."[8]

In 1960 Happenings and performance events like the Oldenburg/Dine collaboration were just as important as exhibitions of paintings and sculpture for artists living in New York. The New York Happenings had their roots in Black Mountain College in North Carolina, where innovative interdisciplinary approaches were being explored in music, poetry, dance, and painting throughout the forties

fig. 80. "Ray Gun" (January 30–March 17, 1960), Judson Gallery, New York, view of Thompson Street entrance. Posters are by Claes Oldenburg and Jim Dine. Photograph © Fred W. McDarrah.

fig. 81. Claes Oldenburg in his *Snapshots from The City* (February 29, March 1–2, 1960), Judson Gallery, Judson Memorial Church, New York. Photograph by Martha Holmes.

and fifties.[9] Black Mountain College's crossing of disciplines, often neo-Dada in its open, exploratory practices, left behind a legacy of inclusiveness, and Black Mountain artists such as John Cage, Merce Cunningham, and Rauschenberg anticipated many of the tenets of postmodernism that would follow in American culture. The artists and poets of Black Mountain College explored the realms of chance as a method of composition and a descriptive literalness as a form of concrete expression. These concepts, as they especially filtered through the work of Rauschenberg and Johns, tended to reappear in the Happenings of early American Pop.

Reuben Gallery at 61 Fourth Avenue became a major home for New York Happenings, many of which were produced and performed by Allan Kaprow (who had originally introduced Happenings to the East Coast at Hansa Gallery in New York and at Rutgers University in New Jersey).[10] Also important to the early history of Happenings were George Brecht, Lucas Samaras, Robert Watts, and Robert Whitman, who were to become associated with Fluxus, an international group of artists that was opposed to tradition and professionalism in the arts; members of Fluxus occasionally produced objects that were considered by some to be Pop Art. Watts' *Stamp Machine* (1961), for instance, shares with Pop Art the literal depiction of mass-produced products, but as an appropriated object, it is also related to the idea of Marcel Duchamp's readymades. When Watts created casts of food products, such as *Whitman's Assorted Chocolates* (1963–64), the prevailing sense of irony in a chrome-plated metal box of candy is of a conceptual nature at the edge of hard-core Pop Art.

Happenings in the early sixties provided an important bridge between avant-garde theater and the more static arts of painting and sculpture. Especially as practiced by Dine and Oldenburg, Happenings and their corollary environments tapped the explosive energy of Action Painting (fig. 82), but avoided the heavy moralizing that both Abstract Expressionist artists and Existentialist playwrights were prone to indulge in. For participants in Dine's "Painter's Theater," celebration of the moment was the main thing. As Oldenburg has said of his assembled environments, serving as both installation and sculpture, they were intended to counter "the notion of a work of art as something outside of experience, something that is terribly precious."[11]

In December 1961, acting on that conviction, Olden-

fig. 82. Jim Dine and Judy Tersch in Dine's *Car Crash* (November 1–6, 1960), Reuben Gallery, New York. Photograph by Robert R. McElroy.

burg opened up his Ray Gun Mfg. Co. store at 107 East Second Street (figs. 151, 152). For two months, he used the back end of the long, narrow storefront space as a studio and the front of the building as a business and a gallery where he sold his plaster recreations of tennis shoes, hamburgers, and pies. To create these works, Oldenburg had developed a process of soaking muslin in plaster, shaping it over a wire frame, then painting it with enamels.[12] His store was inspired by the mom-and-pop delicatessens and storefront shops that were ubiquitous on New York's Lower East Side. In it he replaced the dirty browns and charred blacks of the cardboard and newspaper debris used in his street Happenings with these brightly colored plaster replicas of foodstuff and clothing. In effect, his move from the street to the store signaled a move from the human form to objects—from figurative art to still life. To a large degree, Pop Art devoted itself to the depiction of common household objects, and in Oldenburg's case, his playful depiction of pants, shirts, and shoes became surrogates for the human form. A further move occurred when he had the opportunity to reinstall his Ray Gun store at the uptown Green Gallery on 57th Street in September 1962, a change of fortune, as Sidney Tillim noted, from blue collar to white collar.[13]

The years 1961–62 were extremely active for both Oldenburg and Dine. They made substantial progress in their approaches to both ideas and materials, advancing the authenticity of their performances and Happenings. One of the prime innovations that they had brought to

their early Happenings was their incorporation of objects into the human drama. The costumes and objects included in the Happenings served a function beyond conventional stage props; as inanimate objects, they could also be seen as art objects and very much had the ability to stand on their own as Assemblage or sculpture without the support of the play itself. As Alan Solomon pointed out, Dine and Oldenburg gave to objects, which played an important part in these events, ". . . . a new importance, with the result, actually that objects often became members of the cast, as important as the human actors."[14]

My feeling is that both Oldenburg and Dine were most classically Pop-like in their approach to art when they kept their objects simple and of human scale. Oldenburg's *Box of Shirts* (1962, pl. 12), three folded canvas shirts set in an open box, is a prime example, as is Dine's *Flesh Tie* (1961, pl. 8), a man's necktie collaged to a canvas and covered with flesh-colored oil paint. But the object never remained anonymous for either Oldenburg or Dine. Their highly developed sense of humor and their graphic playfulness did not allow their works to just sit there as depersonalized things. Oldenburg was perhaps more content to let his objects stand for themselves with the humor present in the thing itself, like his soft sculptures, which sag into themselves, shaped by their own gravity. Dine, on the other hand, treated his subject matter much more symbolically: his works seem more psychologically loaded and more suggestive of things outside of themselves. The diverse objects commingling in Dine's

fig. 83. Robert Whitman, Jim Dine as Ball Man, and Rosalyn Drexler in rehearsal for Whitman's *E.G.* (1960), Reuben Gallery, New York. Photograph by Robert R. McElroy.

3 Panel Study for Child's Room (1962, pl. 14) suggest multiple interpretations, including those beyond the mere description of what the child's raincoat, handprints, and toys are as objects.

Another artist who was part of the Reuben Gallery action early on is Rosalyn Drexler. Her first solo exhibition occurred at the gallery in 1960, the same year she performed with Dine as one of the ball girls (Pat Oldenburg was the other ball girl) in Whitman's Happening *E.G.*, also held at the gallery (fig. 83). Drexler is a playwright and a novelist as well as an artist, the winner of four Obies (given for Off-Broadway plays) with eight novels to her credit. What she explored in her fiction writing—the contemporary human dilemma—she also addressed in her collage paintings. Her subjects came from newspapers, magazines, and movie posters, which she cut and glued to canvas supports as in *Death of Benny "Kid" Paret* (1963, pl. 27). Drexler's themes in these works vary: lovers in an embrace, a gangster being gunned down, mourners at a funeral. These fragments of tabloid love and violence were composed on isolated color fields, with Drexler painting in oil or Liquitex directly upon the photos, not really obliterating the form but simplifying it by eliminating photographic detail. What Drexler did with her painted collage material is just the opposite of what hand-tinting does in fine art photography, where a blush of color over black-and-white prints produces a softening effect and a sense of nostalgia. There is no sentimentality about

Drexler's paintings of the early 1960s. When I visited her recent exhibition of early collage paintings at New York's Mitchell Algus Gallery,[15] I was struck by their iconographic Pop Art-like presence and by the cool and direct handling of her hot topics. Like Warhol's silkscreens from his Disasters series, Drexler's collage paintings freeze a heightened, emotional moment into a memorable static image.

Critics over the years have assigned Drexler a somewhat marginal place in the history of American Pop Art, compared to another collage-based artist, Wesselmann, who has always been placed at dead center of the movement. The reason for this disparity is the feeling that Drexler's art, other than a few paintings based upon pop stars like the Beatles and Chubby Checker, are devoted to sex and violence and are too hot and emotionally loaded to be thought of as classical Pop. Wesselmann's art, on the other hand, epitomizes the cool, optimistic, bright-and-shiny American household, which he depicted in collage paintings that are sexy and sparkling clean.

Wesselmann started out as a painter completely under the spell of Abstract Expressionism; he especially loved the work of de Kooning. But by 1959 he had realized that he needed to free himself of past influences, and he made the conscious decision to work as a representational painter. Toward that end, he began to explore collage. Wesselmann, who was living in New York, initially looked for his collage material in the streets, but unlike his friends Oldenburg and Dine, who tended to embrace the funky, battered, and torn-up state of street material, Wesselmann wanted his collages clean. He once recalled "...rummaging through subway trash cans on days when old subway posters had been taken down, carrying them home and washing them to remove as much of the old wallpaper paste and dirt as possible."[16] Eventually he gave up scrounging street material and instead wrote to billboard companies and advertisement agencies in order to acquire pristine copies of their printed sign material (fig. 85).[17] The shift from torn-down subway material to previously unused advertising posters gave Wesselmann's collages a decidedly cleaner look. It also aligned him with Pop Art, both by virtue of the commercial subject matter and by distancing him from other more painterly forms of realism. Formally his work was closer to hard-edge abstraction and even aspects of color field painting—both Pop related—than it was to the more painterly collage approaches of, say, Rauschenberg or Larry Rivers.

For many, Wesselmann's Pop-era collage still lifes and

fig. 84. James Rosenquist and billboard painters from Artkraft Strauss Company working on *Big Country* billboard, exterior Astor Theater, Times Square, New York, 1958.

his ongoing Great American Nude series seem to be the easiest Pop Art to get a handle on. The work comes across as aggressive, colorful, and sexy, qualities that the commercial advertising world valued as the best ways of selling their products. But while the emphasis on subject matter may have provided an easy hook for a lay audience, it was problematic for the artist himself, who was equally interested in the formal problems his compositions proposed. For one thing, the large scale of Wesselmann's billboard material, when seen at eye level in a painting, presented problems that demanded exact placement and a calculated overlapping of images. Once Wesselmann began to use real objects within his compositions—for instance, a working television in *Still Life No. 28* (1963)—he had to contend with the demands of three-dimensional sculptural space as well.

By 1964 Wesselmann had started to move away from using brand names in his still lifes. This retreat from easy identification was not atypical: the faceless, provocative, and sexy ladies of his Great American Nude series had always had an anonymous air. While Wesselmann certainly emphasized the models' sexuality, especially the lips and breasts, they were not, as in Ramos' paintings, derived from soft porn magazines like *Playboy*. Instead Wesselmann practiced a very traditional approach when it came to the human figure: rather than use magazines as a source material, he drew directly from the posed model.

fig. 85. Tom Wesselmann working in his studio, New York, 1964. Photograph by Ken Heyman.

Wesselmann's use of billboard imagery was basically conservative in approach, relying almost solely on placement—the depicted images never lost their meaning or form. By comparison, Rosenquist's highly allegorical paintings present billboard-scale slices of popular culture as fragments, juxtaposed in a manner that encourages multiple interpretations. But Rosenquist's subject matter, like Wesselmann's, is entirely man-made, reflecting urban and/or suburban realities, and his compositions are just as brilliantly controlled.

From the early 1950s, starting out in the Midwest, Rosenquist painted outdoor signs on grain elevators and gasoline tanks. In 1957 he began to paint billboards in New York, working for Artkraft Strauss on signs in Manhattan; at times he worked on as many as three signs at once, perched high above Times Square (fig. 84, page 111). Because he was prolific and worked so quickly, Rosenquist has said that during the four years he worked for ArtKraft Strauss, he produced the equivalent of fifteen solo shows.[18] Then in 1960, shortly after a sign painter friend was killed in a fall from a scaffold above a Union Square department store, Rosenquist decided that the potential danger of his occupation and his desire to be a fine arts painter made it a good time to quit his commercial job.

When Rosenquist rented a large loft studio at Coenties Slip, a unique studio complex on the East River, he began participating in an important part of American art history. His studio had been formerly occupied by Agnes Martin, and his new neighbors included Robert Indiana, Ellsworth Kelly, and Jack Youngerman. Coenties Slip was directly on the waterfront with a view of the Brooklyn Bridge. On its backside, the studios faced Wall Street

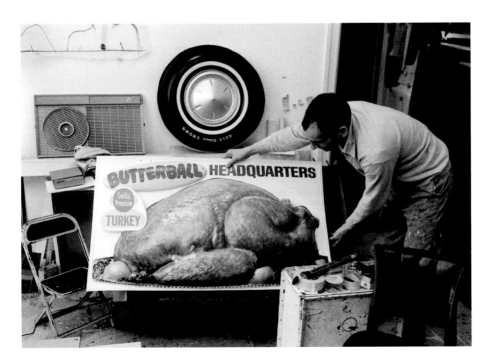

twelve feet, *President Elect* is composed of images that Rosenquist adapted by carefully applying a grid on top of magazine illustrations, then transferring, as realistically as possible, the images of John F. Kennedy, a woman holding a single slice of cake, and a view of a tire and fender from a Chevrolet.

Rosenquist's predilection for treating objects and figures as fragmented images in his work was reinforced by his close association with the abstract artists who were his neighbors. Although he used realistic imagery, Rosenquist's paintings resisted a quick read, unlike billboards, which are pictorially organized to be read instantly. His odd disproportion of image and scale dramatically altered the narrative flow of his works, encouraging the viewer to consider his overlapping collage-like images more abstractly. Rosenquist used the compositional styles of the close-up, the compressed image, and the collage-like juxtaposition of images (fig. 88). All three are used in the single work *I Love You with My Ford* (1961), which includes the stacked images of an automobile grill and fender, a fragment of a face in profile, and a close-up of a tangle of Franco-American spaghetti.[20]

There is no question that Rosenquist is key to the American Pop Art era, as exemplified by his huge painting *F-111* (1964–65), which was first exhibited at Leo Castelli Gallery (fig. 87), then at New York's Jewish Museum. *F-111* is obviously an anti-Vietnam War painting: its motif includes the profile of a fighter-bomber interrupted by images as diverse as an angel food cake, a Firestone tire, a young girl's head under a hair dryer, and a mushroom cloud from a nuclear explosion. Measuring ten by eighty-six feet, *F-111* is also Pop Art's biggest picture. It would become an icon of Pop Art and American painting in the 1960s. Despite this, Rosenquist's position within Pop Art has always been problematic to those critics inclined to accept the isolated, iconic image—the single-subject painting, such as a Warhol soup can or a Lichtenstein comic—as the quintessential Pop Art image. Lippard recognized the difficulty in assessing Rosenquist's work, pointing out that his paintings employed a vast range of extraneous materials, which along with paint and canvas could include the use of plastic sheets, mirror, Plexiglas, and neon and electric lights. This profusion of material elements accompanied an almost classic Pop compendium of meticulously reproduced mass-market images. As Lippard has stated, "Rosenquist's freewheeling inventiveness makes other Pop artists (except

fig. 86. Delphine Seyrig and son, Duncan Youngerman, Robert Indiana, Ellsworth Kelly, Jack Youngerman, and Agnes Martin on the roof of their studio building, 3–5 Coenties Slip, New York, c. 1958. Photograph by Hans Namuth.

fig. 87. "James Rosenquist: *F-111*" (April–May 12, 1965), Leo Castelli Gallery, New York, installation view. Work shown is *F-111* (1965, detail). Photograph by Rudolph Burckhardt.

with its cliff of high-rise office buildings (fig. 86). The Coenties Slip artists valued this isolation, the sense of being removed from the dominating world of Pollock and de Kooning. "Coenties Slip," wrote Mildred Glimcher, "was a place apart, physically and spiritually distant from the Abstract Expressionist power center of Tenth Street and the Cedar Bar."[19] For Indiana, Kelly, and Youngerman, all of whom were working in a nonfigurative mode, Coenties Slip was also where they had arrived at their mature forms of expression. The same can be said of Rosenquist, who began working in an abstract mode but soon started to employ his old sign painting techniques. He incorporated popular commercial subject matter into his first Pop painting, *President Elect* (1960–61). Measuring seven by

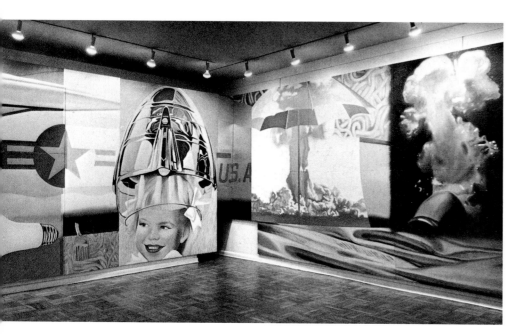

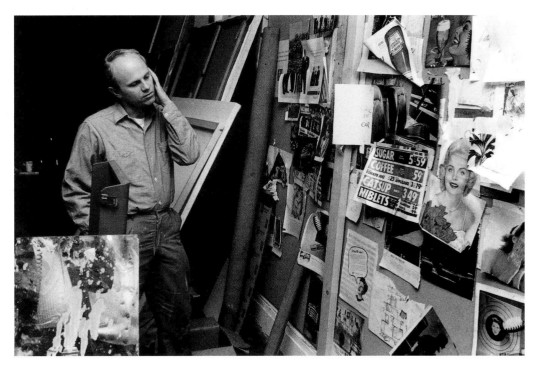

perhaps Oldenburg) look conservative, yet he has been called the academic of the group because of his quasi-photographic style of rendering images and his inverse illusionism."[21]

Another artist receiving qualified acceptance by Pop Art purists is Indiana, whose paintings incorporated stenciled words and letters familiar from street signs and businesses. Indiana was inspired by the commercial traffic and environment of Coenties Slip, where he lived: it both provided him with materials and excited his creative imagination. Having moved to Coenties Slip in 1956, remaining there until 1965 when the building was razed to make room for new construction, Indiana was transfixed by the rich history and literary legacy of a place haunted in previous eras by Walt Whitman, Hart Crane, and Herman Melville. But his romance with nineteenth-century America was tempered by his love of twentieth-century street and highway signage. In 1961 Indiana declared himself an artist of geometry and letters: "I am an American painter of signs charting the course," he said, then continued with Whitmanesque flair, "I would be a people's painter as well as a painter's painter."[22] Strongly influenced by the hard-edge abstraction of his friend Kelly, Indiana was drawn to the simple shapes of things he found in the neighborhood, such as the leaf of a ginkgo tree, which grew in adjacent Jeanette Park and whose elegant shape became an abstracted form in his paintings of

the late 1950s. The loft itself provided Indiana with materials, and he made use of the discarded planks and beams he found there to build a series of stile-like sculptures, four to six feet in height, on which with stenciled lettering he added titles like "SOUL," "HUB," "AHAB," and "MOON." He also found a set of brass stencils, which provided an alphabet of letters for his drawings (rubbings) and for his Pop Art-related paintings.

Indiana kept elaborate journals during the period when he was developing his art in the 1960s, including personal observations of politics and news events, accounts of meetings with friends, notes, and sketches of planned paintings and sculptures. One entry from April 1961 mentions a studio visit from Warhol with Indiana's notation about introducing Warhol to the I Ching.[23] Along with the I Ching, Indiana was passionate about the board games Monopoly and Scrabble, often recording words from his Scrabble games as journal entries.

Indiana's sign paintings, inscribed with stenciled words such as "TILT," "EAT," and "DIE," follow the Pop ethos by chronicling an American urban environment. They boast, declare, quote, and warn; backed by Indiana's archival journals, his paintings present a condensed romantic vision of a particular American point of view in compositions that are related in their formal structure both to Pop Art and to hard-edge abstraction. In the mid 1960s, just before moving up to the Bowery, Indiana

characters Dick Tracy, Superman, Nancy, and Popeye precede Lichtenstein's first cartoon paintings by a year. But once he visited Leo Castelli Gallery and saw Lichtenstein's work, Warhol decided to stop painting comic strip images and switched to Campbell's Soup cans.

During the 1950s, before either Lichtenstein or Warhol took up comic strip imagery, the San Francisco artist Jess created a series of collage panels based on the Dick Tracy comic strip. Clearly a precursor figure in Pop Art, Jess used his newspaper-derived collages to subvert the original text of the strip, scrambling its narrative by rearranging the words in the speech balloons as well as re-collaging the images themselves. Jess named these collages *Tricky Cad* (1954–59, fig. 89), and they are as close to Pop Art as he would get. The *Tricky Cad* collages retained the format of the original cartoons: they were simply recut and repasted into odd surrealistic couplings, with each panel column identified as a "case," like a weird, unsolvable detective investigation.[25] In contrast, Lichtenstein's comic images were transferred to canvas, greatly increased in scale, and restricted in both image and narrative to a single frame. But like Jess, Lichtenstein would subtly alter the content of the wording in his speech balloons.

Lichtenstein's earliest Pop paintings were inspired by cartoon images from a comic strip found in a bubble gum wrapper. He had been teaching at Douglass College, Rutgers University, in New Jersey, where he befriended Kaprow, and as Diane Waldman wrote, "Kaprow remembers that once, in a discussion with Lichtenstein, he pointed to a Bazooka Double Bubble Gum wrapper and remarked, 'You can't teach color from Cézanne, you can only teach it from something like this.'"[26] Lichtenstein, who was painting abstract works at the time, then showed Kaprow a painting he had done that included an image of Donald Duck. Kaprow wasn't overly impressed by this particular painting, but he was encouraging nonetheless. More importantly for Lichtenstein, a seed had been planted. He would soon drop his expressionistic paint handling, and in 1961 he produced his first Pop-related painting, *Look Mickey*. In this painting, not only did he introduce cartoon figures from an appropriated comic, but he also used a speech balloon for the first time.

Lichtenstein's range of subjects eventually went beyond comic strips to include single-object advertisements for balls of twine, electric cords, socks, engagement rings, hot dogs, and so on—all the consumer goods that Americans were being told they could not live without. He treated

fig. 89. Jess, *Tricky Cad (Case IV)*, 1957, newspaper comic strip collage pasted in handmade book, 19¼ x 11 in. (48.9 x 27.9 cm), Odyssia Gallery, New York.

stood in front of his studio entrance at 25 Coenties Slip and reflected: "The front of number 25 was covered with words that influenced me in my work every day. Not just that: every boat, barge, ferry, train, or truck that passed, nearby or on the river next to Coenties Slip, etched its markings into my work...."[24]

Unlike the cityscape that so strongly influenced the work of Oldenburg, Dine, and Indiana, the world that provided inspiration for Lichtenstein and Warhol was the world of mass communication. The newspapers and magazines from which they lifted their images—including comics and advertisements as well as, in Warhol's case, labels from mass-produced products—acted as their cityscape. Both Lichtenstein and Warhol raided the American print media, using primarily *The New York Times* but also other daily newspapers as well as American comic books for material. That their choice to use commercial images in their paintings was made nearly simultaneously and without any knowledge of each other's efforts in that direction is one of the legends of Pop Art history. Though Warhol saw Lichtenstein's paintings of enlarged single-frame comic strip panels at Leo Castelli Gallery in 1961, after Warhol's friend Ted Casey told him about them, Warhol actually came to comic strip paintings before Lichtenstein: his 1960 versions of the comic

these objects as still lifes, renditions of the originals drawn by the anonymous commercial artists of the world of newspaper advertisement. There was no art involved in these renderings, which Lichtenstein found attractive. Approaching his resource material very abstractly, even though the subject matter was realistic, he often enlarged his sketches, transferring them to canvas with the use of an overhead projector. This tactic led to his real trademark: his adaptation of the benday dot (fig. 90), a cheap method to produce tonal effects that was part of the reproduction of images in early commercial printing. Lichtenstein also used stencils, rulers, and tape in the process of creating his paintings, giving them a mechanical appearance. As Coplans once noted, "Lichtenstein crops away until he gets to the irreducible minimum and compresses into the format the exact cliché he desires to expose."[27]

Warhol's entry into the art world came when he was at the height of a very successful career in advertising. He began that career in New York in 1949, the same year that Lichtenstein received his master of fine arts degree from Ohio State University. Warhol's debut "exhibition" as a Pop artist was actually a window display for the Bonwit Teller department store. In April 1961, five of his paintings derived from advertisements and the comics were exhibited along with store mannequins modeling clothes. The five paintings were *Advertisement*, *Little King*, *Superman*,

Before and After, and *Saturday's Popeye* (all 1960). (It's interesting to note that one year earlier Rosenquist had painted a large-scale portrait of a woman's smiling face also as a window display for Bonwit Teller.) Bonwit Teller was located in midtown on the very fashionable corner of Fifth Avenue and 57th Street. Thousands of pedestrians passed by the Warhol window display, glancing if not actually looking at the paintings that served as backdrops to the clothed mannequins.

During his early career, Warhol also did illustrations for such magazines as *The New Yorker*, *Vogue*, *Seventeen*, and *Harper's Bazaar*. His years in the commercial art world gave him insight into products and the market value of a clear identity. As a result, he never made value judgments about the objects he selected for his drawings or paintings; he simply tried to present them as dispassionately as possible.

By 1960 Warhol was doing paintings based on ads for consumer products such as Coca-Cola, Del Monte peaches, and Campbell's Soup. The first of these iconic and single-image paintings were banded with vertical borders of loose paint and crayon markings, but by 1962 the images had become centered and were devoid of any expressionistic paint handling. Soup cans or Coke bottles once presented as a single image were now painted many times over in stacked rows, like those commonly found on the

The initial group of Campbell's Soup cans were the last hand-painted works that Warhol was to do. By late 1962 he was exclusively silkscreening his images onto canvas (fig. 91). To the consumer products, he added images of movie and media stars currently dominating popular American culture—Marilyn Monroe, Liz Taylor, Elvis Presley, etc.—which, like the Campbell's Soup cans, he repeated in rows (figs. 76, 92). This multiple presentation of the same image became a Warhol hallmark. Serial imagery was being explored on several fronts in abstraction and Minimalism, and as Coplans has pointed out, central to serial imagery was the issue of redundancy. The seemingly endless quality of repeated images threatens to be visually boring, but it also can give off "…the appearance of being boundless, never finished and without wholeness."[29] Warhol's art suggests the tedium (and amorphous promise) of an open-ended yet never-changing continuum.

Like Lichtenstein with his mechanical reductions, it was Warhol's championing of an impersonal style that most galled his detractors, who were accustomed to paintings whose dramatic, psychologically charged themes were enriched by compositional variation. Both artists had touched a nerve. Their product and comic book images mirrored what was most banal about contemporary life and, not unlike the media-driven desires that Americans had bought into, what was most fleeting.

fig. 91. Gerald Malanga and Andy Warhol silkscreening *Campbell's Soup Can* paintings, The Factory at 231 East 47th Street, New York, 1964. Photograph by Ugo Mulas.

shelves of a grocery store. The familiarity of the shape and labeling of the Coca-Cola and Campbell's Soup was critical. Unlike Lichtenstein's common household objects, which were painted without any indication of a company logo, Warhol's products were meant to be immediately recognized. For this reason, Warhol chose products available worldwide whose labels had not changed in decades.[28]

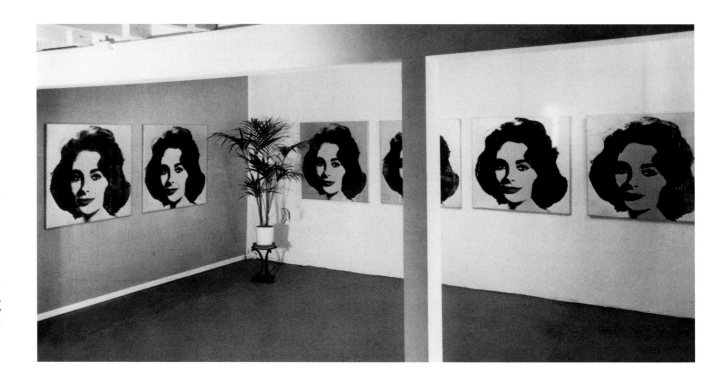

fig. 92. "Andy Warhol" (September 30–October 26, 1963), Ferus Gallery, Los Angeles, rear gallery installation view. Works shown are from the *Liz* series. Photograph by Frank J. Thomas.

The banal and the fleeting are endemic to the other great center of Pop Art—Los Angeles. Where New York is the older city, more closely tied to Europe both intellectually and culturally, Los Angeles is much younger, spread out geographically between deserts, mountains, and the Pacific Ocean. Los Angeles in the 1960s was also much more laid back, less burdened by the heavy weight of self-conscious justification that infused much of the New York art world. It was an environment as close to "pure Pop" as one could get.[30] Its culture of automobiles and freeways (fig. 93), its suburbs carved out of orange groves, and its landscape of billboards and Hollywood stars made the city a man-made Eden. Los Angeles was youthful, hedonistic, and self-possessed. It also had its own inner city landscape of automobile junkyards, vacant lots, and trash-choked back alleys— along with its masters of Assemblage.

Assemblage art in California has a history not unlike that of the Happenings in New York. Both art forms were rambunctious and tended towards the ephemeral (in the case of Happenings, the form was entirely ephemeral, save for the photographic documentation of the performances). Both relied on multimedia formats, and both dealt with the common objects of Americana. Assemblage, however, had its strongest connections with sculpture rather than performance, although it was much more variant in its methods than traditional sculpture.

The Assemblage masters of California in the 1960s were Wallace Berman, Bruce Conner, George Herms, and Edward Kienholz, with interesting contributions also made by Fred Mason and Ben Talbert. A largely Southern California phenomenon, Assemblage was fed by a strong interest in poetry and jazz, and was shot through at times with a symbolic critique of popular culture. But in spite of this social criticism, Assemblage in California tended to remain arcane and private in nature.

The one exception was Kienholz. As his former Ferus Gallery partner, Hopps, would acknowledge in the late 1960s, Kienholz's maturity as a sculptor had taken shape by the time he created *John Doe* (1959, fig. 94) and *Jane Doe* (1960): "This was the critical moment when he began to combine actual everyday objects and things in works that would embody his insights about our everyday thoughts and lives. The figures are absurd, humorous, pathetic, corny and tragic, as are the materials used in their making."[31] Because of this early use in his art of familiar, public, everyday things, Kienholz is often considered to be proto-Pop. His major Assemblages of the 1960s were room-sized environments—"tableaux" as he called them. A master of recycled Americana, Kienholz and his Assemblages shared with Pop Art a concern for the implications

fig. 93. Dennis Hopper, Untitled [giant Mobil Oil station attendant], c. 1964, gelatin-silver print, 16 x 24 in. (40.6 x 61 cm), courtesy of the artist and Tony Shafrazi Gallery, New York.

fig. 94. Edward Kienholz, *John Doe*, 1959, paint and resin on mannequin parts set on metal perambulator with wood, metal, rubber, and plastic toy, 41 x 19 x 34 in. (104 x 48.2 x 86.4 cm), The Menil Collection, Houston.

of overconsumption and the very limited life span of most objects in our disposable society.

Like New York, Los Angeles had galleries that provided early support to Pop-related work. Ferus Gallery in Los Angeles opened in the spring of 1957. Run by Hopps and Kienholz, it was known for its exhibitions of contemporary Northern and Southern California artists, as well as for its exhibitions of internationally known modernists. Later on, Irving Blum would join the gallery and offer Warhol his first solo exhibition, featuring his Campbell's Soup can works (July 9–August 4, 1962). Ferus Gallery was extremely important to the art community of Los Angeles, and along with Dwan Gallery (fig. 95),[32] it played a vital role in introducing Pop artists to Southern California. The high standards set by Ferus Gallery were important in creating an atmosphere of serious competition. As Bengston recalled, "The only way to know my work was any good was to hang it mentally between the work of two artists I admired; if it held up in that context, it was okay. There was no other test."[33]

The three Los Angeles-based artists with the closest relationship to Pop Art are Bengston, Goode, and Ruscha. Each practiced a kind of formal rigor and adopted an iconography that, if not entirely dependent upon commercial imagery, at least shared with Pop Art a number of qualities such as non-illusionistic space, flat color, and a centrally composed image.

Bengston was born in Kansas but moved to Los Angeles in 1948. Along with an early interest in art, Bengston developed a fascination with Southern California's automobile and motorcycle culture. Cars and bikes were much more than a means of transportation for many young peo-

fig. 95. "The Arena of Love" (January 5–February 1, 1965), Dwan Gallery, Los Angeles, installation view.

ple in Los Angeles during the 1950s and 1960s; they were also unique objects and symbols of freedom. Bengston raced motorcycles professionally, in an environment where the spray painting and lacquering of vehicles in metallic candy-colored coats of paint was an art unto itself.

Bengston's first truly mature (and highly individualized) works were the valentine or heart paintings that he exhibited in his second solo exhibition at Ferus Gallery in February 1960 (fig. 96). While he was traveling through Europe, Bengston had the opportunity to see Johns' target paintings at the 1958 Venice Biennale. Once back in Los Angeles, Bengston pursued the idea of the single image, isolated and centered in the middle of the canvas. The image of the heart, or valentine, developed when Bengston seized upon the idea that his exhibition was to open very near Valentine's Day.[34] He went on to title his newly created valentine paintings after Hollywood starlets: *Grace* (for Grace Kelly), *Kim* (for Kim Novak), etc. This very Warholian gesture had little to do with connecting the valentines to specific movie stars as subjects, but was rather Bengston's way of distinguishing the paintings from one another. While other American and British Pop artists—Warhol and Peter Blake, for example—were fascinated by Hollywood stars and used them as subjects for their painting, Los Angeles-based Pop artists for the most part avoided direct connections with Hollywood. Bengston's titles for his valentine paintings are one of the few instances of a local Pop artist's recognizing the hometown movie industry.

Bengston's third one-person exhibition at Ferus Gallery was held in November 1961. At the time, he didn't have available enough of his better known chevron paintings

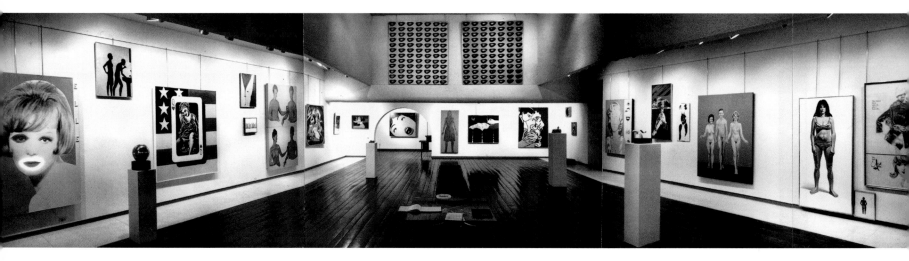

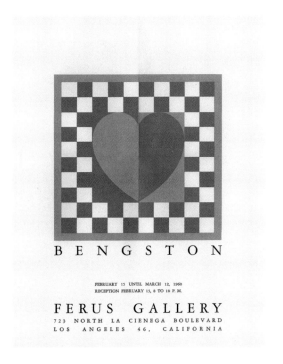

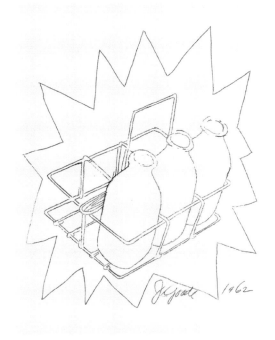

fig. 96. Poster for "Bengston" (February 15–March 12, 1960), designed by Billy Al Bengston, Ferus Gallery, Los Angeles.

fig. 97. Joe Goode, Untitled [related to *Dark Garage*], 1962, drawing mimeographed on colored paper, from the Pasadena Art Museum "New Painting of Common Objects" portfolio, 11 x 8½ in. (28 x 21.6 cm), Rosalind Constable Papers, Menil Archives, Houston.

featuring the heraldic V shape of a sergeant's stripes, so in about a month's time, he painted a dozen works based on the parts of his motorcycle. These paintings are the closest in Bengston's oeuvre to Pop Art iconography. Nearly square in format, each painting locates the selected motorcycle part—a gear box or a carburetor float bowl—in the center of the canvas. Bengston then surrounded the image with rich, Rothko-like hues, a tangerine orange or buttery yellow. Sleek color was important to Bengston, and as early as 1960, he was adding lacquer to his paint, then both spray painting and hand-brushing his colors onto masonite, which offered him a harder and smoother surface than canvas, more appropriate for the highly polished look of his emblematic imagery. This emphasis on glossy finish, much like that achieved by California auto body shops, combined with his iconic imagery caused Bengston's paintings of the early to mid 1960s to fall somewhere between Pop imagery and abstraction.

Some of Bengston's paintings paid homage to the Southern California surfing cult. *Tubesteak* (1965) wed veneer and lacquer on Formica, making reference to "woodies," the wood-panel station wagons popular with surfers along the California coast.[35] Bengston's work thus strongly reflects the environment in which he lived, sharing with Indiana's paintings a sign system that implies much more than its handsome heraldic design. But while Indiana's paintings respond to the Northeast—a Yankee's

viewpoint—Bengston's world is clearly based upon the Southern California life style. Bengston said it best about his own work: "My earlier work took off from things I saw in the street: cars, signs, etc.—man-made things that we see in harsh California light."[36]

Goode and Ruscha grew up together in Oklahoma. Both attended Classen High School in Oklahoma City and eventually migrated to Los Angeles, where they continued their studies at Chouinard Art Institute in the late 1950s. In a recent tribute to his friend, Ruscha remembered that in high school Goode's art teacher assigned him the task of rendering, as a poster assignment, a Champion spark plug. "This project . . . opened another door: Joe realized that lowly, mundane objects could be funny and terrifying all at the same time, and could be beautiful devices for making paintings."[37] Once in California, Goode continued working in pencil and paint on paper and canvas, rendering such common objects as telephones, keys, milk bottles (fig. 97), and the exterior views of homes taken from newspaper real estate ads. From 1961 to 1963, Goode created thirteen oil paintings, each incorporating a paint-covered Alta-Dena Dairy milk bottle, which was placed upon the floor directly and strategically in front of the accompanying monochrome painting. The milk bottle as object—placed in close relationship with, and considered part of, the painting behind it—acts much like the tools in Dine's series of paintings that involved

fig. 98. Joe Goode driving a Cadillac on Route 66, January 1963. Photograph by Edward Ruscha.

painting tools, then attaching them to the canvas, where the paint was allowed to freely drip. Goode's milk bottle paintings are highly enigmatic in a way that escapes the strict definition of Pop Art, since they eschew any reference to the objects as symbols of advertisement. Instead Goode made the painted bottle itself into an art object—rather than, as Warhol would do, giving us back a painted version of the Coke bottle as the uninflected subject of art.

Ruscha is perhaps best known primarily as a painter, but his enigmatic books and various excursions into print-making are evidence that he is equally accomplished in those media. Along with photography, which allows him to meticulously measure and record his environment, Ruscha has a passion for typography. The photographs in his 1962 book *Twentysix Gasoline Stations* document one of the many trips Ruscha and Goode made along U.S. Highway 66 from Los Angeles back to Oklahoma (figs. 98, 99). Ruscha's little book is without text, containing just the

series of black-and-white photographs, with an indication of the location of each gas station pictured. In a magazine interview, Ruscha once acknowledged that the photographs he took for *Twentysix Gasoline Stations* could have been taken by anyone.[38] His statement sounds very much like what Warhol used to say about the production of his own silkscreen paintings. This is not to suggest that there is anything dissembling about Ruscha's remark; his point was that these were not "arty" photographs, but documentation. He continued: "The title came before I even thought about the pictures. I like the word 'gasoline' and I like the specific quality of 'twenty-six.'"[39] Before the image, then, comes the word.

It is very easy to think of Ruscha in relationship to Los Angeles. He is mysteriously tied to the city, although he could hardly be considered a regional artist in the conventional sense. While his word paintings like *Automatic* (1966), which features white letters set against a smoggy greenish field of oil paint, are too elusive, and too lacking in detail, to be considered "realistic," it is difficult to think of any artist better at depicting the sense of what Los Angeles seemingly represents. For those of us who have spent time there, the consensus is that Ruscha is right on. The conventional, flat typeface of his word images in early paintings like *Ace*, *War Surplus*, and *Annie* (all 1962), is generic, and the images hardly refer to a specific location. They tend instead to function cinematically, like movie titles, appealing to what is real and to what is of the imagination. I think of Ruscha's word paintings as

fig. 99. Edward Ruscha, *Union, Needles, California*, 1963, from the artist's book, *Twentysix Gasoline Stations*, 1963.

fig. 100. Wayne Thiebaud, *Delicatessen Counter*, 1962, oil on canvas, 30¼ x 36¼ in. (76.8 x 92 cm), The Menil Collection, Houston.

often painted in rows, just as they would be displayed in a delicatessen or bakery counter (fig. 100). These still life paintings, their objects isolated against buttery white fields, have a kind of cake-icing creaminess that perhaps could only be achieved with oil paint. But it is this lush and delicious paint handling that would ultimately disqualify Thiebaud as a Pop artist.

Thiebaud's student, Ramos, more truly meets the definition of a classic Pop artist. Ramos studied with Thiebaud at Sacramento State College in the mid to late 1950s. By the early 1960s, he was doing oil paintings of Batman and Superman, the macho comic book heroes of the day, employing the lush, paint-loaded brushwork of his teacher. (Ramos began painting these comic strip figures without any knowledge of Warhol's similar efforts on the East Coast.) By 1963 Ramos had switched his attention from masculine comic book heroes to girlie magazine pinups copied from *Playboy* magazine. Robert Rosenblum has described Ramos as following in a long line of academic pinup illustrators, men like Alberto Vargas and George Petty:

> It is to this long tradition that many of Ramos' nudes are addressed and the challenge of reviving these erotic goddesses with a satirical twist is one that energized his entire career. He cast a new light on this tradition by showing us how familiar was the American mix of sex and advertising, linking as he often did in the 60's American brand names— Kellogg's, Firestone, Lucky Strike, Del Monte, Kraft—with an anthology of sexy girls who hawk these wares.[40]

By 1964 Ramos had started smoothing out his gooey paint application and increasing the size of his paintings. He posed his nicely centered, smiling cheesecake girls with oversized products whose labels were always visible (pl. 49). This was Pop Art as soft porn—sexually titillating in an age when America was just beginning to loosen its prudish public posture about nudity in art.

Other California artists had fleeting relationships with Pop Art, in some cases producing Pop Art gems whose subjects and treatment were both timely and appropriate. For example, Jim Eller's *Scrabble Board* (1962) is a classic example of Pop Art appropriation. He used an actual fourteen-inch-square Scrabble board, added elements enabling it to be wall mounted, and glued onto the game board wooden letters that spelled out the word "RAT." In *Kitchen Unit with Three Rats* (1962, fig. 37), Eller's use of toy rubber rats as a recurring motif introduced a dark or subterranean element into otherwise immaculate, miniature domestic and commercial settings. The paintings of

verbs rather than nouns. They exist, like Los Angeles itself, somewhere between promise and reward.

Los Angeles in the 1960s was thought to be a kind of twentieth-century Eden, home to Disneyland, the aerospace industry, and Hollywood. But the other reality behind Los Angeles was the hardscrabble life of commuting along mile after mile of smog-choked freeways, living in anonymous sprawling bedroom communities, and enduring the constant raucous babble of mass communication. Ruscha is the poet of this faux Eden. His melding of word and image is direct and dryly humorous. As images, his words have the look of being immediately siphoned from popular media. In some cases that may be true: the *Annie* paintings pay homage to the Sunday newspaper comic *Little Orphan Annie*. But it is also true that Ruscha's word paintings are invented. They are like fragments of overhead conversation, some tidbit from the world of print media, or a greeting card's throwaway line, at odds with the very air in which they seem to float.

Pop Art was less of a dominant presence in Northern California, where in the early 1960s Thiebaud was developing into a very competent realist painter. On the surface, his paintings of contemporary foodstuff qualified him for inclusion in many early Pop Art exhibitions. And indeed his subject matter was pure Pop: creamy decorated cakes, gumball machines, and hot dogs, the food items

fig. 101. Phillip Hefferton, *The White House*, 1963, oil on canvas, 84 x 108 in. (213.4 x 274.3 cm), collection of Robert A. Rowan, Pasadena.

odd appearance, as if it originated in chinaware patterns or book jacket illustrations for obscure and wacky nineteenth-century novels. A work such as *T.R. #1 and T.R. #2* (1964, pl. 38) evokes a poster assignment for twentieth-century American history in which the artist's imagination and sense of humor have taken great liberties with the material. Wesley's art tended to both amuse and frustrate his critics, one of whom commented at the end of his review of an exhibition, "Wesley's peculiar brilliance is that he makes it silly to talk about his work in art critical terms."[41]

The year 1962 saw Pop Art clearly established in the United States. At that point the American artists now considered to be the movement's originators had fully matured into their signature styles, and important precursors like Johns and Rauschenberg had assumed the status of recent American masters. Other interesting American artists, including Jess, Ray Johnson, and Rivers, were being assessed as important but not central to Pop Art's agenda—their work was deemed too personal and expressive to qualify. And artists more closely associated with Happenings on the East Coast and Assemblage on the West Coast were taking Pop Art's exploration of popular culture into realms of even more arcane sign systems and visual poetry.

American paper currency by Robert Dowd and Phillip Hefferton, two artists originally from Detroit who came to Los Angeles in the early 1960s, are another case in point. (Dowd, who was the more straightforward of the two, also did a series of paintings around United States postage stamps.) In these works, both artists accepted the inherent compositional design of American money, though they often altered the lettering with misspellings (fig. 101). Hefferton's paintings of the presidential portraits within the bill's ovals were also subject to humorous alterations: George Washington is shown sinking out of the cameo frame in *Sinking George* (1962, pl. 21), and Abraham Lincoln appears, tilting his head and flashing us a wink, in *Winkin' Lincoln* (1963). While Hefferton's money paintings tended to be much larger than Dowd's, up to seven by eight feet, the paint application by both artists was brushy and textured, and in Hefferton's case it exhibited a certain crudeness, not unlike what one would expect to find in the work of a self-taught sign painter.

If Thiebaud is considered as having the subject matter right for Pop Art but the painting method wrong, then John Wesley reversed that characterization. Wesley was born in Los Angeles and during the 1950s worked in the aircraft industry, first as a riveter, then for Northrup Aircraft as an illustrator. In 1960 he moved to New York and began to quietly develop his idiosyncratic paintings. Wesley's flat, opaque, coloring book-like presentation shares with Lichtenstein's work a cooled out approach to paint application. Where Wesley veered from Pop, however, was in his iconography, none of which was derived from mass communication. Wesley's invented imagery has an

fig. 102. Roy Lichtenstein, *Keds*, 1961, oil on canvas, 48½ x 34¾ in. (123.2 x 88.3 cm), private collection. Photograph by Rudolph Burckhardt.

fig. 103. Title page of Roy Lichtenstein article, *Life* magazine (January 31, 1964).

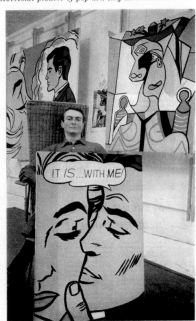

Also in 1962 *Artforum* magazine began publication, first in San Francisco, then in 1965 in Los Angeles, occupying an office on La Cienega Boulevard above Ferus Gallery. The magazine was extremely important in building links between West and East Coast artists, and it offered early exposure and criticism of Pop Art. The competitive spirit of the times produced natural rivalries among both artists and gallery dealers. In particular, the West Coast artists, well aware of how myopic portions of the New York art world had become, tended to pride themselves on being aloof and independent. Nonetheless, there was much respect between individual artists on the different coasts. On a return trip from Europe in 1961, Ruscha stopped in New York and visited Leo Castelli Gallery, where Ivan Karp showed him Lichtenstein's painting of tennis shoes, *Keds* (1961, fig. 102), that greatly impressed the younger California artist.[42] Dine met Bengston when he came to New York to see John Chamberlain's exhibition at Martha Jackson Gallery in 1962 (Bengston himself was to exhibit at Martha Jackson Gallery in May the same year); Bengston impressed Dine as being a bit older and sharper, about both his art and his career.[43]

In September 1962, the Pasadena Art Museum organized "New Painting of Common Objects," the first Pop Art exhibition in an American museum. Curator Hopps invited three New York artists—Dine, Lichtenstein, and Warhol—to exhibit along with five West Coast artists—Dowd, Goode, Hefferton, Ruscha, and Thiebaud. Three works by each artist were included.

Two subsequent and important Pop Art exhibitions that came to the West Coast in 1963 were Lawrence Alloway's two-part exhibition "Six Painters and the Object" and "Six More," shown simultaneously at the Los Angeles County Museum of Art, and Coplans' "Pop Art USA," which was shown at both the Oakland Art Museum and the California College of Arts and Crafts, also in Oakland. "Six Painters and the Object" originated at the Solomon R. Guggenheim Museum (March 14–June 12, 1963) and included work by Dine, Johns, Lichtenstein, Rauschenberg, Rosenquist, and Warhol. When Alloway brought the exhibition to Los Angeles (July 24–August 25, 1963), he added six California artists; joining the New York artists in "Six More" were Bengston, Goode, Hefferton, Ramos, Ruscha, and Thiebaud. Alloway was extremely important to the Pop Art movement, both in Britain and in America, possessing a great understanding of the issues Pop Art addressed and what the movement meant internationally.

Coplans' "Pop Art USA" (September 7–29, 1963) was more of a large-scale survey and included forty-eight American artists, represented by one work each.

What no one could have known at the time was how big a splash American Pop Art would make in the public's imagination. Pop Art in America was never an artist-driven movement. In fact, it was scarcely a movement at all, in any conventional sense, only settling into the name "Pop Art" after laboring under other titles such as "Commonism," "neo-Dada," and "New Realism." By 1963, however, American Pop Art had been ingrained into the art world's imagination, resulting in a flood of Pop Art exhibitions in galleries and museums, as well as the development of a second wave of Pop Art collectors. By January 1964, when *Life* magazine published an article on Lichtenstein titled "Is He the Worst Artist in the U.S.?"[44] (fig. 103), Pop artists were already developing their art beyond the confining labels that popular culture and the art world were assigning to them.

Although American Pop Art grew directly out of the experience of its two dominant cities, New York and Los Angeles, many of its leading artists originally came from the Midwest. Indiana changed his surname to reflect the state of his birth. Rosenquist was born in North Dakota, and Oldenburg was raised in Chicago. Warhol was raised in Pittsburgh, which arguably had more in common with Dine's and Wesselmann's Cincinnati than it did with New York. On the West Coast, Hefferton and Dowd are from Detroit, Bengston from Kansas, and Goode and Ruscha from Oklahoma. It is pure conjecture to suggest that being raised in middle America led to one's development as a

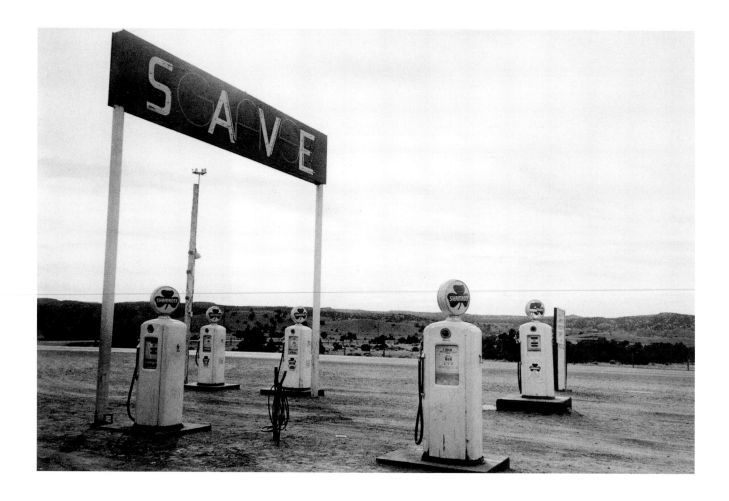

fig. 104. Robert Frank, *Santa Fe, New Mexico*, 1955, gelatin-silver print, 8¾ x 12⅞ in. (22.2 x 32.7 cm), The Museum of Fine Arts, Houston, Target Collection of American Photography, Museum purchase with funds provided by Target Stores.

Pop artist later on, but much of the flavor of American Pop had to do with the sameness that mass communication preached as a way of lifting everyone's standard of living. The American artists producing Pop Art recognized the societal changes beginning to occur all around them, and the best of American Pop Art was able to articulate what was most positive, as well as negative, about the United States at mid century. What separated New York from Los Angeles was the country's vast middle, and the highways that linked the East and West Coasts traced a landscape that in itself looked a lot like Pop Art (fig. 104).

Warhol made his first cross-country road trip in October 1963 to attend his second one-person exhibition at Ferus Gallery in Los Angeles. While there, he also attended the opening of Duchamp's retrospective at the Pasadena Art Museum and visited an Oldenburg exhibi-

tion at Dwan Gallery. Warhol had already turned to the exclusive use of silkscreening, and his Ferus Gallery exhibition featured silver paintings of Elvis Presley and Liz Taylor. Warhol's account of his cross-country road trip conjures up the image of one of Allan D'Arcangelo's highway sign paintings—typically flat silhouettes of fields, trees, and road signs bordering a highway that points toward the horizon—even as it acknowledges the confluence of East and West Coast Pop Art:

> The farther West we drove, the more Pop everything looked on the highways. Suddenly we all felt like insiders because even though Pop was everywhere—that was the thing about it, most people took it for granted, whereas we were dazzled by it—to us, it was the new Art. Once you "got" Pop, you could never see a sign the same way again. And once you thought Pop, you could never see America the same way again.[45]

NOTES

1. John Coplans, *Pop Art USA*, exh. cat. (Oakland, Calif.: Oakland Art Museum, 1963), p. 10.

2. Lucy R. Lippard, *Pop Art* (New York and Washington, D.C.: Praeger, 1966), p. 69.

3. Lippard, *Pop Art*, p. 69.

4. Nancy Marmer, "Pop Art in California," in *Pop Art* by Lucy Lippard (New York: Praeger, 1966), p. 140.

5. Steven Henry Madoff, ed., *Pop Art: A Critical History*, The Documents of Twentieth-century Art (ed. Jack Flam) (Berkeley, Los Angeles, London: University of California Press, 1997), p. xviii.

6. Madoff, *Pop Art*, p. xviii.

7. Jim Dine, quoted in *Jim Dine: Walking Memory 1959–1969*, exh. cat. (New York: Solomon R. Guggenheim Museum, 1999), p. 66.

8. Claes Oldenburg, quoted in *Claes Oldenburg: An Anthology*, exh. cat. (New York: Solomon R. Guggenheim Museum, 1995), p. 42.

9. See Martin Duberman, *Black Mountain, An Exploration in Community* (New York: E. P. Dutton, 1972).

10. See Juan Marter, ed., *Off Limits, Rutgers University and the Avant-Garde 1957–1963*, exh. cat. (Newark, N.J.: Newark Museum and Rutgers University Press, 1999). Not only is this an excellent source for the early involvement of Rutgers faculty in the evolution of Happenings, but it also provides information on George Segal and Lichtenstein, who were also teaching at Rutgers and beginning to develop sculpture and paintings that were important in the evolution of Pop Art.

11. Claes Oldenburg, quoted in *Blam! The Explosion of Pop, Minimalism and Performance, 1958–1964* by Barbara Haskell, exh. cat. (New York: Whitney Museum of American Art, 1984), p. 43.

12. Oldenburg, *Claes Oldenburg: An Anthology*, p. 36. This process was an elaboration upon an idea that came to him several years earlier while he was working in the library stacks at Cooper Union, finding here a children's book on papier-mâché.

13. Sidney Tillim, quoted in Haskell, *Blam*, p. 71.

14. Alan Solomon, quoted in Madoff, *Pop Art*, p. 307.

15. The art critic Rene Richard followed Drexler and me into the gallery at 25 Thompson Street on March 23, 2000. A regular at the Andy Warhol Factory, Richard had heaped praise upon Drexler's work, making a connection between her collage paintings and the early Pop of Warhol and collages by Al Hansen. "Rosalyn Drexler 'I Won't Hurt You' Paintings 1962–1999" opened at the same time that Drexler's more recent paintings were being shown at Nicholas Davies Gallery in Greenwich Village.

16. Sam Hunter, *Tom Wesselmann* (Barcelona: Ediciones Poligrafa, S.A., 1995), p. 21.

17. Thomas H. Garver, *Tom Wesselmann: Early Still Lifes: 1962–1964*, exh. cat. (Newport Beach: Newport Harbor Art Museum, 1970). According to Garver, Wesselmann would write ten to twenty letters a week to various companies in quest of clean, unused, outsized collage material, unpaginated.

18. Judith Goldman, *James Rosenquist*, exh. cat. (Denver: Denver Art Museum, 1985), p. 24.

19. Mildred Glimcher, *Indiana, Kelly, Martin, Rosenquist, Youngerman at Coenties Slip*, exh. cat. (New York: The Pace Gallery, 1993), p. 8.

20. See Goldman, *James Rosenquist*, p. 36.

21. Lippard, *Pop Art*, pp. 121–22.

22. Robert Indiana, quoted in *Robert Indiana* by John W. McCoubrey, exh. cat. (Philadelphia: Institute of Contemporary Art, 1968), p. 9.

23. Daniel E. O'Leary, "The Journals of Robert Indiana," excerpted in *Love and the American Dream: The Art of Robert Indiana*, exh. cat. (Portland, Maine: Portland Art Museum, 1999), p. 16. "Studio visit: Andy Warhol and John [Ardoin] and Norman [Fisher]. Having never heard of *I Ching* I gave him a reading. Watched 'Godot' again. Dinner for Andy, John and Norman—A red spread on my work table" (April 4, 1961).

24. Robert Indiana, quoted in *Towards an Immobile Voyage: Robert Indiana, the Reality Dreamer* by Hélené Depotte, exh. cat. (Nice, France: Musée d'Art Moderne et d'Art Contemporain, 1998), p. 36.

25. See Madeleine Burnside's essay in *Jess*, exh. cat. (New York and San Francisco: Odyssia Gallery and John Berggruen Gallery, 1989). As Burnside has pointed out, "Each *Dick Tracy* strip was cheaply available in quantity, and as the adventures themselves were numerous. It

was possible to achieve a variety of effects without having to look beyond the material offered in the original cartoons," unpaginated.

26. Diane Waldman, *Roy Lichtenstein*, exh. cat. (New York: Solomon R. Guggenheim Museum, 1993), p. 21.

27. John Coplans, ed., *Roy Lichtenstein*, Documentary Monographs in Modern Art (ed. Paul Cumings) (New York and Washington D.C.: Praeger, 1972), p. 23.

28. Adolf Wolfli, the brilliant outsider artist and schizophrenia patient interned at the Waldau Mental Asylum in Bern, Switzerland, included in a 1929 collage drawing a colored reproduction of a Campbell's Soup can that he had lifted from a magazine. It was almost identical in lettering to the same tomato soup labels that Warhol used as models more than thirty years later.

29. John Coplans, quoted in Madoff, *Pop Art*, p. 297.

30. See Christopher Knight, "The Word Made Flesh: L.A. Pop Redefined," in *Art in Los Angeles—Seventeen Artists in the Sixties*, exh. cat. (Los Angeles: Los Angeles County Museum of Art, 1981), p. 25.

31. Walter Hopps, *Assemblage in California: Works from the 50's and Early 1960's*, exh. cat. (Irvine, Calif.: Irvine Art Gallery, University of California, 1968), p. 16.

32. Virginia Dwan's gallery exhibited early Pop-related shows like "My Country 'Tis of Thee" and individual exhibitions featuring Europeans Jean Tinguely, Niki de Saint Phalle, and Martial Raysse, as well as Americans Rivers, Rosenquist, and Samaras.

33. Billy Al Bengston, quoted in "A remembrance of the Emerging Los Angeles Art Scene" by Henry Hopkins, in *Billy Al Bengston—Paintings of Three Decades*, exh. cat. (Houston: Contemporary Arts Museum and Oakland: The Oakland Art Museum, 1988), pp. 43–44.

34. The exhibition "Bengston" was held at Ferus Gallery, 723 North La Cienega Blvd., Los Angeles. It opened on February 15, 1960.

35. See Karen Tsujimoto, *Billy Al Bengston—Paintings of Three Decades*, exh. cat. (Houston: Contemporary Arts Museum and Oakland: The Oakland Museum, 1988), p. 25.

36. Billy Al Bengston, quoted in "Fabulous Confusion! Pop Before Pop?" by Dick Hebdige, in *Hand-Painted Pop: American Art in Transition 1955–62*, exh. cat. (Los Angeles: Museum of Contemporary Art, 1992), p. 210.

37. Edward Ruscha, *Joe Goode*, exh. cat. (Newport Beach, Calif.: Orange County Museum of Art, 1997), p. 9.

38. Edward Ruscha, quoted in "An Interview with Ed Ruscha," in *Provocations: Writings by John Coplans* (London: London Projects, 1996), p. 40.

39. Ruscha, quoted in *Provocations*, p. 39.

40. Robert Rosenblum, *Mel Ramos: Pop Art Images* (Cologne: Taschen, 1997), p. 18.

41. Carter Ratcliff, "New York Letter," *Art International*, vol. 19, no. 10 (December 20, 1975), p. 42.

42. From the chronology compiled by Miriam Roberts, edited by Anne Livet, in *The Works of Edward Ruscha*, exh. cat. (San Francisco: San Francisco Museum of Modern Art, 1982), p. 159.

43. Dine, quoted in *Jim Dine: Walking Memory*, p. 140.

44. *Life* (January 31, 1964), pp. 79–83.

45. Andy Warhol and Pat Hackett, *POPism: the Warhol '60s* (New York: Harcourt Brace Jovanovich, 1980), p. 39.

**Plates and
Catalogue Commentary**

1. **Richard Hamilton**
British, b. 1922
London

Richard Hamilton
British, b. 1922
London

Just what is it that makes today's homes
so different, so appealing?
1988 (facsimile of 1956 original)

Cibachrome
10¼ x 9⅞ in. (26 x 25 cm)
Collection of the artist

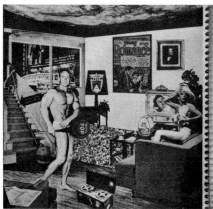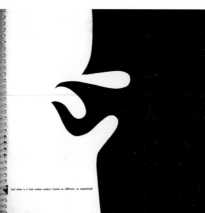

fig. 105. Richard Hamilton,
two-page spread from
exhibition catalogue *This Is
Tomorrow* (1956), Whitechapel
Art Gallery, London.

One of the most famous and reproduced images of Pop
Art, the original collage was made for use as a cata-
logue illustration and poster (figs. 105, 138) for the
1956 "This Is Tomorrow" exhibition held at White-
chapel Art Gallery, London. The title came, as often
occurs with Hamilton, from popular media, in this
case a discarded piece of magazine text.

Many of the collage components were culled from
the magazines that John McHale brought back from
America. This small work is shot through with visual
puns: the carpet is a long-distance view of people on a
beach, and the ceiling is a view of the curvature of the
earth seen from space. (Hamilton's own categories for
elements in the collage were: "Man, Woman, Humanity,
History, Food, Newspapers, Cinema, TV, Telephone,
Comics, Words, Tape recording, Cars, Domestic appli-
ances, Space.")[1]

The prominent word "Pop" on the Tootsie Pop that
the new Adamic man holds was anticipated by Eduardo
Paolozzi in his 1947 collage *I Was a Rich Man's Play-
thing*. Hamilton here covered all the bases of modern
communications systems: information is transmitted and
received through print, logos, television, films, photogra-
phy, reproductions, telephones, and tape recorders—an
anthology of the creeping influences of the information
age on modern life.

John Russell wrote of this work:

> Our English way is by contrast [to the American artists]
> aloof, distanced, oblique. . . . English people examine ideas
> that purport to be new. Hamilton in 1956 was engaged in a
> revolutionary act: nothing less than the overthrow of that
> hierarchy of preoccupations which had been accepted in
> art for as long as anyone could remember. But in terms of
> method his approach has always been that of the lock-
> smith, not that of the dynamiter; and in this case he worked
> so subtly that even now, after seventeen years, we are still
> finding new pockets of meaning in this little picture.[2]

page 110. Joe Tilson working
on *Key Box* (1963) in his
studio, London, 1963.
Photograph by Tony Evans.

page 111. James Rosenquist
atop his Zippo Lighter billboard
painted for the Artkraft Strauss
Company, Times Square, New
York, summer 1961. Photograph
by Robert Freeman.

1. Richard Hamilton, *Richard Hamilton: Collected Words, 1953–1982*
(London: Thames and Hudson, 1982), p. 24.
2. John Russell, "Introduction," in *Richard Hamilton*, exh. cat. (New
York: Solomon R. Guggenheim Museum, 1973), pp. 10–11.

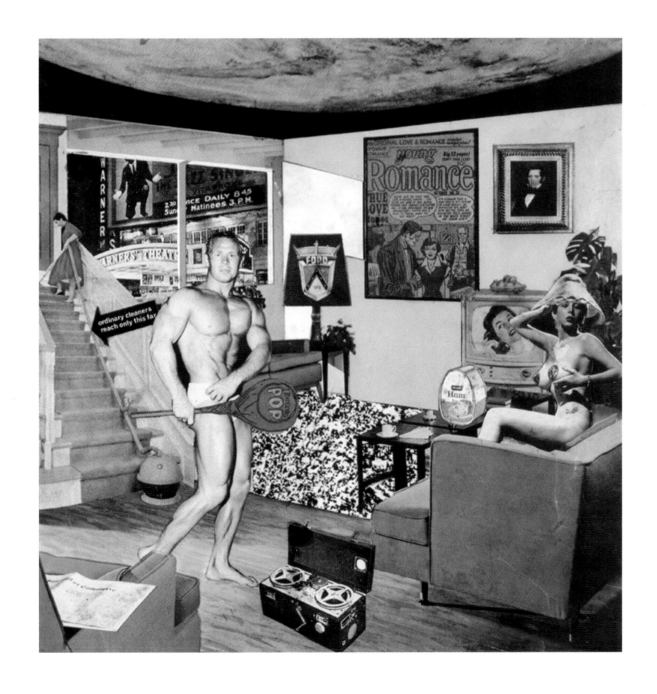

2. **R. B. Kitaj**
American, b. 1932
Cleveland, Ohio
Worked in London

Tarot Variations
1958

Oil on canvas
43 x 33⅞ in. (109.2 x 86 cm)
High Museum of Art, Atlanta. Purchase with J. J. Haverty
Memorial Fund for the J. J. Haverty Collection, 68.7

According to Kitaj, he was inspired by T. S. Eliot's poem "The Waste Land" (1922) "to place abstract images abreast...as if they were poetic lines on a page.... Some few early modernist poets had arranged words to resemble pictures or designs and I began to think I could do the reverse for art: to lay down the pictures as if they were poems to look at."[1] *Tarot Variations* takes its title from Eliot's "Notes on 'The Waste Land.' "

Almost any section of Eliot's prismatic poem might be extracted to compare with Kitaj's process:

> And I will show you something different from either
> Your shadow at morning striding to meet you
> Or your shadow at evening rising to meet you:
> I will show you fear in a handful of dust.[2]

Kitaj's painting is the first major work in which he entered into a dialogue with modern writing, in this case two other American expatriates, Eliot and his editor Ezra Pound, themselves linked by country and friendship and later separated by war and politics—all perennial issues in Kitaj's thinking. Kitaj's enormous influence, not only on many of his contemporaries at the Royal College of Art but extending far beyond, was in showing how ideas from any field of investigation could be transformed into images. This concept is now so much a part of late modernism that the daring of it at the time is dimmed.

Technically, this relatively early work experiments with episodes of contained activity, somewhat tightly sequestered within the four compartments, none quite the same dimensions as the others. The sequence of numbers takes us clockwise from upper left to lower left, the terminal areas being unnumbered, save for a clock face showing the time. In two of the compartments figuration is clear, while in the others it is only suggested. Linear drawing mixes with scumbled and dragged areas of paint, with a fair presence of stained and dripped marks. Overall it evokes the shifting in and out of focus of Eliot's method and becomes itself a subtle new form of visual poetics.

1. R. B. Kitaj, quoted in Jerome Tarshis, *R. B. Kitaj*, exh. cat. (New York: Rizzoli, 1994), p. 70.
2. T. S. Eliot, "The Waste Land" (Second Section: I. The Burial of the Dead), 1922; in *The Complete Poems and Plays of T. S. Eliot* (London: Faber & Faber Limited, 1969), pp. 611–62.

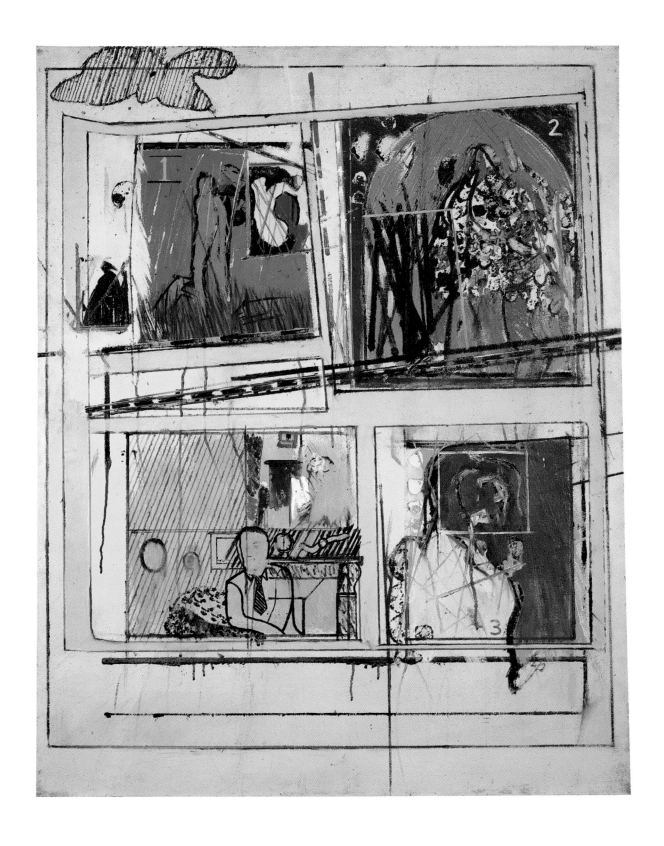

3. **Peter Blake**
British, b. 1932
Dartford, Kent, England

Everly Wall
1959

Paper, printed reproductions, wood, oil, and ink on Masonite
36 x 24 in. (91.4 x 61 cm)
Collection of Terry Blake

fig. 106. Sheet music for the Everly Brothers' *Cathy's Clown* (1959).

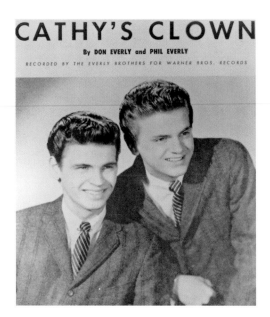

In 1959 Blake's technique and subject matter underwent changes that brought his work fully in line with Pop Art, and he made several of his most familiar works, including *Kim Novak Wall, Sinatra Door,* and *Everly Wall* here. From early on, Blake was interested in various aspects of popular culture and urban folk art, and he collected innumerable objects, images, photographs, and toys that in time were subsumed in a wide variety of collaged and assemblaged works, often used with areas of paint. His favorite sources of American popular culture were movies and rock and roll. As for American art, Blake later said, "I don't think I was ever influenced by Warhol or Lichtenstein, I'd done my things earlier or parallel to them. The only people I admit a debt to are Johns and Rauschenberg in the late '50s."[1]

The title of this work refers to a pair of the first and most enduringly popular of the American rock and roll performers to tour Britain: The Everly Brothers. Their first hit song, "Bye Bye Love" (1957), was a fusion of country-western music and early rock and roll. Subsequent songs like "When Will I Be Loved" and "Wake Up, Little Susie" prepared the way for "Cathy's Clown," their greatest hit—it sold over two million copies. After 1962, however, Don and Phil Everly never had another Top Ten success.

Blake's work is in the spirit of an homage. The row of photographs of the two brothers is from the same studio shoot that produced the photo used on the cover of their song sheet of "Cathy's Clown" (fig. 106), although Blake did not use the cover photograph with the same pose in his collage painting. In the lower part of the work, a lozenge-shaped piece of paper bears the Everly Brothers' autographs, added in 1983 when the singers met Blake's brother, Terry, the work's owner. The use of collaged photographic imagery over a painted imageless area and the personal nature of the piece make this work a particularly "pure" example of British Pop Art.

1. Peter Blake, quoted in "Thirty Years On," by Andrew Lambirth, *The Royal Academy Magazine: RA,* Special Pop Issue, no. 32 (Autumn 1991), pp. 32–38.

4. **Billy Al Bengston**
American, b. 1934
Dodge City, Kansas

Gas Tank and Tachometer II
1961

Oil on canvas
42 x 40 in. (106.7 x 101.6 cm)
Collection of the artist

Somewhat atypically for Bengston, the motorcycle equipment in this painting is rendered in a pronounced representational manner. His series of paintings of motorcycle parts was created when Bengston had the sudden opportunity to exhibit at Ferus Gallery in Los Angeles in November 1961. By isolating the motorcycle parts, whether the tank and tachometer in this case, or the carburetor or gearbox in other paintings, Bengston approached his subjects as factually as possible. But unlike the machine parts that Francis Picabia adopted for purposes of Dada disorientation, Bengston's motorcycle parts are purely and even lovingly portrayed. They are also as close to "pure" Pop as Bengston would get. Following his exhibition at Ferus Gallery, he moved on to more abstract, emblematic oil and lacquer paintings on Masonite and aluminum.

5. **Billy Al Bengston**
American, b. 1934
Dodge City, Kansas

Birmingham Small Arms I (B.S.A.)
1961

Oil on canvas
34½ x 37 in. (87.6 x 94 cm)
Collection of the Orange County Museum of Art, Newport Beach,
California. Gift of Dr. and Mrs. Merle S. Glick

In this oil painting, the golden halo around the motorcy-cle insignia mimics the radiant luminosity of the sprayed lacquer paintings that Bengston would produce in the early 1960s. A master technician, even in this early phase of his career, Bengston created this work as a trib-ute to the BSA motorcycle that he had recently pur-chased. The heraldic BSA logo, which is centrally located within Bengston's composition, is not as commonly rec-ognizable as, say, a Campbell's Soup can, nor is it as dis-passionately rendered as one of Andy Warhol's works. Although *Birmingham Small Arms I (B.S.A.)* is associ-ated with Pop Art by virtue of its subject, it is more of a precursor to the oil and spray lacquer paintings that Bengston was to do from 1962 on, which were more ab-stract and clearly not Pop in orientation.

6. **Derek Boshier** Situation in Cuba Oil on canvas with artist-made wood frame
British, b. 1937 1961 13 x 20 in. (33 x 50.8 cm)
Portsmouth, England Collection of the artist

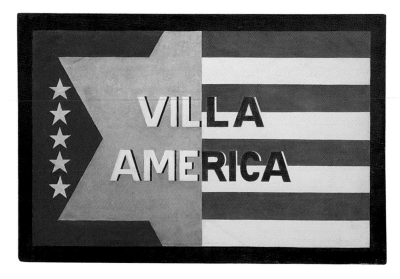

fig. 107. Gerald Murphy, *Villa America*, 1922, tempera and gold leaf on board, 14½ x 21½ in. (36.8 x 54.6 cm), private collection, courtesy Curtis Galleries, Minneapolis.

One of Boshier's early sixties paintings using formal devices such as maps, board games, and flags, this work reflects the artist's interest in both the Cuban Revolution and Fidel Castro's confrontation with the United States. The fall of Fugencio Batista y Zaldívar and Castro's establishment of a communist regime in Cuba were greeted with enthusiasm by many western liberals and intellectuals who still felt that socialism held out a better future than an American-led capitalism. With Russian communism discredited and the Chinese experiment too remote, the Cuban example had romantic appeal: Castro and Che Guevara looked like "real" revolutionaries, and there were true villains and true heroes, seen from a certain perspective. The disastrous Bay of Pigs action on April 17, 1960, only intensified those feelings.

This little painting by Boshier echoes the prevailing anti-American sentiment, showing the Cuban flag being encroached upon by the American Stars and Stripes. Gerald Murphy was among the first artists to introduce a flat uninflected American flag as subject matter for fine art (fig. 107). As with the flag paintings of Jasper Johns a few years earlier than Boshier's (available in Britain only through reproductions), Boshier played on the visual pun of the flatness of the flag imagery, but the message of the painting clearly points toward the political situation of the moment. Several other Pop artists would refer to the Cuban situation in their work, including Robert Indiana's *Cuba* (1961) and Pauline Boty's *Cuba Si!* (1963). Still, Boshier was notable for approaching his subject matter less to celebrate the obvious aspects of popular culture or icons of mass media than to investigate the causes and effects of American cultural influences.

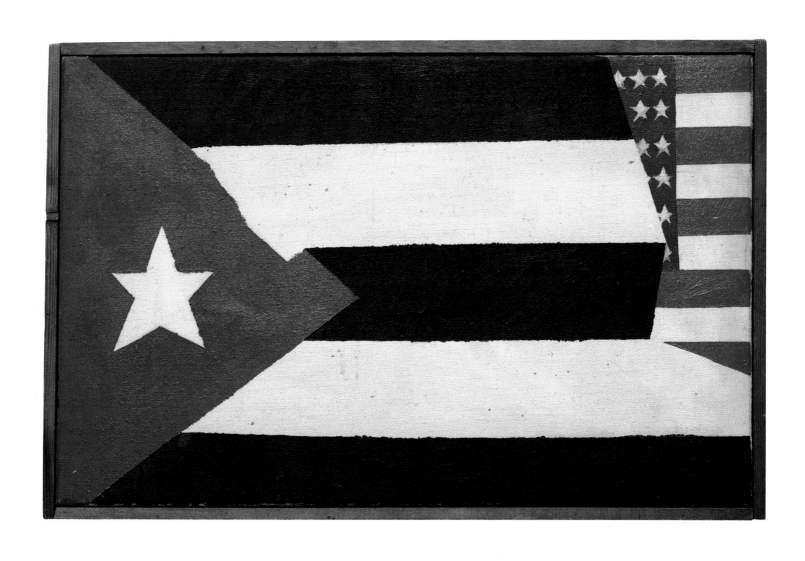

7. **David Hockney**
British, b. 1937
Bradford, England

I'm in the Mood for Love
1961

Oil on board
48 x 36 in. (122 x 91.5 cm)
Royal College of Art Collections, London

Hockney's early paintings have been occluded, perhaps not surprisingly, by his California works. So closely is the artist identified with Los Angeles and its hedonistic life style that the darker, gestural nature of his earlier work seems merely to exist as a shadowy prologue to sunlight. Much of what survives of Hockney's earliest paintings has the typical dark tones of the Kitchen Sink painters, though after Hockney enrolled in the Royal College of Art (RCA), his drab works gave way to a new technical openness, gesturalism, and color. This was paralleled by an even more dramatic openness in his subject matter, namely his homosexuality. The example of Francis Bacon and the encouragement of R. B. Kitaj to pursue the most personal of interests assisted in the development of these works of Hockney's early maturity.

The period when this painting was completed, 1960–61, was a particularly important and fertile one during which Hockney achieved a technical and expressive unity. His first visit to New York in the summer of 1961 was revelatory, and by the time Hockney arrived back in London for the fall semester at RCA, he was ready to begin a new series of paintings. *I'm in the Mood for Love* is a major work of that fall. A bespectacled Hockney, horned like a satyr, stands between two phallic skyscrapers in one of the last major dark paintings by the artist. Words and graffiti from New York subways appear—"No Smoking," "New York"—as does the countdown to his arrival: "July 7, 8, 9 then NYC 10."[1] Along the artist's outstretched and pointing arm is the direction "to Queens uptown," with its double entendre, below which we see a valentine heart. The painting originally had a souvenir button from New York attached to it that read "I'm in the Mood for Love," but it was later stolen.

By the end of that fall, Hockney's gestural style would give way to the use of thin, stained paint on unprimed canvas, introducing a cooler, more open format.

1. July 9 is Hockney's birthday.

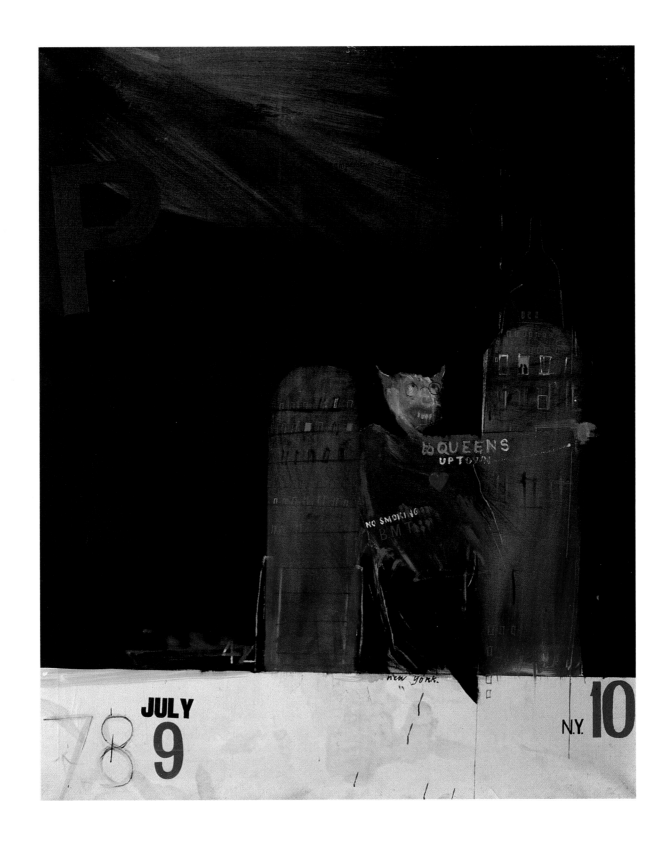

8. **Jim Dine**
American, b. 1935
Cincinnati, Ohio

Flesh Tie
1961

Oil on canvas with fabric necktie
22 x 16 in. (56 x 40.6 cm)
Collection of Jasper Johns

Dine has always been a prolific painter who throughout his career tended to work in sets, producing a series of works on similar subject matter. In 1961 he focused on a group of similar sized paintings, each canvas accomodating the length of a man's knotted tie. *Flesh Tie* was painted during the same year as *Orange Tie* and *A Tie in a Red Landscape*: all three paintings are small-scale, single-image collage works. By applying heavy coats of paint directly upon a tie that has been collaged to the canvas, Dine melded the object with the painting—in a sense, they become one and the same thing.

It is Dine's straightforward response to the tie as object in *Flesh Tie* that gives the painting its Pop Art reference. Although Dine's very physical approach to painting is at odds with Pop Art's cooler mannerisms, *Flesh Tie* is emphatically an object painting. Yet its extremely expressive paint handling contributes to the illusion that the collaged tie was formed out of the act of painting itself: "flesh" is a paint color as well as an indication of replicated skin.

Dine has always placed his trust in objects as things in and of themselves. His tie paintings were immediately followed by paintings of tools, rooms, and artist palettes. The forms of the objects that Dine paints also have other associations, and when asked in a recent interview what the tie represents to him, Dine responded by saying, "What did occur to me was that the tie was a vaginal form."[1]

1. Jim Dine, quoted in *Jim Dine: Walking Memory 1959–1969* (New York: Solomon R. Guggenheim Museum, 1999), p. 114.

127

9. **Peter Phillips**
British, b. 1939
Birmingham, England

War/Game
1961

Oil and newspaper on four canvases with wood
85½ x 61⅝ in. (217.2 x 156.5 cm)
Albright-Knox Art Gallery, Buffalo, New York.
Gift of Seymour H. Knox, Jr., 1964

fig. 108. Larry Rivers, *The Last Civil War Veteran*, c. 1960, oil on canvas, 33½ x 26⅜ in. (85.1 x 67 cm), private collection, Houston.

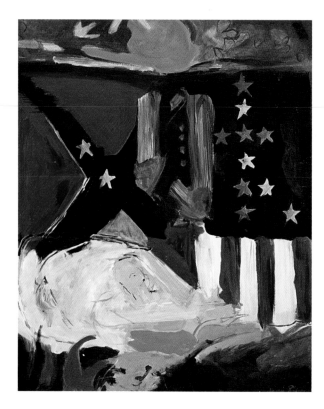

This work based on comic strip imagery culled from American magazines is one of the few paintings that Phillips admits to having a specific theme: the American Civil War, which was being commemorated in America at this time. A series done by Larry Rivers from 1959 into the early 1960s concerning the last living Civil War veteran employs related imagery (fig. 108). There is a strong element of satire in Phillips' work, yet its formal aspect is consistent not only with other works by Phillips from this period, but with the frontal, flat, heraldic imagery—combined with figurative imagery, whether comic strip or photographic—that appeared in so much Pop work of the time. Phillips later recalled that period in the early sixties: "I was very interested in what I called 'game formats.'… A big image subdivided into little pictures. I had a lot of comic strips, but I wasn't conscious that this was anything particularly important. To me nobody had done it, so I thought I'd just stick it in, paint a comic strip."[1]

Technically, *War/Game* was created from a variety of different processes: black gloss paint smoothed down with a pumice stone as well as areas of matte paint, waxed paint, and polished paint. The images in the uppermost row were painted on separate canvases, united by strip frames of polished wood (Phillips' father was a carpenter). The methods of construction and of painting became integral to the whole work.

In the late fifties and early sixties, it was still possible in British art schools to take a course on the subject of heraldry as Phillips did. Heraldic imagery was, in its age and time, what the corporate logo became in the modern period, a fact that was not lost on many British artists. Heraldic forms were easy to connect to contemporary imagery, not only of the corporate world but in aspects of contemporary art, most notably in the paintings of Kenneth Noland, both familiar and influential in the London scene. As Pop Art does, heraldry deals in flat colors, hard-edge imagery, and the incorporation of virtually any figure into the shield. For Derek Boshier, Gerald Laing, and Phillips, heraldic elements were an active and conscious part of their works.

1. Peter Phillips, quoted in *Retrovision: Peter Phillips Paintings, 1960–82,* exh. cat. (Liverpool: Walker Art Center, 1982), pp. 19–22.

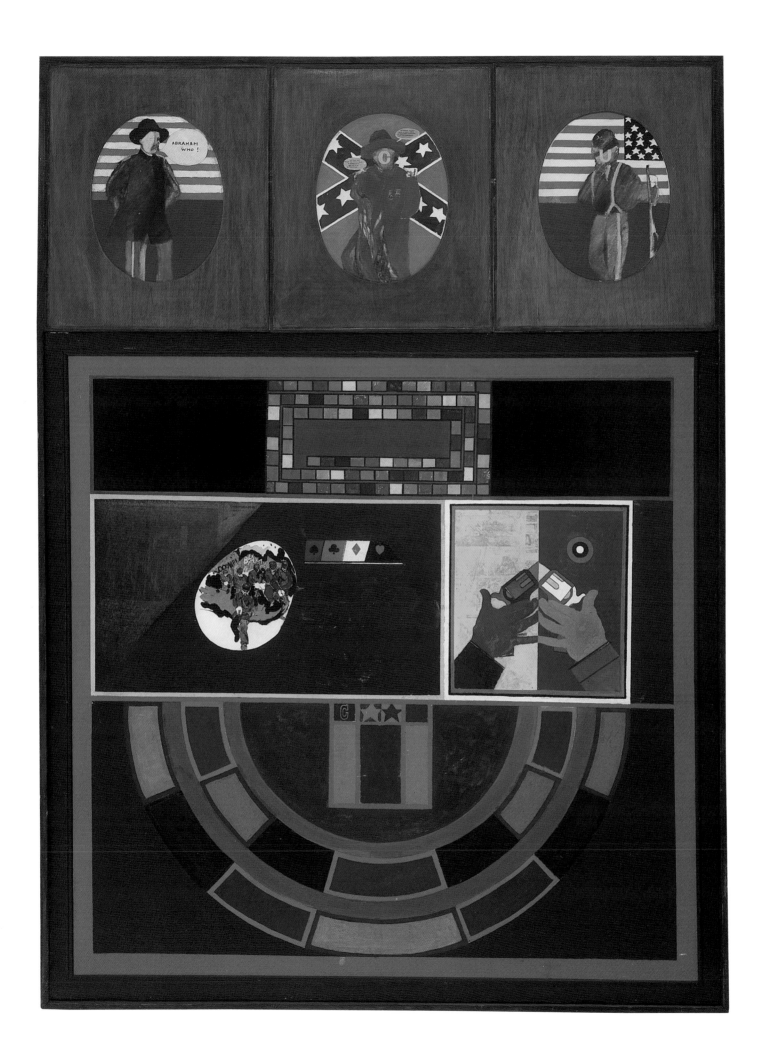

10. **Roy Lichtenstein**
American, 1923–1997
New York City

Mr. Bellamy
1961

Oil on canvas
56¼ x 42⅛ in. (143 x 107 cm)
Collection of the Modern Art Museum of Fort Worth. Museum
Purchase, The Benjamin J. Tillar Memorial Trust, Acquired from
the Collection of Vernon Nikkell, Clovis, New Mexico, 1982

This depiction of the potential confrontation of a military officer on his way to a meeting also serves as an art world in-joke. The "Mr. Bellamy" of the officer's speech balloon refers to Richard Bellamy of New York's Green Gallery, an early supporter of Pop Art. Lichtenstein's cartoon images are derived from the world of adventure and war comics, and *Mr. Bellamy* is his adaptation of the newspaper comic *Steve Roper* by William Overgard. But as in all of Lichtenstein's early works featuring macho comic heroes, he took great liberty in the speech balloon's narrative.

Mr. Bellamy also provides an example of Lichtenstein's early use of the tonal effects achieved with benday dots, visible on the officer's face, in the sky out the window, and in several spots on the figure's cap and jacket. Lichtenstein was to become much more adept in the use of the benday dots in his later romance comic works of 1963–65, as well as more lyrical in his use of line. However, a stiffness in the stylization of this work seems appropriate to the masculine figure and situation that Lichtenstein is depicting.

11. **Roy Lichtenstein**
American, 1923–1997
New York City

Washing Machine
1961

Oil on canvas
55³/4 x 67¹/2 in. (141.6 x 171.5 cm)
Yale University Art Gallery, New Haven, Connecticut.
Gift of Richard Brown Baker, B.A. 1935

fig. 109 Source material for Roy Lichtenstein, *Washing Machine* (1961), from the artist's scrapbook, Estate of Roy Lichtenstein.

This work is part of an informal group of early paintings devoted to the world of the American homemaker. American magazine advertisements of the fifties focused on the kitchen, bathroom, and laundry room as domains of cleanliness and order. Lichtenstein's painting *The Refrigerator* (1962) illustrates a woman cleaning off the food racks of the refrigerator, and in *Spray* (1962, fig. 31) a woman's finger is depressing the nozzle of an aerosol can, disinfecting the air with a spray of mist.

Lichtenstein inserted private jokes into several of his household paintings. In the painting *Sponge II* (1962), a feminine hand swipes a sponge across a flat surface, leaving a path of erased benday dots, suggesting perhaps that Lichtenstein is erasing his signature working process. In *Washing Machine*, based on a printed advertisement (fig. 109), a woman's hand is pouring detergent from a box into a water-filled washer. Whether intentionally or not, the agitated water and soap treated as flat areas of black, white, and yellow seem stylistically to anticipate Lichtenstein's brushstroke paintings of 1965–66.

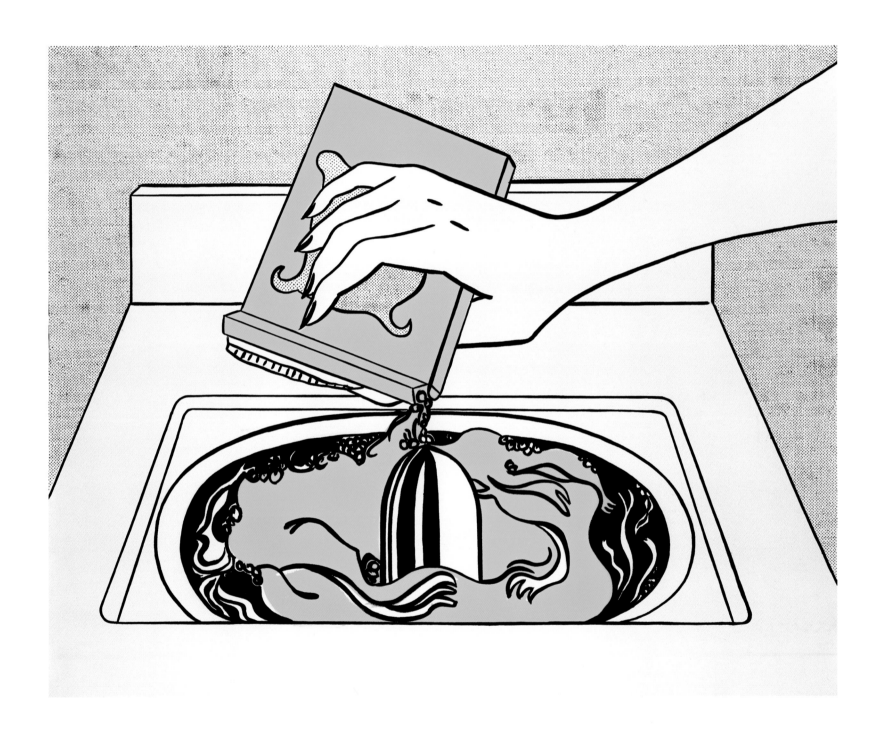

Claes Oldenburg
American, b. 1929
Stockholm, Sweden

Box of Shirts
1962

Canvas filled with foam-rubber, painted with spray enamel,
in painted wood box
13 x 10 x 20 in. (33 x 25.4 x 50.8 cm)
Alice F. and Harris K. Weston

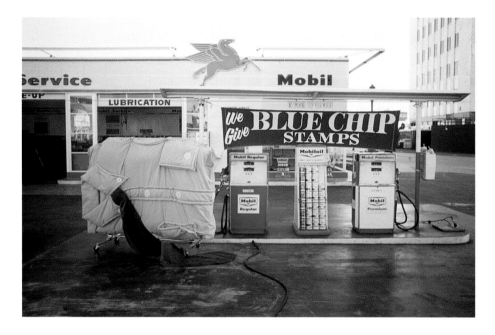

fig. 110. Claes Oldenburg's *Giant
Blue Shirt with Brown Tie* (1963)
at a Mobil Oil service station, at
the time of his performance *Auto
Bodies*, Los Angeles, December 9
and 10, 1963. Photograph by
Dennis Hopper.

Oldenburg's earliest shirt sculptures were made of painted
plaster that had been applied to muslin and stretched
over a wire frame. They were loosely painted with
enamel, giving the otherwise stiff plaster constructions
both color and a softer effect. By 1963 Oldenburg had
begun to broaden his repertoire of materials to include
canvas, fake fur, and vinyl filled with kapok, which he
used to construct not only pliable clothing (such as *Giant
Blue Shirt with Brown Tie* [1963, fig. 110]), but soft
typewriters, light switches, and Good Humor ice cream
bars as well. His *Box of Shirts* here incorporated this
change, making use of the fact that canvas is a fabric that
can be folded and fashioned sculpturally to represent
shirts as easily as it can be stretched over a frame, the
traditional support for a painting. The ensemble of
folded shirts sitting upright in a flatly painted wooden
box as if on a shop counter is one of Oldenburg's most
straightforward Pop Art statements. Their close approxi-
mation in both material and scale to an actual clothing
store's box of packaged shirts, while less humorous than
most of Oldenburg's work, is Pop Art-like in its sem-
blance of a commercial product prepared for consump-
tion.

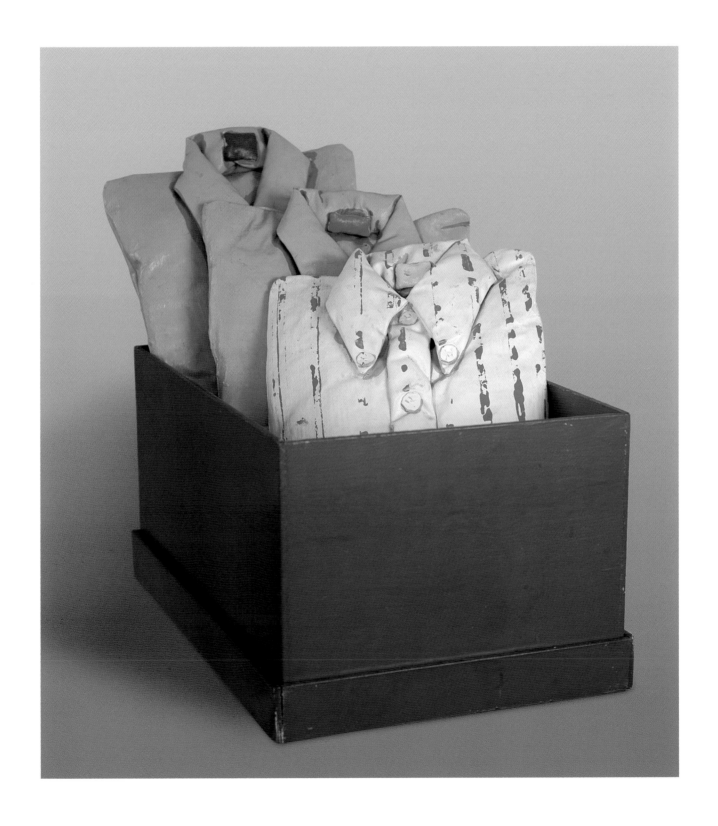

13. **Joe Goode**
American, b. 1937
Oklahoma City, Oklahoma

Happy Birthday
1962

Oil and pencil on canvas with oil on glass milk bottle
67⅛ x 67 x 3 in. (170.5 x 170.2 x 7.6 cm)
San Francisco Museum of Modern Art.
Gift of The Gerard Junior Foundation

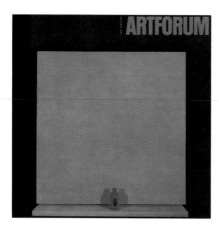

fig. 111. Cover of *Artforum* (November 1962) with Joe Goode, *Happy Birthday* (1962).

Goode exhibited his series of milk bottle paintings in his first solo exhibition at Dilexi Gallery's Los Angeles location in 1962. He began working on the bottle paintings in 1961, and when he finished the series almost two years later, he had completed thirteen works.

It was common even in the 1960s for dairy companies in Southern California to deliver bottled milk right to a customer's doorstep. Goode took advantage of this domestic custom, using the Alta-Dena Dairy Company's glass milk bottles as part of, and an extension to, his paintings. Two of the milk bottle paintings celebrate the birthday of his daughter. Both canvas and bottle in *One Year Old* (1962) are a creamy, light brown color,[1] while *Happy Birthday* contrasts the painting's field of pink with a dark blood-red bottle. The painting commemorates his daughter's second birthday.

Happy Birthday was used as the cover image (fig. 111) for the November 1962 issue of *Artforum* magazine, which included John Coplans' review of the Pasadena Art Museum's exhibition "New Painting of Common Objects."

1. *One Year Old*, oil on canvas and oil on glass milk bottle, 66¾ x 67½ in., Orange County Museum of Art, Newport Beach, California.

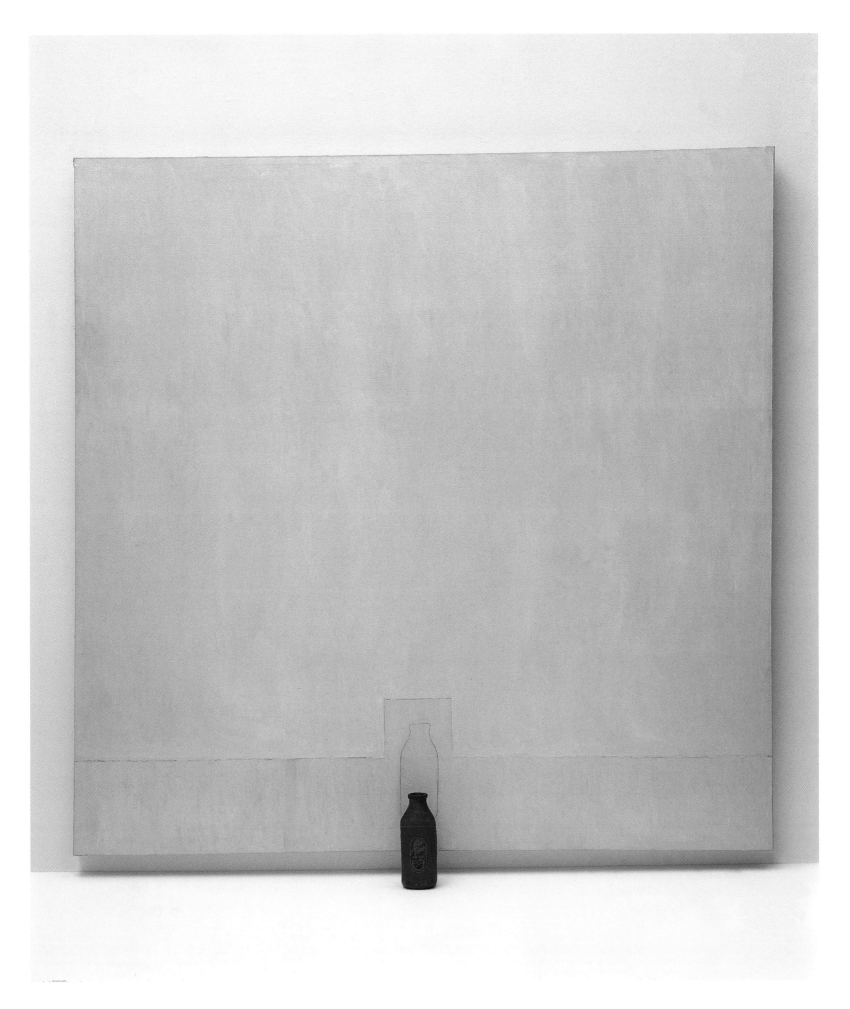

14. **Jim Dine**
American, b. 1935
Cincinnati, Ohio

3 Panel Study for Child's Room
1962

Oil, charcoal, child's rubber raincoat, plastic toys (train, Popeye, car, and gun), metal coathanger, metal hook, and wood on three joined canvases
84 x 72³⁄₈ in. (213.4 x 183.8 cm)
The Menil Collection, Houston

fig. 112. Jim Dine, *Child's Blue Wall*, 1962, oil on canvas with painted wood electric light fixture and switch, 60 x 72 in. (152.4 x 182.9 cm), Albright-Knox Art Gallery, Buffalo, New York, gift of Seymour H. Knox.

In 1963 fellow artist Öyvind Fahlström wrote about Dine's *3 Panel Study for Child's Room*, asking, "Is the imprint of a child's hand on a canvas a 'fact' or an 'object?' Is it an 'event?' Is it a 'popular' or 'vulgar' way of painting?"[1] Fahlström himself was an artist/poet who was fully aware of the power of objects and all that they can symbolize.

3 Panel Study for Child's Room was included in the exhibition "New Paintings by Jim Dine" held at Sidney Janis Gallery on February 4–March 2, 1963. Also in that exhibition was the related work *Child's Blue Wall* (1962, fig. 112), a much simpler mixed-media Assemblage composition: the five by six-foot canvas has an electric light wall switch attached to the left edge and a small shelf holding a lamp made from a toy wooden soldier and castle secured to the bottom righthand corner, while the canvas itself, simulating wallpaper, is painted blue with a field of white stars. The toy lamp in *Child's Blue Wall* actually belonged to Dine's son Jeremy, just as the erector sets and other toys of *3 Panel Study for Child's Room* were "real life" objects that his sons, Jeremy and Matthew, would have had in their own room.

In concluding the catalogue essay for Dine's Janis Gallery exhibition, Fahlström spoke about the trace of an object as a sign of possession, noting that in *3 Panel Study for Child's Room* "[by] imprinting one of his children's hands against the canvas, Dine links to the first painting act, the cave man's supposed discovery of representation, of painting as an act of exteriorization."[2] The autobiographical sensibility of this work can also be seen as alluding to a personal iconography outside the usual sphere of Pop Art.

1. Öyvind Fahlström, catalogue essay in *New Paintings by Jim Dine*, exh. cat. (New York: Sidney Janis Gallery, 1963), unpaginated.
2. Fahlström, unpaginated.

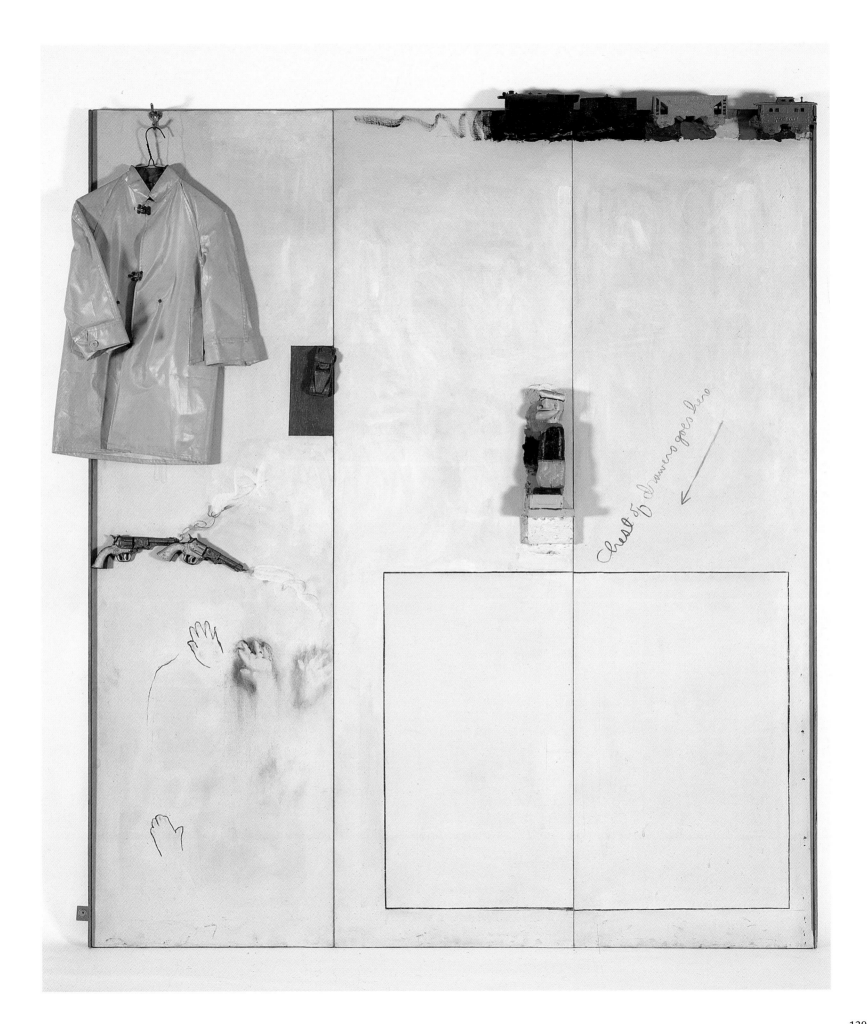

15. **Tom Wesselmann**
American, b. 1931
Cincinnati, Ohio

Still Life No. 16
1962

Enamel and polymer on Masonite with printed reproductions,
paper, and fabric
48 x 59¾ in. (122 x 151.8 cm)
Georges Pompidou Art and Culture Foundation

From 1962 to 1964, Wesselmann worked on an extended series of still lifes that made use of billboard and advertisement display material. These early still lifes used the commercial advertising images in a direct way, juxtaposing Wesselmann's own painted passages with the collaged elements, all of them composed within a very shallow space. He also tended to arrange these compositions without a central image or focus, instead distributing the still life objects equally across the surface of the picture. There is a marvelous abstract formal order to these works. What personal feelings or emotions Wesselmann may have harbored toward the objects he was depicting are much less important than how he composed the disparate objects into a cohesive whole. The red fabric-covered, half-round form in *Still Life No. 16* is a shape that Wesselmann often uses in his still lifes: it replicates a chairback used with his old kitchen table in Cincinnati. The rigor of his composition and the collaged images of the two 7-Up bottles, the can of fruit cocktail being poured into a glass container, and the cigar lying on the table represent American Pop Art in its purest form.

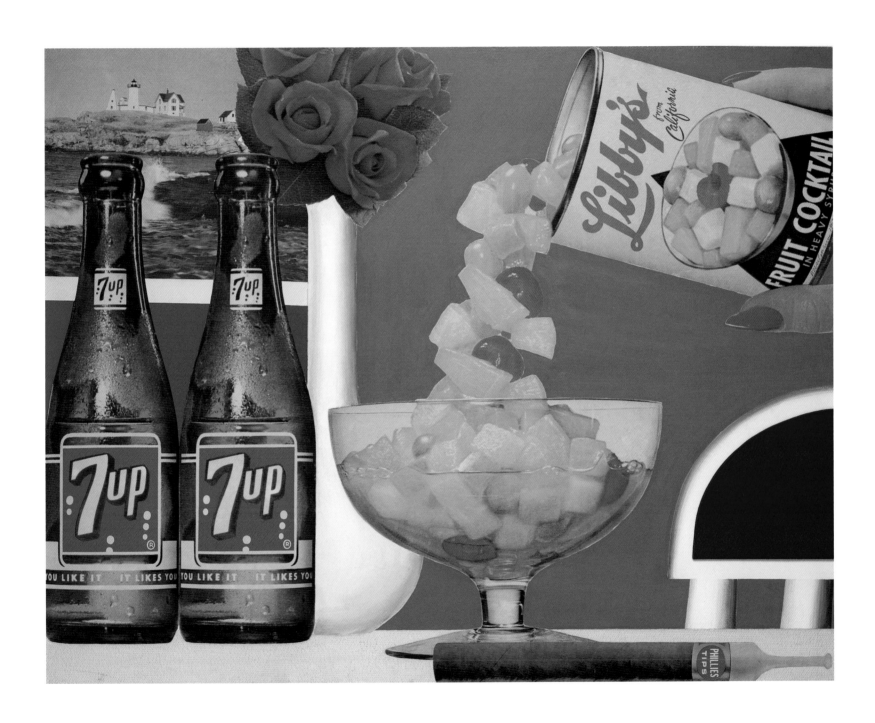

16. **Ben Talbert**
American, 1933–1975
Los Angeles

...dis mess...
1962

Cut-and-pasted newsprint with ink on printed postcard
4 x 6 in. (10.2 x 15.2 cm)
Collection of Hal Glicksman

Talbert was closely aligned with a small group of Southern California Assemblagists and poets whose art in the early 1960s tended to address Americana in a personal, somewhat arcane, manner. Talbert's diminutive collage, with its cartoon speech balloon affixed to a reproduction of a Paul Cézanne still life, is a hilarious Pop Art rejoinder. Presented in the guise of a self-made postcard, it relates in spirit to the punning mail art and embellished correspondences of Talbert's contemporaries Ray Johnson and Wallace Berman. The nature of Talbert's playful spoofing also recalls the *Tricky Cad* pasted collages of Jess (fig. 89), whose adaptations of the *Dick Tracy* comic strip are often cited as proto-Pop examples.

The whimsical mockery expressed in this collage conveys the prevailing mode at that time among the West Coast Assemblagists, who felt isolated not only from the "official" art world of New York but also from the traditional art found in museums. These artists were also aware that proliferating fine art reproductions had become as much a commodity as any other American commercial product. On a more personal level, Talbert's poke at Cézanne, the consummate painter, celebrates Talbert's 1961 decision to abandon painting in favor of working in Assemblage and collage.

17. **Derek Boshier**
British, b. 1937
Portsmouth, England

Sunset on Stability (SOS)
1962

Oil on canvas
48 x 48 in. (121.9 x 121.9 cm)
Museum Sztuki, Lodz, Poland

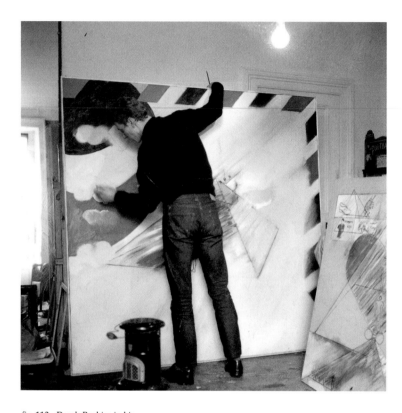

fig. 113. Derek Boshier in his
Royal College of Art studio
working on *Sunset on Stability
(SOS)* (1962), London, 1962.
Photograph by Tony Evans.

Of this work, Boshier said, "The sunset is painted in a fairly traditional way but with the sun being a Pepsi-Cola sign, a symbol I've often used to stand for America and Americanism. The pyramid is the sign of stability."[1] Here, the pyramid is clearly being occluded by the Pepsi-Cola "sun."

If William Hogarth saw the church and the ruling classes as the agents of oppression in eighteenth-century society, for Boshier it was politics in collusion with mass media, especially advertising. In the postwar world, few corporate entities were as clearly identified with American geopolitical globalism as Pepsi-Cola. The logo became a virtual synonym for America that was as recognizable, if not more so, than the United States flag.

Boshier's painting contains several elements common in his pictorial vocabulary of the period: the Pepsi-Cola logo, the linear form of the pyramid (it appears in related works such as *Look Versus Life Versus Time* and *Megaloxenaophobia* (both 1962), and the design of an air-mail letter (the subject of the painting *Airmail Letter* [1961]). The top and righthand sides of the painting are the same red, white, and blue as the Pepsi-Cola logo, and the line of figures tumbling from center to lower right undergoes a metamorphosis. This was a consistent device in Boshier's works of this period—and one that is also found in Hogarth's prints, as in the borders of the engraving for Hogarth's theoretical work *The Analysis of Beauty* (1753). The flatness of the logo and the "air-mail" edges, the scumbled paint across the upper pyramid, the falling figures—all are signature Boshier motifs.

1. Derek Boshier, conversation with David E. Brauer, London, March 2, 1999.

18. **Derek Boshier**
British, b. 1937
Portsmouth, England

The Most Handsome Hero of the Cosmos,
Mr. Shepard
1962

Oil on canvas
48 x 72 in. (121.9 x 182.9 cm)
Museum Sztuki, Lodz, Poland

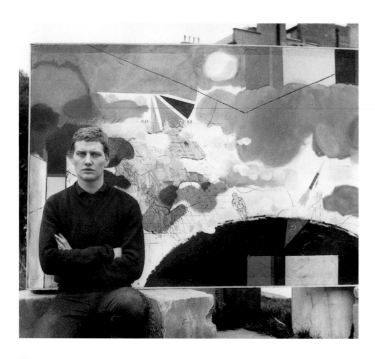

fig. 114. Derek Boshier
seated in front of *The Most
Handsome Hero of the
Cosmos, Mr. Shepard* (1962),
London, 1962. Photograph by
Tony Evans.

This painting is arguably the most important of those made by Boshier during the highly productive year of 1962. In this large and complex work (with the astronaut's name in the title originally misspelled as "Shepherd"), Boshier brought together many of his familiar images drawn from the American and Russian space race. The curvature of the earth is seen, and above that, areas of clouds, with the whole painting tightly bound together by nonfigurative areas of paint. Several drawn images of astronauts appear on the curvature of the planet, along with star maps, Ursa Major, a fragment of the American flag, a transfer-drawn image of Russian cosmonaut Yuri Gagarin, and floating near the top of the painting, perhaps the moon—but a moon seemingly about to take on the familiar aspect of the Pepsi-Cola logo. Although slightly smaller in its dimensions than *I Wonder What My Heroes Think About the Space Programme* (1962), the different scale of the images in relation to the larger constructed whole gives *The Most Handsome Hero . . .* an epic quality. This work has rarely been exhibited in recent years.

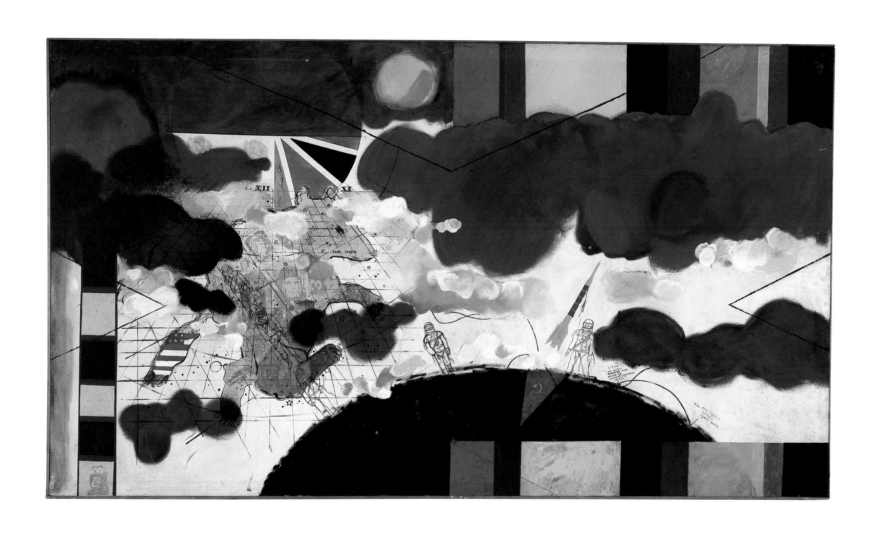

19. **Robert Indiana**
American, b. 1928
New Castle, Indiana

The Eateria
1962

Oil on canvas
60 x 48 in. (152.4 x 122 cm)
Hirshhorn Museum and Sculpture Garden, Smithsonian
Institution, Washington, D.C. Gift of Joseph H. Hirshhorn, 1966

fig. 115. New York State
Pavilion, New York World's Fair,
1964. Works shown are Robert
Indiana, *Eat* (1962), and a par-
tial view of Robert Rauschen-
berg, *Skyway* (1963). Photo-
graph © Fred W. McDarrah.

The word "EAT," very important in Indiana's lexicon, held a particularly esteemed place in the works that he produced from 1962 through 1965. The word was repeated twice in his X-shaped, five-letter electric sign commissioned by Philip Johnson that graced the exterior of Johnson's circular building for the New York State Pavilion at the 1964 New York World's Fair (fig. 115). "EAT" also made an appearance as one of four signs within Indiana's American Dream series, represented both in the painting *The Black Diamond American Dream #2* (1962) and in the painting *The Beware-Danger American Dream #4* (1963).

The painting here conjures up thoughts of the roadside diners that were once an important part of American highway culture. Further, its circular format, sequence of numerals, and alternating color bands suggest a wheel of fortune at a Midwest country fair. For Indiana, the word "EAT" carries both positive and negative connotations, and its polar word, "DIE," would become the second part of his two-panel paintings *The Green Diamond Eat and The Red Diamond Die* and *Eat/Die* (both 1962). This duality is rooted in the artist's personal history: his mother, Carmen, served home-cooked meals to travelers for twenty-five cents when Indiana was a boy in the Midwest, and "eat" was the last word she said before she died of cancer in 1949.

In November 1963 Andy Warhol filmed Indiana eating just one mushroom in his Coenties Slip studio. The resulting forty-five minute movie was titled *Eat*.

Andy Warhol
American, 1930–1987
Pittsburgh, Pennsylvania

Big Campbell's Soup Can, 19¢
1962

Acrylic and pencil on canvas
72 x 54½ in. (182.9 x 138.4 cm)
The Menil Collection, Houston

This work belongs to a group of single-image soup cans that Warhol painted in 1962, each painting measuring six by four and a half feet. In contrast to his more famous stacked soup cans, this particular group of acrylic paintings depicts each can in the midst of some transformation process. A can opener has just split open the top of *Big Campbell's Soup Can, 19¢*, and other paintings from this series have torn and peeling labels; the tattered appearance of *Big Soup Can with Torn Label (Pepper Pot)*, *Campbell's Soup Can with Peeling Label (Black Bean)*, and *Big Torn Campbell's Soup Can (Vegetable Beef)* is especially marked in comparison to the pristine regimentation of Warhol's other familiar soup can works.

It is tempting to read some kind of message into Warhol's violated soup cans, but Warhol himself insisted on remaining noncommittal about what they represented to him, refusing to discuss even his feelings about painting them. But Warhol's association with the red-and-white Campbell's Soup can remains the element that most readily identifies his position in Pop Art.

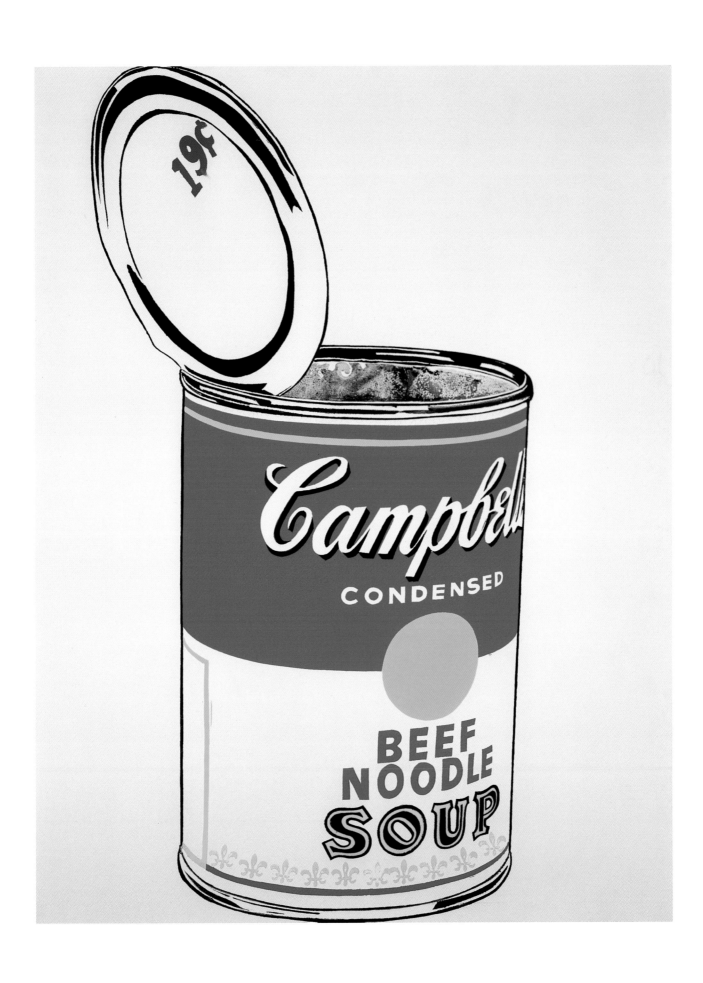

21. **Phillip Hefferton**
American, b. 1933
Detroit, Michigan

Sinking George
1962

Oil on canvas
90 x 67½ in. (228.6 x 171.5 cm)
Betty and Monte Factor Family Collection

Hefferton and his friend Robert Dowd both began separate series of paintings based on American paper money while sharing studio space in downtown Los Angeles in 1962. Both artists were originally from Detroit and had moved first to San Francisco in 1960 before relocating in Southern California a year later. They saw the adoption of American currency as subject matter as a way for them to explore an already developed and commonplace iconography. At the time, their decision had nothing to do with an attempt to become associated with the nascent development of the as yet undefined Pop Art vernacular. They in fact knew nothing about the painted or silkscreened images of money that Andy Warhol was producing at the same time.

Although the use of dollar bills as subject matter is a decidedly Pop Art gesture, the manner in which Hefferton dealt with the subject was less convincingly so. Hefferton's depiction of George Washington on his hand-painted dollar bill here has the President sliding out of his cameo window. In a related painting titled *Poo Poo* (1962), half of Washington's hairpiece hangs down across his face. Hefferton used humor to cut the blandness that was a feature of so much American Pop. The humorous parody *Sinking George* is also painted in a quasi-amateurish manner, making the work something of a forefather both to Northern California funk art and to the later 1970s variations upon figurative art that became known, unpejoratively, as "bad" painting.

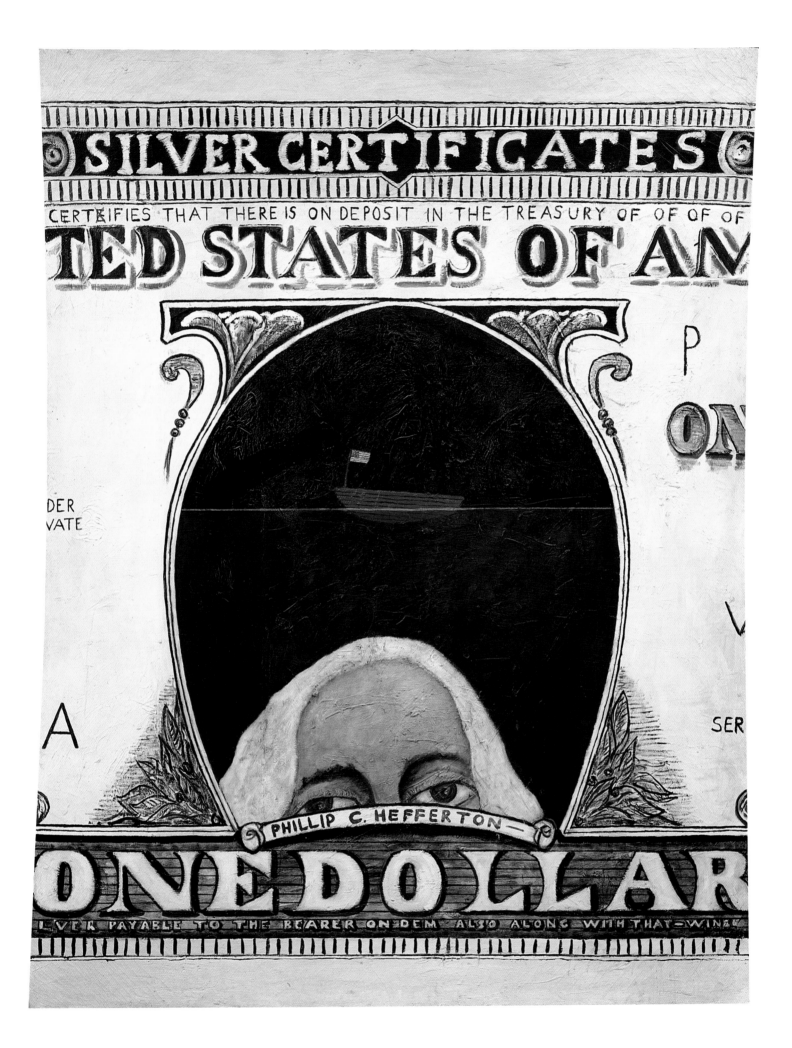

22. **Allan D'Arcangelo**
American, 1930–1998
Buffalo, New York

Full Moon
1962

Acrylic on four canvases
65½ x 62 in. (166.4 x 157.5 cm) overall
The Sydney and Frances Lewis Collection

America's interstate highway system was conceived very pragmatically as a series of interconnecting roads running as directly as possible from one metropolitan center to another. The vast, nearly indistinguishable blandness of these highways and their roadside architecture became the subject of D'Arcangelo's most well-known paintings. *Full Moon* is a multi-panel painting unusual for D'Arcangelo. Its four-panel construction reveals, in a stylized time sequence, the Gulf Motor Oil Company logo rising moonlike above the highway landscape.

The American highway, a source of fascination to the American Precisionists of the 1930s and 1940s, was especially prominent in the paintings of Ralston Crawford. The mood of Crawford's paintings, which tend to depict the geometric patterns of roads and railings against expansive skies, is optimistic: the roadways diminishing into a vanishing point seem to point toward a promising future. In contrast, D'Arcangelo's highway paintings are much more foreboding. There is something rather haunting about *Full Moon*, where the gas sign "moon" appearing ahead achieves metaphysical proportions. The sunny idealism of the Precisionists has been replaced here by D'Arcangelo's quasi-surrealistic, quasi-Pop acknowledgment that the man-made ecosystem of the interstate highway system has assumed the power of nature itself.

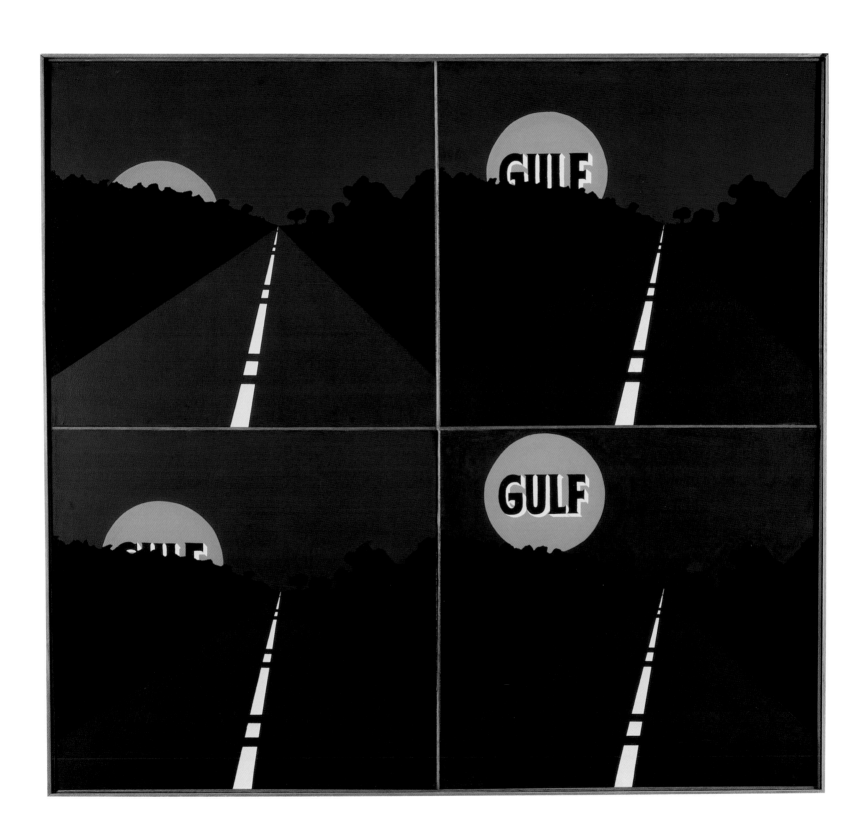

23, 24. James Rosenquist
American, b. 1933
Grand Forks, North Dakota

Promenade of Merce Cunningham
1963

Oil on canvas
60 x 70 in. (152.4 x 177.8 cm)
The Menil Collection, Houston

Nomad
1963

Oil on two canvases with plastic and paint-splattered wood
and string
90 x 141 in. (228.6 x 358.1 cm)
Albright-Knox Art Gallery, Buffalo, New York.
Gift of Seymour H. Knox, Jr. 1963

The central image of a man's feet and the painting's very title tell us that this work is a tribute to the innovative American choreographer and dancer. But there is always an elusive quality to Rosenquist's paintings, with their fragmented images composed in unlikely combinations—they resist easy interpretation. Rosenquist's juxtapositions suggest the complex, multilevel associations that we, as modern day humans, seem destined to sort through in the course of our image-filled existence. What seems most important to Rosenquist, however, are not the one-dimensional associations we form about isolated objects, but our assorted responses triggered by the endless parade of images offered by consumer culture. A study collage demonstrates how the artist developed the imagery of the painting directly from advertising source materials (fig. 116).

fig. 116. James Rosenquist, source for *Promenade of Merce Cunningham*, 1963, printed reproductions with pencil and paper mounted on paper, 7½ x 10⅜ in. (19 x 26.2 cm), collection of the artist.

Rosenquist's training as a commercial billboard painter gave him insight into not only the size of the objects he was depicting, but also their appropriate scale. The dominant mode of most billboard art is to project images outward toward the viewer. Whatever field or background that lay behind the objects tended to be read on the same plane as the objects themselves. In this painting, Rosenquist has drastically altered the relative size of the objects within the composition, the open billfold being a bit larger than the picnic table, with the bottom section of a light bulb serving as a giant bowl for spaghetti.

Compositionally, *Nomad* plays with a repeated motif of "X"s and "O"s. In the lower lefthand corner of the Oxydol detergent label, half of the letter "X" is shadowed by the leg of a ballerina; the "X" is repeated again in the crisscrossing of the picnic bench and table. The letter "O" on the box label is mirrored in the smaller-scale olives and meatballs in the dish of spaghetti, as well as suggested in the half-revealed light bulb.

Nomad is related to other important large-scale Rosenquist paintings of 1963–65, including *Taxi, Lanai,* and *Painting for the American Negro;* as Marcia Tucker has pointed out, the scale, size, and presence of the objects depicted in these compositions give equal weight to field (background) and detail (foreground).[1] Psychologically, *Nomad* is an elusive work. In spite of the fidelity of its parts and fragments, which compositionally lock into place, there is a disorienting quality overall to this large-scale work.

1. See Marcia Tucker, *James Rosenquist,* exh. cat. (New York: Whitney Museum of American Art, 1972), p. 17.

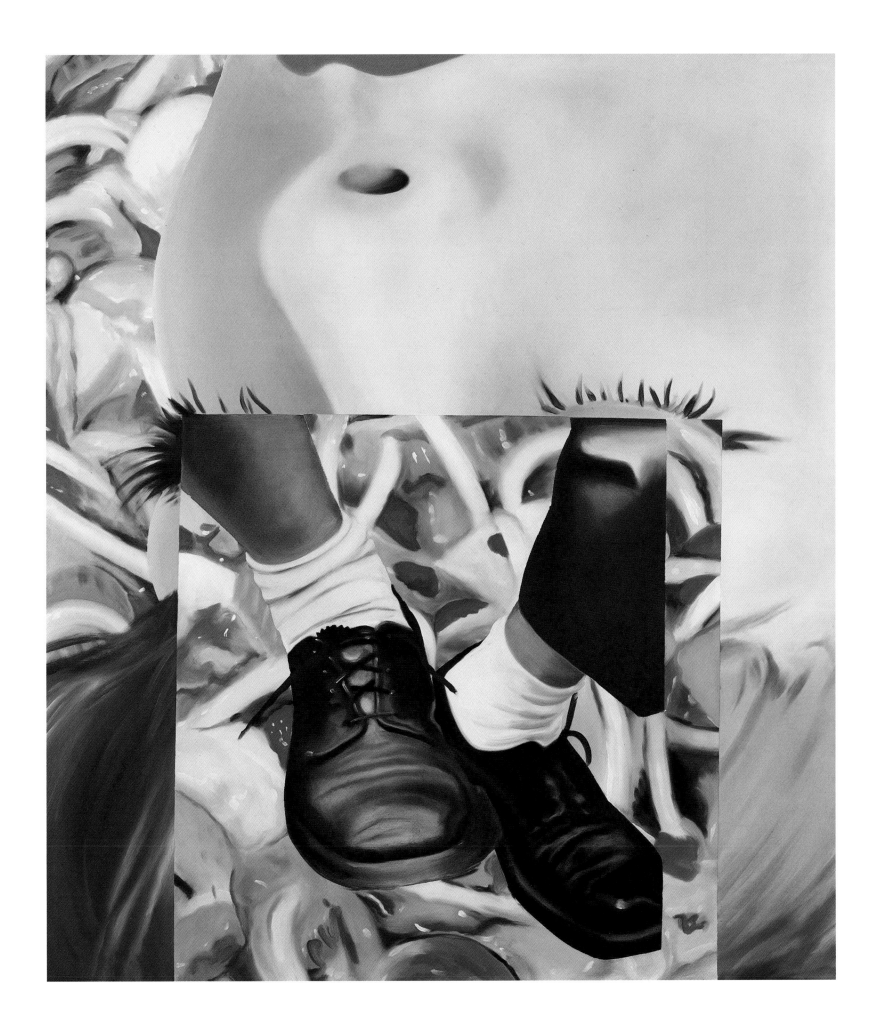

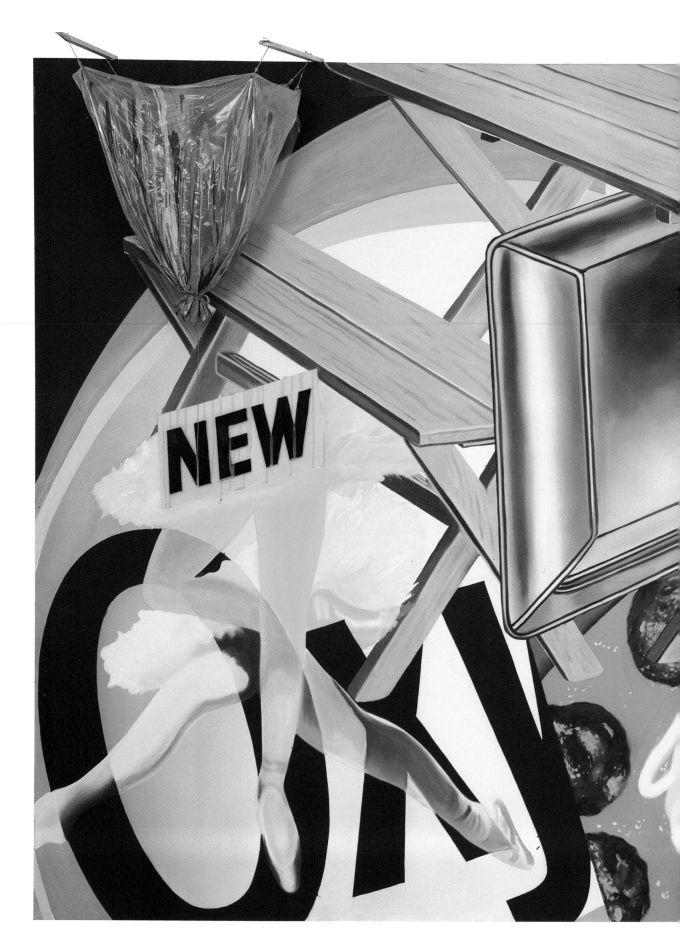

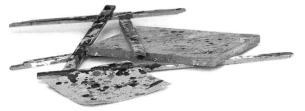

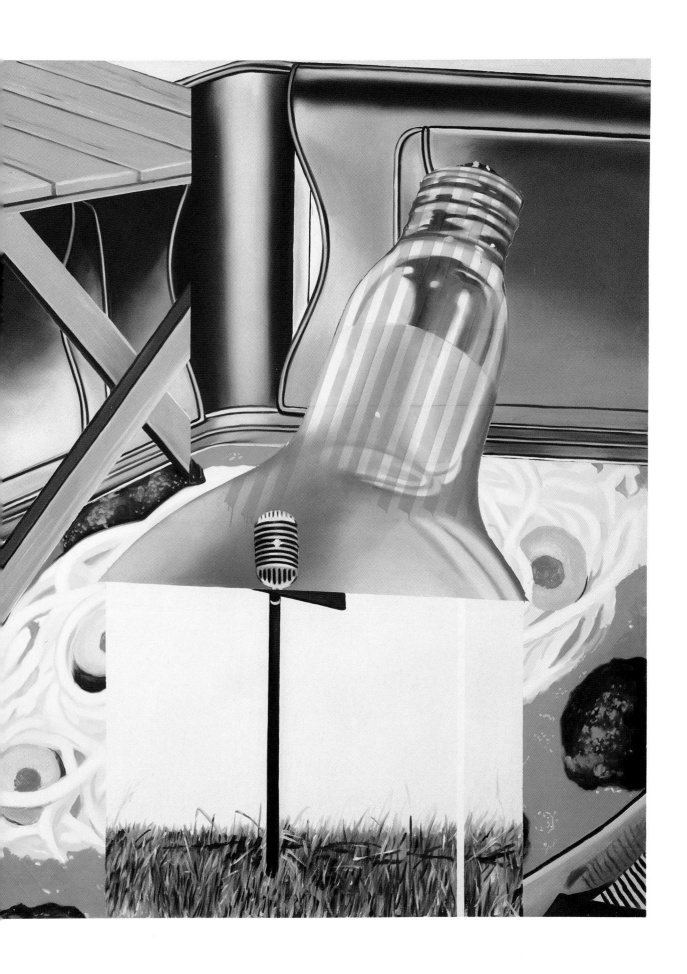

25. James Rosenquist Toaster

American, b. 1933 1963

Grand Forks, North Dakota

Enamel paint on wood with chromed barbed wire,
metal saw blades, and plastic
11¼ x 11 x 12 in. (28.6 x 28 x 30.5 cm)
Frederick R. Weisman Art Foundation, Los Angeles

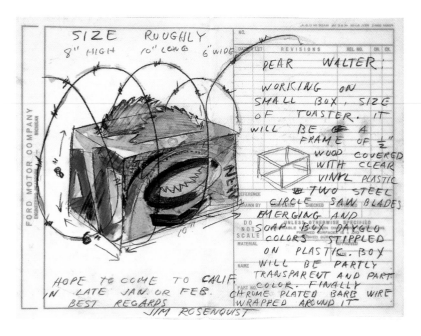

fig. 117. James Rosenquist,
study for *Toaster*, 1963, pencil
and watercolor on Mylar,
9 x 12 in. (22.9 x 30.5 cm),
private collection.

In 1962 Rosenquist began to add extraneous materials to the surfaces of his canvases, sticking plastic, wood, and tin to the face of some paintings. From these Assemblage additions, it was an easy step into the three-dimensional space of sculpture. *Toaster* is one of the experimental sculptures that Rosenquist produced in 1963–64, when he began embracing more abstract ideas of space to go along with the illusionistic space of his paintings of bill-board fragments.

Toaster is from the same period as *Tumbleweed* (1964–66), a large work inspired by the tangle of weeds that the wind blows across the prairies and deserts of the west. *Tumbleweed*—an armature made of sticks of wood with a squiggly line of neon, all wrapped in barbed wire—is like a sculptural drawing in space. *Toaster* is also wrapped in barbed wire, its box form cut through by the protruding circular power saw blades that project from the top. A rendering produced by Rosenquist during the sculpture's facture clearly delineates these some-what threatening elements (fig. 117). Yet animated by loose gestural paintwork over the simulated advertise-ment fragments on its sides, *Toaster* has a playful, free-wheeling complexity. The multiple allusions within this work are the antithesis of Oldenburg's *Soft Toaster* (1964, pl. 39), which seems to settle comfortably into it-self. In contrast, Rosenquist's *Toaster* is sharp-edged, even gaudy, giving the impression that it is about to explode beyond the dimensions of its box form.

26. Gerald Laing
British, b. 1936
Newcastle-upon-Tyne,
England

Astronaut 4
1963

Oil on three canvases
57¾ x 37¾ in. each (146.7 x 96 cm each)
The University of New Mexico Art Museum, Albuquerque.
Gift of Mr. and Mrs. Michael Findlay

fig. 118. Alan Shepard in orbit,
Freedom 7 Mission, 1961.

A growing awareness of Pop Art generally, plus the presence of Richard Smith, Peter Blake, and Joe Tilson on the teaching staff of St. Martin's School of Art in London where Laing was a student, led him toward contemporary imagery, and by 1962 he had developed his signature technique of hand-painting dots in varying sizes to imitate the effect of halftone photographic reproduction. Laing has described this evolution:

> When I began using photographs as a starting point, I was interested in being able to make figurative paintings with a simple and unequivocal content which were at the same time "un-loaded" from the point of view of previous figurative paintings. This was followed by a series of black-and-white literal representations of newspaper photographs.... I used a grid of a predetermined interval and painted black dots of various sizes, thus making a halftone area which described form. This process amounted to drawing with tone, but from my point of view the feeling of "possession by recreation" was the most important facet of this activity.[1]

Laing's primary images were often small grainy photographs cut from daily newspapers, rather than slick magazine photography. As with many of the other British Pop artists, this scrutiny of photographic sources brought a growing awareness of American-derived media imagery, and Laing used many such images, including NASA photos of astronauts (fig. 118), as in this work.

Laing's astronaut paintings were done during early American and Russian manned space programs. Although Derek Boshier, Richard Hamilton, and Joe Tilson also used astronaut imagery, no major American artist produced as many images of early space endeavors as Laing, with the single exception of Robert Rauschenberg. Space flight held a far greater fascination for the British artists.

Laing's painting shows American astronaut Alan Shepard during his historic sub-orbital mission. The upper curve of the canvas suggests the curvature of the earth, and space is signaled by the blue background. The lower panels contain flamelike forms signifying those extruded from the rocket at liftoff. The fusion of photograph-derived imagery, the hand-painted dots, and the flat, almost Art Nouveau-like stylization of the flames makes this one of the major works on the subject.

1. Gerald Laing, quoted in *The Painter & the Photograph from Delacroix to Warhol* by Van Deren Coke (Albuquerque: University of New Mexico Press), 1964; revised and enlarged, 1972.

27. **Rosalyn Drexler**
American, b. 1926
Bronx, New York

Death of Benny "Kid" Paret
1963

Oil over cut paper on canvas
13⅞ x 18 in. (35.2 x 45.7 cm)
Collection of the artist

On March 4, 1962, Emile Griffith regained the world welterweight boxing championship in a televised twelfth round knockout of Benny "Kid" Paret at New York's Madison Square Garden. Paret was to die of the head injuries received in that prizefight. Drexler's serial painting on collage portrays the progression of images that appeared on television during the broadcast of the boxing match. One of the most compelling aspects of the new medium of television was its ability to record live action, bringing an event that could be witnessed by relatively few fans at Madison Square Garden into the living rooms of millions.

Like Edward Kienholz's treatment of the Kennedy assassination in *Instant On* (1964, pl. 37), Drexler's painting pays tribute to a death essentially immortalized on television. This was not an unusual subject for the artist, who also produced paintings related to gangland Mafia assassinations and other stories from newspaper tabloids. Yet Drexler's *Death of Benny "Kid" Paret* differs from Andy Warhol's Disaster series of car wrecks, where the same image is repeated as if in the stop-action of a film clip. While her television windows do give an account of the sequence of Griffith's fatal punches, she has enlarged the images progressively from frame to frame as Paret lapses into death. Along with glamour and sex, death had become the captivating subject of modern day television.

28. Joe Goode
American, b. 1937
Oklahoma City, Oklahoma

November 13, 1963
1963

Oil and pencil on Masonite
24 x 24 in. (61 x 61 cm)
Collection of the Orange County Museum of Art, Newport Beach,
California. Gift of Betty and Monte Factor Family Collection

fig. 119. Joe Goode, *House Drawing (aHOUSEd1)*, 1963, pencil on tracing paper, 26 x 21¾ in. (66 x 55.2 cm), Museum of Contemporary Art, Los Angeles. Purchased with funds provided by Ruth and Murray Gribin.

After completing his 1961–62 series of milk bottle paintings, Goode turned his attention to a series of tract home portraits. Los Angeles, in its postwar boom, was fast becoming a haven of new American suburban architecture. Goode made many drawings or thumbnail sketches of these Southern California bungalows and ranch houses, often grouping his small-scale renderings on large sheets of tracing paper. Such two-foot-square sheets might include as many as sixteen house portraits (fig. 119).

In this oil and pencil on Masonite work, a single sketch of a home has been isolated within a field of color. The sketched house, Goode's copy of a real estate advertisement as it would have appeared in a newspaper, is rendered as yet another American product. His tract home portraits ruefully capture the bland sameness of middle American life in contemporary Southern California.

29. **Peter Blake**
British, b. 1932
Dartford, Kent, England

Bo Diddley
1963

Acrylic and scotch tape on board
48¼ x 30¼ in. (122.5 x 76.8 cm)
Museum Ludwig, Cologne. Ludwig Donation 1976

Among the many American subjects Blake used as Pop icons were Sammy Davis Jr., Tuesday Weld, Marilyn Monroe, Elvis Presley, Fabian, and as in this work, Bo Diddley. One of the true pioneers of rock and roll, incorporating women backup singers, electric violins, and much more in his band, Diddley played his guitar as though playing drums, developing a strong, percussive attack that deeply influenced the Rolling Stones. His rhythm guitar style was paralleled by the playing of surfer guitarist Dick Dale and influenced by the drumming of Gene Krupa. Blake used a Bo Diddley album cover as the basis for this work, one of his best-known paintings and one of the last to feature a Pop subject.

At the time, Blake was still working on his portrait of the Beatles, a retrospective image of the group at the beginning of their career. Later Blake and his then-wife, American artist Jann Haworth, would produce the tableaux for the now famous album cover for *Sgt. Pepper's Lonely Hearts Club Band*. This was a major collaborative work of late British Pop Art: not simply a clever collage, the famous image used life-size figures with tinted photographic images attached; Shirley Temple and Mae West were stuffed sculptures made by Haworth, and complex kinetic elements figured in the piece. Blake later commented on his Pop works:

> For me, hard-core Pop art was probably 1959–64, with pictures like *Couples* and *Kim Novak Wall* of 1959 predating other Pop art by a year or two.... I decided that what I wanted to do as a painter was to comment on my particular interests. Pop art was for me almost a kind of excursion.... I'm quite proud to have been involved in the movement....[1]

1. Peter Blake, quoted in "Thirty Years On" by Andrew Lambirth, *The Royal Academy Magazine: RA,* Special Pop Issue, no. 32 (Autumn 1991), pp. 32–38.

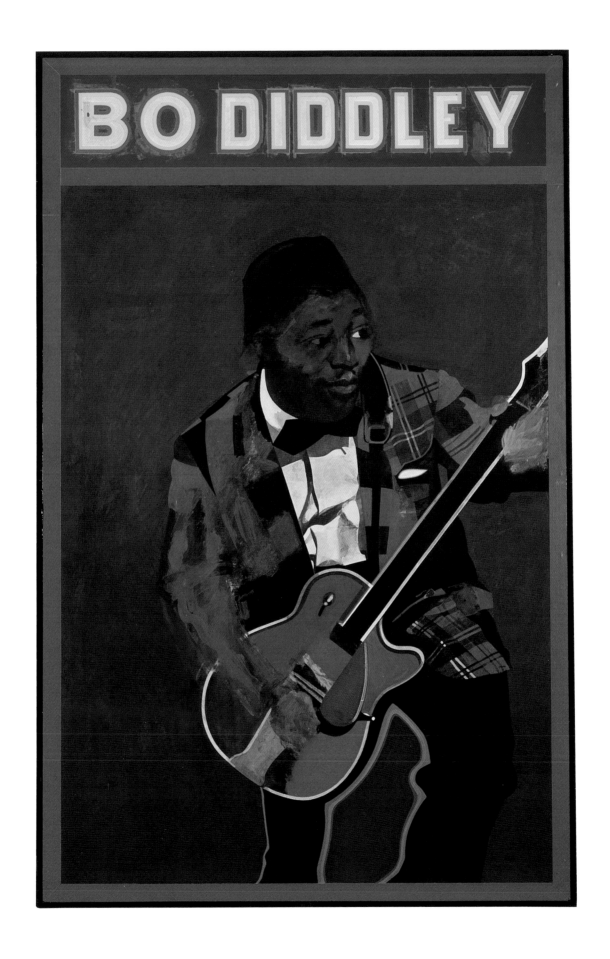

30. **Andy Warhol** Triple Elvis Aluminum paint and silkscreened ink on canvas
American, 1930–1987 1963 82 x 71 in. (208.3 x 180.3 cm)
Pittsburgh, Pennsylvania Virginia Museum of Fine Arts, Richmond.
Gift of Sydney and Frances Lewis

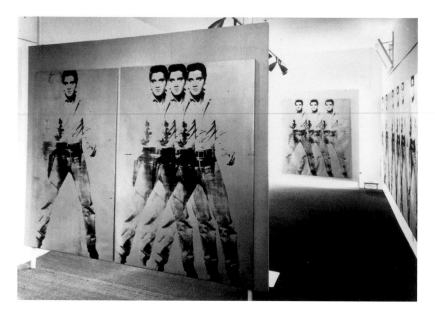

fig. 120. "Andy Warhol"
(September 30–October 26,
1963), Ferus Gallery, Los Angeles,
installation view. Works shown
are from the *Elvis* series.
Photograph by Frank J. Thomas.

The faintness of the image here is probably the result of the silkscreen's mesh becoming clogged during the repeated squeegee pulls of the printing process, an effect Warhol chose to exploit. Because of the overlapping images, *Triple Elvis* effectively produces a "strobe light" or stop motion effect suggesting the passage of time.

After creating the series for his 1963 exhibition at Ferus Gallery in Los Angeles (fig. 120), Warhol simply sent the entire uncut roll of canvas to gallery director Irving Blum, leaving it up to him to cut and mount the canvases on stretcher bars as he saw fit. This gesture emphasized an element of chance that dovetailed with Warhol's publicly avowed diffidence toward the importance of the artist's own hand in the creative act. The production of this Elvis series and a group of Liz Taylor works (among his first featuring movie stars) immediately preceded Warhol's first visit to Hollywood to attend the exhibition's opening.

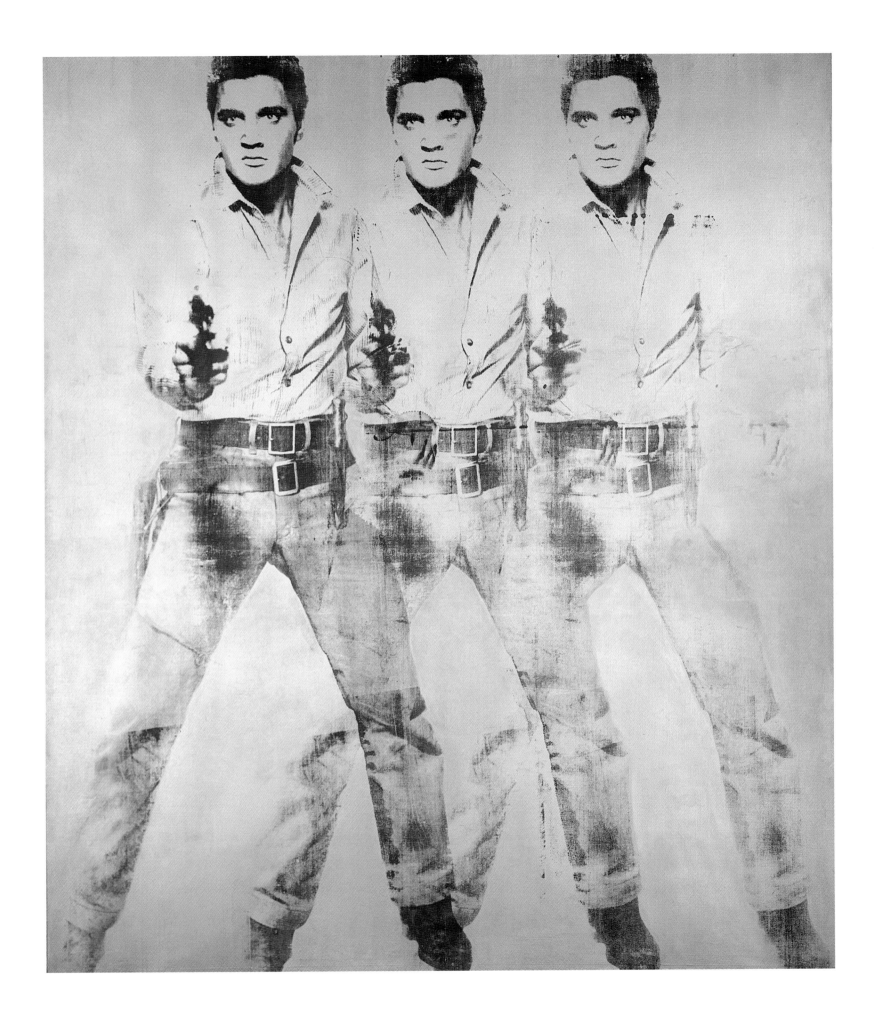

171

31. **Pauline Boty**
British, 1938–1966
South London, England

Monica Vitti with Heart
1963

Oil on canvas
31½ x 25⅝ in. (80 x 65 cm)
The Mayor Gallery, London

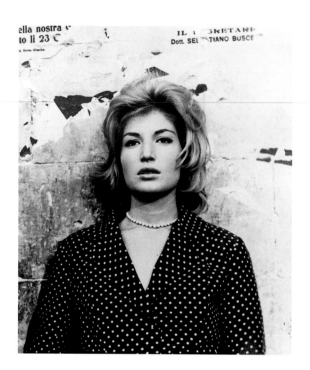

fig. 121. Film still of Monica Vitti in *L'Avventura* (1960).

Much of Boty's work was characterized by intense color at a time when such saturated color was still unusual in British painting, even in works by other Pop artists. References to movies were also characteristic, including homages to the French movie star Jean-Paul Belmondo, the American icon Marilyn Monroe, and as in this work, the Italian actress Monica Vitti. Vitti starred in Michelangelo Antonioni's early sixties films *L'Avventura* (fig. 121), *Eclisse [Eclipse]*, *La Notte [The Night]*, and *Red Desert*. Much admired among London sophisticates, she possessed a nervous vulnerability that made her a contemporary icon. Her work in Antonioni's tetralogy brought her international fame as the "thinking man's Brigitte Bardot": in the early sixties in London, nothing could have been more "cool" than preferring Vitti to Bardot or Monroe.

The heart in Boty's work is also one of the more ubiquitous Pop Art icons, found in works by Robert Indiana, Jim Dine, and Peter Blake, among others. One of Boty's more straightforward works, *Monica Vitti with Heart* appeared in the seminal 1963 Grabowski Gallery exhibition "Image in Progress." Subsequent paintings by Boty would address more political issues: *Countdown to Violence* (1964) and *It's a Man's World I* (1964) both refer to the Kennedy assassination. Boty also pushed the classic Pop pinup imagery further than her male cohorts, showing several images of nudes in a frontal portrayal with pubic hair—at that time a very confrontational image. From the present perspective, her life and works contain much that relates to later feminist issues, especially but not exclusively in matters of sexual subject matter.

173

32. **Richard Hamilton**
British, b. 1922
London

Towards a definitive statement on the coming
trends in men's wear and accessories (d)
1963

Oil, printed reproductions, and Perspex relief on panel
48 x 32 in. (122 x 81.3 cm)
Museum Ludwig, Cologne. Ludwig Donation 1976

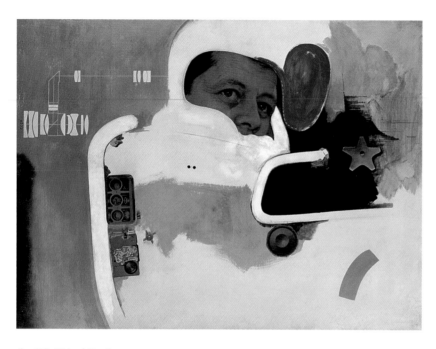

fig. 122. Richard Hamilton,
*Towards a definitive statement on
the coming trends in men's wear
and accessories (a) "Together let
us explore the stars,"* 1962, oil
and printed reproductions on
panel, 24 x 32 in. (61 x 81.3 cm),
Tate Gallery, London.

This work is the fourth of a quartet of mixed-media pieces by Hamilton, all with the same title. The first is subtitled "*Together let us explore the stars,*" quoted from President Kennedy, who is seen in an astronaut helmet (fig. 122). The second has references to race cars and American football, and the third has the subtitle *Adonis in Y Fronts,* Y fronts being a style of men's underwear and the title parodying the American pop song and British Top 5 hit "Venus in Blue Jeans." The first three works relate, respectively, to technological man, sporting man, and classical man, joined together in the fourth, the largest work of the series.

The work here, designated version *(d)*, is unique in that the artist permits it to be hung in any orientation. This hanging option suggests an astronaut's weightlessness and the absence of an up or down direction in deep space. Several of the themes found in the previous three reappear. The football helmet becomes a Mercury astronaut's helmet enclosing the face of John Glenn, the first U.S. astronaut to complete an orbit of the earth. The stripes represent trunks from a men's fashion photograph in *Playboy* magazine. In the center there is a page taken from *Esquire,* which shows the selection displayed on a jukebox in the Times Square subway station, the only jukebox known to Hamilton that plays only classical music.

Representative of Hamilton's techniques of the time in the use not only of mixed media and collage but of different paint applications—from the feathered paint around the helmet to the Morris Louis-like stripes of the shorts—the work combines hard-edge and soft-edge paint surfaces into a complexly worked surface.

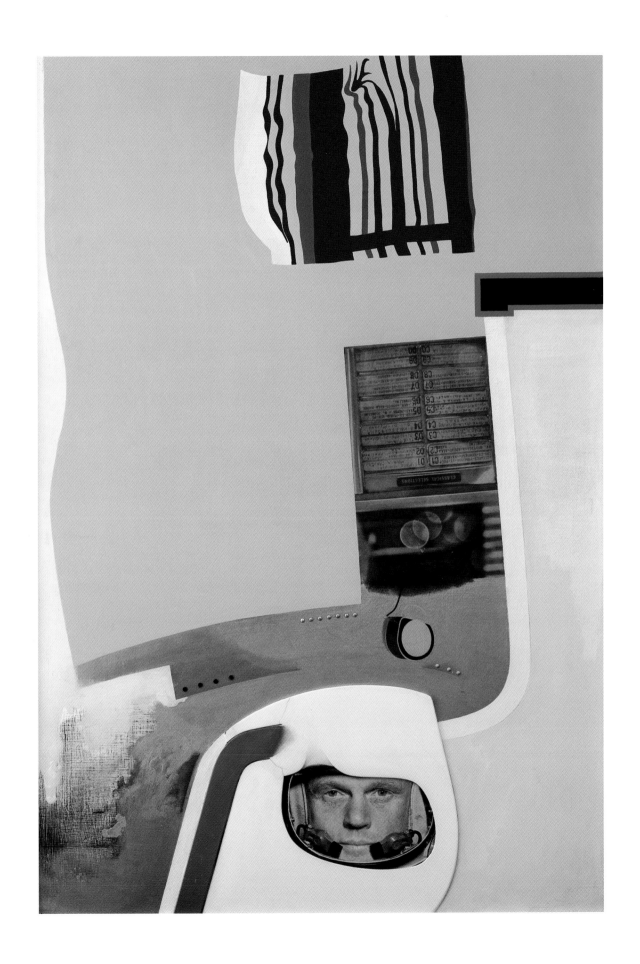

33. **Richard Hamilton**
British, b. 1922
London

Interior study (a)
1964

Printed reproductions and oil on paper
15 x 20 in. (38 x 50.8 cm)
Collection of Swindon Museum and Art Gallery,
Swindon Borough Council, England

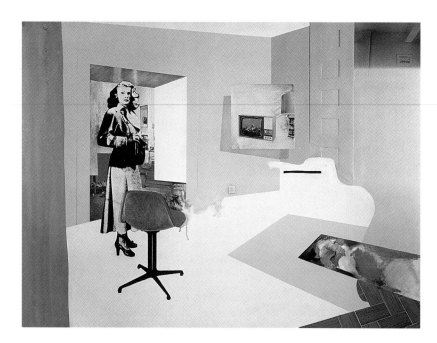

fig. 123. Richard Hamilton,
Interior II, 1964, oil, collage,
cellulose, and metal relief on
panel, 48 x 64 in. (122 x 162.5
cm), Tate Gallery, London.

This small work is a study for the screenprint *Interior* (1964–65), which took as its subject the modern interior, both as a sort of museum of commodities and as a psychological environment—a consistent presence in Hamilton's work since 1956.

Interior study (a) allows a reading of how Hamilton gathers his visual material. The room itself is based on a photograph of the drawing room of the French painter and printmaker Berthe Morisot; the figure of the woman is taken from an advertisement for a washing machine; and a sports scene is seen on the television. For this series, Hamilton made three collages, two larger paintings (*Interior II* is illustrated, fig. 123), and four states of the silkscreen print. The artist has described the three collage studies as: "ominous, provocative, ambiguous; with the lingering residues of decorative style that any inhabited space collects. A confrontation with which the spectator is familiar yet not at ease."[1] In this study, the viewer becomes aware of the incongruities within the room: a late nineteenth-century drawing room, but with the contemporary presence of the woman and the television, as well as De Stijl-like areas of red and yellow. In each of the three studies and the various states of the print, Hamilton continually adjusted the relationships of the collage ingredients, and this rarely exhibited study shows the original thought being worked out:

> ...I wanted to get back to the visual world, and when I did, I asked myself, What do I look at? And I thought, well, I go to the cinema three times a week, I look at *Playboy,* I look at *Esquire,* I look at *Look* magazine. These were the things that enriched my visual life. You could read art reviews in the *Times* in the 1950s and it was just stupid meandering crap. But you would find wonderful articles in *Architectural Review* or *Design.* There was this new area of myths—of fantasies and desires and dreams—to tap into.[2]

1. Richard Hamilton, catalogue entry for Interior series in *Richard Hamilton: Paintings etc. '56–64,* exh. cat. (London: Hanover Gallery, 1964), unpaginated.
2. Andrew Graham-Dixon, "Richard Hamilton: Father of Pop," *Art News* (February 1991), p. 106.

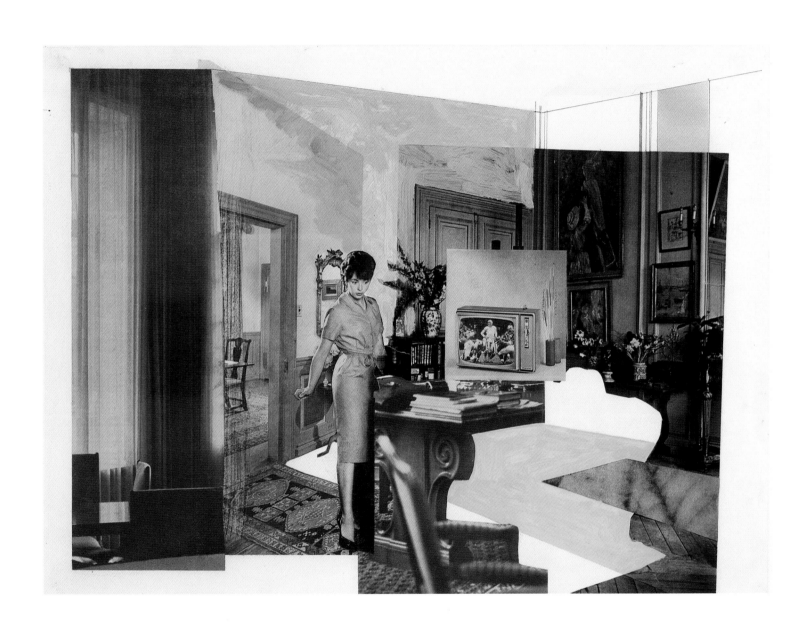

34. **Andy Warhol**
American, 1930–1987
Pittsburgh, Pennsylvania

Brillo Boxes
1969 (version of 1964 original)

Silkscreened ink on wood
20 x 20 x 17 in. (50.8 x 50.8 x 43.1 cm) each
Norton Simon Museum, Pasadena, California.
Gift of the artist, 1969

Warhol's first venture into sculpture was the replication of cardboard packing cases for supermarket products including Brillo soap pads, Campbell's tomato juice, Del Monte peach halves, Heinz tomato ketchup, and Mott's apple juice. Warhol had the boxes constructed out of plywood to the exact dimensions of the cardboard originals. Then the wooden boxes were painted to simulate a cardboard color or a flat printed background color corresponding to the original commercial box. Finally the relevant label was silkscreened on all sides. The assembly line set up to produce the boxes was also mirrored by their exhibition, first at Dwan Gallery in Los Angeles in February 1964 and again at Stable Gallery in New York in April 1964. Hundreds of these boxes were lined up or stacked on the gallery floor, giving the exhibiting spaces the look of grocery store warehouses.

Warhol's boxes make explicit what was required by America's pioneering efforts in the prepackaging of food products. A byproduct of convenience and fixed-price marketing is the easily recognized mass market logo. *Brillo Boxes* also indirectly paralleled the development of the serial explorations of Minimalism, with its sculpture based upon a uniform size arranged at regular intervals.

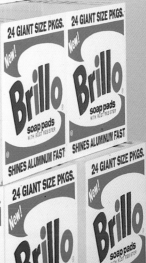

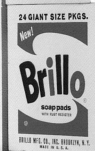
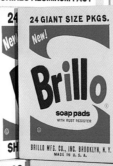
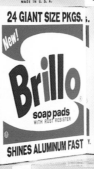
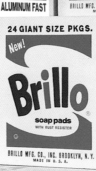
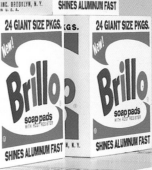
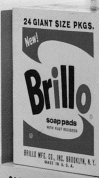
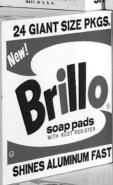
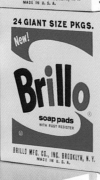
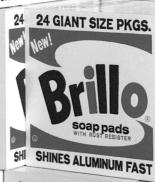
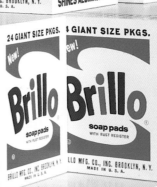
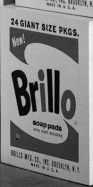
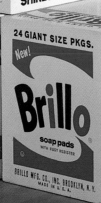
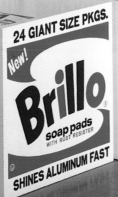
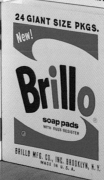
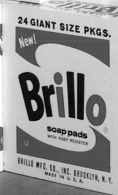
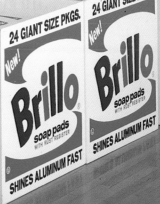

35. **Allen Jones**
British, b. 1937
Southampton, England

Love Box
1964

Oil, glass, mirrors, wood, colored Plexiglas, and metal chain
11½ x 27 x 9½ in. (29.2 x 68.6 x 24.1 cm)
Private collection, Houston

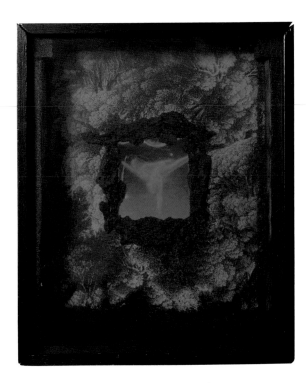

fig. 124. Joseph Cornell, Untitled [Renée Jeanmarie in *La belle au bois dormant*], 1949, blue glass-paned, stained, and papered wood box with photomechanical reproduction, bark, glitter, and electric light, 14½ x 11⅞ x 6¾ in. (36.8 x 30.2 x 17.1 cm), private collection.

This work predates the more widely exhibited and re-produced erotic "furniture" sculptures by Jones, which were executed after his extended residency in New York during 1964–65. Where many of Jones' paintings of the mid sixties deal with hermaphroditic male/female imagery, *Love Box* is unambiguous in its feminine subject. Jones has stated, "At that time I was interested in conventions of drawing used in commercial art and the pin-up and the small canvases were essays in modelling provocative parts of the body."[1]

Like their American contemporaries, several British Pop artists became interested in the box format, Clive Barker and Derek Boshier among them. For Jones this interest arose during his visits to America: "I remember becoming aware of artists who used the box as a vehicle for their invention. Joseph Cornell (see fig. 124) was represented by my dealer Richard Feigen and Lucas Samaras was showing at that time."[2] The box is divided into three compartments with mirrored walls; the central third of each compartment has a mirrored screen, and the front is covered by a pane of frosted glass except for the transparent letters "O V E" that allow the viewer to look inside the box. A red plastic letter "L," secured by a chain, stands atop the box completing the word "LOVE."

About the work, Jones added:

> When the viewer looked through these letters they saw themselves. Only by looking into the mirrored side walls would they be able to see the small pictures.... I did not see them as finished pictures and the idea of putting them into a box with a small screen in each compartment that obstructed a clear view of the image appealed to me, and provided a format for their display.... The eroticism of the painted images was filtered through reflection. A cool look at a hot subject! *Love Box* is a play on words and popular slang of that time.[3]

1. Allen Jones in a letter to David E. Brauer, June 2, 2000.
2. Jones to Brauer, June 2, 2000..
3. Jones to Brauer, June 2, 2000.

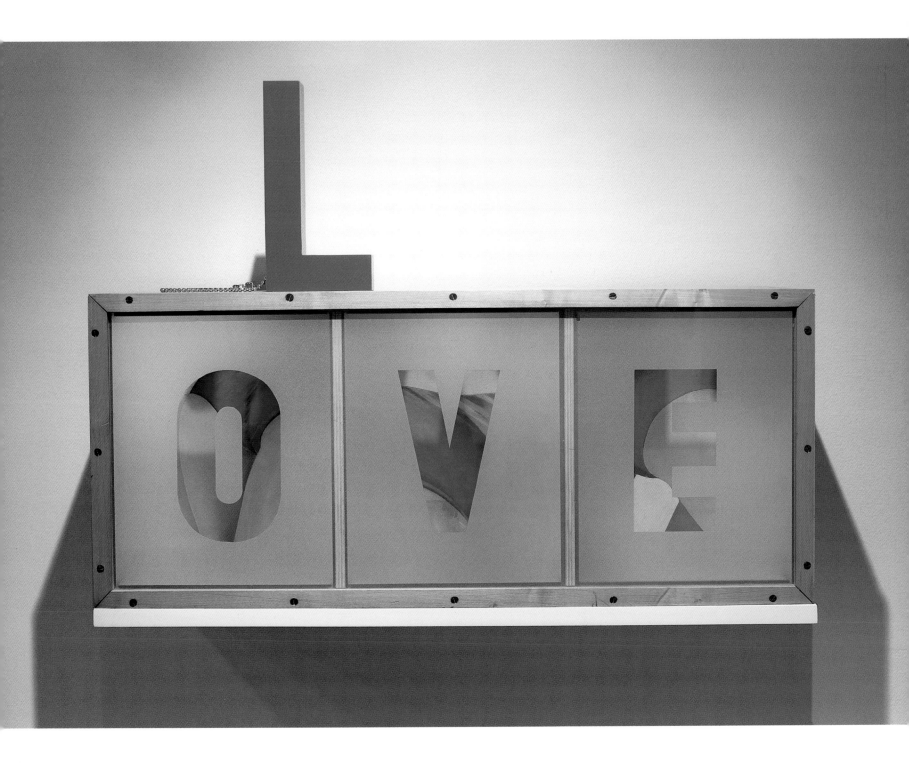

36. **Clive Barker**
British, b. 1940
Luton, Bedfordshire,
England

Two Palettes for Jim Dine
1964

Chrome-plated brass and leather over wood
26 x 30 x 2 in. (66 x 76.2 x 5 cm)
Private collection, London

This is a major transitional work for Barker, the first in which he used chrome-plated brass and leather, a carry-over from his assembly line work at Vauxhall Motors after graduation from art school. Having seen automobiles transformed by the application of chrome finishing, Barker decided to apply the same technique to his own works: "I thought it very boring, all that brown bronze. I wanted to do something shiny."[1] Each palette form in this work was cut from a sheet of brass, one covered with black leather and the other chrome-plated.

Formally the work echoes a series of Jim Dine works on the same subject of standard artist palettes. The title reflects Barker's friendship with Dine: both artists showed with London's Robert Fraser Gallery, which, on February 19, 1966, gave London artists their first exposure to West Coast art. The show, "Los Angeles Now," featured eight artists from California: Edward Ruscha, Dennis Hopper, Larry Bell, Wallace Berman, Jess Collins, Bruce Conner, Llyn Foulkes, and Craig Kauffman.[2]

The sale of *Two Palettes for Jim Dine* enabled Barker to travel to America for the first time in April 1966 where he stayed with Gerald Laing. During his New York visit, at the club Max's Kansas City, Barker met California artist Larry Bell, with whom he became friends. Barker already knew of Bell's work from his representation by Robert Fraser Gallery in London. Barker also met Jasper Johns briefly on this trip and he saw more of Johns when he returned in 1971. Barker later recalled:

> ...in London, before I left, everything was at that time what I call the "bent metal brigade." The sculptures were mostly abstract...I seemed as though I was on my own, that's how I felt. What that visit to New York did for me was that I found there were other people doing things like me...I never actually saw sculpture, but I saw paintings, and I saw that other people were doing figurative stuff.[3]

1. Unpublished interview with Barker by David E. Brauer, London, 1999.
2. Though the exhibition was titled "Los Angeles Now," Collins and Conner actually lived in San Francisco.
3. Clive Barker, quoted in *World Sculpture News*, article by Peter Davies, (Autumn 1998), p. 9.

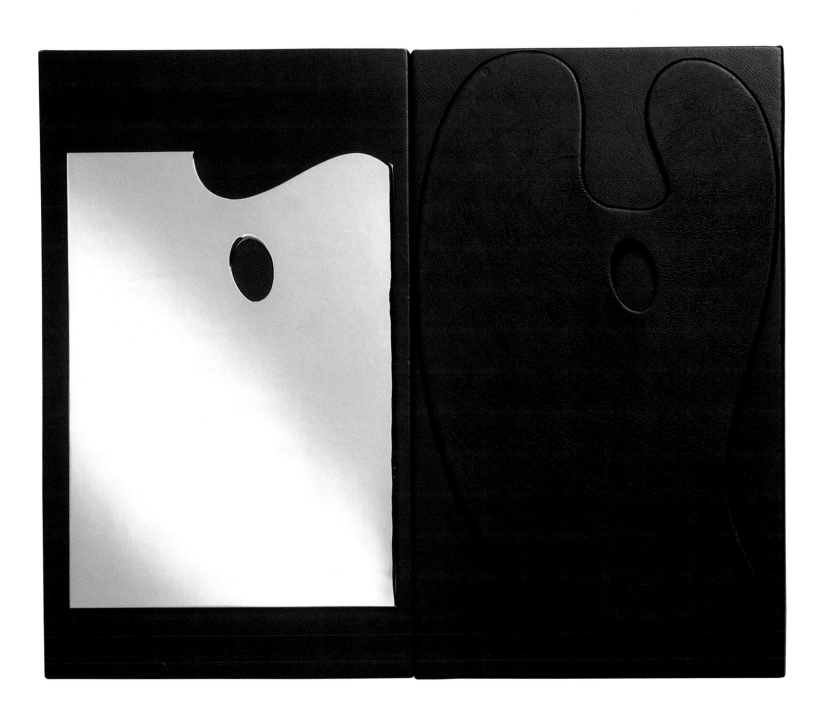

37. **Edward Kienholz**
American, 1927–1994
Fairfield, Washington

Instant On
1964

Gasoline can with glass, photographic reproductions, tar, paint, and polyester resin
9½ x 6½ x 6¼ in. (24.1 x 16.5 x 15.9 cm)
Betty and Monte Factor Family Collection

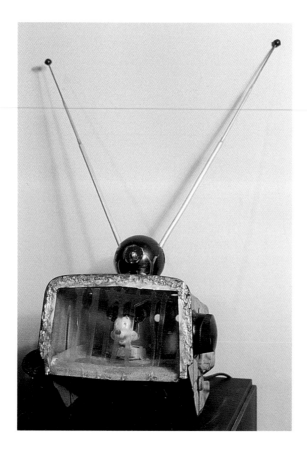

fig. 125. Edward Kienholz, *Six O'Clock News*, 1964, metal, fiberglass, flock, mop squeezer, Mickey Mouse night light, glass, and plastic knobs, 20½ x 10 x 9½ in. (52 x 25.4 x 24.1 cm), whereabouts unknown (ex. coll. WIlliam Copley).

By the 1960s, television had exceeded in popularity all other forms of mass communication in American society. It had become our eye to the outside world, providing us with both news and entertainment. But the prevalence of television and its constant onslaught of information also had a way of desensitizing its audience. Among American artists, Kienholz did more than others to make his audience aware of the repetitions in television news coverage and its insidious nature, noting how it infringes upon, and even controls, many of our attitudes about life. Bluntly stating his point in a 1968 tableau entitled *The Eleventh Hour Final*, Kienholz made a floor model television set in the form of a concrete tombstone with a Vietnam War body count etched onto the screen.

In the sculpture *Instant On*, Kienholz revamped a gasoline can into a makeshift portable television. Using photographs of the assassination of President Kennedy, Kienholz then replicated the events surrounding that terrible week in November 1963 when Americans and the world stayed glued to their televisions for the constant reenactment and ongoing appraisal of Kennedy's death. The title—which literally refers to a 1960s innovation for rapidly warming TV picture tubes—implies the seductive power of the media connection to mesmerize then "turn on" the viewer.

In a related work titled *Six O'Clock News* (also 1964, fig. 125), Kienholz constructed a fiberglass replica of a television set. Then he placed a nightlight bust of the cartoon figure Mickey Mouse inside the screen box where the image of a news broadcast anchorman would appear, suggesting that the heavily edited network news may be as "unreal" as the Disney character.

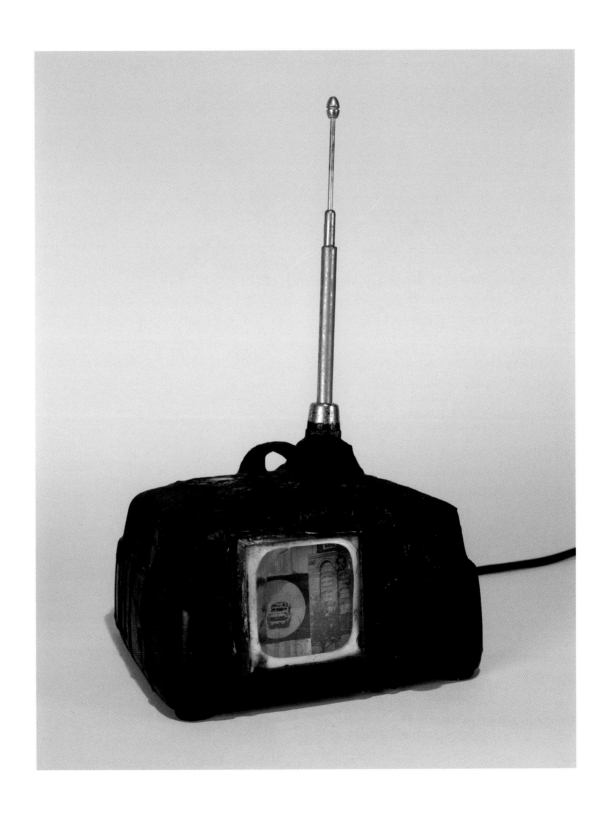

T.R. #1 and T.R. #2
1964

Duco and oil on two Masonite panels
24 x 48 in. (61 x 122 cm) overall
Courtesy Fredericks Freiser Gallery, New York

Wesley's diptych presents a double portrait of Teddy Roosevelt, before and after style: he is straight-faced in #1 and widely grinning in #2. Wesley had originally exhibited this painting in the window of San Francisco's Dilexi Gallery as part of a group exhibition titled "The Republican Convention Show" during 1964, the year that party's national convention was held in San Francisco.

Although diptychs are unusual in Wesley's body of paintings, his use of multiple images within a single work is not. And although Wesley's use of a limited range of flat, opaque colors and strong contour drawing may recall the early 1960s paintings of Lichtenstein, the emotional tenors of the two artists are distinctive and unrelated. Lichtenstein's paintings, tied to issues of popular culture, are sexy in a commercial way, while Wesley's more eccentric paintings are at times privately erotic.

T.R. #1 and T.R. #2 can be linked to a group of mid 1960s paintings, all having a painted inner frame with rounded "billiard table pockets" at the corners. Wesley's early Pop-era paintings were often very formal in their presentation, like a banner or coat of arms, but they also, like *T.R. #1 and T.R. #2,* could be humorous in an idiosyncratic way.

39. **Claes Oldenburg**
American, b. 1929
Stockholm, Sweden

Soft Toaster
1964

Vinyl and cloth filled with kapok, painted with enamel, on painted wood base
20 x 15 x 10 in. (50.8 x 38.1 x 25.4 cm)
Allen Memorial Art Museum, Oberlin College, Oberlin Ohio.
Ellen H. Johnson Bequest, 1998

fig. 126. "Exhibition of Recent Work by Claes Oldenburg" (April 7–May 2, 1964), Sidney Janis Gallery, New York, installation view. Works shown are *Plan for Wall Switches* (1964) and *Soft Toaster* (1964). Photograph by Ken Heyman.

Oldenburg's renowned soft sculptures had their origins in the Happenings he staged for his Ray Gun Theater Company in New York in the early 1960s. While preparing the props for his productions, Oldenburg and his wife, Pat, created giant figures and objects from sewn and stuffed forms of canvas and fabric. A 1962 Green Gallery exhibition included a number of large-scale soft sculptures. By 1963 he had begun creating similar objects for an April 1964 exhibition of his work at Sidney Janis Gallery (fig. 126). Included in that exhibition were soft versions of a typewriter and a telephone, and in addition to the *Soft Toaster* illustrated here, also its model, or "ghost," version.

The playful absurdity of producing hard-surfaced objects as soft and pliable became Oldenburg's signature style during this period. It strongly reinforces the notion that he is one of the most tactile artists of his generation, his soft objects appealing as much to the sense of touch as to sight.

Oldenburg has always thought of the objects that he creates not only as extensions of the human environment but also as surrogates for the human anatomy. His use of lightly textured vinyl as an exterior skin for his soft sculptures of industrial and household objects gives Oldenburg's works an immediate human dimension. The evident sense of humor, a constant in Oldenburg's sculptures, tends to sidetrack the cynicism that seems to underscore much of Pop Art. Instead Oldenburg's art is one of celebration, of wonder at the world and even its utilitarian objects.

40. **Gerald Laing**
British, b. 1936
Newcastle-upon-Tyne,
England

Deceleration No. 3
1964–69

Acrylic on canvas
52 x 48 in. (135 x 122 cm)
Private collection, Houston

fig. 127. Poster for "Gerald Laing" (November 2–30, 1965), Richard Feigen Gallery, New York.

This work belongs to a series of paintings on the subject of drag racing and parallels those works by Laing featuring astronauts and parachutists. Each of these activities is not only physically dangerous but, for Laing, also heroic, having their own mythology, costumes, and logos. Works by Laing done during his first two years at St. Martin's School of Art featured images of medieval helmets, emblems, and heraldic insignias. Another influence that the artist acknowledged was that of Quattrocento painters such as Paolo Ucello, admiring the fact that the subjects were painted in the costume of the day. Ucello's method of contrasting volumetric forms with flatter, patterned areas was sympathetic to Laing's "knights" (dragsters, parachutists, astronauts) and "damsels" (movie star pinups) in form.

The earlier works Laing did in the "dot" technique tended to be virtually monochromatic, but after his first visit to New York, he began to integrate larger flat areas of sharp color. This showed the influence of his contact with Robert Indiana while in New York. Laing had used Indiana's studio in Coenties Slip (Jack Youngerman was also working in the same building), where he absorbed the flat, hard-edge technique of these artists, combining it with his black-and-white tonal painting. Laing's personal fascination with race cars is illustrated by the poster for his 1965 New York exhibition showing the artist seated behind the wheel of a hopped-up roadster (fig. 127).

41, 42. **Edward Ruscha**	Hurting the Word Radio I	Norms, La Cienega, On Fire

Edward Ruscha
American, b. 1937
Omaha, Nebraska

Hurting the Word Radio I
1964

Oil on canvas
59⅛ x 55⅛ in. (150.2 x 140 cm)
The Menil Collection, Houston

Norms, La Cienega, On Fire
1964

Oil on canvas
64¼ x 124½ in. (163.2 x 316.2 cm)
The Broad Art Foundation, Santa Monica

In 1964 Ruscha completed seven works that played with the concept of altering a word's typography by reshaping one of its letters including two versions of *Hurting the Word Radio*.[1] In these works, Ruscha used the image of a carpenter's C-clamp, shown securing, stretching, or squeezing one of the word's letters. Ruscha loves words and their typographic styles and has used them extensively in his art. The perverse humor of distorting a letter in a word, in Ruscha's hands, can be as powerful as altering a more traditional image. Hurting the word "RADIO" by stretching its letter "O" not only plays with the word's meaning and tonal structure, but also calls to our attention the seemingly inflexible formal structure of words and their component letters, even as Ruscha suggests that these elements are in fact subject to change.

This work belongs to a group of drawings and paintings whose dimensions are twice as wide as they are high. Beginning at a point in the lower righthand corner, the objects depicted increase in scale as they project diagonally to the lefthand side of the composition. Ruscha began this series in 1962 with depictions of a wrapped loaf of Wonder Bread and of the 20th Century Fox logo. By 1963 he had painted *Standard Station, Amarillo, Texas*, and three years later he would complete *Burning Gas Station*.

Norms is a Los Angeles all-night coffee shop (fig. 128) that shares its roadside architecture with fifties-style gas stations: the same low-slung overhanging roof lines, open airy design, large glass windows, and prominent vertical thrusts, all accentuated by the floating sign out front. The building, with its gleaming interior and neon embellishments, is designed to attract customers at night, and Ruscha depicts a nighttime setting in his painting. At a certain point, he abandoned *Norms…*, and it was even shown leaning against his studio wall in a photograph with the erroneous caption "destroyed" in the catalogue of his 1982 San Francisco Museum of Modern Art exhibition.[2] In many ways, it is a singular painting and certainly the only restaurant that Ruscha depicted on fire, though burning architecture was a recurring theme. He painted other buildings in flames—*Burning Gas Station* (1965–66), and *The Los Angeles County Museum On Fire* (1965–68)— and his word painting *Damage* (1964) shows the second "A" and its neighboring "G" also aflame.

fig. 128. Armet & Davis Architects, Norms Coffee Shop, La Cienega Boulevard, Los Angeles, 1957. Photograph by Jack Laxer.

1. The seven works (all 1964) are: *Dimple* (P-64.04 [parentheses indicate Ruscha studio inventory numbers]), *Dimple* (P-64.05), *Squeezing Dimple* (P-64.06), *Securing the Last Letter* (P-64.17), *Not Only Securing the Last Letter, But Damaging It As Well* (P-64.18), *Hurting the Word Radio I* (P-64.19), and *Hurting the Word Radio II* (P-64.20). *Hurting the Word Radio II* has the same dimensions as *Hurting the Word Radio I*, a similar color scheme with darker blue background, and one C-clamp on the letter "R" and one on the letter "O."
2. Hickey, Dave and Peter Plagens. *The Works of Edward Ruscha*, exh. cat. (New York: Hudson Hills Press with the San Francisco Museum of Modern Art, 1982), p. 25.

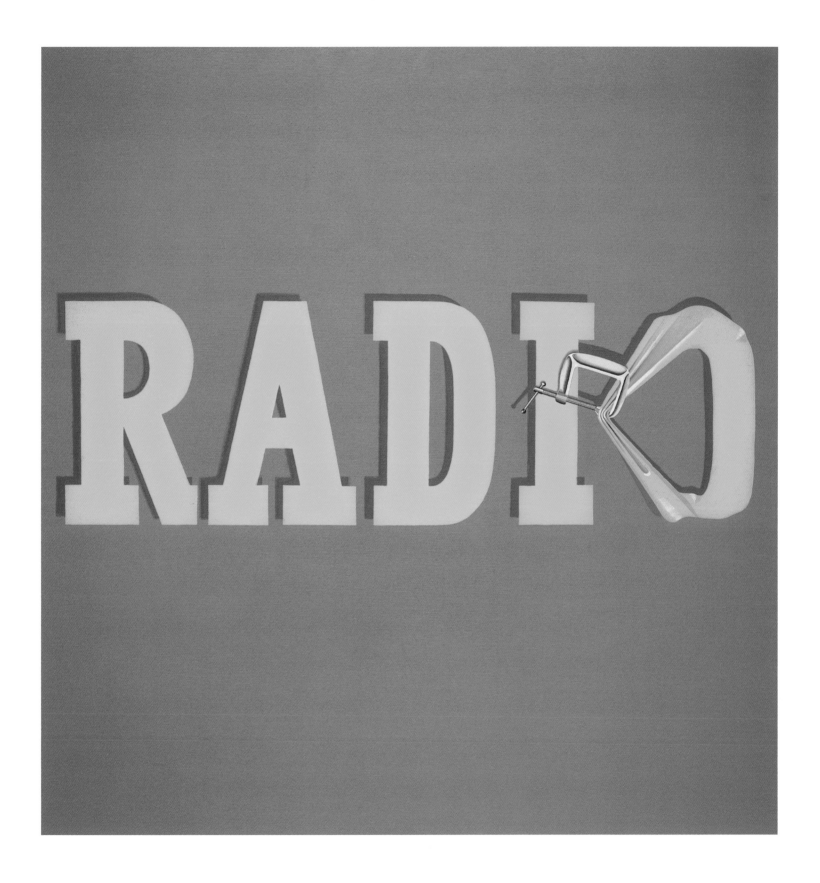

43. Patrick Caulfield
British, b. 1936
London

Corner of the Studio
1964

Oil on board
36 x 84 in. (91.5 x 213.4 cm)
Collection of Clodagh and Leslie Waddington

At first glance Caulfield's paintings would seem to have little in common with Pop Art, but he has invariably, and rightly, been included in many Pop Art exhibitions. Numerous elements in Caulfield's works—his use of preexisting images, "tasteless" objects, linearity, and episodicity; his rejection of "fine art" handling of paint; his mixture of figuration with nonfiguration, and nonspatial color with perspectival line; and his "cool" tone and the presence of irony—all fall firmly within the larger technical and expressive arsenal of transatlantic Pop Art. Further, this painting's evocation of a Eugène Delacroix work of the same title places it in the category of homages to other artists that is also typical of Pop. Critics have also noted: "One of Caulfield's main interests is in the devalued motif—pictorial matter...which has lost its original virtue because it has become either vulgarized or dated..."[1]

The extended horizontal format is characteristic of many of Caulfield's works, producing a Cinemascope ratio that requires of the viewer a long gaze to encompass not only the off-center activity but also those open areas that are nonetheless defined, both by the orthogonals of the triangular forms and by the perspectival drawing of the stove. The scattered red dots, loosely contained by the adjacent black lines, restrain the strong red of the stove, a device that Caulfield used to great effect in several works of the early and mid sixties.

Comparisons to Roy Lichtenstein were inevitable, but "...Caulfield's consistently even thickness of line produces an emotionally uncommitted effect rather different from Lichtenstein's scrupulous imitation of 'expressive' drawing."[2]

1. David Thompson, catalogue entry in *The New Generation: 1964*, exh. cat. (London: Whitechapel Art Gallery, 1964), p. 19.
2. Thompson, p. 20.

44. R. B. Kitaj
American, b. 1932
Cleveland, Ohio
Worked in London

The Ohio Gang
1964

Oil and graphite on canvas
72⅛ x 72¼ in. (183.1 x 183.5 cm)
The Museum of Modern Art, New York.
Philip Johnson Fund, 1965

fig. 129. R. B. Kitaj in front of
The Ohio Gang (1964), 1965.
Photograph by Jerry Shatzberg.

In his own statement regarding "this (very) late Surrealist picture," Kitaj described it as "a freely associated depictive abstraction." After identifying the source of the yellow ribbon and the woman imprecated by two suitors as "Ford's great movie [*She Wore a Yellow Ribbon*]," Kitaj stated that he modeled the men on two friends, the poet Robert Creeley (standing) and the actor Jack Wardell. He then observed that the woman is naked, "as in Manet's *Déjeuner,* and attended like his *Olympia,* by a black maid ... an American tragedy." The source of the "Maenad-Nanny on the right lay in those pre-Christian wraiths the Warburgers[1] detected at the base of crucifixions in art," while the homunculus she pushes refers to Kitaj's child who died at birth when he began this painting. The apelike figure is associated with both vice and lust, and the art of painting. Kitaj concluded: "There was no rational plan for this picture, no programme to speak of. The irrational title doesn't refer to the Ohio Gang of Mark Hanna etc. But to my own cast of characters associated here in free verse or as in early [Luis] Buñuel."[2]

The Ohio Gang is the first major example of what Kitaj refers to as modern history painting, not the mythological or historical past, but the psychological present. "Everyone carries an enormous, passionate psychological-historical experience within him," Kitaj once observed. "There is an awful resistance from the history of painting, which is going in another direction. You can't call the drift of modernism Joycean ... in painting, and so I was tugging the other way."[3] Kitaj built a pictorial atmosphere of ambiguity, danger, sexuality, and squalor, a Weimar tableau permeated with personal references.

Technically, *The Ohio Gang* clearly shows a shift from the painterliness of *Tarot Variations* (1958, pl. 2). The dripped and gestural surface has become flatter, more linear. Kitaj noted: "I'm so careful about the contours of the things I'm making, . . . it's in the contour that all the critical decisions about form get to be made."[4]

1. These were followers of the German art historian Aby Warburg who approached the art of the Florentine quattrocentro not in formal terms but as part of the period's intellectual history.
2. R. B. Kitaj, quoted in *R. B. Kitaj,* exh. cat. (London: Tate Gallery, 1994), p. 84.
3. R. B. Kitaj, quoted in "The 'fugitive passions' of R. B. Kitaj" by Jerome Tarshis, *Art News* (October 1976), p. 41.
4. R. B. Kitaj, quoted in Tarshis, p. 41.

45, 46. Allen Jones
British, b. 1937
Southampton, England

Curious Woman
1964–65

Female and Male Diptych
1965

Oil and spray paint on wood with epoxy-filled plastic falsies
48 x 40 in. (122 x 101.6 cm)
Collection of Kimiko Powers

Oil and pencil on canvas
72 x 120 in. (182.9 x 304.8 cm)
Hirshhorn Museum and Sculpture Garden, Smithsonian Institution,
Washington, D.C.. Gift of the Joseph H. Hirshhorn Foundation, 1972

After his inclusion in "The New Generation: 1964" exhibition at Whitechapel Art Gallery in London, Jones felt the need for some firsthand experience of the United States, suspecting that British Pop was perhaps only a shadow version of its American counterpart. During 1964–65 Jones and his wife lived and worked at the Chelsea Hotel in New York, and in this fertile environment his works took on a new, more confrontational aspect. Jones credits David Hockney, in New York at the same time, with pointing out to him the linkage between his paintings of hermaphrodites and the sort of illustrations that appeared in American fetish magazines:

> I nearly blew my mind on the 6th Avenue book shops looking at all this drawing. I began to appreciate the vitality of this kind of drawing of the human figure, which had been produced outside the fine art medium. So I started to collect as much of the stuff as I could and began going through mail order catalogues. The point is, if you're doing a drawing to sell a product, like the Frederick's of Hollywood catalogue, there is no way that the product would sell if the drawing didn't come to the point. There was no extraneous line or information...[1]

Jones painted *Curious Woman* as a companion piece to a work that he had painted in London and brought to New York, both of them part of a series of paintings done on wood panels. The epoxy-filled plastic falsies were bought at a novelty store, their use perhaps prompted by the appearance of a similar device in Richard Hamilton's painting *Pin-up* (1961, fig. 24).

1. Allen Jones, quoted in *Allen Jones* by Victor Arwas (London: Academy Editions, 1993), pp. 35–36.

In 1961 Jones began to explore the area of male-female imagery and issues of sexual identity in paintings that have become his most reproduced works. The binary relationship of male/female implies the dualistic nature of human experience (mind/body, sexual/spiritual, concrete/abstract). Jones clearly had read his Nietzsche, Freud, and Jung, though he refrained from making these an overt presence in the works. In fact, the artist was always careful to distance his paintings from being read too literally as a narrative.

About this 1965 diptych, Jones has said the following:

> Nietzsche's *Zarathustra* provided me with a theme for my painting which has run like a thread through my work ever since. His idea of likening the creative process to a happy marriage appealed to me and in 1964 I made a folio on the subject, called *Concerning Marriage*, in which one suggested various ways in which the male and female body could be fused into one.
>
> It occurred to me that a very graphic and physical way of dealing with this subject would be to physically join (screw) two canvases together and to designate a gender to each canvas. This was a departure point for the imagery that was painted upon them, so the union was complete, not only in the subject matter but also in the physical fact of the diptych.
>
> In my studio at the Chelsea [Hotel, New York], the diptych occupied a large amount of wall space and when it was finished I stacked the canvas one upon another, to one side of the room. It was by chance that the female legs that rested against the left side of the painting were now standing on the floor, sharing the same space in which I was standing. The implications of this I was to pursue in the subsequent series of leg paintings which showed a pair of woman's legs from the knee to the shoe, with a small shelf attached to the bottom of the canvas.[2]

2. Allen Jones, conversation with David E. Brauer, June 2, 2000.

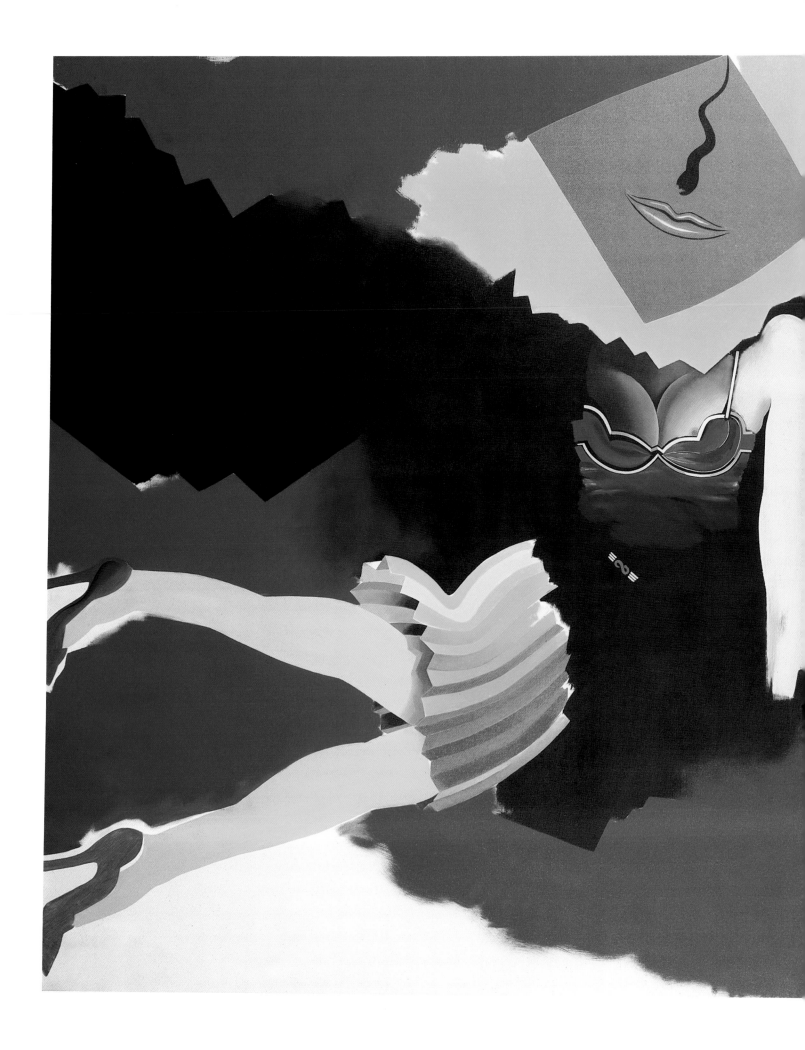

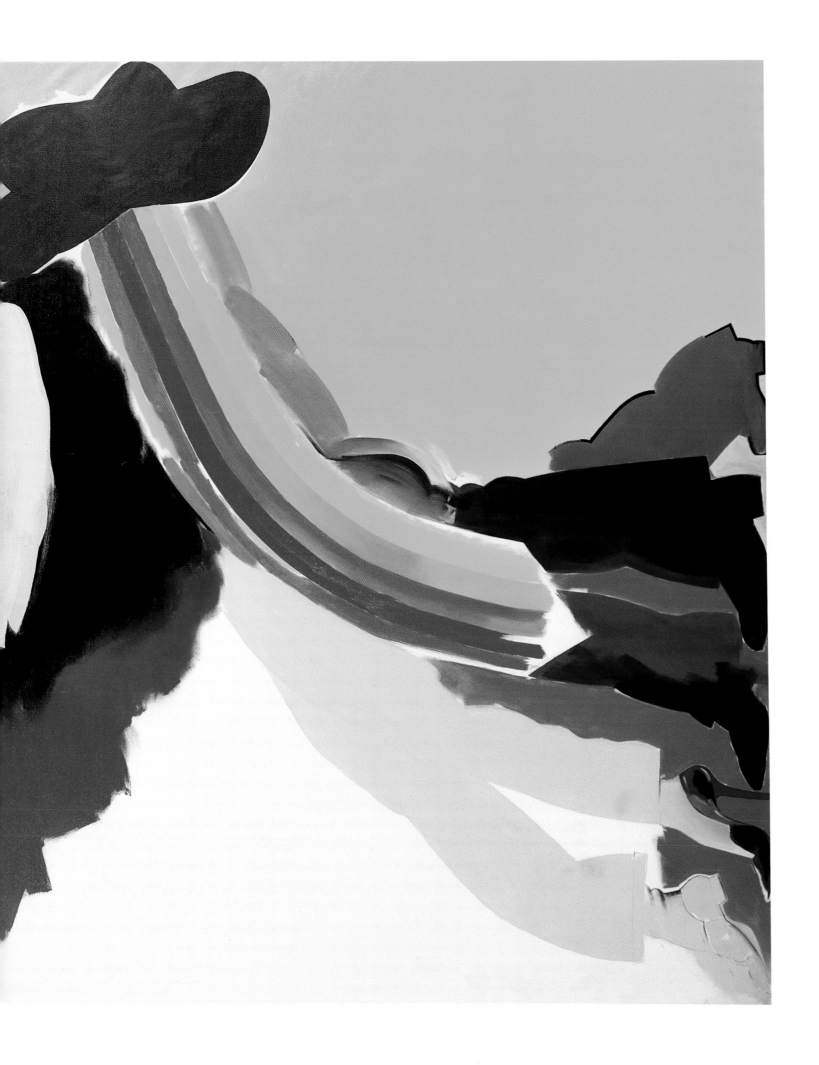

47. **Roy Lichtenstein**
American, 1923–1997
New York City

Head with Blue Shadow
1965

Glazed ceramic
15 x 8¼ x 8 in. (38.1 x 21 x 20.3 cm)
The Patsy R. and Raymond D. Nasher Collection, Dallas, Texas

Lichtenstein's early ventures into the three-dimensional world of sculpture and ceramics were a direct response to the images he was using in his paintings. In 1965 he began working closely with ceramist Hui Ka Kwong, a colleague from Douglass College, Rutgers University, in the creation of ceramic cups and heads. The cups were made from either commercial molds or molds prepared by Kwong. Lichtenstein also made two ceramic heads, each fifteen inches in height, that were three-dimensional versions of the girls from true romance cartoons he had included in his paintings of 1963–65. Both *Head with Black Shadow* (1965) and *Head with Blue Shadow*, along with his cups and saucers, were part of the exhibition "Roy Lichtenstein: Brushstrokes and Ceramics" at Leo Castelli Gallery in New York (November 20–December 11, 1965).

Moving from the flat surface of the canvas to the round forms of the ceramic heads presented a new set of problems. In explaining the processes that he and Kwong devised for reproducing his trademark benday dots, Lichtenstein stated that they began with "decals made of ceramic material and then, primarily for the faces, I made a tape of evenly punched holes which was fairly flexible so that I could adjust it and bend it to conform to the contours."[1] Next a glaze would be sprayed and some areas painted by hand, but once the perforated tape was removed, Lichtenstein's benday dot patterns were left in place.

1. Roy Lichtenstein, quoted in *Roy Lichtenstein* by Diane Waldman, exh. cat. (New York: Solomon R. Guggenheim Museum, 1993), pp. 315, 321.

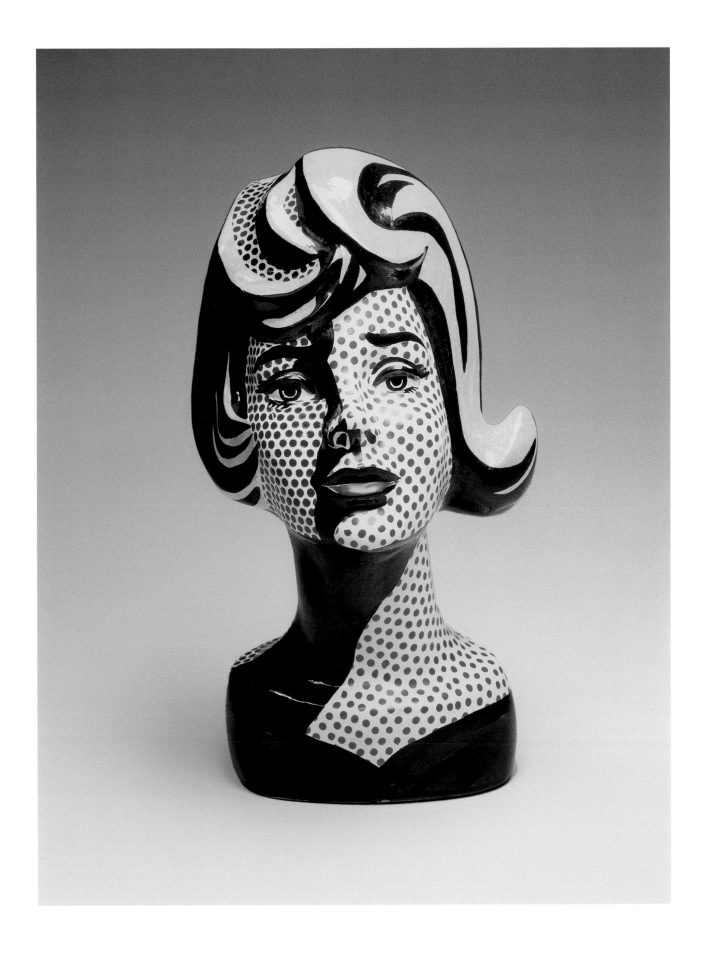

48. Peter Phillips Custom Painting no. 5 Oil on canvas
British, b. 1939 1965 67³/₄ x 118¹/₈ in. (172 x 300 cm)
Birmingham, England Collection of Bruno Bischofberger, Zurich

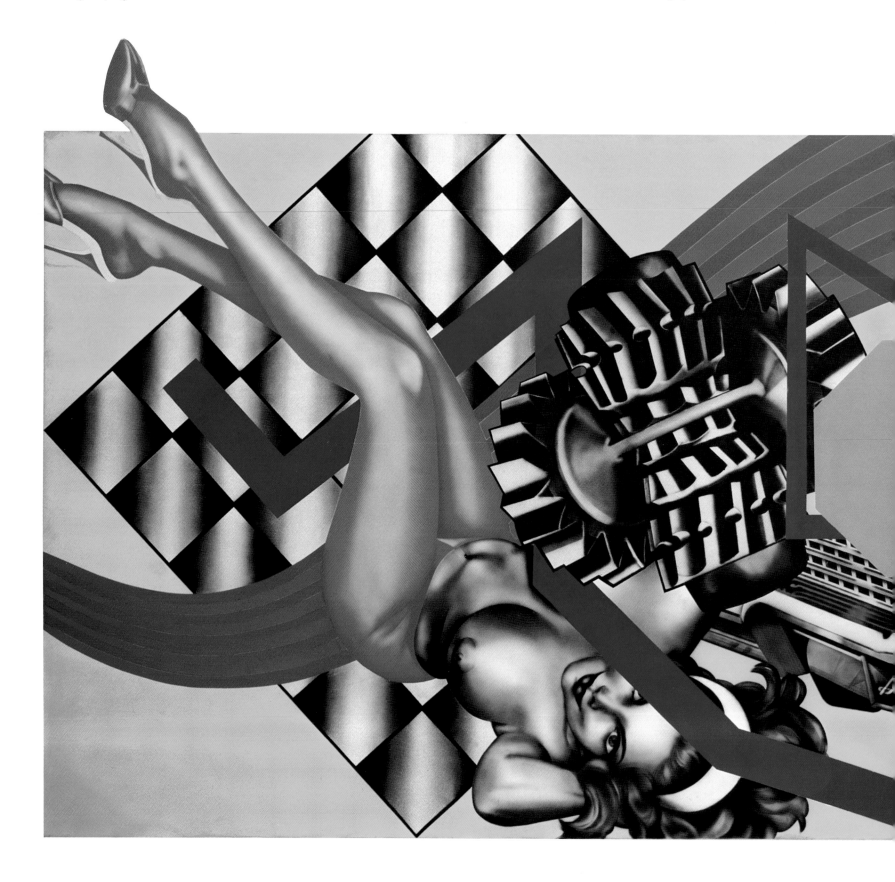

Phillips began the series of eight "custom paintings" in New York in September 1964 while on a two-year Harkness Fellowship; the last of the series was completed in 1967. For these works Phillips employed the airbrush technique, resulting in a smooth, unified surface of collage-like images. The work here includes a figure from a pinup magazine and other images, photographed and then projected onto the canvas, Phillips' usual practice at this time.

He also adopted a shaped canvas, with the contour of one foot extending beyond the rectangle of the canvas. Many artists on both sides of the Atlantic were experimenting with the shaped canvas, which had become something of a fad by the mid sixties.[1] Phillips' earlier awareness of the architectural forms often found in early Italian painting and his study of heraldic forms, flat colors, and figurative imagery are useful markers by which to read these large works.

Phillips once commented:

> I did particularly like early Italian paintings, pre-Sienese and Florentine painting, where they split up the surface of the painting. It wasn't an illusionistic space. . . . I was fascinated by the way they would divide up a panel. They would paint a figure and then they would have five or six little scenes going on, and to me that was very beautiful, and still is.[2]

In the year he completed the work, Phillips had his first one-person exhibition at Kornblee Gallery in New York, joined Allen Jones to explore America by automobile, and saw James Rosenquist's monumental *F-111* at Leo Castelli Gallery in New York, which would influence Phillips' subsequent move to larger canvases. As the artist has said: "I could never work on a small scale, I never felt satisfied. I need room to move around in, and to get the compositional elements to relate, I've got to have a certain amount of space in between."[3]

1. Among the earliest artists to explore this format were Frank Stella and Ellsworth Kelly. David Hockney can be credited with the first such work done in Britain, followed by Richard Smith, Derek Boshier, and Phillips.
2. Peter Phillips, quoted in *Retrovision: Peter Phillips Paintings, 1960–82*, exh. cat. (Liverpool: Walker Art Center, 1982), p. 14.
3. Ibid, pp. 19–22.

49. **Mel Ramos**
American, b. 1935
Sacramento., California

Hunt for the Best
1965

Oil on canvas
47¾ x 30¾ in. (121.3 x 78.1 cm)
Collection of Richard L. Weisman

fig. 130. Mel Ramos, *Lola Cola #2*, 1971, oil on canvas, 60 x 50 in. (152.4 x 127 cm), private collection, France.

In 1964 Ramos began his large group of paintings depicting *Playboy* magazine's centerfold Playmates posing with outsize American consumer products. By juxtaposing the girlie magazine poses with blatantly phallic popular American brand packaging, Ramos expanded upon the implied sexual tease that underlies much of straight commercial advertisement. The erotic nature of *Hunt for the Best* is heightened by the model's near embrace of the tumescent bottle of ketchup. Ramos often reused the same model in an identical pose for different paintings, and the model in *Hunt for the Best* appeared in two later works, first in the 1971 oil on canvas *Lola Cola #2* (fig. 130), where the brunette model "rests" upon a bottle of Coca-Cola, and again in a 1981 watercolor that replicates the original painting.

50, 51. Eduardo Paolozzi

British, b. 1924
Leith, Scotland

Wittgenstein in New York

from the *As Is When* series

1965

Silkscreen on paper
37³/4 x 25³/4 in. (95.9 x 65.4 cm)
Yale Center for British Art, New Haven, Connecticut.
Paul Mellon Fund

Wittgenstein at the Cinema Admires Betty Grable

from the *As Is When* series

1965

Silkscreen on paper
37³/4 x 25³/4 in. (95.9 x 65.4 cm)
Yale Center for British Art, New Haven, Connecticut.
Paul Mellon Fund

fig. 131. Cover and pages from sales promotion for *As Is When* portfolio by Eduardo Paolozzi, published by Editions Alecto, London, 1965.

Prints, in a variety of mediums, played an important role in Paolozzi's experiments, and the finest of them began in the early 1960s when he started making screenprints with Christopher Prater at the Kelpra Studios in 1962. Printmaking generally is a conservative activity: often the process takes precedence over the content, and screenprint techniques in particular were seen as more the activity of the printer rather than the artist. For Paolozzi this distancing was almost the virtue of the medium: "For me the day of the artist struggling with his bare hands is finished. Nobody would expect an aerodynamicist to build his own wind tunnel."[1]

In his presentations given at the Institute of Contemporary Arts in 1952, Paolozzi had shown his numerous images culled from advertisements, science fiction magazines, and the like. Paolozzi recycled many of these images into his great portfolio of screenprints *As Is When*, including the two examples here. This suite of twelve prints was based on the twentieth-century philosopher Ludwig Wittgenstein. Most of these prints were functionally abstractions, but three of them incorporated images pertaining to the philosopher's life: his time as a soldier, his sojourn in New York City, and his frequent visits to the movies. The portfolio also included Paolozzi's text "Wild Track for Ludwig–The Kakafon kakoon laka oon Elektrik lafs," a collage of texts drawn from a variety of sources.

Paolozzi assembled the collages, which were then developed into stencils using both photomechanical processes and manual color separation, working in total collaboration with the printer. The prints were made from multiple screen pulls using precision registration techniques. The *As Is When* portfolio (fig. 131) has come to be regarded as among the greatest and most complex works in the silkscreen medium and one of the monuments of British Pop Art, encapsulating many of the original aspirations of the Independent Group.

1. Eduardo Paolozzi, quoted in "Spotlight on *Moonstrips Empire News*—Eduardo Paolozzi's dialogue with the mass media" by Christopher Finch, *Vogue* (August 1967) p. 62.

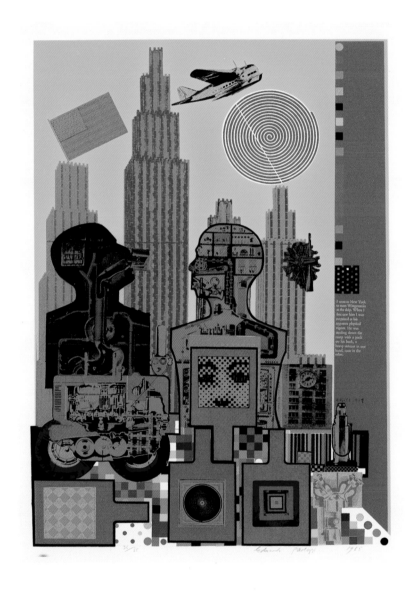

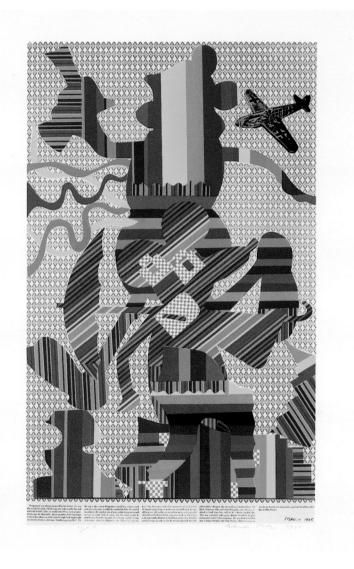

52. **Joe Tilson**
British, b. 1928
London

P.C. from N.Y.C.
1965

Silkscreen with collage
77½ x 25½ in. (196.8 x 64.8 cm)
Courtesy Alan Cristea Gallery, London

In looking at half a century of Tilson's immensely varied and original oeuvre, it seems obvious that, with a few exceptions in the constructions, the screenprints that Tilson produced between 1964 and 1969 constitute a major part of his contribution to British Pop Art. By 1965 Tilson was experimenting with the idea of three-dimensional prints, such as the Rainbow Grill matchbook that he had kept as a souvenir of an evening in the company of Barnett Newman. *P.C. from N.Y.C.*, one of the primary prints from the sixties, was in part a product of that interest:

> *P.C. from N.Y.C.* was derived from a foldout postcard package of New York City landmarks titled "New York–Magic City of Light," images in sync with Tilson's general interest in urban life during this period. Enlarging it photographically to over six feet in height, Tilson emblazoned

famous American symbols in brash colors against dramatic night skies. He created the illusion of a three-dimensional, unfolding accordion with the zigzag format composed of three sheets of irregular-shaped paper, and cleverly simulated details like the wrapped flap and publicity text out of stiffer board in his complex paper assemblage. Tilson, like so many of the Pop artists, was attracted to screenprint for its photographic capabilities, and this print is a tour de force for the artist …it has become one of the quintessential examples of the inventiveness with materials, the creative recycling of popular images, and the British fascination with American culture that characterized printmaking of the Pop era.[1]

Tilson went on to experiment with vacuum-formed plastics and screenprint images integrated into wood reliefs. He said:

I was trying to make very strong, unforgettable images using the latest technology and printing and vacuum forming methods . . . consciously avoiding "fine art" etching and lithography—making work that strongly represents the time and culture—avoiding nostalgia. . . . Richard Smith, Peter Blake, Derek Boshier, and myself were all engaged in making paintings using ideas taken from paper ephemera—enlarged Japanese paper toys, postcards, tickets, air-mail letters, newspapers, sweet wrappings, packaging, match boxes, etc., etc.[2]

1. Pat Gilmour, *Kelpra Studio,* exh. cat. (London: Tate Gallery, 1980), p. 3.
2. Joe Tilson, conversation with David E. Brauer, February 1988.

53. **R. B. Kitaj**
American, b. 1932
Cleveland, Ohio
Worked in London

Walter Lippmann
1966

Oil on canvas
72 x 84 in. (182.9 x 213.4 cm)
Albright-Knox Art Gallery, Buffalo, New York.
Gift of Seymour H. Knox, Jr. 1967

fig. 132. Lobby card showing Robert Donat in *The 39 Steps* (1935).

This is one of the most complex in conception and clearest in construction of Kitaj's paintings: the references to other art and to film are direct, and the larger expressive uses to which they are applied are given sharp focus. The title refers to the American journalist Walter Lippmann who is seen in the lower righthand side of the painting, his written name a part of the image.

He gazes toward the two figures in the center left, the closest of whom is a young girl on a ladder whose lower rungs seem to evaporate. Her skirt is semi-transparent, and her contoured bottom and pubic hair can clearly be discerned. Her face, painted in a Fauve yellow (Henri Matisse is an important artist to Kitaj), is framed by braids and supported by a strip of green, which extends to, or descends from, the top of the canvas; on both sides of the strip are bulldog paper clips.

The male figure to the right gazes at the girl's bottom as he is about to drink, or has just drunk, from the cocktail glass. The figure's pose is taken from a studio still on a lobby card featuring Robert Donat (fig. 132), an asthmatic British actor who usually portrayed quietly heroic figures here seen as the British adventurer Richard Hannay from *The 39 Steps* (1935). Kitaj has transformed the actor into a wounded figure, head bandaged and also supported by a green band, without clips. The figure's melancholy is echoed in the film noir-derived image of a man and woman confronting each other at the top of a staircase. Between is a slightly perspective grid of sharply defined horizontals and rectangles, almost De Stijl-like in its starkness and in contrast to the thinly rubbed paint of the figures. The image at the top right of two hands extending out from a coffin and raising the lid is appropriated from the famous painting by the Romantic Belgian painter Antoine Wiertz who pursued morbid, Poe-like subjects. As with many of Kitaj's works of this period, the painting is permeated by a sense of restraint and constraint, voyeurism and desire, of modern unease.

54. **David Hockney**
British, b. 1937
Bradford, England

Peter Getting Out of Nick's Pool
1966
Not in the exhibition

Acrylic on canvas
84 x 84 in. (213.4 x 213.4 cm)
Walker Art Center, Liverpool

fig. 133. "Living Extra" advertising take-off, *The Observer Magazine* (June 2, 1985, London).

I'm in the Mood for Love resulted from Hockney's first trip to New York, but it is the California scene with which he is most closely identified. However, for all their apparent celebration of the hedonistic Los Angeles life style, Hockney's works have a cool technical and expressive quality. This is, in part, due to his conversion from oil to acrylic paint with its attendant thinner, often stained quality.

The detachment of these works may also reflect, if not the influence, then the awareness of aspects of California painting: like Edward Ruscha and Wayne Thiebaud, Hockney has the ability to find pictorial interest in the most near-at-hand and mundane objects and environments of a city hitherto regarded as devoid of scenic possibilities. The images of swimming pools, much reproduced (and sometimes parodied, as in fig. 133), capture the essence of Hockney's fascination with his chosen environment, one as far removed from his native Bradford as could be imagined. Hockney has given frequent expression to what fascinated him in this scene—"three times better than I ever imagined it"—recalling that as he flew in over San Bernadino, he looked down, "and saw the swimming pools and the houses and everything and the sun, I was more thrilled than I have ever been arriving in any other city."[1] Hockney returned to Los Angeles from London in the summer of 1966 and stayed for a year, teaching for six weeks at the UCLA summer school.

As with most Pop Art, Hockney often uses photography as the primary source material for his paintings, and the California works of this period are usually a persuasive synthesis of figurative naturalism with stylized depictions of architecture and Jean Dubuffet-like swirls in the water. This work's homoerotic nature, classical in its restraint, is self-evident.

1. David Hockney, quoted in *Portrait of David Hockney* by Peter Webb (New York: E. P. Dutton, 1989), pp. 130–31, caption to illus. 80.

55. Richard Hamilton
British, b. 1922
London

The Solomon R. Guggenheim (Spectrum)
1965–66

Fiberglass and cellulose
48 x 48 x 7¼ in. (122 x 122 x 18.4 cm)
Solomon R. Guggenheim Museum, New York

fig. 134. Cover of the souvenir booklet for the opening ceremonies of the Frank Lloyd Wright building of the Solomon R. Guggenheim Museum, New York, 1959.

The Solomon R. Guggenheim Museum

1959

The Solomon R. Guggenheim Museum is the most uniquely identifiable museum structure in the world, even more of a signature building than its sibling in Bilbao, Spain. It was designed by the esteemed American architect Frank Lloyd Wright in 1943–46 and constructed in 1956–59 (fig. 134). Hamilton asked Lawrence Alloway, a curator at the Guggenheim at the time of this work, to send him some photographs of the building, which the artist first rendered in "heroic" terms. Several paper studies were executed, followed by six large fiberglass cast versions, which were sprayed with various coatings using an airbrush.

In the first of these reliefs, Hamilton rendered the form in black and white. The second, shown here, was produced in black, its sheer, highly reflective finish warping the structure of the building with mirrored reflection. The third version was coated in a type of automobile finish called "metal flake," which mixes particles of anodized aluminum with clear lacquer, producing a very "California" glossy effect. The fourth was painted with Neapolitan ice cream colors: vanilla, strawberry, and pistachio. The fifth sported gold leaf, giving the building a medieval quality, and the sixth, *Spectrum*, was banded with the Newtonian prism.

While the "edition" aspect of the Guggenheim series is consistent with the sixties Pop Art preoccupation with screenprints, multiples, and other serial productions, Hamilton's activities can be related to the works and editions of Marcel Duchamp, an artist whom Hamilton deeply admired and with whose works his name is indissolubly linked. Their relationship was also a matter of like temperaments: intellectual and analytical, ironical and skeptical. From Duchamp Hamilton learned to question the verities of art and the sanctity of the unique object, and to expand, if not always reject, traditional methods of technique.

56. Clive Barker
British, b. 1940
Luton, Bedfordshire,
England

Van Gogh's Chair
1966

Chrome-plated steel and brass
34 x 36 x 20 in. (86.4 x 91.4 x 50.8 cm)
Private collection, London

fig. 135. Vincent van Gogh, *Van Gogh's Chair*, 1888, oil on canvas, 36⅛ x 28¾ in. (91.8 x 73 cm), The National Gallery, London.

Barker made a series of sculptures as homages to other artists, including Francis Bacon, Jim Dine, and René Magritte. Since his youth, Barker had also admired the painting of Vincent van Gogh's chair at the National Gallery, London (fig. 135), and he decided to make his own three-dimensional version of it. Although the painting shows a rough-hewn, wooden Provençal chair, Barker wanted to make its material antithesis: a smooth, metallic surface that would emphasize van Gogh's loneliness and isolation.

In 1966 Barker visited the exhibition "Los Angeles Now" at the Robert Fraser Gallery, which gave London artists their first exposure to West Coast American art by artists such as Larry Bell. Both Bell and Barker were familiar with industrial processes and both placed an emphasis on refined finishes. When asked the difference between New York and West Coast Pop Art, Bell once replied simply, "Finish!"[1] Echoing Bell's remark in 1989, Barker said, "...I was looking for a perfect finish, in a way. Maybe that was something to do with Vauxhall Motors [his former employer], but I think I'm a perfectionist anyway."[2]

Barker executed three versions of the chair. While all three chairs are identical, the bases on which they stand are each different. In the first version, the chair stands on movable tiles; in the version here, the tiles follow the orthogonal lines of the painting; and the third version has a circular base, as if the chair were in a spotlight. Technically, the flooring is of one piece, adhering to the frame and the perspectival lines.

The chair is remarkably light, being made of chrome-plated brass tubing. The bronze ladder-back segment was cast separately from a real chair, then welded onto the brass seat, after which the whole was chrome-plated. Barker would continue the theme in later works: *Van Gogh's Ear* (1967), *Van Gogh's Sunflowers* (1969), and *Van Gogh's Hat with Candles* (1969) followed.

1. Larry Bell, conversation with David E. Brauer, Taos, 1997.
2. Clive Barker, quoted in *Pop Art: An International Perspective*, (London: The Royal Academy of Arts, 1991), p. 155.

57. **Edward Ruscha**
American, b. 1937
Omaha, Nebraska

Annie, Poured from Maple Syrup
1966

Oil on canvas
55 x 59 in. (139.7 x 150 cm)
Norton Simon Museum, Pasadena, California.
Gift of the Men's Committee, 1966

This important transitional painting followed several single-word *Annie* paintings including Ruscha's six-foot-square *Annie* (1962), an oil painting on canvas whose fat balloon letters replicate the typography of the heading for the newspaper comic strip *Little Orphan Annie.* Both the bulbous letters and the name "Annie" itself were as distinctive as the brand names appearing in other Pop works, such as "Campbell's" for soup or "Kellogg's" for cereal.

The name of the comic strip is again replicated, but it has changed in colors from a bright red, boldly outlined in black, to the amber color of maple syrup. The word rises, in a trompe l'oeil fashion, above the orange background, but individual letters are beginning to decompose at their edges, underscoring the ephemeral nature of any object formed from a liquid. A 1969 lithograph, *Annie,* used essentially the same treatment and coloration.

Annie, Poured from Maple Syrup is also one of Ruscha's first "liquid" paintings. In 1967, shortly after completing this work, Ruscha embarked on an extended series of paintings based on words formed from renderings of various poured fluids. While the liquid paintings simply represented such fluid elements as soap bubbles, syrup, and jelly, in 1970 Ruscha went a step further: he created a series of prints (*News, Mews, Pews, Brews, Stews,* and *Dues*) using actual organic mediums ranging from black-currant pie filling and red salmon roe to chocolate syrup and mango chutney.

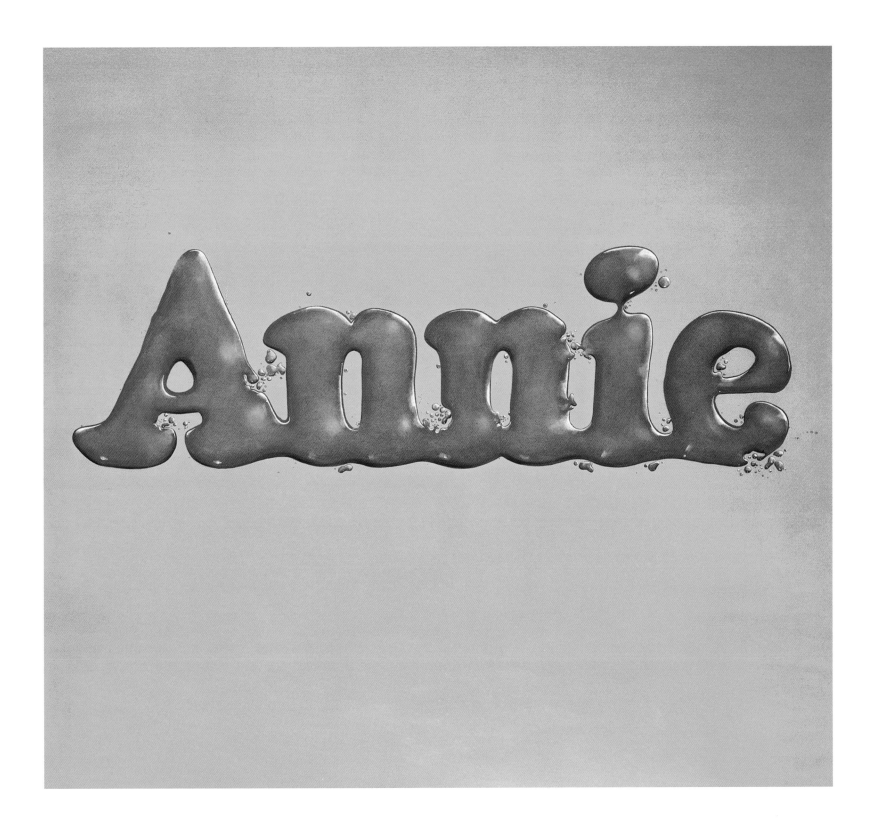

Chronology and Selected Bibliography

Chronology: 1956–1966

U.S./U.K. Pop Art, Historic and Cultural Events

pages 224–25. Wall in Roy Lichtenstein's studio, 36 West 26th Street, New York, 1964, showing sketches and source materials. Painting at left is *Sound of Music* (1964, detail); a study drawing and its comic strip source are at right center. Photograph by Ugo Mulas.

fig. 136. Now Gallery, Los Angeles, exterior view, 1956.

fig. 137. Announcement for "objects on the new landscape demanding of the eye" (March 15, 1957), inaugural exhibition at Ferus Gallery, Los Angeles.

an invitation to the opening of
FERUS GALLERY

Friday March 15th, 1957 from 8:30 p.m.

OLdfield 2-7859
736a north la cienega, los angeles

objects on the new landscape
demanding of the eye

open daily 1 to 5; evenings, wednesday thru saturday

United States

Jim Edwards

1956

Dwight D. Eisenhower is reelected President of the United States.

The National Defense Highway Act is passed by Congress authorizing the construction of an interstate highway system.

Allen Ginsberg's *Howl and Other Poems* is published.

Johnny Cash records "I Walk the Line," Elvis Presley records "Heartbreak Hotel," and Little Richard records "Tutti-Frutti."

The movies *Giant*, *Love Me Tender*, and *The Trouble with Harry* are released.

February 23–March 10 "George Segal," the artist's first one-person exhibition, is held at Hansa Gallery, New York.

May 21–June 9 "Ellsworth Kelly," the artist's first one-person exhibition in the United States, is held at Betty Parsons Gallery, New York.

May 29–September 9 "Twelve Americans," The Museum of Modern Art, New York, includes the work of Larry Rivers.

June Edward Kienholz opens Now Gallery at the Turnabout Theater, 716 North La Cienega Boulevard, in Los Angeles.

August 11 Abstract Expressionist artist Jackson Pollock dies.

September 27 Black Mountain College in Asheville, North Carolina, closes; the college was a bohemian teaching environment and the site of John Cage's 1952 "Theater Piece #1" (a prototype Happening).

December 19–February 3, 1957 "Jackson Pollock," a memorial exhibition of the artist's work, is held at The Museum of Modern Art, New York.

1957

President Dwight D. Eisenhower sends federal troops to Central High School in Little Rock, Arkansas, to enforce the integration of black students into an all-white school.

Jack Kerouac's *On the Road* is published.

American television premieres *Perry Mason*, *Leave It to Beaver*, and *Wagon Train*.

Leonard Bernstein's and Stephen Sondheim's *West Side Story* premieres on Broadway.

Jerry Lee Lewis records "Great Balls of Fire," and Elvis Presley records "All Shook Up" and "Jailhouse Rock."

February 1 Leo Castelli Gallery opens at 4 East 77th Street in New York with a group show including Willem de Kooning and Jackson Pollock.

March 10–April 28 "Artists of the New York School: Second Generation" is held at the Jewish Museum, New York.

March 15–April 11 Edward Kienholz and Walter Hopps open Ferus Gallery at 736A North La Cienega Boulevard in Los Angeles with the exhibition "objects on the new landscape demanding of the eye."

June 7–July 4 "Wallace Berman," the artist's first one-person exhibition, is held at Ferus Gallery, Los Angeles. The exhibition is closed during the second week by the Los Angeles Police Department, which declares parts of it to be pornographic.

United Kingdom

David E. Brauer

1956

Anglo-French forces invade the Suez Canal on October 31.

Commercial television begins broadcasting; the first advertisement is for Pepsodent toothpaste.

Teenagers are identified as a new social presence.

John Osborne's play *Look Back in Anger* premieres at Royal Court Theatre, London, launching a new wave of British realist theater.

Elvis Presley breaks into the British Top Ten with "Heartbreak Hotel" and "Blue Suede Shoes."

BBC Radio airs "Drums Along the Mersey" by the cast of *The Goon Show*, an important voice in anti-Establishment absurdism.

Colin Wilson's novel *The Outsider* is published.

January "Modern Art in the United States" at the Tate Gallery, London, includes works by Mark Rothko, Jackson Pollock, William Baziotes, Willem de Kooning, Arshile Gorky, and others.

January 16–February 16 "Statements: A Review of British Abstract Art in 1956" is held at the Institute of Contemporary Arts, London, featuring artists of the St. Ives school and Constructivism.

July Richard Hamilton creates the collage *Just what is it . . . ?* for the *This Is Tomorrow* catalogue and Group Two's poster advertising the exhibition.

August 9–September 9 "This Is Tomorrow" is held at Whitechapel Art Gallery, London. The environment of popular culture imagery designed by Richard Hamilton, John McHale, and John Voelcker [Group Two] later gains status as a Pop prototype.

November Roger Coleman's article on Peter Blake, "A Romantic Realist," appears in *ARK* (the magazine of the Royal College of Art). The same issue includes Peter and Alison Smithson's article "But Today We Collect Ads."

November Lawrence Alloway publishes the article "Dada 1956" in *Architectural Design* magazine.

1957

The Treaty of Rome creates the European Common Market (EEC).

Harold Macmillan becomes Prime Minister, and in July he gives his "Most of Our People Have Never Had It So Good" speech at a Bedford football stadium.

Britons closely follow the launching of Sputnik 1 and 2 by the Soviets.

John Osborne's play *The Entertainer* premieres, using the decline of the British musical tradition as a paradigm for the postwar decline of British power.

The Everly Brothers' "Wake Up, Little Susie" enters the British Top Ten, and Jerry Lee Lewis' "Whole Lotta Shakin' Goin' On" is released.

Richard Hoggart's *The Uses of Literacy* and Colin MacInnes' *City of Spades* are published.

January 16 Richard Hamilton writes "Pop Art Is . . ." as a letter to Peter and Alison Smithson. This statement is later published in *Richard Hamilton: Collected Words, 1953–1982*.

March Roger Coleman, editor of *ARK*, devotes an issue to an investigation of Hollywood culture termed Pop Art. Lawrence Alloway contributes an essay.

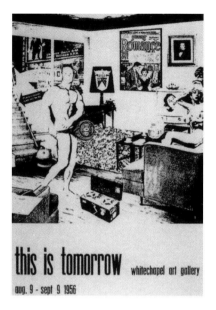

fig. 138. Poster for Group Two [Richard Hamilton, John McHale, and John Voelcker], "This Is Tomorrow" (August 9–September 9, 1956), Whitechapel Art Gallery, London, designed by Richard Hamilton. Work shown is *Just what is it that makes today's homes so different, so appealing?*

fig. 139. Richard Hamilton, *Collage of the Senses,* 1956, cut printed reproductions and ink on paper, 12 x 18½ in. (30.5 x 47 cm), Museum Ludwig, Cologne. Maquette for wall panel at Group Two pavilion, "This Is Tomorrow" exhibition.

September 4–28 "Contemporary Bay Area Figurative Painting" is held at the Oakland Art Museum, Oakland, California.

December 16–January 4, 1958 "Collage in America" is held at Zabriskie Gallery, New York.

1958

President Dwight D. Eisenhower establishes the National Aeronautics and Space Administration (NASA).

Books published this year include Vladimir Nabokov's *Lolita*, Lawrence Ferlinghetti's *A Coney Island of the Mind*, and John Kenneth Galbraith's *The Affluent Society*.

D. H. Lawrence's *Lady Chatterly's Lover* is seized by the United States Postmaster General on grounds that the book is obscene.

January 14–March 16 "Nature in Abstraction: The Relation of Abstract Painting and Sculpture to Nature in Twentieth-Century American Art" is held at the Whitney Museum of American Art, New York; it travels to several venues.

January 20–February 8 "Jasper Johns: Paintings," the artist's first one-person exhibition, is held at Leo Castelli Gallery, New York, featuring his paintings of American flags and targets. Thomas Hess puts Johns' *Target with Four Faces* on the cover of *Art News*.

March 3–29 "Paintings Done in 1957 and 1958 by Bengston," an exhibition of the work of Billy Al Bengston, is held at Ferus Gallery, Los Angeles.

March 4–29 "Robert Rauschenberg" at Leo Castelli Gallery, New York, includes the artist's combine paintings.

November 25–December 13 Allan Kaprow creates an environment with sound, light, and odors at Hansa Gallery, New York.

fig. 140. Cover of *Art News* (January 1958) with Jasper Johns' *Target with Four Faces* (1955).

1959

Alaska and Hawaii become the forty-ninth and fiftieth states, respectively, of the United States.

IBM markets the first fully transistorized computer in the United States.

Naked Lunch by William S. Burroughs is published.

January 12–30 "Robert Whitman" at Hansa Gallery, New York, features the artist's three-dimensional multimedia constructions.

February 13–March 7 "Jim Dine, Marc Ratliff and Tom Wesselmann," inaugural exhibition at Judson Gallery, New York, includes prints, drawings, and collages.

Spring Allan Kaprow first uses the word "Happening" in an article titled "The Demi-Urge," which appears in the *Anthologist*, a magazine published by Rutgers University.

May 22–June 10 "Drawings, Sculptures, Poems by Claes Oldenburg" is held at Judson Gallery, New York.

September 16–October 18 "Four Abstract Classicists" at the Los Angeles County Museum of Art includes the work of Karl Benjamin, Lorser Feitelson, Frederick Hammersley, and John McLaughlin. Critic Jules Langsner, writing in the exhibition catalogue, first uses the term "hard edge."

October 4, 6–10 Allan Kaprow's "18 Happenings in 6 Parts" inaugurates Reuben Gallery, New York.

October 21 The Solomon R. Guggenheim Museum, designed by Frank Lloyd Wright, opens at 1071 Fifth Avenue in New York.

November 13–December 3 Allan Kaprow's "Two Man: Dine/Oldenburg" at Judson Gallery, New York, features the two artists' paintings and drawings.

April 4–May 4 "Metavisual-Tachiste-Abstract: Painting in England Today" is held at Redfern Gallery, London.

May 16 "Sam Francis: Oil Paintings and Watercolours" is held at Gimpel Fils Gallery, London. Herbert Read writes the catalogue essay.

July Richard Smith paints *Everly 2.*

August 12 Richard Hamilton and Victor Pasmore organize "an Exhibit" at the Institute of Contemporary Arts, London.

September Richard Hamilton begins teaching at the Royal College of Art and in the fall meets Richard Smith and Peter Blake.

October *Reveille*, a tabloid magazine, publishes a segmented, life-sized pinup of Brigitte Bardot, which Peter Blake uses in a collage of knives taken from a catalogue of kitchen utensils.

November 7 "Eight American Artists" is held at the Institute of Contemporary Arts, London.

November 10–January 11, 1958 The first "John Moores Liverpool Exhibition," an annual juried exhibition with an emphasis on young artists, opens.

December "Dimensions – British Abstract Art 1948–57," organized by Lawrence Alloway at O'Hana Gallery, London, includes the work of Richard Smith, Robyn Denny, William Turnbull, and Eduardo Paolozzi.

1958

Late summer race riots erupt in the Notting Hill Gate area of London.

Transatlantic passenger service by jet from New York to London is inaugurated.

Harold Pinter's play *The Birthday Party* premieres at the Arts Theater, Cambridge.

Leonard Bernstein's and Stephen Sondheim's American musical *West Side Story* opens at Her Majesty's Theater, London.

January 9–February 8 "Five Young Painters" at the Institute of Contemporary Arts, London, includes works by Richard Smith and Peter Blake.

January 18 John Berger, a British Marxist art critic, attacks the "Five Young Painters" exhibition and advocates Soviet Socialist Realism.

February Lawrence Alloway publishes the article "The Arts and Mass Media" in *Architectural Design* magazine.

February 13–April 19 "Some Paintings from the E. J. Power Collection" at the Institute of Contemporary Arts, London, includes works by Franz Kline, Willem de Kooning, Jackson Pollock, Mark Rothko, and Clyfford Still.

February 19–March 10 "Young Contemporaries 1958" is held at RBA (Royal British Artists) Galleries, London.

April Lawrence Alloway makes his first visit to America, where he meets Barnett Newman, Jasper Johns, and Robert Rauschenberg.

July 8 Lawrence Alloway lectures on "Art in America Today" at the Institute of Contemporary Arts, London.

November The United States Information Service (USIS) opens an art gallery at the American Embassy in Grosvenor Square, London, with "17 American Painters," which includes the work of Ellsworth Kelly and Richard Diebenkorn.

November *Motif: A Journal of the Visual Arts* begins publication.

November–December "Jackson Pollock," organized by The Museum of Modern Art, New York, is held at Whitechapel Art Gallery, London. The Hans Namuth film of Pollock painting is screened at the Institute of Contemporary Arts, London.

November 11–December 31 Eduardo Paolozzi exhibits work at Hanover Gallery, London.

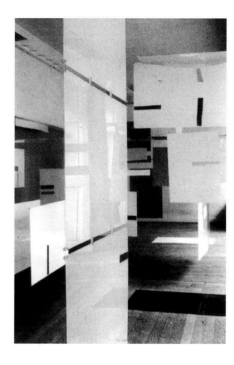

fig. 141. "an Exhibit" (August 12, 1957), Institute of Contemporary Arts, London, installation view, designed by Richard Hamilton and Victor Pasmore with Lawrence Alloway.

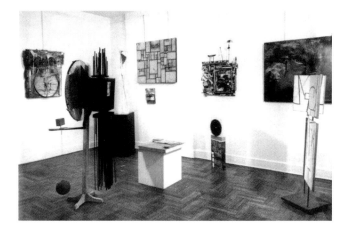

fig. 142. "New Forms–New Media (Part 1)" (June 4–24, 1960), Martha Jackson Gallery, New York, installation view. Photograph by Rudolph Burckhardt.

fig. 143. Cover of the exhibition catalogue *New Forms–New Media* (1960), Martha Jackson Gallery, New York.

fig. 144. Cover of the first issue of *Ray Gun Comics* (1960), designed by Jim Dine.

December 16–February 14, 1960 "Sixteen Americans" at The Museum of Modern Art, New York, includes the work of Jasper Johns and Robert Rauschenberg.

December 18–January 5, 1960 "Below Zero" at Reuben Gallery, New York, features the mixed media work of George Brecht, Jim Dine, Al Hansen, Ray Johnson, Allan Kaprow, Claes Oldenburg, Robert Rauschenberg, George Segal, Richard Stankiewicz, Robert Whitman, and others.

1960

John F. Kennedy is elected President.

Black students begin civil rights sit-ins.

First business photocopying machine is marketed in the United States.

Alfred Leslie and Robert Frank make the film *Pull My Daisy* in New York. Included in the cast are Allen Ginsberg, Gregory Corso, Jack Kerouac, and Larry Rivers.

Chubby Checker records "The Twist."

It is reported that 87 percent of American homes have television.

January 4–March 23 "Ray Gun" at Judson Gallery, New York, includes Jim Dine's environment *The House* and Claes Oldenburg's *The Street*.

February 15–March 12 "Bengston" at Ferus Gallery, Los Angeles, features the artist's heart paintings.

February 19–March 10 "Rosalyn Drexler" at Reuben Gallery, New York, features the artist's sculptures.

March 14 "A Concert of New Music" is presented by The Living Theater, New York, and includes works by George Brecht, John Cage, Al Hansen, Ray Johnson, Robert Rauschenberg, and others.

March 14–April 2 "Eduardo Paolozzi," the British artist's first American exhibition, is held at Betty Parsons Gallery, New York. His exhibition of works from the Venice Biennale, "Sculpture Today," tours the United States in 1960–1961.

March 17 Jean Tinguely constructs *Homage to New York* from material gathered in a Newark, New Jersey, junkyard. The Assemblage self-destructs during a performance in the sculpture garden of The Museum of Modern Art, New York.

May 6–19 Claes Oldenburg's *The Street* is held at Reuben Gallery, New York.

June 6–24 Martha Jackson Gallery, New York, presents "New Forms— New Media in Painting and Sculpture." Artists participating include George Brecht, Jim Dine, Jasper Johns, Allan Kaprow, Claes Oldenburg, Robert Rauschenberg, Lucas Samaras, and Robert Whitman. This two-part exhibition is considered a precursor to the Pop Art exhibitions that are to follow. Part 2 is held September 27–October 22.

September 6–30 "Jasper Johns – Kurt Schwitters" is held at Ferus Gallery, Los Angeles.

1959

Jack Clayton's film of John Braine's book *Room at the Top* premieres, an exercise in northern realism that introduces a new sexual openness in British film.

Other films released include *Expresso Bongo, A Sobo Pastoral,* starring British pop singer Cliff Richards; a version of John Osborne's play *Look Back in Anger;* and Alain Resnais' *Hiroshima Mon Amour.*

Britons mourn the death of Buddy Holly, who is killed in a plane crash in America, along with the Big Bopper and Richie Valens.

Colin MacInnes' Absolute *Beginners* is published.

February 24 "New American Painting" at the Tate Gallery, London, includes many of the artists shown in "Modern Art in the United States" in 1956.

Summer Anthony Caro meets American critic Clement Greenberg in London.

July David Hockney admires the Cliff Richards' pop song "Living Doll" and paints *Doll Boy* in response.

Fall Peter Blake makes *Everly Wall.*

September Richard Smith leaves London to spend time in New York on a Harkness Fellowship.

October David Hockney, R. B. Kitaj, Peter Phillips, Derek Boshier, and Allen Jones (the '59 generation) enter the Royal College of Art, London.

November 14 Kurt Schwitters exhibition is held at the Arts Council, Cambridge.

fig. 145. Poster for the lecture "Action Painting" by Lawrence Alloway (February 1959), Royal College of Art, London, designed by Robyn Denny.

fig. 146. Advertisement for *How to Marry a Millionaire* (1960), used by Richard Hamilton in his lecture "Glorious Technicolor, Breathtaking Cinemascope, and Stereophonic Sound" (1959), Institute of Contemporary Arts, London.

1960

In February British Prime Minister Harold Macmillan gives his "Wind of Change" speech in South Africa.

The Campaign for Nuclear Disarmament (CND) holds a rally in Trafalgar Square on Easter Day; 100,000 protestors participate. A CND rally a year later will result in the largest mass arrests in British history.

Director Karel Reisz's realist film *Saturday Night and Sunday Morning,* about northern working-class life, is released; Federico Fellini's *La Dolce Vita* and Alfred Hitchcock's *Psycho* premiere in Britain.

The Goon Show radio series ends.

The satirical revue *Beyond the Fringe* premieres at the Edinburgh Festival, signaling a new wave of British satire.

Keith Spencer Waterhouse's *Billy Liar* premieres on stage.

The British *Lady Chatterley's Lover* obscenity trial begins in October, inspiring the Phillip Larkin poem.

January "Theo Crosby Sculptures, Peter Blake Objects, John Latham Libraries" is held at the Institute of Contemporary Arts, London.

January 8–February 6 Peter Blake exhibits his *Gold Paintings* at New Vision Centre Gallery (NVCG), London.

January 21 Richard Hamilton gives a lecture on media techniques and culture, "Glorious Technicolor and Breathtaking Cinemascope and Stereophonic Sound," at the Institute of Contemporary Arts, London. He later receives the annual William and Noma Copley Foundation award.

March R. B. Kitaj exhibits work in the "Young Contemporaries 1960" exhibition in London.

March 7 Peter Blake, Roddy-Maude Roxby, and Ivor Abrahams exhibit work at Portal Gallery, London.

March 11 Lawrence Alloway, Richard Hamilton, and Eduardo Paolozzi discuss "Artists as Consumers: The Splendid Bargain" on BBC Radio's *Third Programme.*

March 23 "West Coast Hard Edge" opens at the Institute of Contemporary Arts, London.

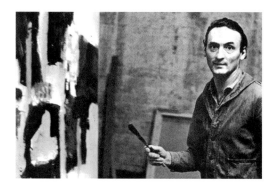

September 25 *Art International* publishes the articles "Jasper Johns" by Robert Rosenblum and "Younger American Painters" by William Rubin.

November 15–December 10 Richard Bellamy presents "George Segal," first exhibition at Green Gallery at 15 West 57th Street in New York, with the backing of Robert and Ethel Scull.

October Larry Rivers leaves America for London, where he marries Welsh musician/artist Clarice Price. Soon after, "Larry Rivers" is held at Tibor de Nagy Gallery, New York (November 28–December 31).

December 5–31 "Edward Kienholz" is held at Ferus Gallery, Los Angeles.

1961

Henry Miller's novel *Tropic of Cancer* (1934) is published legally in the United States for the first time.

American television airs *Ben Casey*, *Dr. Kildare*, *The Dick van Dyke Show,* and *CBS Reports*.

John F. Kennedy is inaugurated as President of the United States. In March he issues an executive order creating the Peace Corps.

February 6–March 4 "Larry Rivers" is held at Dwan Gallery, Los Angeles.

February 26 A letter sent to *The New York Times* and signed by forty-nine art world figures protests the conservative art criticism of John Canaday.

Spring At the Leo Castelli Gallery, New York, director Ivan Karp shows Andy Warhol some comic strip paintings by Roy Lichtenstein. Warhol is surprised to find another artist using subject matter similar to his own comics-based paintings and invites Karp to his studio. Lichtenstein visits Warhol's 1342 Lexington Ave. studio that fall.

March George Maciunas chooses "Fluxus" as the name for a proposed interdisciplinary journal to feature new work by experimental artists, musicians, and writers.

April 4–29 Richard Smith exhibits his work at Green Gallery, New York.

May 17–June 21 "Recent Works by Edward Kienholz" is held at the Pasadena Art Museum in California.

May 25–June 23 "Environments Situations Spaces," organized by John Weber at Martha Jackson Gallery, New York, includes works by George Brecht *(Three Chair Events)*, Jim Dine *(Spring Cabinet)*, Allan Kaprow *(Yard)*, Claes Oldenburg *(The Store)*, and Robert Whitman (Untitled).

May 29–June 17 "War Babies," organized by Henry Hopkins at Huysman Gallery, Los Angeles, features works by Larry Bell, Ed Bereal, Joe Goode, and Ron Miyashiro.

Summer Roy Lichtenstein paints his first Pop work, *Look Mickey*.

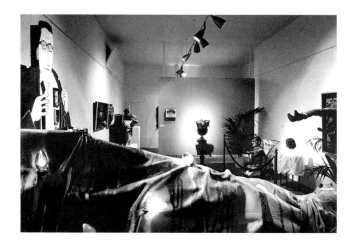

March–April *Evergreen Review* publishes an article by John Bernard Myers titled "The Impact of Surrealism on the NY School" with color reproductions of Jasper Johns' *Target with Plaster Casts* (1955), Robert Rauschenberg's *Canyon* (1958), and Larry Rivers' *The Next to Last Confederate Veteran* (1959), which will have an influence on Peter Phillips' later *War/Game*. Allen Jones also acquires a copy of this issue.

May Royal College of Art students de-contextualize the Union Jack for the first time.

May 17 An exhibition of Morris Louis' color field paintings opens at the Institute of Contemporary Arts, London.

June–October Eduardo Paolozzi's work is featured in the British Pavilion at the 30th Venice Biennale in Italy.

July 22 Allen Jones is expelled from the Royal College of Art.

September Lawrence Alloway resigns his position as Institute of Contemporary Arts program director.

September Eduardo Paolozzi begins teaching at Hochschule für bildende Künste, Hamburg, where he meets the Beatles.

September The first Situationist exhibition, "An Exhibition of British Abstract Painting," is held at the RBA Galleries, London. Large-scale, formal abstraction dominates, though Robyn Denny and Richard Smith and Harold Cohen, both on a Harkness Fellowship in New York, contribute more painterly works. Other artists include Bernard Cohen, John Hoyland, William Turnbull, Henry Mundy, and Gwyther Irwin.

September Peter Blake begins teaching at St. Martin's School of Art in London and remains there for the next two years. Richard Smith (1961–1963) and Joe Tilson (1958–1963) also serve on the St. Martin's faculty.

October 26–28 Richard Hamilton lectures on "Popular Culture and Personal Responsibility" at the National Union of Teachers' Conference, London.

November 17 Richard Hamilton lectures on Marcel Duchamp's *Green Box* at the Institute of Contemporary Arts, London. Hamilton and George Heard Hamilton have recently published an English translation and typographic version of the *Green Box*.

December 3 "The Mysterious Sign" at the Institute of Contemporary Arts, London, includes the first painting exhibited by Jasper Johns in the U.K., *White Numbers* (1958).

fig. 150. "Have Image Will Travel" (October 1960), Oxford University Divinity School, Oxford, installation view, designed by Terry Green, Denis Postle, and Mike Kidd.

1961

Birth control pills begin to be marketed in the U.K.

The E-type Jaguar automobile is launched, becoming an instant icon of the period.

John Le Carre's novel *Call from the Dead* is published, marking the first appearance of fictional master spy George Smiley.

Comedian Tony Hancock's film *The Rebel* premieres, parodying Abstract Expressionist art.

John Osborne's "Letter to My Fellow Countrymen" is published in the *Tribune,* a left-wing newspaper.

The satirical magazine *Private Eye* begins publication.

The Establishment Club opens in Greek Street, Soho, London, featuring a satirical cabaret.

January Richard Hamilton's article "For the Finest Art Try—Pop!" appears in the *Gazette* published by Graphis, London.

January Richard Hamilton gives critiques at the Royal College of Art, where he meets R. B. Kitaj. He sees Pop works by Royal College of Art students for the first time.

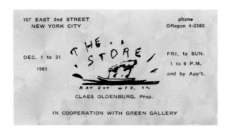

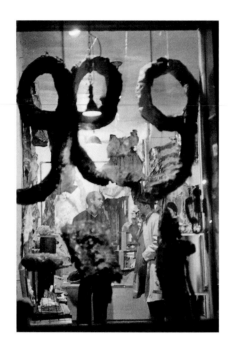

fig. 151. Business card for
Claes Oldenburg, Proprietor,
"The Store," Ray Gun Mfg.
Co., New York, 1962.

fig. 152. Front window of
"The Store," Ray Gun Mfg.
Co., New York, December
1961. Pictured at left is Claes
Oldenburg. Photograph by
Robert R. McElroy.

fig. 153. Assemblage cover of
the exhibition catalogue 1961
(1962), The Dallas Museum
for Contemporary Art,
designed by Roy Fridge.

fig. 154. Announcement for
"James Rosenquist" (January
30–February 17, 1962), his
first one-person exhibition,
Green Gallery, New York,
designed by James Rosenquist.

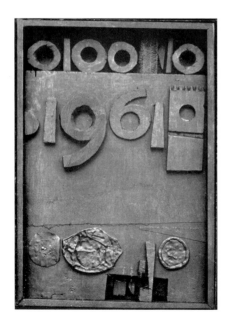

October 2–November 12 The Museum of Modern Art, New York, presents William Seitz's major exhibition "The Art of Assemblage," which includes the work of 139 artists and is considered the definitive exhibition on Assemblage.

November 7–December 5 Robert Rauschenberg exhibits his combine paintings at Leo Castelli Gallery, New York, rearranging, installing, and de-installing the works on a daily basis to create a kind of Happening.

November 13–December 2 Billy Al Bengston exhibits his motorcycle paintings at Ferus Gallery, Los Angeles.

December 1–January 31, 1962 Claes Oldenburg opens *The Store* at Ray Gun Mfg. Co., 107 East Second Street, New York.

December 8–30 "Tom Wesselmann: Great American Nude," the artist's first one-person exhibition, is held at Tanager Gallery, New York, and includes collages from his Great American Nude series.

1962

President Kennedy confronts and resolves the Cuban missile crisis.

Marilyn Monroe dies at the age of thirty-six.

Bob Dylan records "Blowin' in the Wind."

Ken Kesey publishes *One Flew Over the Cuckoo's Nest*, and John Steinbeck is awarded the Nobel Prize for Literature..

Philip Johnson begins designing a new east wing and lobby for The Museum of Modern Art, New York; the addition opens in May 1964.

January 9–February 3 "Jim Dine: New Works" at Martha Jackson Gallery and David Anderson Gallery, New York, is the artist's first post-performance era exhibition.

January 30–February 17 "James Rosenquist," the artist's first one-person exhibition, is held at Green Gallery, New York. The exhibition sells out.

February 10–March 3 "Roy Lichtenstein," the artist's first one-person exhibition, is held at Leo Castelli Gallery, New York. Works include *Turkey*, *Washing Machine*, *The Kiss*, *The Refrigerator*, *Blam*, and *The Grip*.

February 23–May 26 Claes Oldenburg produces "Ray Gun Theater" in the Ray Gun Mfg. Co. A different Happening is staged each weekend for ten weeks.

March *Art International* publishes "Pop Culture, Metaphysical Disgust and the New Vulgarians" by Max Kozloff. This is the first article that links Jim Dine, Roy Lichtenstein, Claes Oldenburg, and James Rosenquist as a group. Also included are artists Peter Saul and Robert Watts.

March 4–31 "Robert Rauschenberg" is held at Dwan Gallery, Los Angeles.

April 3–May 13 "1961," organized by Douglas MacAgy at The Dallas Museum for Contemporary Arts, surveys works produced in 1961 including those by Jim Dine, Jasper Johns, Roy Lichtenstein, Claes Oldenburg, Robert Rauschenberg, and James Rosenquist. The exhibition includes the performance of Oldenburg's Happening *Injun* on April 6 and 7; the Happening is filmed by Texas artist Roy Fridge.

February 8–25 Lawrence Alloway supervises the "Young Contemporaries 1961" exhibition at the RBA Galleries, London, which includes four works each by Peter Phillips, David Hockney, Allen Jones, and R. B. Kitaj; three works by Derek Boshier; and two works by Patrick Caulfield. Paul Kasmin purchases David Hockney's *Doll Boy* for 40 pounds sterling.

March *ARK* entitles issue no. 28 "The Adam Faith Show."

May 25 Richard Hamilton quotes U.S. President John F. Kennedy's space exploration speech in his work subtitled . . . "*Together let us explore the stars*" (1962). David Hockney completes his painting *The Most Beautiful Boy in the World* (1962).

Summer Richard Smith returns to London after a two-year American visit on a Harkness Fellowship.

July Lawrence Alloway leaves London to become a curator at the Solomon R. Guggenheim Museum, New York.

July–August David Hockney leaves London to spend two months in New York.

September R. B. Kitaj begins teaching at Ealing School of Art, London.

September After returning from New York, David Hockney begins his *A Rake's Progress* series of sixteen etchings.

October 10–November 12 "Mark Rothko: A Retrospective, Paintings 1945–1960," organized by The Museum of Modern Art, New York, is held at Whitechapel Art Gallery, London.

October– November "New New York Scene" at Marlborough Fine Art Ltd., New London Gallery, London, includes works by Helen Frankenthaler, Morris Louis, Ellsworth Kelly, and Kenneth Noland.

December The Jasper Johns painting *Zero through Nine* (1961) enters the collection of the Tate Gallery, London.

December 11 Peter Blake's *Self-Portrait with Badges* wins top honors at "The John Moores Liverpool Exhibition" in Liverpool; R. B. Kitaj and David Hockney also win prizes.

December 17 Neville Wallis, art critic for *The Observer,* hails the "School of Satire," as he refers to the Pop painters from the Royal College of Art.

1962

The Sunday Times Colour Magazine (February 4) is launched in London with a cover by photographer David Bailey featuring model Jean Shrimpton wearing a Mary Quant dress. Bailey and Shrimpton later leave London for New York to shoot *Vogue* magazine's "Young Idea" fashion article, the beginning of the British invasion of the United States. A subsequent April 8 issue will ask on the cover "How American Are We?" with a photograph of a 1959 Cadillac's tailfins in front of Big Ben.

Britain receives live television from the U.S. via the Telstar satellite.

British news widely covers American John Glenn's successful Friendship 7 earth orbits, as well as Mercury flights by Scott Carpenter and Wally Schirra.

Film premieres include Alain Resnais' *Last Year at Marienbad* and François Truffaut's *Jules and Jim.* Stanley Kubrick's film *Lolita* premieres, as does the first James Bond film, *Dr. No,* and David Lean's *Lawrence of Arabia*, featuring two secret agents from four different eras of the imperial past and the post-colonial present.

Record producer George Martin hears the Beatles' demo tape and later becomes their producer/arranger.

Ken Russell's docudrama *Elgar* appears on the BBC Television arts program *Monitor*, and the satirical series *That Was the Week That Was* premieres on British television.

Rock musician Pete Townshend, then a student at Ealing School of Art, sees slides of the Japanese Action Group *Gutai* smashing screens and later incorporates the guitar-smashing element into The Who concerts.

fig. 155. Cover of the exhibition catalogue *New New York Scene* (1961), Marlborough Fine Art, New London Gallery, London.

fig. 156. Cover of *The Sunday Times Colour Magazine* (May 2, 1962, London) with the fashions of Mary Quant.

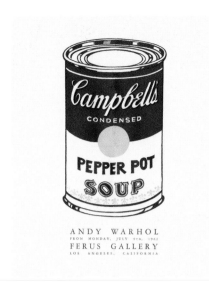

fig. 157. Announcement for "Andy Warhol" (July 9–August 4, 1962), Ferus Gallery, Los Angeles.

fig. 158. Cover of the exhibition catalogue *International Exhibition of the New Realists* (1962), Sidney Janis Gallery, New York, designed by Arman.

fig. 159. Announcement for "Larry Rivers" (November 1962), Dwan Gallery, Los Angeles, designed by Larry Rivers.

April 17–May 5 "Wayne Thiebaud," the artist's first one-person exhibition in New York, is held at Allan Stone Gallery.

April 23–May 12 Eduardo Paolozzi exhibits his work at Betty Parsons Gallery, New York.

May "Joe Goode," the artist's first one-person exhibition, is held at Dilexi Gallery, Los Angeles.

May 1–26 "Billy Al Bengston" is held at Martha Jackson Gallery, New York.

May 8–June 2 "George Segal" at Green Gallery, New York, features first works in the artist's signature style, plaster sculptures made from life casts.

May 13 Abstract Expressionist painter Franz Kline dies.

July 9–August 4 "Andy Warhol" at Ferus Gallery, Los Angeles, featuring the artist's paintings of Campbell's Soup cans, is Warhol's first commercial one-person exhibition of Pop images.

September Gene Swenson's article "The New American 'Sign Painters,'" published in *Art News*, discusses the work of Jim Dine, Stephen Durkee, Robert Indiana, Roy Lichtenstein, James Rosenquist, Richard Smith, and Andy Warhol.

September 11–22 "Words," an environment by Allan Kaprow, is presented at Smolin Gallery, New York.

September 24–October 20 "Claes Oldenburg" at Green Gallery, New York, features the artist's large-scale soft sculptures.

September 25–October 19 "New Painting of Common Objects," organized by Walter Hopps at the Pasadena Art Museum in California, includes the work of Jim Dine, Robert Dowd, Joe Goode, Phillip Hefferton, Roy Lichtenstein, Edward Ruscha, Wayne Thiebaud, and Andy Warhol.

October 16–November 3 "Robert Indiana," the artist's first one-person exhibition, is held at Stable Gallery, New York.

November John Coplans' review "The New Paintings of Common Objects" about the Pasadena Art Museum exhibition is published in *Artforum* magazine.

November 1–December 1 "International Exhibition of the New Realists" at Sidney Janis Gallery, New York, includes the work of Claes Oldenburg (*The Stove*), Jim Dine (*Lawnmower*), Roy Lichtenstein (*Blam*), James Rosenquist (*Silver Skies*), Andy Warhol (*Do It Yourself [Flowers]*, a paint-by-number painting), Robert Indiana (*The Black Diamond American Dream #2*), and Tom Wesselmann (*Still Life No. 17*). Also featured is work by British Pop artists Peter Blake and Peter Phillips and a selection of European artists.

November 6–24 "Andy Warhol" is held at Stable Gallery, New York.

November 13–December 1 "Wesselmann: Collages/Great American Nude & Still Lifes" at Green Gallery, New York, features recent collage paintings.

November 13–December 16 "British Art Today," organized by Lawrence Alloway, is held at the San Francisco Museum of Art, including works by Peter Blake, Allen Jones, Eduardo Paolozzi, Peter Phillips, and Joe Tilson among others; it travels to Santa Barbara, California, and Dallas, Texas.

November 16 "Rivers: Recent Work" opens at Dwan Gallery, Los Angeles.

November 18–December 15 "My Country 'Tis of Thee," organized by Virginia Dwan and John Weber at Dwan Gallery, Los Angeles, includes the following Pop-related works: Robert Indiana's *The American Reaping Company* (1961), Jasper Johns' *Flag on Orange Field* (1957), Edward Kienholz's *Untitled American President* (1962), Roy Lichtenstein's *Takka Takka* (1962), Robert Rauschenberg's *Coexistence* (1961), Larry Rivers' *Cedar Bar Menu* (1962), James Rosenquist's *Hey, Let's Go for a Ride* (1961), Claes Oldenburg's *Coffee Cup* (1962), Andy Warhol's *Marilyn Monroe* (1962), and Tom Wesselmann's *Great American Nude #X* (1961).

December 13 The Museum of Modern Art, New York, hosts "Pop Art Symposium," a panel discussion with Peter Selz as moderator. Panelists include art historian Dore Ashton, curator Henry Geldzahler, critic Hilton Kramer, art historian Leo Steinberg, and poet Stanley Kunitz.

Anthony Burgess' novel *A Clockwork Orange* is published.

The Hidden Persuaders by American Vance Packard is published in the U.K., providing the first critique of the influence of mass-media advertising; the book introduces the term "built-in obsolescence."

February Ken Russell shoots the documentary film *Pop Goes the Easel* for the BBC Television arts program *Monitor*. The film features Peter Blake, Pauline Boty, Peter Phillips, and Derek Boshier in a freewheeling documentary and semi-fictionalized style which introduces Pop Art to the British public.

February 4 An article by John Russell on Peter Blake, "Pioneer of Pop Art," appears in the inaugural issue of *The Sunday Times Colour Magazine*. The term "Pop Art" is now applied to artwork rather than popular culture.

February 27 An article in upscale *Queen* magazine on David Hockney, his first glossy feature, is illustrated with his painting *A Grand Procession of Dignitaries in the Semi-Egyptian Style.*

March 23 Reyner Banham writes "Coffin Nails in Handy Packs" on cigarette pack design in *New Statesman* magazine. Richard Smith begins his cigarette pack paintings.

March 25 BBC Television broadcasts *Pop Goes the Easel* on *Monitor*.

April 3 "British Painting Today" at Arthur Tooth & Sons, Ltd., London, includes works by Howard Hodgkin and Allen Jones.

April 10–May 12 Robert Fraser Gallery, London, opens with an exhibition of black-and-white works by Jean Dubuffet.

May "Larry Rivers" at Gimpel Fils Gallery, London, includes the paintings *French Money I & II.*

May 30 "Ellsworth Kelly," an exhibition of the artist's paintings, opens at Arthur Tooth & Sons, Ltd., London.

May 30 Peter Blake's one-person exhibition opens at Portal Gallery, London.

Summer Richard Smith's article "New Readers Start Here," published in *ARK*, endorses Derek Boshier, David Hockney, and Peter Phillips. Richard Smith exhibits work at his studio at 13 Bath Street, London.

June The Royal College of Art presents a diploma exhibition for its 1959 graduates. Peter Phillips displays his heraldic Pop paintings along with a pinball machine.

June Derek Boshier leaves London for a year in India.

July "Four Young Artists" at the Institute of Contemporary Arts, London, includes works by Maurice Agis, John Bowstead, David Hockney, and Peter Phillips.

August 15–September 8 "Image in Progress," the first anthology exhibition of Pop Art, is held at Grabowski Gallery, London. It includes works by Derek Boshier, David Hockney, Allen Jones, Peter Phillips, and Norman Toynton.

August 28–September 28 "New Approaches to the Figure" at Arthur Jeffress Gallery, London, includes the work of Peter Blake, Derek Boshier, Pauline Boty, Richard Hamilton, and David Hockney.

September An illustrated *London News* article asks, "How Good Is Pop Art?"

October 5–November 3 "Image in Revolt" at Grabowski Gallery, London, features works by Derek Boshier and Frank Bowling.

October 18–November 24 Richard Smith's paintings are exhibited at the Institute of Contemporary Arts, London.

November 8 Lawrence Alloway talks on "Pop Art Since 1949" on BBC Radio's *Third Programme*; later the talk is published in *The Listener* magazine (December 27).

Winter Robert Melville's article "The Durable Expendables of Peter Blake" appears in *Motif* (London).

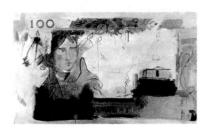

fig. 160. Cover of the exhibition catalogue *Four Young Artists* (1962), Institute of Contemporary Arts, London.

fig. 161. Cover of the exhibition catalogue *Larry Rivers* (1962), Gimpel Fils Gallery, London.

fig. 162. "Image in Revolt" (October 5–November 13, 1962), Grabowski Gallery, London, installation view. Works shown are Derek Boshier's *Icarus Gives a Man Oxo Appeal, ABCDEFGHI*, and *Sunset on Stability (SOS)* (all 1962).

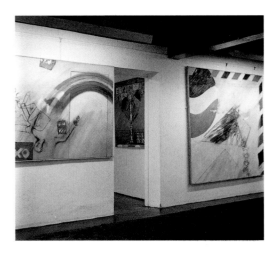

fig. 163. Cover of the exhibition catalogue *Six Painters and the Object* (1963), Solomon R. Guggenheim Museum, New York.

fig. 164. Announcement for the exhibitions "Six Painters and the Object" and "Six More" (July 24–August 25, 1963), Los Angeles County Museum of Art, Los Angeles.

fig. 165. Cover of the exhibition catalogue *The Popular Image Exhibition* (1963), The Washington Gallery of Modern Art, Washington, D.C., designed by Jim Dine.

1963

The United States Post Office introduces zip codes.

Martin Luther King Jr. delivers his "I have a dream" speech at the March on Washington.

President John F. Kennedy is assassinated on November 22 in Dallas.

Television network news expands from fifteen to thirty minutes.

Popular hit records include the Beach Boys' "Surfing U.S.A." and Jan and Dean's "Surf City."

Betty Friedan publishes *The Feminine Mystique.*

January Edward Ruscha publishes his first book, *Twentysix Gasoline Stations,* documenting road trips from California to Oklahoma, and establishes Heavy Industry Publications in Los Angeles.

February "John Wesley," the artist's first one-person exhibition, is held at Robert Elkon Gallery, New York.

February 19–March 16 Richard Smith exhibits work at Green Gallery, New York.

March 8–30 "Joe Goode" is held at Rolf Nelson Gallery, Los Angeles.

March 14–June 12 Curator Lawrence Alloway's exhibition "Six Painters and the Object" is presented at the Solomon R. Guggenheim Museum, New York, featuring works by Jim Dine, Jasper Johns, Roy Lichtenstein, Robert Rauschenberg, James Rosenquist, and Andy Warhol. The thirty-three paintings include Jim Dine's *The Plant Becomes a Fan* (1961–63), Jasper Johns' *Three Flags* (1958), Roy Lichtenstein's *Live Ammo* (1962), Robert Rauschenberg's *Factum II* (1957), James Rosenquist's *Zone* (1960), and Andy Warhol's *Silver Disaster No. 6* (1963). The exhibition tours widely across the U.S.

March 31–May 12 "Robert Rauschenberg," a retrospective exhibition organized by Alan Solomon, is held at the Jewish Museum, New York.

April 1–27 "Roy Lichtenstein" is held at Ferus Gallery, Los Angeles.

April 4–30 "Pop! Goes the Easel," organized by Douglas MacAgy at the Contemporary Arts Museum, Houston, includes the work of Roy Lichtenstein, Jim Dine, Mel Ramos, James Rosenquist, Wayne Thiebaud, Andy Warhol, and Tom Wesselmann.

April 18–June 2 "The Popular Image Exhibition," organized by Alice Denney at The Washington Gallery of Modern Art, Washington, D.C., includes works by Pop artists Jim Dine, Roy Lichtenstein, Claes Oldenburg, James Rosenquist, John Wesley, and Tom Wesselmann, as well as works by Fluxus artists George Brecht and Robert Watts, Jasper Johns, and Robert Rauschenberg.

April 28–May 26 "Popular Art, Artistic Projections of Common American Symbols" is held at the Nelson Gallery-Atkins Museum of Fine Art, Kansas City, Missouri.

May 20–June 15 "Edward Ruscha," the artist's first one-person exhibition, is held at Ferus Gallery, Los Angeles, and includes the paintings *Annie* and *Large Trademark with Eight Spotlights.*

June 25 Charles Henri Ford takes Andy Warhol, James Rosenquist, and Robert Indiana to visit Joseph Cornell at his Utopia Parkway studio in Queens.

July Andy Warhol makes his first film, *Sleep,* in New York.

July 24–August 25 "Six Painters and the Object" and "Six More," Lawrence Alloway's Guggenheim exhibition with the addition of six California artists, is held at the Los Angeles County Museum of Art. The six California artists are Billy Al Bengston, Joe Goode, Phillip Hefferton, Mel Ramos, Edward Ruscha, and Wayne Thiebaud. At the public opening, Alloway and Peter Selz, The Museum of Modern Art curator, exchange words in a heated argument.

September Ivan Karp's article "Anti-Sensibility Painting" appears in *Artforum,* where Karp uses the term "common-image artists" to identify Pop artists Roy Lichtenstein, James Rosenquist, Robert Rauschenberg, Andy Warhol, and Tom Wesselmann, as well as marginally related Pop artists Richard Lindner, Lee Bontecou, Bruce Conner, and Lucas Samaras.

1963

British postwar unemployment peaks at 900,000.

The British double agent Kim Philby defects to Russia.

The Bishop of Woolwich, Dr. John Robinson, publishes *Honest to God*, introducing the term "The New Morality," which quickly passes into general usage.

Film premieres include Joseph Losey's *The Servant*, showing the corruption of the upper classes by the lower classes; Lindsay Anderson's *This Sporting Life*, portraying individual resistance against authority; Stanley Kubrick's *Dr. Strangelove, or How I Learned to Stop Worrying and Love the Bomb*; and *Billy Liar*, the last of the northern realist films.

The Beatles' single "From Me to You" debuts.

British news continues close coverage of the Mercury space program with Gordon Cooper's concluding flight.

February 12–March 2 "Allen Jones: Recent Paintings" is held at Arthur Tooth & Sons, Ltd., London.

February 17–March 9 "R. B. Kitaj: Pictures with Commentary, Pictures without Commentary" is held at Marlborough Fine Art Ltd, New London Gallery, London.

March 21 "Paintings as Photographs" at St. Martin's School of Art, London, features the work of Gerald Laing, including *Brigitte Bardot*.

April 18–May Kasmin Ltd. opens in London with "Kenneth Noland: Paintings 1959–62."

May Peter Blake, visiting in Los Angeles, agrees to do drawings for *The Sunday Times Colour Magazine* in London.

May "Joe Tilson Recent Works" is held at Hatton Gallery, University of Durham.

May 21–June 29 "Alphonse Mucha" at Grosvenor Gallery and Arthur Jeffress Gallery, London, begins an Art Nouveau revival, leading to "psychedelic" designs in fashion.

June 1–30 "British Painting in the Sixties," organized by the Contemporary Art Society, is held at the Tate Gallery and Whitechapel Art Gallery, London.

June 2 David Sylvester's article "British Painting Now" with photographs by Lord Snowdon appears in *The Sunday Times Colour Magazine*.

June 9 In a rebuttal letter, Anthony Caro, Robyn Denny, R. B. Kitaj, Harold Cohen, and other artists attack David Sylvester's charge of "amateurism" in British art.

August 9 Derek Boshier and Pauline Boty dance on the pop music program *Ready, Steady, Go!*.

September–October *The Sunday Times Colour Magazine* commissions David Hockney to make drawings on assignment in Egypt, but the drawings are never published.

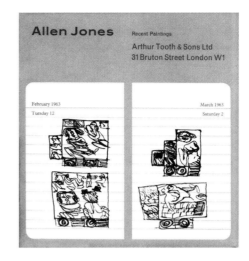

fig. 166. Cover of the exhibition catalogue *Allen Jones: Recent Paintings* (1963), Arthur Tooth & Sons, Ltd., London.

fig. 167. Cover of the exhibition catalogue *British Painting in the Sixties* (1963), organized by Contemporary Art Society, Tate Gallery, and Whitechapel Art Gallery, London.

fig. 168. "Senses Portrait" pictorial spread from the exhibition catalogue *Joe Tilson Recent Works* (1963), Hatton Gallery, University of Durham, designed by Richard Hamilton with photographs by Robert Freeman.

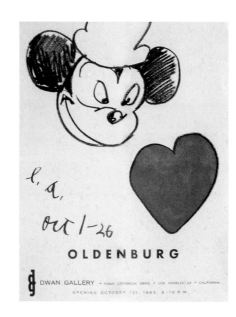

fig. 169. Cover of the exhibition catalogue *Pop Art USA* (1963), Oakland Art Museum, Oakland, California.

fig. 170. Poster for "Oldenburg" (1963), Dwan Gallery, Los Angeles, designed by Claes Oldenburg.

fig. 171. Cover of the exhibition catalogue *Mixed Media and Pop Art* (1963), Albright-Knox Art Gallery, Buffalo, New York. Work shown is Roy Lichtenstein, *Head–Red and Yellow* (1962).

September 7–29 "Pop Art USA," organized by John Coplans at the Oakland Art Museum in California, features forty-eight American Pop artists.

September 30–October 26 Andy Warhol drives to Los Angeles with poet Gerald Malanga, painter Wynn Chamberlain, and actor Taylor Mead for the opening of "An Exhibition by Andy Warhol" at Ferus Gallery, Los Angeles, which includes his silkscreen paintings of Elvis Presley and Liz Taylor. Warhol films *Tarzan and Jane Revisited . . . Sort Of* while staying in California.

October 1–26 "Oldenburg" is held at Dwan Gallery, Los Angeles.

October 8–November 3 "by or of Marcel Duchamp or Rrose Selavy," the artist's first retrospective, organized by Walter Hopps, is held at the Pasadena Art Museum in California.

November Andy Warhol opens his studio, known as The Factory, at 231 East 47th Street. Billy Name moves in and silver-coats the interior with paint and aluminum foil.

November Part 1 of "What is Pop Art?" a two-part article in which Gene R. Swenson interviews various Pop artists, is published in *Art News*. Part 1 has interviews with Jim Dine, Robert Indiana, Roy Lichtenstein, and Andy Warhol. Part 2 (published in February 1964) has interviews with Stephen Durkee, Jasper Johns, James Rosenquist, and Tom Wesselmann.

November 12–December 26 "Hard-Edge and Emblem: New York – England and America" at the Pasadena Art Museum in California includes the work of Billy Al Bengston and Frank Stella.

November 19–December 15 "Mixed Media and Pop Art" at Albright-Knox Art Gallery, Buffalo, New York, includes sixty-six artists.

1964

U.S. Senate passes the Gulf of Tomkin resolution giving defacto authorization to escalation of the Vietnam War.

Los Angeles Free Press begins publication.

The Free Speech Movement is launched at Berkeley, California, and during the protest 796 people are arrested.

Marshall McLuhan's *Understanding Media: The Extensions of Man* is published.

City Lights Books publishes Frank O'Hara's *Lunch Poems*.

Andy Warhol makes the films *Batman*, *Dracula*, *Harlot*, *Henry Geldzahler*, *Soap Opera*, *The Thirteen Most Beautiful Boys*, and *The Thirteen Most Beautiful Women*. He receives the independent film award from *Film Culture* magazine.

January Jim Dine begins his bathrobe paintings based on an advertisement in the Sunday *New York Times Magazine*.

January Larry Rivers moves to London and acquires a studio at the Slade School of Fine Art. He begins work on the collage *Robert Fraser's London*.

January 3–February 1 "Four Environments by Four New Realists" at Sidney Janis Gallery, New York, features the installation of Claes Oldenburg's furniture works based upon a Malibu, California, motel, as well as environments created by Jim Dine, James Rosenquist, and George Segal.

January 7–February 1 "Phillip Hefferton" is held at Rolf Nelson Gallery, Los Angeles.

January 11–February 6 Gerald Laing exhibits his work at Feigen-Palmer Gallery, Los Angeles.

January 31 *Life* magazine publishes an article on Roy Lichtenstein titled "Is He the Worst Artist in the U.S.?"

February Gerald Nordland's article "Marcel Duchamp and Common Object Art" appears in *Art International* magazine.

September–November "Troisième Biennale de Paris: Manifestation biennale et internationale des jeunes artists" at Musée d'Art moderne de la ville de Paris includes works by Peter Blake, Derek Boshier, David Hockney, Allen Jones, Gerald Laing, Peter Phillips, and Joe Tilson. Allen Jones wins the Prix des Jeunes Artistes.

September 10–October 5 Pauline Boty has her first one-person exhibition at Grabowski Gallery, London.

September 26 "Morris Louis Painting 1960–62" opens at Kasmin Ltd., London.

October Richard Hamilton leaves London to attend the Marcel Duchamp retrospective in California, driving from New York across America with Marcel and Teeny Duchamp. Hamilton buys a "Slip It To Me" souvenir button (source for *Epiphany*, 1964) in Pacific Ocean Park. He stays in America to lecture on Duchamp at the Solomon R. Guggenheim Museum, Yale University, and in Boston, and sees work by Jim Dine, Roy Lichtenstein, Claes Oldenburg, James Rosenquist, and Andy Warhol.

October 6 *The Sunday Times Colour Magazine* features a Peter Blake cover for an article titled "The Criminal Core."

October 24–November 23 "The Popular Image" at the Institute of Contemporary Arts, London, is the first London overview of current American Pop Art. It includes the first Roy Lichtenstein works seen in London, as well as works by Allan D'Arcangelo, Jim Dine, Robert Indiana, Jasper Johns, Claes Oldenburg, Robert Rauschenberg, Mel Ramos, James Rosenquist, Wayne Thiebaud, Andy Warhol, John Wesley, and Tom Wesselmann.

November Richard Smith's shaped canvases featuring abstracted commercial objects such as cigarette packs, are exhibited at Kasmin Ltd., London.

December "David Hockney: Pictures with People In," the artist's first one-person exhibition, is held at Kasmin Ltd., London. At the end of the year, Hockney returns to New York.

1964

The Labor Government comes to power; Harold Wilson remains Prime Minister until 1970.

For the first time in Britain, over one million crimes are recorded, including 16,000 involving violence. Cocaine and heroin use increase tenfold in the first half of the 1960s.

Designer Terence Conran opens his first Habitat store in London.

The Beatles' first film, *A Hard Day's Night,* directed by the American Richard Lester, premieres in Liverpool at the height of the British pop music "invasion" of the United States, including the Beatles' February television debut on the *Ed Sullivan Show* in New York, followed in October by the Rolling Stones.

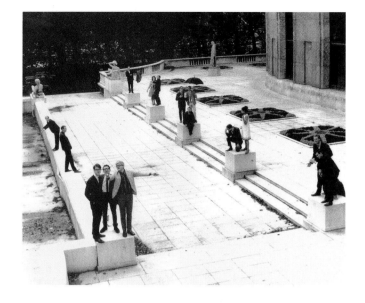

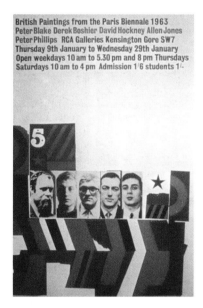

fig. 172. (left row, back to front) Terry Stewart, Francis Morland, Marquis of Duffering and Ava, John Kasmin, and David Hockney; (right row) Norbert Lynton, two British Council officers, Joe Tilson, Peter Blake, Allen Jones, Gerald and Jenny Laing, Derek Boshier, Peter Phillips, and Mark Berger in the plaza of the Musée national d'art moderne de ville de Paris during "Troisième Biennale de Paris: Manifestation biennale et internationale des jeunes artists" (September–November 1963).

fig. 173. Poster for "British Paintings from the Paris Biennale 1963" (January 1964), Royal College of Art Galleries, London.

fig. 174. Cover of the exhibition brochure *Pauline Boty* (1963), Grabowski Gallery, London.

fig. 175. Cover of the exhibition catalogue *the popular image* (1963), Institute of Contemporary Arts, London.

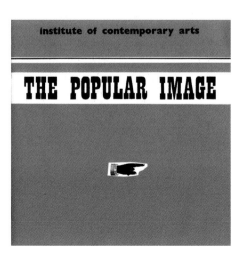

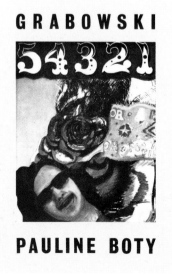

fig. 176. Exhibition catalogue for "Boxes" (1964), Dwan Gallery, Los Angeles. Eight-foot, eight-inch-long scroll shown partially unrolled.

fig. 177. New York State Pavilion, New York World's Fair, 1964. Work shown is mural by Andy Warhol, *Thirteen Most Wanted Men* (1964), prior to overpainting by fair organizers.

fig. 178. Poster for "American Supermarket" (October 6– November 7, 1964), Bianchini Gallery, New York.

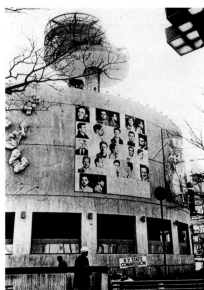

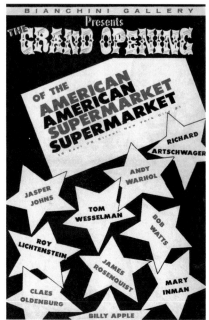

February 2–29 "Boxes" at Dwan Gallery, Los Angeles, includes works by George Brecht, Joseph Cornell, Robert Indiana, James Rosenquist, Lucas Samaras, Kurt Schwitters, Ben Talbert, Andy Warhol, and Tom Wesselmann.

February 13–April 12 "Jasper Johns: A Retrospective" is held at the Jewish Museum, New York.

April–October At the New York World's Fair in Flushing Meadows, the Theaterama Building of the New York State Pavilion, designed by Philip Johnson, displays Andy Warhol's *Thirteen Most Wanted Men* (which is overpainted by fair organizers who decide that it is politically charged), a mural by Roy Lichtenstein, and Robert Indiana's *Eat* sign. Other artists included are Peter Agostini, John Chamberlain, Ellsworth Kelly, Alexander Lieberman, Robert Mallory, Robert Rauschenberg, and James Rosenquist.

April 7–May 2 "Recent Work by Claes Oldenburg" is held at Sidney Janis Gallery, New York.

April 21–May 9 "Andy Warhol" at Stable Gallery, New York, features nearly four hundred wooden boxes silkscreened with the brand names for Brillo, Kellogg's cornflakes, and Heinz ketchup.

April 23–June 7 "Post Painterly Abstraction" at the Los Angeles County Museum of Art features the work of thirty-one American artists, including Al Held, Alfred Jensen, Ellsworth Kelly, Nicholas Krushenick, Morris Louis, Kenneth Noland, Ray Parker, Frank Stella, and Emerson Woelffer.

May 31 John Canaday publishes the article "Pop Art Sells On and On— Why?" in the *New York Times Magazine*.

June 20–October 18 The United States Pavilion at the 32nd Venice Biennale in Italy includes "Four Germinal Painters" (Jasper Johns, Morris Louis, Kenneth Noland, and Robert Rauschenberg) and "Four Younger Artists" (John Chamberlain, Jim Dine, Claes Oldenburg, and Frank Stella); the exhibition is organized by Alan Solomon. Rauschenberg is awarded the Biennale's international painting prize.

September–October David Hockney's first one-person exhibition in the United States, held at Charles Alan Gallery, New York, receives positive reviews, and the show sells out.

September 29–October 24 "Edward Kienholz" at Dwan Gallery, Los Angeles, features three tableaux including *Back Seat Dodge '38*.

October 6–November 7 "American Supermarket" inaugurates Bianchini Gallery, New York, where Pop artworks are displayed in a mock store setting.

October 20 "Ed Ruscha" opens at Ferus Gallery, Los Angeles, showing the artist's Standard Station series of paintings.

October 27–November 24 "James Rosenquist" is held at Dwan Gallery, Los Angeles.

November London-based Marlborough Graphics opens a gallery in New York.

November Allen Jones exhibits work at Richard Feigen Gallery, New York.

November Eduardo Paolozzi has his first American one-person museum exhibition at The Museum of Modern Art, New York.

November "Mel Ramos," the artist's first one-person exhibition, is held at Paul Bianchini Gallery, New York.

November 21–December 17 "Andy Warhol" at Leo Castelli Gallery, New York, features the artist's flower works.

November 24 "Roy Lichtenstein" at Ferus Gallery, Los Angeles, features the artist's landscapes.

December Philip Leider's article "The Cool School" appears in *Artforum*.

December "The Studs" opens at Ferus Gallery, Los Angeles, featuring the work of Billy Al Bengston, Robert Irwin, Ed Moses, and Ken Price.

A pirate radio ship, Radio Caroline, begins broadcasting pop music from the North Sea.

Bob Dylan's "The Times They Are A' Changing" is released in Britain.

January 21–February 15 Allen Jones exhibits work at Arthur Tooth and Sons, Ltd., London.

January 26 *The Sunday Times Colour Magazine* features the Roy Lichtenstein painting *Hopeless* on the cover with the headline "Pop Art: Way Out or Way In?" accompanying the in-depth David Sylvester article "Art in a Coke Climate."

February 5–March 8 "Robert Rauschenberg: Paintings, Drawings and Combines 1949–64," organized by the Jewish Museum, New York, is held at Whitechapel Art Gallery, London.

Spring Allen Jones moves to America into the Chelsea Hotel, New York, for one year. Before returning to London, he takes an extended tour of America by car.

March–May "The New Generation: 1964," featuring new Situationist abstraction and new Pop Art figuration, is held at Whitechapel Art Gallery, London. The exhibition includes works by Derek Boshier, Patrick Caulfield, Anthony Donaldson, David Hockney, John Hoyland, Paul Huxley, Allen Jones, Peter Phillips, Patrick Procktor, Bridget Riley, Michael Vaughan, and Brett Whiteley.

April A Francis Picabia retrospective is held at the Institute of Contemporary Arts, London.

April Jules Olitski's color field paintings are exhibited at Kasmin Ltd., London.

April–June "Painting & Sculpture of a Decade: 1954–64," organized by the Gulbenkian Foundation at the Tate Gallery, London, includes five works by Roy Lichtenstein.

May 18 Helen Frankenthaler's color field paintings are exhibited at Kasmin Ltd., London.

June 20–October 15 Joe Tilson is one of four artists representing Britain at the 32nd Venice Biennale in Italy.

July Eduardo Paolozzi's work on *As Is When* (published by Editions Alecto, May 1965), a portfolio of screenprints inspired by the writings of Ludwig Wittgenstein, marks the artist's shift from European to more American imagery; these silkscreen prints are influential on many other artists.

July Peter Phillips leaves London to visit New York, where he meets Robert Indiana and James Rosenquist. He later tours America with Allen Jones.

September–October Frank Stella's *Running Vs* is exhibited at Kasmin Ltd., London.

October 20–November 20 "Richard Hamilton, Paintings etc. '56–64" is held at Hanover Gallery, London. Hamilton, one of the originators of the Pop Art impulse, has his work reintroduced to the art public.

November "Gerald Laing" is held at the Institute of Contemporary Arts, London. Soon after, Laing leaves London to live in New York City.

November 15 Robert Fraser Gallery, London, exhibits works by Peter Blake, Derek Boshier, and Harold Cohen.

December "Jasper Johns: Paintings, Drawings, and Sculpture, 1954–64," organized by the Jewish Museum, New York," is held at Whitechapel Art Gallery, London.

fig. 179. Cover of the exhibition catalogue *Allen Jones Work* (1964), Arthur Tooth & Sons, Ltd., London.

fig. 180. Cover of the exhibition catalogue *The New Generation: 1964* (1964), Whitechapel Art Gallery, London.

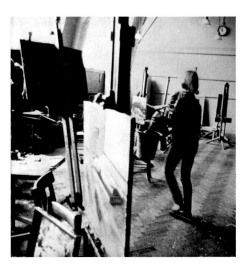

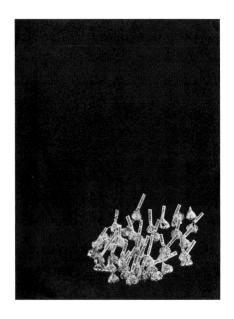

fig. 181. Cover partially opened to frontispiece of specialty publication *Pop Art One* (1965).

fig. 182. Announcement for "The Arena of Love" (January 5–February 1, 1965), Dwan Gallery, Los Angeles. Artists' names appear on paper strips wrapped in Hershey's chocolate kisses.

fig. 183. Cover of the exhibition catalogue *London: The New Scene* (1965), Walker Art Center, Minneapolis.

1965

U.S. President Lyndon Johnson escalates the war in Vietnam.

Antiwar protests are staged in Berkeley and New York. Young men begin burning their draft cards. Teach-ins launched at the University of Michigan start to spread to other university campuses across the country.

Race riots erupt in Watts, Los Angeles.

Tom Wolfe publishes *The Kandy-Colored-Tangerine-Flake Streamline Baby*.

Bob Dylan records the album *Highway 61 Revisited*.

Ralph Nader publishes *Unsafe at Any Speed*, an exposé of dangers in American automobile design.

Edward Ruscha publishes the book *Some Los Angeles Apartments*.

January 5–February 1 "The Arena of Love" at Dwan Gallery, Los Angeles, includes works by Allan D'Arcangelo, Roy Lichtenstein, Mel Ramos, Wayne Thiebaud, and Andy Warhol.

January 26–February 28 "Jasper Johns" is held at the Pasadena Art Museum in California.

January 29 Andy Warhol designs the cover of *Time* magazine using photographs taken in a photo booth.

February 2–March 6 "R. B. Kitaj: Paintings" is held at Marlborough Gerson Gallery, New York.

February 6–March 14 "London: The New Scene" is held at the Walker Art Center, Minneapolis, with a catalogue essay by Martin Friedman. Of the thirteen artists in the exhibition (which includes David Hockney, Allen Jones, Richard Smith, and Joe Tilson), Peter Blake is singled out as the only bona fide practitioner of Pop Art. The exhibition travels to Washington, D.C., Seattle, Vancouver, Boston, Toronto, and Ottawa.

February 23–April 25 Curator William Seitz's exhibition "The Responsive Eye" is presented at The Museum of Modern Art, New York. Devoted to "Op" art, the exhibition includes works by Joseph Albers, Ellsworth Kelly, Morris Louis, Larry Poons, Bridget Riley, Frank Stella, and others.

Spring Nicolas Calas' article "Why Not Pop Art?" appears in *Art and Literature* magazine.

March Customs agents in Canada charge a duty on Warhol's works that replicate Brillo, Mott's apple juice, and Kellogg's cornflakes boxes, declaring that they are not art.

March Peter Phillips and Gerald Laing exhibit their *Hybrid* project at Kornblee Gallery, New York.

March Allen Jones has an exhibition at Feigen-Palmer Gallery, Los Angeles.

March John Rublowsky's *Pop Art*, the first book devoted to American Pop Art, is published by Basic Books Inc., New York. It features Ken Heyman's photographs of Roy Lichtenstein, Claes Oldenburg, James Rosenquist, Andy Warhol, and Tom Wesselmann and also Pop collectors at home.

April–May 12 James Rosenquist exhibits the painting *F-111* at Leo Castelli Gallery, New York, in his first one-person exhibition at the gallery.

April 9–May 9 "Pop Art and the American Tradition" is held at the Milwaukee Art Center.

April 13–May 8 "Rauschenberg at Dwan" is held at Dwan Gallery, Los Angeles.

Summer *Artforum* magazine moves principal office from San Francisco to Los Angeles, where it occupies a space on North La Cienega Boulevard above Ferus Gallery.

August 10–September 5 "Larry Rivers Retrospective," organized by Sam Hunter, is held at the Pasadena Art Museum in California.

August 11– September 12 "R. B. Kitaj: Paintings and Prints" is held at the Los Angeles County Museum of Art.

Winston Churchill dies at the age of ninety-one.

British interest remains strong in the American space program as the Gemini missions commence with Gus Grissom and John Young, the first space walk by Edward White, Gordon Cooper and Pete Conrad, and a rendezvous mission with Frank Borman, James Lovell, Wally Schirra, and Thomas Stafford.

Fashion designer Mary Quant opens her first shop, Bazaar, in King's Road, London.

Len Deighton's novel *The Ipcress File* is published, introducing fictional working-class secret agent Harry Palmer.

Film premieres include Richard Lester's *The Knack* and Martin Ritt's *The Spy Who Came In From the Cold*, adapted from the John le Carre novel, with Richard Burton as a disillusioned spy.

The Beatles are awarded MBEs by Queen Elizabeth II.

David Bailey's book of photographs, *A Box of Pin-Ups*, includes the Beatles, the Kray Brothers (two violent East End criminals), and other "celebrities" of the period.

The Rolling Stones song "I Can't Get No Satisfaction" and The Who's "My Generation" are released.

January 20–February 19 Patrick Caulfield's first one-person exhibition is held at Robert Fraser Gallery, London.

February A large-format book, *Private View, The Lively World of British Art*, by Bryan Robertson and John Russell is published with photographs by Lord Snowdon.

March 30–May 1 Derek Boshier exhibits his optical paintings at Robert Fraser Gallery, London.

April The *Sunday Telegraph Colour Magazine* publishes the article "London, The Most Exciting City" by John Crosby and a review of "London: The New Scene," an exhibition in America of British Pop Art that opened at the Walker Art Center in Minneapolis.

April Kenneth Noland's *Chevrons* paintings are exhibited at Kasmin Ltd., London.

June Richard Hamilton begins making his replica of Marcel Duchamp's *The Bride Stripped Bare by Her Bachelors, Even (Large Glass)*.

June 1–July 3 "Jim Dine Recent Paintings" is held at Robert Fraser Gallery, London.

October 20–November 27 Peter Blake exhibits work at Robert Fraser Gallery, London.

November–December Gerald Laing begins printmaking at Tamarind Lithography Workshop in Los Angeles.

December "David Hockney: Pictures with Frames and Still Life Pictures," is held at Kasmin Ltd., London.

December Mario Amaya's *Pop as Art* is published by Studio Vista, London.

fig. 184. Cover of the exhibition catalogue *Jim Dine: Recent Paintings* (1965), Robert Fraser Gallery, London.

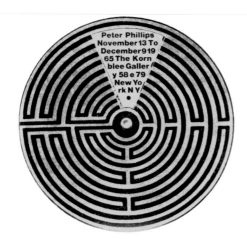

fig. 185. Cover of the exhibition catalogue *Ten from Rutgers University* (1965), Bianchini Gallery, New York.

fig. 186. Announcement for "Peter Phillips" (November 1965), Kornblee Gallery, New York. Metallicized cardboard disks with die-cut window and rotating images.

fig. 187. Jim Dine, cover and prints from the portfolio *A Tool Box* (1966).

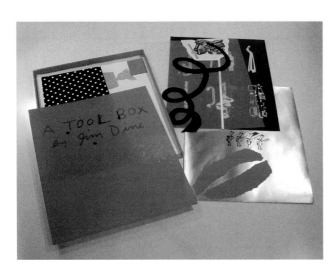

October Edward Ruscha begins doing graphic design work for *Artforum* under the pseudonym Eddie Russia; he continues until June 1969.

October 8–November 21 "Andy Warhol" retrospective is held at the Institute of Contemporary Art, University of Pennsylvania, Philadelphia. Four thousand people attend the opening (for security reasons, Warhol's paintings are removed from the gallery walls and floor before the opening in anticipation of the large crowd).

October 12–November 6 "Mel Ramos" is held at David Stuart Gallery, Los Angeles.

November Sidney Tillim's article "Further Observations on the Pop Phenomenon: 'All Revolutions Have Their Ugly Aspects'" appears in *Artforum*.

November–December "The English Eye" at Marlborough Gerson Gallery, Inc., New York, includes works by Peter Blake, R. B. Kitaj, and Joe Tilson, among other British artists.

November 13–December 9 "Peter Phillips," the artist's first one-person exhibition in the United States, is held at Kornblee Gallery, New York.

November 16 "Edward Ruscha" at Ferus Gallery, Los Angeles, features the artist's bird paintings.

November 20–December 11 "Roy Lichtenstein: Brushstrokes and Ceramics" at Leo Castelli Gallery, New York, includes the artist's brush stroke paintings and his ceramic works (heads and cups and saucers) done collaboratively with the potter Hui Ka Kwong.

December 18–January 12 "Ten from Rutgers University" at Bianchini Gallery, New York, includes work by Allan Kaprow, Roy Lichtenstein, Robert Watts, and Robert Whitman.

December "Word and Image," organized by Lawrence Alloway at the Solomon R. Guggenheim Museum, New York, includes works by Jim Dine, Robert Indiana, Roy Lichtenstein, and Edward Ruscha, among others.

1966

Bombing of Hanoi begins.

National Organization for Women (NOW) founded.

Batman, a new television series, makes its debut.

Andy Warhol's film *The Chelsea Girls*, a dual-screen projection, is released, the first of Warhol's films to receive national attention.

Edward Ruscha publishes his book *Every Building on the Sunset Strip*, a composite panoramic photograph.

Gregory Battcock's *The New Art* is published by Dutton, New York.

January–February Barbara Rose's article "Los Angeles: The Second City" appears in *Art in America*.

January 2–February 2 "Eduardo Paolozzi: Recent Sculpture" is held at Pace Gallery, New York.

January 15–February 5 "Master Drawings: Picasso to Lichtenstein" is held at Bianchini Gallery, New York.

March Jim Dine designs the sets and costumes, including his first heart motif, for a production of *A Midsummer's Night's Dream,* San Francisco Actors Workshop Guild in the Marines Memorial Theater, San Francisco.

March 15–April 8 "Joe Goode" at Nicholas Wilder Gallery, Los Angeles, features the artist's stair sculptures.

March 30–May 15 "Edward Kienholz" is held at the Los Angeles County Museum of Art. Due to controversy over Kienholz's *Back Seat Dodge '38,* the L. A. Board of Supervisors tries unsuccessfully to close the exhibition.

April Jim Dine, making his first trip abroad, travels to London. He works with Christopher Prater at Kelpra Studios and completes his first print portfolio, *A Tool Box,* which is published by Editions Alecto.

1966

Britons follow Gemini missions with Neil Armstrong and David Scott, Thomas Stafford and Gene Cernan, John Young and Michael Collins, Charles Conrad and Richard Gordon, and Buzz Aldrin and James Lovell.

The "Swinging London" era winds down as the U.K. economy enters a crisis.

A British football team defeats Germany in the World Cup match.

John Lennon meets conceptual artist Yoko Ono.

Eric Clapton, Jack Bruce, and Ginger Baker form the rock group Cream.

Michelangelo Antonioni's film *Blow Up*, set in London, is released.

January 26–February 19 "Los Angeles Now" at Robert Fraser Gallery, London, features eight artists from the Los Angeles area: Larry Bell, Wallace Berman, Bruce Conner, Llyn Foulkes, Dennis Hopper, Jess, Craig Kauffman, and Edward Ruscha.

February 20 The article "Faces of Pop" appears in *The Sunday Times Colour Magazine.*

March 22–April 16 "Works in Progress" at Robert Fraser Gallery, London, includes works by Richard Hamilton and Peter Blake.

March 27 *The London Observer Colour Magazine* features an Allen Jones painting on the cover and the article "The New Isms of Art: A Quick Guide to Modern Painting."

April 13 "London Under Forty" is organized by Jasia Reichardt at Gallery Milano.

April 15 The article "Swinging London" appears in *Time* magazine.

May 19 "Richard Smith," a retrospective exhibition, is held at Whitechapel Art Gallery, London.

June 18–July 31 "The Almost Complete Works of Marcel Duchamp," the first Duchamp retrospective in Europe, organized by Richard Hamilton at the invitation of the British Arts Council, is held at the Tate Gallery, London.

July 1 Pauline Boty dies.

July–August Two David Hockney exhibitions, "David Hockney: Preparatory Drawings of the Sets for the Production of *Ubu Roi* by Alfred Jarry" and "Twelve Etchings Inspired by Poems of C. P. Cavafy," are held at Kasmin Ltd., London.

September *Art in America* publishes an article by Reyner Banham, "Mobile Heraldry," discussing the customized painting of American racing cars and dragsters, with illustrations by Gerald Laing.

September 13–October 15 Collages by Jim Dine and Eduardo Paolozzi are exhibited at Robert Fraser Gallery, London. Scotland Yard seizes twenty-one Dine works on the basis of indecency charges.

October–November Richard Hamilton exhibits his *The Solomon R. Guggenheim* reliefs at Robert Fraser Gallery, London.

October–November Lawrence Alloway resigns his position at the Solomon R. Guggenheim Museum, New York over a disagreement on the selection of artists to represent the United States at the Venice Biennale.

November "Psychedelic" art and graphics begin to proliferate.

November "Frank Stella" is held at Kasmin Ltd., London.

November Gerald Laing's work moves into abstract painting and sculpture.

November 22–January 15 "Claes Oldenburg" is held at Robert Fraser Gallery, London.

December Artist Patrick Heron publishes "The Ascendancy of London in the Sixties" in *Studio International.*

fig. 188. Cover of the exhibition catalogue *Tilson* (1966), Marlborough Fine Art, New London Gallery, London.

fig. 189. Drawings by Gerald Laing [top and bottom of page] with American race car emblems, illustrating "Mobile Heraldry," *Art in America* (July 1966).

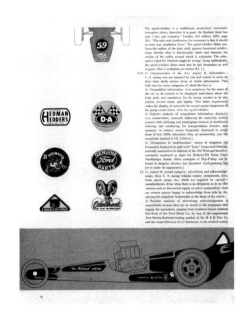

fig. 190. Cover jacket of the book *Pop Art* (1966), designed by James Rosenquist.

April Andy Warhol presents "Exploding Plastic Inevitable" with the rock band The Velvet Underground, a multimedia event including sound, image, and light projections, at Polsky Dom Narodny Hall in New York's East Village.

April 2–27 "Andy Warhol: Wallpaper and Clouds" at Leo Castelli Gallery, New York, features cow wallpaper and silver clouds (metallized polyester film inflated with helium).

April 25 *Newsweek* magazine publishes "The Story of Pop," devoting a special report to the subject.

Summer British artist Joe Tilson teaches at the School of Visual Arts, New York, and exhibits his prints at Marlborough Graphics, New York. Clive Barker visits New York for the first time.

June 18–October 16 American artists whose work appears at the Venice Biennale in Italy include Helen Frankenthaler, Ellsworth Kelly, Roy Lichtenstein, and Jules Olitski. Henry Geldzahler makes the selection.

July 15–September 5 "Ten from Los Angeles" at the Seattle Art Museum includes the work of Billy Al Bengston, Joe Goode, and Edward Ruscha.

July 25 Frank O'Hara, poet and curator, dies on Fire Island, New York.

Fall Claes Oldenburg makes first trip to London and designs a sculptural multiple titled *London Knees,* published in 1968 by Editions Alecto. In 1967 he makes designs for monumental floating toilet ballcocks: *Proposed Colossal Monument for Thames River: Thames "Ball."*

September 27 The Whitney Museum of American Art opens its new building designed by Marcel Breuer at 945 Madison Avenue, New York.

November 10 Barbara Rose moderates a panel discussion at New York University on the subject "Is Easel Painting Dead?" with Darby Bannard, Donald Judd, Larry Poons, and Robert Rauschenberg.

November *Pop Art* by Lucy Lippard is published as part of the Praeger World Art series, with essays by Lawrence Alloway, Nancy Marmer, and Nicolas Calas; it is published simultaneously in London by Thames and Hudson.

November Patrick Caulfield has his first one-person American exhibition at Robert Elkon Gallery, New York.

November 4–December 1 "Works by Roy Lichtenstein," the artist's first one-person museum exhibition, is held at the Cleveland Museum of Art.

1967 – CODA

First of several upcoming Vietnam War protest marches in Washington, D.C., takes place at the Pentagon; Norman Mailer records the event in *The Armies of the Night* (1969 Pulitzer Prize in Non-Fiction).

April 18–May 28 "Roy Lichtenstein," co-organized by the Walker Art Center, Minneapolis, is held at the Pasadena Art Museum in California.

April 28–October 27 At Expo '67 in Montreal, Canada, the United States Pavilion includes the exhibition "American Painting Now" with works by Allan D'Arcangelo, Jim Dine, Robert Indiana, Nicholas Krushenick, Jasper Johns, Roy Lichtenstein, Robert Rauschenberg, James Rosenquist, Andy Warhol, and Tom Wesselmann.

May 1–31 "Richard Hamilton Paintings, 1964–1967," the artist's first American exhibition, is held at Alexander Iolas Gallery, New York.

Summer *Artforum* moves from Los Angeles to New York.

June Jim Dine leaves New York and moves to London for three years.

Winter Andy Warhol prepares for February 1968 move of The Factory from 231 East 47th Street to 33 Union Square West, New York.

December 12–January 13, 1968 "Gunpowder Drawings—Edward Ruscha," the artist's first one-person exhibition in New York, is held at Alexander Iolas Gallery, New York.

BBC 2 Television broadcasts in color for the first time.

Mick Jagger and art dealer Robert Fraser are arrested on drug charges; Richard Hamilton appropriates a tabloid photo of the two men in a police van for his series entitled "Swingeing London" (alternate spelling refers to corporeal punishment).

An open letter, published in the *London Times,* declaring "the law against marijuana is immoral in principle and unworkable in practice," is signed by sixty-four personalities, including the Beatles, David Hockney, Derek Boshier, and Graham Greene.

March Peter Blake and Jann Haworth design the cover tableau for the Beatles' *Sgt. Pepper's Lonely Hearts Club Band* album.

May The article "What Ever Happened to British Pop?" by Edward Lucie-Smith appears in *Art and Artists* magazine.

Summer "Joe Goode" is held at Rowan Gallery, London.

June The article "The American Invasion and The British Response" by Allen Bowness appears in *Studio International* magazine.

November 2 The Royal College of Art celebrates its Royal Charter and new university status by installing its first provost. The first official visitor is the Duke of Edinburgh, and the *London Times* publishes an eight-page history of the college. The Establishment appropriates the anti-Establishment.

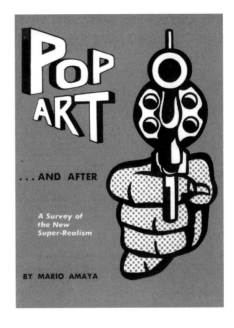

fig. 191. Cover jacket of the book *Pop Art ... and After* (1966). Work shown is Roy Lichtenstein, *Pistol* (1964).

fig. 192. Tableaux for the album cover of the Beatles' *Sgt. Pepper's Lonely Hearts Club Band* (1966–67), designed by Peter Blake and Jann Haworth (with photographer Michael Cooper). © Apple Corps Ltd.

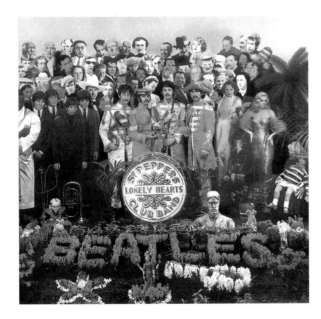

Selected Bibliography

EXHIBITION CATALOGUES

Alloway, Lawrence. *American Pop Art*. New York and London: Collier Books and Collier/Macmillan, in association with the Whitney Museum of American Art, 1974.

_____. *Six More*. Los Angeles: Los Angeles County Museum of Art, 1963.

_____. *Six Painters and the Object*. New York: Solomon R. Guggenheim Museum, 1963.

Alloway, Lawrence, and Marco Livingstone. *Pop Art: U.S.A.–U.K.* Toyko: Odakyu Grand Gallery, 1987.

Atkinson, Tracy. *Pop Art and the American Tradition*. Wisconsin: Milwaukee Art Center, 1965.

Auping, Michael. *Jess: Paste-Ups (and Assemblies) 1951–1983*. Sarasota, Fla.: The John and Mable Ringling Museum of Art, 1983.

Ayres, Anne. *LA Pop in the Sixties*. Newport Harbor, Calif.: Newport Harbor Art Museum, 1989.

Bois, Yve-Alain. *Edward Ruscha: Romance with Liquids/ Paintings 1966–1969*. Interview of the artist by Walter Hopps. New York: Rizzoli and Gagosian Gallery, 1993.

British Art Today. Essay by Lawrence Alloway. San Francisco: San Francisco Museum of Art, 1963.

Buchloh, Benjamin H. *Andy Warhol's One-Dimensional Art 1956–1966*. New York: The Museum of Modern Art, 1989.

Burnside, Madeleine. *Jess*. New York: Odyssia Gallery, and San Francisco: John Berggruen Gallery, 1989.

Carey, Martin. *The New American Realism*. Worchester, Mass.: Worchester Art Museum, 1965.

Celant, Germano, and Clare Bell. *Jim Dine: Walking Memory 1959–1969*. New York: Solomon R. Guggenheim Museum, 1999.

Claes Oldenburg: An Anthology. Essays by Germano Celant, Dieter Koepplin, and Mark Rosenthal. Washington, D.C.: National Gallery of Art, and New York: Solomon R. Guggenheim Museum, 1995.

Compton, Michael, Robert Melville, and Nicholas Usherwood. *Peter Blake*. London: Tate Gallery, 1983.

Coplans, John. *Pop Art USA*. California: Oakland Art Museum, 1963.

_____. *Roy Lichtenstein*. California: Pasadena Art Museum, 1967.

Crichton, Michael. *Jasper Johns*. New York: Harry N. Abrams, with the Whitney Museum of American Art, 1977.

The Expendable Ikon: Works by John McHale. Essay by Lawrence Alloway. Buffalo, N.Y.: Albright-Knox Art Gallery, 1984.

Fahlström, Öyvind. *New Paintings by Jim Dine*. New York: Sidney Janis Gallery, 1963.

Gallery Notes (brochure). Essays by Douglas MacAgy and Lawrence Alloway. Buffalo, N.Y.: Albright-Knox Art Gallery, 1963.

Garlake, Margaret. *New Art New World: British Art in Post-war Society*. New Haven and London: Paul Mellon Center for Studies in British Art, Yale University, 1998.

Garner, Thomas H. *Tom Wesselmann: Early Still Lifes: 1962–1964*. Newport Harbor, Calif.: Newport Harbor Art Museum, 1971.

Geldzahler, Henry. *New York Painting and Sculpture 1940–1970*. New York: E. P. Dutton, with the Metropolitan Museum of Art, 1969.

Glimcher, Mildred. *Indiana, Kelly, Martin, Rosenquist, Youngerman at Coenties Slip*. New York: Pace Gallery, 1993.

Goldman, Judith. *James Rosenquist: The Early Pictures 1961–1964*. New York: Rizzoli and Gagosian Gallery, 1992.

_____. *The Pop Image: Prints and Multiples*. New York: Marlborough Graphics, 1994.

Gordon, John. *Jim Dine*. New York: Whitney Museum of American Art, 1970.

Hamilton, Richard. *Richard Hamilton*. New York: Solomon R. Guggenheim Museum, 1973.

Hand-Painted Pop: American Art in Transition 1955–1962. Essays by David Deitcher, Stephen Foster, Dick Hebdige, Linda Norden, Kenneth E. Silver, and John Yau. New York: Rizzoli, with the Los Angeles Museum of Contemporary Art, 1993.

Haskell, Barbara. *Blam! The Explosion of Pop, Minimalism, and Performance 1958–1964*. New York: W. W. Norton & Company, with the Whitney Museum of American Art, 1984.

Hickey, Dave, and Peter Plagens. *The Works of Edward Ruscha*. New York: Hudson Hills, with San Francisco Museum of Modern Art, 1982.

The Highway. Philadelphia: Institute of Contemporary Art, University of Pennsylvania, 1970.

Image in Progress. Essay by Jasia Reichardt. London: Grabowski Gallery, 1962.

The International Exhibition of the New Realists. Essays by Sidney Janis, John Ashbery, and Pierre Restany. New York: Sidney Janis Gallery, 1962.

Joe Goode: Work Up Until Now. Fort Worth: Fort Worth Art Center Museum, 1972.

Joe Goode: Works on Paper 1960–1973. Los Angeles: Manny Silverman Gallery, 1998.

Lipman, Jean, and Richard Marshall. *Art About Art*. New York: E. P. Dutton, with the Whitney Museum of American Art, 1978.

Livingstone, Marco. *Patrick Caulfield: Paintings 1963–81.* London: Tate Gallery, 1981.

_____. *Retrovision: Peter Phillips Paintings 1960–82.* Liverpool: Walker Art Center, 1982.

London: The New Scene. Essay by Martin Friedman. Minneapolis: Walker Art Center, 1965.

MacAgy, Douglas. *1961.* Dallas: Dallas Museum for Contemporary Arts, 1962.

_____. *Pop Goes the Easel.* Houston: Contemporary Arts Museum, 1963.

Marter, Joan. *Off Limits: Rutger's University and the Avant-Garde 1957–1963.* Newark, N.J.: Newark Museum, 1999.

McShine, Kynaston. *Andy Warhol: A Retrospective.* New York: The Museum of Modern Art, 1989.

Mel Ramos: A Twenty-Year Survey. Waltham, Mass.: Rose Art Museum, Brandeis University, 1980.

Mellor, David. *The Sixties Art Scene in London.* London: Phaidon, 1993.

Mixed Media and Pop Art. Foreword by Gordon M. Smith. Buffalo, N.Y.: Albright-Knox Art Gallery, 1963.

My Country 'Tis of Thee. Essay by Gerald Nordland. Los Angeles: Dwan Gallery, 1962.

Nathanson, Carol, and Nina Sundell. *American Pop Art and the Culture of the Sixties.* Cleveland: New Gallery of Contemporary Art, 1976.

New Forms–New Media. Essays by Martha Jackson, Lawrence Alloway, and Allan Kadron. New York: Martha Jackson Gallery, 1960.

The New Generation: 1964. London: Whitechapel Art Gallery, 1964.

Peter Phillips: 1962–1997. Palma, Spain: Casal Solleric, 1997.

Pop Art: An International Perspective. Edited by Marco Livingstone. London: Royal Academy of the Arts, 1991.

Popular Art. Essay by Ralph T. Coe. Kansas City, Mo.: William Rockhill Nelson Gallery and Atkins Museum of Art, 1963.

the popular image. Essay by Alan Solomon. London: Institute of Contemporary Arts, 1963.

Quintavalle, Arturo Carlo. *Joe Tilson.* Parma, Italy: Istituto di Storia dell'Arte, University of Parma, 1974.

R. B. Kitaj: A Retrospective. Edited by Richard Morphety. London: Tate Gallery, 1994.

Radical Past: Contemporary Art & Music in Pasadena, 1960–1974. Pasadena, Calif.: Armory Center for the Arts and Art Center College of Design, 1999.

Robbins, David. *The Independent Group: Postwar Britain and the Aesthetics of Plenty.* Cambridge and London: MIT Press, 1990.

Robert Indiana. Introduction by John W. McCoubrey. Philadelphia: Institute of Contemporary Art, University of Pennsylvania, 1968.

Robert Indiana, Retrospective 1958–1998. Nice: Musée d'art moderne et d'art Contemporain, 1998.

Rose, Barbara. *Claes Oldenburg.* New York: The Museum of Modern Art, 1970.

Seitz, William C. *The Art of Assemblage.* New York: The Museum of Modern Art, 1961.

Solomon, Alan. *The Popular Image Exhibition.* Washington, D.C.: Washington Gallery of Modern Art, 1963.

Starr, Sandra L. *Lost and Found in California: Four Decades of Assemblage Art.* Santa Monica, Calif.: James Corcoran Gallery, 1988.

Stich, Sidra. *Made in USA: An Americanization in Modern Art, The '50s and '60s.* Berkeley: University Art Museum, University of California Press, 1987.

Sunshine & Noir: Art in LA 1960–1997. Humlebaek, Denmark: Louisiana Museum of Modern Art, 1997.

This Is Tomorrow. Essay by Richard Hamilton, et al. London: Royal College of Art, 1956.

Tilson. Rotterdam: Boymans-van Beuningen Museum, 1973.

Tuchman, Maurice. *Art in Los Angeles: Seventeen Artists in the Sixties.* Los Angeles: Los Angeles County Museum of Art, 1981.

Tucker, Marcia. *James Rosenquist.* New York: Whitney Museum of American Art, 1972.

Waldman, Diane. *Roy Lichtenstein.* New York: Solomon R. Guggenheim Museum, 1969.

_____. *Roy Lichtenstein.* New York: Solomon R. Guggenheim Museum, 1994.

Young Contemporaries 1966. Introduction by Anton Ehrenzweig. London: Arts Council of Great Britain, 1966.

BOOKS

Altshuler, Bruce. "Pop Art Triumphant: A New Realism." In *The Avant-Garde in Exhibition: New Art in the 20th Century.* New York: Harry N. Abrams, 1994.

Amaya, Mario. *Pop Art . . . and After: A Survey of the New Super-Realism.* New York: Viking, 1966. Published in Britain in 1965 as *Pop as Art: A Survey of the New Super Realism.*

Bernstein, Roberta. *Jasper Johns' Paintings and Sculptures 1954–1974: The Changing Focus of the Eye*. Ann Arbor, Mich.: UMI Press, 1985.

Bourdon, David. *Warhol*. New York: Harry N. Abrams, 1989.

Calas, Nicolas, and Elena Calas. *Icons and Images of the Sixties*. New York: E. P. Dutton, 1971.

Compton, Michael. *Pop Art*. London: Hamlyn, 1970.

Compton, Michael, and Marco Livingstone. *Tilson*. London: Thames and Hudson, 1992.

Coplans, John. *Provocations: Writings by John Coplans*. Edited by Stuart Morgan. London: London Projects, 1996.

_____. *Roy Lichtenstein*. Documentary Monographs in Modern Art (ed. Paul Cummings). New York and Washington, D.C.: Praeger, 1972.

Crow, Thomas. *The Rise of the Sixties: American and European Art in the Era of Dissent*. New York: Harry N. Abrams, 1996.

Finch, Christopher. *Image as Language: Aspects of British Art 1950–1968*. London: Penguin, 1969.

_____. *Pop Art: Object and Image*. London: Studio Vista, 1968.

Hall, Stuart, and Paddy Whannel. *The Popular Arts*. London: Hutchinson Educational, 1964.

Hamilton, Richard. *Collected Words 1953–1982*. London: Thames and Hudson, 1982.

Hockney, David. *David Hockney by David Hockney*. Edited by Nikos Stangos. London: Thames and Hudson, 1976.

Hunter, Sam. *Tom Wesselmann*. Barcelona: Ediciones Poligrafa, S.A., 1995.

Johnson, Ellen H. *Claes Oldenburg*. Baltimore: Penguin New Art 4, 1971.

Leslie, Richard. *Pop Art: A New Generation of Style*. New York: Todtri Productions, 1977.

Lippard, Lucy, with contributions by Lawrence Alloway, Nicolas Calas, and Nancy Marmer. *Pop Art*. New York and Washington, D.C.: Praeger, 1966.

Lippard, Lucy, with introduction by William Rubin. *Three Generations of Twentieth-Century Art: The Sidney and Harriet Janis Collection of The Museum of Modern Art*. New York: The Museum of Modern Art, 1972.

Livingstone, Marco. *Pop Art: A Continuing History*. New York: Harry N. Abrams, 1990.

_____, ed. *The Pop 60's: Transatlantic Crossing*. Lisbon: Centro Cultural de Belém, 1997.

Livingstone, Marco, with Jim Dine. *Jim Dine, The Alchemy of Images*. New York: The Monacelli Press, 1998.

Madoff, Steven Henry, ed. *Pop Art: A Critical History*. The Documents of Twentieth-Century Art (ed. Jack Flam). Berkeley, Los Angeles, and London: University of California Press, 1997.

Mamiya, Christin J. *Pop Art and Consumer Culture: American Super Market*. Austin: University of Texas Press, 1992.

Melly, George. *Revolt into Style: The Pop Arts in Britain*. London: Penguin, 1970.

Mulas, Ugo. *New York: The New Art Scene*. Text by Alan Solomon. New York: Holt, Rinehart, and Winston, Inc., 1967.

Oldenburg, Claes. *Store days: documents from the Store 1961 and Ray Gun Theater 1962*. New York: Something Else Press, 1967.

Osterwold, Tilman. *Pop Art*. Koln: Taschen, 1999.

Ratcliff, Carter. *Andy Warhol*. New York: Abbeville Press, 1983.

Rosenberg, Harold. *The De-Definition of Art: Action Art to Pop to Earthworks*. New York: Horizon, 1972.

Rosenblum, Robert. *Mel Ramos: Pop Art Images*. Bonn: Taschen, 1997.

Rublowsky, John. *Pop Art*. New York: Basic, 1965.

Russell, John, and Suzi Gablik. *Pop Art Redefined*. New York and Washington, D.C.: Praeger, 1969.

Schneede, Uwe M. *Paolozzi*. New York: Harry N. Abrams, Inc., 1970.

Seago, Alex. *Burning the Box of Beautiful Things*. London: Oxford University Press, 1995.

Seitz, William C. *Art in the Age of Aquarius 1955–1970*. Washington, D.C., and London: Smithsonian Institution Press, 1992.

Sinclair, Andrew. *In Love and Anger: A View of the Sixties*. London: Sinclair-Stevenson, 1994.

Varnedoe, Kirk, and Adam Gopnik. *Modern Art and Popular Culture: Readings in High and Low*. New York: The Museum of Modern Art, 1990.

Waldman, Diane. *Roy Lichtenstein*. New York: Abbeville Press, 1983.

Walker, John A. *Cultural Offensive: America's Impact on British Art Since 1945*. London and Sterling, Va.: Pluto Press, 1998.

Warhol, Andy, and Pat Hackett. *POPism: the Warhol '60s*. New York: Harcourt Brace Jovanovich, 1980.

Webb, Peter. *Portrait of David Hockney*. New York: E. P. Dutton, 1988.

Weinhardt, Carl J. Jr. *Robert Indiana*. New York: Harry N. Abrams, 1990.

JOURNAL ARTICLES

Banham, Reyner. "Representations in protest." *Newsociety*, 13 (May 8, 1969), pp. 717–18.

Benchley, Peter. "The Story of Pop, what it is and how it came to be." *Newsweek* (April 25, 1966), pp. 56–61.

Campbell, Lawrence. "Rosalyn Drexler." *Art News*, vol. 63, no. 1 (March 1964), pp. 30–31, 63–64.

Canaday, John. "Pop Art Sells On and On—Why?" *New York Times Magazine*, May 31, 1964, sec. 6, pp. 7, 48, 52–53.

Coplans, John. "The New Paintings of Common Objects." *Artforum* (November 1962), pp. 26–29.

Factor, Don. "An Exhibition of Boxes." *Artforum*, vol. 11, no. 10 (April 1964), pp. 21–23.

Green, Hannah. "A Journal in the Praise of the Art of John Wesley." *The Unmuzzled Ox*, vol. 11, no. 3 (1974), pp. 46–65.

Hamilton, Richard. "For the Finest Art try—Pop!" *Gazette* (London), no. 1 (1961), p. 3.

_____. "Personal Statement." *ARK*, no. 19 (Spring 1957), pp. 28–29.

Heron, Patrick. "The Ascendancy of London in the Sixties." *Studio International* (December 1966), pp. 280–81.

Hopps, Walter. "An Interview with Jasper Johns." *Art Forum*, 3 (March 1965), pp. 33–36.

Judd, Donald. "John Wesley." *Arts,* vol. 37 (April 1963), p. 51.

Karp, Ivan. "Anti-Sensibility Painting." *Art Forum*, 2 (September 1963), pp. 26–27.

Leider, Philip. "Joe Goode and the Common Object." *Art Forum*, vol. 4, no. 7 (March 1966), pp. 24–27.

Lynton, Norbert. "Addressing Pop." *The Royal Academy Magazine*, no. 32 (Autumn 1991), pp. 25–29.

Melville, Robert. "The Durable Expendables of Peter Blake." *Motif*, no. 10 (Winter 1962–63), pp. 14–35.

_____. "English Pop Art." *Quadrum* (Brussels), no. 17 (1964), p. 23–38, 182–83.

Norland, Gerald. "Pop Goes the West." *Arts Magazine*, 37 (February 1963), pp. 60–62.

"Pop Art." *Art & Design* (special issue). Edited by Andreas Papadakis. London: Academy Editions, 1992.

Read, Herbert. "Disintegration of Form in Modern Art." *Studio International* (New York), vol. 169, no. 864 (April 1965), pp. 144–55.

Reichardt, Jasia. "Pop Art and After." *Art International,* vol. 7, no. 2 (February 1963), pp. 42–47.

Richardson, John Adkins. "Dada, Camp, and the Mode Called Pop." *Journal of Aesthetics and Art Criticism,* vol. 24, no. 4 (Summer 1966), pp. 549–55.

Russell, John. "Art News from London." *Art News* (May 1957), p. 57.

_____. "Art News from London." *Art News* (January 1960), p. 53.

_____. "Art News from London." *Art News*, 61 (March 1962), p. 46.

_____. "The Arts and the Mass Media." *Architectural Design,* 28 (February 1958), pp. 84–85.

_____. "City Notes." *Architectural Design*, 29 (January 1959), pp. 34–35.

_____. "London/NYC: The Two-Way Traffic." *Art in America*, no. 2 (April 1965), p. 130.

_____. "Notes on Abstract Art and the Mass Media." *Art Notes and Review*, no. 12 (February 1960), pp. 3–12.

_____. "Pop Art Since 1949." *The Listener* (London), vol. 68, no. 1961 (1962), pp. 1085–87.

_____. "Pop Reappraised." *Art in America* (July–August 1969), pp. 78–79.

_____. "Tenth Street and the Thames." *Art in America*, vol. 52, no. 2 (April 1964), pp. 74–76.

Selz, Peter, with Henry Geldzahler, Hilton Kramer, Dore Ashton, Leo Steinberg, and Stanley Kunitz. "A Symposium on Pop Art." *Arts Magazine*, no. 37 (April 1963), pp. 36–44.

Simon, Sidney. "From England's Green and Pleasant Bowers." *Art News* (April 1965), pp. 29–64.

Smithson, Alison and Peter. "But Today We Collect Ads." *ARK*, no. 18 (Autumn 1956), pp. 48–50.

Swenson, G. R. "The New American Sign Painters." *Art News*, vol. 61, no. 5 (September 1962), pp. 44–47.

_____. "What Is Pop? Part 1." *Art News*, vol. 62, no. 7 (November 1963), pp. 24–27, 60–65.

_____. "What Is Pop? Part 2." *Art News*, vol. 62 no. 10 (February 1964), pp. 40–43, 62–67.

Sylvester, David. "Art in a Coke Climate." *The Sunday Times Colour Magazine*, January 26, 1964, pp. 14–23.

_____. "'British Painting Now': Dark Sunlight." *The Sunday Times Colour Magazine*, June 2, 1963, pp. 3–14.

_____. "The Kitchen Sink." *Encounter* (December 1954).

Index

Photography Credits

Courtesy Alan Cristea Gallery: pl. 52

© Allen Memorial Art Museum, Oberlin College, Ohio. Ellen H. Johnson Bequest, 1998: pl. 39

Damian Andrus: pl. 26

© Apple Corps Ltd.: fig. 192

Courtesy *Art News*: fig. 140

Courtesy *Artforum*: fig. 111

Courtesy of BBC Picture Library: figs. 51–59

Courtesy Billy Al Bengston: fig. 96

Ben Blackwell: pl. 13

Courtesy Terry Blake: pl. 3

Chris Bliss: pl. 28

Courtesy Frederik R. Brandt: pl. 22

Courtesy David Brauer: figs. 43, 44

The Bridgeman Art Library, London: figs. 16, 23

Courtesy Broad Art Foundation: pl. 42

Rudolph Burckhardt, courtesy Estate of Roy Lichtenstein: fig. 102

Richard Caspole: pls. 50, 51

Lee Clockman: pl. 47

Ken Cohen: pl. 49

© 1986 D. James Dee: pl. 23

Courtesy England & Co. Gallery, London: fig. 40

Tony Evans, Timelapse Library Limited, Recloses, France: pages 4, 7, 19, 110; figs. 6, 8, 10, 12, 17, 38, 60–63, 72, 113, 114, 162

Courtesy Fredericks Freiser Gallery: pl. 38

Robert Freeman: cover, page 111

Courtesy Galerie Bischofberger: pl. 48

© Gaumont British: fig. 132

Courtesy Granada Television: fig. 9

Courtesy Richard Hamilton: pl. 1; figs. 1, 46–49, 139, 141

David Heald and Carmelo Guadagno © The Solomon R. Guggenheim Foundation, New York (FN 67.1859.1): pl. 55

Biff Hendrich/Keystone, Buffalo, NY: pls. 9, 53; fig. 112

Courtney Herman: pl. 12

Paul Hester, Houston: pls. 20, 35, 40; figs. 26, 108, 117

Ken Heyman, New York, courtesy of Woodfin Camp & Associates, Inc.: pages 5, 8–9; figs. 85, 88, 90, 126

Hickey-Robertson, Houston: pl. 45; figs. 100, 124

Courtesy Hirshhorn Museum and Sculpture Garden, Smithsonian Institution, Gift of the Joseph H. Hirshhorn Foundation, 1966: pl. 19

George Hixson, Houston: pls. 6, 15, 16, 41; figs. 36, 37, 94

Courtesy David Hockney: fig. 5, pls. 7, 54

Martha Holmes, courtesy *Time* and *Life*, Inc.: fig. 81

Dennis Hopper, Alta Light Productions, courtesy the artist and Tony Shafrazi, New York: figs 32, 33, 69, 93, 110

Courtesy John Kasmin, London: fig. 66

Carl Kaufman, Yale University Art Gallery, New Haven: pl. 11

Courtesy Nancy Reddin Kienholz: figs. 136, 149

Reprinted with special permission of King Features Syndicate: fig. 35

Courtesy Kunstverein, Hamburg: fig. 177

Courtesy Gerald Laing: figs. 74, 172, 189

Jack Laxer: fig. 128

Courtesy Leo Castelli Gallery: fig. 87

Courtesy Estate of Roy Lichtenstein, New York: fig. 109

John Loengard/*Life*/*Timepix*: fig. 103

Courtesy Ludwig Forum, Aachen: fig. 25

Gered Mankowitz © Topham/The Image Works: fig. 133

Courtesy Manny Silverman Gallery, Los Angeles: fig. 119

Courtesy The Mayor Gallery, London: pl. 31

© Fred W. McDarrah, New York, NY: page 6; figs. 27, 80, 115

Photographs © Robert R. McElroy, Licensed by VAGA, New York, NY: figs. 82, 83, 152

Menil Archives, Rosalind Constable Papers: figs. 2–4, 29, 65, 71, 95, 97, 105, 127, 131, 134, 138, 142–44, 147, 148, 151, 153, 155, 157–61, 163–68, 170, 171, 174–76, 178–80, 182–86, 188

Menil Archives, Rosalind Constable Papers, courtesy Claes Oldenburg and Coosie van Bruggen: figs. 151, 170

The Menil Collection, Houston: figs. 137, 169, 181

Courtesy the Modern Art Museum of Fort Worth: pl. 10

Ugo Mulas, Archivio Ugo Mulas, Milan: pages 18, 226–27; fig. 91

Courtesy Museum of Fine Arts, Houston; Target Collection of American Photography. Museum purchase with funds provided by Target Stores: fig. 104

© 2001 The Museum of Modern Art, New York: pl. 44; figs. 24, 77

Hans Namuth Estate, New York: fig. 86

NASA, National Aeronautics and Space Administration: fig. 118

© The National Gallery Picture Library, London: fig. 135

©1966 *Newsweek*, Inc. All rights reserved. Reprinted by permission: fig. 73

Kevin Noble: fig. 18

Courtesy Norton Simon Museum, Pasadena: fig. 28, pls. 34, 57

Courtesy Odyssia Gallery, New York: fig. 89

Gene Ogami: pl. 5

Courtesy Claes Oldenburg and Coosie van Bruggen: pls. 12, 39; figs. 110

Courtesy Michael Parkin Fine Art, Ltd., London: fig. 41

Courtesy Peter Phillips: figs. 14, 15, 75

Eric Pollitzer, courtesy Peter Phillips: fig. 75

© Praeger Publishers: fig. 190

Courtesy *Private Eye*: fig. 39

Prudence Cuming Associates, Ltd., London: pl. 43

Don Quaintance: Fig. 187

Courtesy Mel Ramos: fig. 130

© Rheinisches Bildarchiv: pls. 29, 32

© Seymour Rosen, Los Angeles: figs. 34, 149

Courtesy James Rosenquist: figs. 84, 154

Courtesy Edward Ruscha: pl. 4; figs. 98, 99

Neal Sacharow: pls. 21, 37

Courtesy Salander-O'Reilly Galleries, New York: fig. 107

Delmore E. Scott: fig. 125

Photo by Jerry Shatzberg, courtesy of Glamour, Condé Nast Archives: fig. 129

Walt Silver: fig. 147

Courtesy the Swindon Museum and Art Gallery: pl. 33

Courtesy Sylvia Sleigh: fig. 45

Courtesy Staatsgalerie, Stuttgart: fig. 31

Lee Stalsworth, courtesy Hirshhorn Museum and Sculpture Garden, Smithsonian Institution, Gift of the Joseph H. Hirshhorn Foundation, 1972: pl. 46

Jim Strong, Wantagh, New York: figs. 64, 78

The Sunday Times, London: figs. 70, 156

David Sundberg: pl. 8

Tate Gallery Archives: fig. 68

© 2000 Tate, London: figs. 11, 20–22, 42, 122, 123

Frank J. Thomas Archives: figs. 76, 79, 92, 101, 120

Tom Powel Imaging: pl. 27

Piotr Tomczyk, Lodz: pls. 17, 18

© Twentieth-Century Fox: fig. 146

© Viking Press: fig. 191

© 1993 Warner Bros. Records: fig. 106

Katherine Wetzel: pl. 30

© Courtesy Whitford Fine Art and The Mayor Gallery, London: fig. 13

Courtesy The Whitworth Art Gallery, University of Manchester, England: figs. 7, 19

Janet Woodward, Houston: pl. 14

Editor: Polly Koch
Design: Don Quaintance, Public Address Design
Design/production assistant: Elizabeth Frizzell
Typography: Frutiger (display) and Rotation (text)
Halftones and color separations: C+S Repro,
 Filderstadt-Plattenhardt, Germany
Printing: Cantz Druckerei, Ostfildern-Ruit, Germany